The publisher gratefully acknowledges the generous contributions of the following organizations and individuals in support of this book:

The Cultural Foundation, Abu Dhabi, United Arab Emirates

The Samuel H. Kress Foundation
D. F. Hepburn
David M. Ransom and Marjorie Ransom
Mildred Mack

The publisher also expresses appreciation to the Art Book Endowment Fund of the Associates of the University of California Press, which is supported by a major gift from the Ahmanson Foundation.

BAZAAR *to* PIAZZA

BAZAAR *to* PIAZZA

ISLAMIC TRADE AND ITALIAN ART, 1300–1600

Rosamond E. Mack

UNIVERSITY OF CALIFORNIA PRESS BERKELEY LOS ANGELES LONDON

Title page illustration: Detail of "Lotto" carpet, Anatolia,
sixteenth century (Fig. 83), Saint Louis Art Museum.

University of California Press
Berkeley and Los Angeles, California
University of California Press, Ltd.
London, England
© 2002 by the Regents of the University of California
Library of Congress Cataloging-in-Publication Data
Mack, Rosamond E.
 Bazaar to piazza : Islamic trade and Italian art,
 1300–1600 / Rosamond E. Mack.
 p. cm.
 Includes bibliographical references and index.
 ISBN 0-520-22131-1 (cloth : alk. paper)
 1. Decorative arts, Renaissance—Italy. 2. Decorative
arts—Italy—Oriental influences. 3. Decorative arts,
Islamic—Influence. 4. Italy—Commerce—Orient.
I. Title.
NK959.M267 2002
745'.0945'09024—dc21
 2001027286
 CIP

Printed and bound in Singapore
11 10 09 08 07 06 05 04 03 02
10 9 8 7 6 5 4 3 2 1
The paper used in this publication meets the
minimum requirements of ANSI/NISO
Z39.48-1992 (R 1997) (Permanence of Paper). ∞

To my parents,
Alexander Hoyt Pratt
and Dorothy Davis Pratt

Contents

■■■■■■■■■■■■■■■■■■■■■■■■■■■■■■■■■■■■ ■

Preface and Acknowledgments

■ ■

THIS BOOK JOINS MY WORK AS AN ITALIAN RENAISSANCE art historian with years of direct contact with Islamic civilization and the ways of international trade, diplomacy, and cultural exchange as a Foreign Service spouse. The project began as lectures on East-West artistic transfer given at the National Gallery of Art, Washington, in 1991, and grew during seven years of independent research at various libraries and museums. My purpose is to link a wide range of art works and specialized scholarship to make this complex subject accessible to a broad readership. Because the material is so vast, there are bound to be omissions and errors. I hope these will stimulate further discussion.

The notes, captions, and picture credits name the numerous institutions that assisted my work as well as the many individuals. In addition, I am indebted to the distinguished public research facilities and expert librarians who made this book possible. David Alan Brown, Esin Atil, and Paul Barolsky provided essential advice and encouragement as I began the project and

continuing multifaceted support as I completed it. Deborah Howard, Linda Safran, Mary Yakush, and Richard Parker helped to resolve issues that arose midway. Patricia Fortini Brown carefully read the entire manuscript, generously offering wise suggestions and some pointed criticism. I am also grateful to other, anonymous, readers, whose sensitive, constructive comments benefited the book. For help in acquiring illustrations, I thank Janet Smith, Graziella Berti, Lucia Tongiorgi Tomasi, Stefano Carboni, Jeffrey Spurr, Dennis Foster, Stephen Kimmel, Mary Ann Whitten, and Ellie Hickerson. My editor Stephanie Fay has expertly guided my manuscript into a book, contributing countless improvements. Despite so much assistance, this book would not have come to light without the faith and generosity of the donors named in its opening pages.

Finally, my deepest thanks go to my husband, David, who took me to the world east of Italy, supported my studies in every possible way, listened to evolving ideas, and smoothed my prose.

Introduction

■■■

> Really all Christendom could be supplied for a year with the merchandise of
> Damascus. . . . There are such rich and noble and delicate works of every kind
> that if you had money in the bone of your leg, without fail you would break it
> to buy of these things. —SIMONE SIGOLI, *FLORENTINE PILGRIM, 1384*[1]

A WEALTHY FLORENTINE LIKE SIMONE SIGOLI DID NOT have to travel to the bazaars of Damascus to acquire the alluring merchandise he described, because Italian merchant galleys were bringing huge quantities to European markets. Between 1300 and 1600, the international luxury trade had a broad impact on Italian artistic taste and development, inspiring tremendous improvements and new variety in the decorative arts—textiles, ceramics, glass, leatherwork, lacquer, and brassware. Even after Italian Renaissance versions of these luxury objects attained international renown, Italians continued to collect, imitate, and adapt imported Oriental art objects.

The imports here called Oriental came from China and from Islamic lands stretching from Spain across North Africa to Syria, Anatolia, Persia, and the vast Mongol empire in Asia. Because Islamic countries included almost three-quarters of the Mediterranean's shores, and the international luxury trade on land and sea became increasingly multidirectional, both the term "East-West" for this trade and traditional semantic distinctions between Europe (or the West) and the Orient (or the East) oversimplify. The imported art objects popular and influential in Italy during the three centuries that are the focus of this study varied considerably in origin, type, and style. Today, they are classified by their place of manufacture— often regional rather than local—and period style as well as medium. Then, however, Italians understood little about the different geographic and artistic origins of the

foreign objects they admired. In the contemporary context, therefore, the term "Oriental" for all the art objects coming to the Italian market from Islamic lands and Asia continues to have some merit because of its imprecision.

The period of this study encompasses the development of Italian Renaissance culture, in particular the fine and decorative arts, and Italy's predominance in trans-Mediterranean trade. The very paintings that revolutionized Italian art about 1300 also reflect the dynamic rise in overseas trade and travel. The Italian textile industry soon began to compete with Oriental silks, and Venetian late Gothic architectural decoration began to advertise the Republic's commercial connections in the East. During the fifteenth century, the imports inspired rapid development in various Italian craft industries. By 1600, when the role of Italy as an international carrier of luxury goods was diminishing, it had become a leading producer.

It is no mere coincidence that Italy became an artistic superpower during its most active and profitable engagement in the international luxury trade. Western scholarship, however, has underestimated the importance of this relationship for two reasons. First, the critical evaluation of Italian Renaissance art has long focused on painting, sculpture, and architecture. Indeed, these "major arts" were the principal concern of the publication that shaped subsequent Renaissance art history, the 1568 edition of *The Lives of the Most Famous Italian Painters, Sculptors, and Architects* by the Tuscan painter and architect Giorgio Vasari. He based his theory of continual progress in Italy's

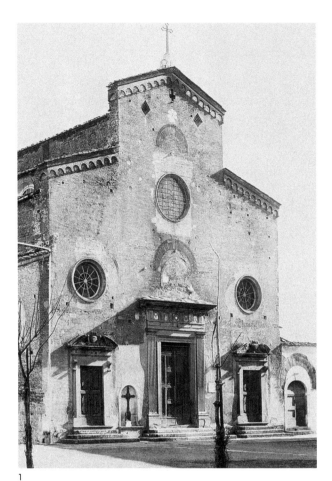

1

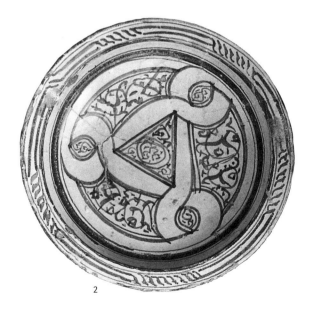

2

visual arts from about 1300 to their peak in his own time on a return to nature and the classical tradition inherited from ancient Rome, emphasizing native artistic genius and sources of inspiration. Vasari knew of both developments in the decorative arts and foreign styles. For example, he sincerely admired inlaid brassware decorated with arabesques made "in Damascus and all over the Levant," rightly crediting it with inspiring recent improvements in Italian metalwork. Undoubtedly because the influence of Islamic metalwork was inconsistent with his theory about the sources of Italian Renaissance art, he disingenuously called the technique antique.[2]

Second, developments in Italy's various decorative arts have rarely been viewed collectively. Specialized studies have identified numerous instances of Islamic and Asian influence. But a true measure of how many foreign, Oriental objects, techniques, and styles of decoration were absorbed into Italian crafts during the three crucial centuries of their development requires a synthetic approach. In addition, to assess the period's transcultural artistic exchange overall, the decorative arts should be considered alongside paintings, sculptures, and architecture that reflect Oriental trade and travel. Such is the approach undertaken in this study.

The one characteristic common to the various popular and influential Oriental objects was their portable size, which meant they could arrive in quantity and spread widely. Ceramics that were mediocre by Islamic standards were long admired throughout Italy and had a significant impact on Italian pottery. The Cathedral of San Miniato near Pisa (Fig. 1), built at the end of the twelfth century, epitomizes the many late-tenth- to early-fourteenth-century church facades and towers in Italy that are decorated with the Islamic earthenware bowls commonly called *bacini*. On this facade, only the shadowed recesses left when the *bacini* were removed show their original location. Most of these *bacini* now in the Museo Nazionale di San Matteo, Pisa, are crudely painted with traditional Islamic animal, plant, and geometric motifs (Fig. 2) and stylized Arabic script in brown and blue over an opaque white tin glaze. They probably came from North Africa: many sherds comparable in design and technique have been excavated in Carthage, a suburb of Tunis, where Pisa had strong trading connections. Excavations

in Pisa indicate that such bowls arrived in large quantities and were used as kitchenware.[3] Most of the *bacini* elsewhere in Italy are also humble objects that probably arrived by ordinary commerce. They contributed color and sheen to brick facades—more cheaply than the marble and mosaic inlay popular in contemporary Italian Romanesque architecture. The importation and use of the *bacini,* in addition to demonstrating the diffusion of Islamic domestic utensils during the late Middle Ages, show that Italians appreciated their aesthetic qualities and were quick to employ them ornamentally, even in their most important religious buildings. Among the early *bacini* are a few high-quality Egyptian or Syrian vessels that may have been brought back from the Holy Land or Constantinople by crusaders and other travelers, who donated them to local institutions and building projects, in which case the origin may have been significant.[4] The *bacini* inspired local imitations (see Fig. 89) and widespread improvements in Italian pottery.

In contrast, two exceptional examples of monumental Oriental art seized during the late Middle Ages and publicly displayed thereafter had no artistic influence. The superb Pisa Griffin (Fig. 3), the largest surviving example of Islamic bronze sculpture, was probably brought back from one of Pisa's many conquests on western Mediterranean Muslim shores during the late eleventh and early twelfth century.[5] The griffin was soon installed on a gable atop the new cathedral of Pisa, which was begun in 1064, and remained there until 1828; it is now in the Museo dell'Opera del Duomo. Inscriptions on the cathedral's facade commemorate the victories that had yielded booty to finance its construction as well as the city's commercial advantages and Christian honor. But the griffin as a victory trophy was raised too high above the public eye for its artistry to be appreciated. The Lion of Venice, a rare antique bronze rendition of a fantastic Oriental beast, probably came from the eastern Mediterranean.[6] From at least 1293 to 1985, it crowned a huge monolithic column at the quayside entrance to the Piazza San Marco in Venice, the city's ceremonial gateway (see Fig. 10). Though the lion originally had wings, technical analysis indicates that they no longer existed when Venetians acquired the statue and transformed it into a symbol of Saint Mark, the patron saint of the Republic, by adding new wings

1 Facade showing locations of inset *bacini* (now removed), Cathedral of San Miniato, Pisa, end of the twelfth century.

2 Bowl painted in blue and brown (*bacino* from the Cathedral of San Miniato, Pisa, end of the twelfth century). North Africa, late twelfth century. Museo Nazionale di San Matteo, Pisa.

3 Pisa Griffin (from a gable of the cathedral of Pisa), bronze, Spain (?), eleventh century. Museo dell'Opera del Duomo, Pisa.

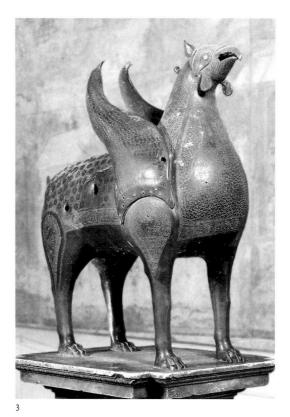

3

and a book beneath one of its forepaws. Although a winged Lion of Saint Mark eventually became the city's emblem, Venetian images of the emblematic lion (see, for example, Fig. 143) were never modeled on the statue, which was approximated only in representations of the piazza with its landmarks.[7]

As historians of Islamic art emphasize, several characteristics of small Islamic objects contributed to their acceptance and influence in Europe. First of all, they were secular, utilitarian articles, technically and artistically superior to what was being produced in Europe.[8] During the ninth century, under the Abbasid caliphs in Baghdad, the Muslim elite had developed a rich urban culture that valued grace and pleasure in everyday life. Major developments in silk weaving, ceramics, metalwork, and wood carving transformed common articles of daily use into works of art. The colorful hangings, cushions, and rugs that traditionally furnished the tent of the nomad were now woven in fine designs of luxurious, sensuous materials. Clothing also became rich and elegant. Bowls, plates, jugs, and lamps were given visual and tactile qualities that added excitement to their use. Elaborate burners and pierced containers were crafted to enhance the enjoyment of costly aromatics. Writing assumed shapes and rhythms to delight even eyes that could not read its meaning. The culture of the Baghdad elite was emulated throughout the Islamic world, and from the ninth to the end of the sixteenth century the objects that were its hallmark were imported, imitated, and further developed by Muslim artists and artisans from Spain to China. These beautiful objects for personal and domestic use began to arrive in quantity in Europe during the Crusades, when the feudal nobility and rising urban bourgeoisie had both the means and the desire to live more comfortably and ostentatiously. The growing wealth of the European elite during the fourteenth and fifteenth centuries created a huge demand for luxury imports, gradually encouraging the development of competitive local products. Even the modest *bacini,* for example, were superior to central and northern Italian ceramics until the fourteenth century, and Italian potters could not match the artistic quality of fine Syrian and Spanish wares until the late fifteenth century. Admiration for Chinese porcelain vessels, which were superior to all earthenware, was international. Though their material could not be replicated, their distinctive decoration was imitated in the Islamic world from about 1400, and in Italy from about 1500.

A second characteristic that increased the popularity of Oriental objects was their decoration. Because of the Muslim ban on idolatry, they bore no overt religious representations or symbols to offend Christian eyes. The human figures appearing on medieval Islamic metalwork, ceramics, and glassware (see Fig. 124) are almost always engaged in the princely pleasures of drinking, music making, riding, or hunting, some of which the European feudal nobility pursued.[9] The ornate Arabic script on many Islamic objects was intended primarily to give visual delight and to convey an association with the faith and community of believers rather than a literal meaning (see, for example, Fig. 3).[10] Europeans as well as Muslims unable to read Arabic inscriptions could admire their beautiful calligraphy. All cultures can enjoy the geometric, plant, and animal ornament that predominates in Islamic art.

Moreover, because European and Islamic cultures of the Mediterranean shared a common Greco-Roman and Byzantine artistic heritage, the organization of Islamic ornament was often familiar to the European eye. A large drug jar (Fig. 4) exemplifies the Spanish pottery that Italians imported in huge quantities during the fifteenth century. The foreign elements are the graceful tapered shape, common in Islamic containers, called *albarelli* in Italy, that were used to ship and store costly spices and the painted decoration of stylized ivy and fern leaves in cobalt blue and golden metallic luster, characteristic of the Hispano-Moresque wares of Valencia. Both the balanced alternation of blue and luster in the ivy leaves and the clear composition of the plant scrolls in horizontal bands that harmonize with, and complement the shape of, the jar suited contemporary Italian aesthetic tastes. Though Vasari certainly considered the intricate arabesque motifs on popular imported metalwork "Levantine" art forms (see Fig. 151), he could have found nothing alien in the organization of surface ornament: the clear outlining of major forms and divisions in silver and their balanced, mathematically regular repetition. Italian Renaissance and Islamic art both emphasize harmony of design, balance of parts, and perfection of the whole composition.[11] The basic difference is that European art retained the natura-

listic and representational bias of the Greco-Roman tradi-
tion, whereas Islamic art is fundamentally ornamental.[12]
In Gothic and Renaissance art, plants or animals used as
decorative motifs increasingly look and grow or behave
as they do in nature, and decoration usually frames, fills,
or links representation, which is foremost in the composi-
tion and bears most of the meaning. The ornamentation
covering the surface of influential Oriental imports was
intended to please the senses and to enhance the object.
Because this decoration was, or could be perceived as,
nondidactic and had a recognizable organizing structure,
Europeans could readily appreciate and adapt its artistry.

Specific religious or social meanings that some objects
had in their Muslim context were lost as Europeans em-
ployed them in their own secular or Christian practices
or displayed them as precious works of art. Egyptian and
Syrian ewers and basins, originally made for ritual hand
washing before prayers and meals, could contain the wine
of the Eucharist, as on the bronze pulpits by Donatello's
workshop in San Lorenzo, Florence, of the mid-1460s,[13]
or be presented at childbirth, as in Paolo di Giovanni
Fei's *Birth of the Virgin Mary* of the 1380s (see Fig. 42).
An inlaid brass bucket that an Egyptian or Syrian might
have carried to the community bathhouse held holy
water in northern Italy (see Fig. 148). Silk brocades with
prominent Arabic inscriptions praising Mamluk sultans,
originally worn as signs of status and allegiance, were
sewn into ecclesiastical vestments throughout Europe.
For example, the inscriptions on a dalmatic made about
1350–1400 read "the sultan the wise" and "the sultan"
(see Fig. 32).[14] Contemporary secular settings in fifteenth-
century paintings of the Annunciation indicate that rich
Italians furnished their bedchambers—the most impor-
tant room in the Italian palace—with fabrics featuring
Arabic inscriptions, either the elite imports or Italian
imitations of them.[15] Expensive carpets, on which the
Oriental elite sat, decorated floors, altars, and furniture
in Italian churches and palaces, and painters commonly
represented them beneath the throne of the Madonna
(see Figs. 71, 76).

As the preceding examples suggest, the elite status
many Oriental artifacts acquired in Italy contributed to
their allure and influence. Throughout the Middle Ages
some of the rich silks that Muslim and Asian rulers cus-
tomarily received as tribute or presented as rewards were

sent to Europe as diplomatic gifts.[16] Crusaders brought
these and other luxury textiles back as booty and wraps
for relics and even as relics themselves, like the "Veil of
Saint Anne" in Apt, France.[17] European princes and ec-
clesiastics presented Oriental silks to each other and were
buried in them (for example, Fig. 21). Many such fabrics
ended up in churches, where they came before the public
eye sewn into vestments or draped on altars, walls, and
funeral biers, including that of Saint Francis of Assisi.[18]
Many fourteenth-century paintings underscore the associ-
ation of the most precious Oriental textiles with royalty
(see Fig. 65), the Church (see Fig. 20), and sacred persons
of both recent (see Fig. 45) and biblical times (see Fig. 158).
Likewise, many Islamic vessels of rock crystal, glass, and

4 Drug jar painted in golden luster and blue,
Valencia, Spain, second half of the fifteenth
century. Hispanic Society of America, New
York (E597).

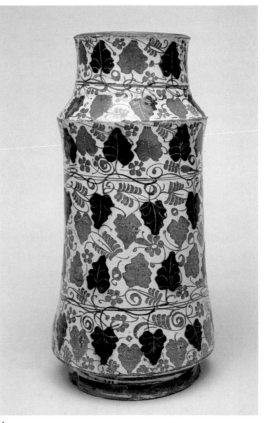

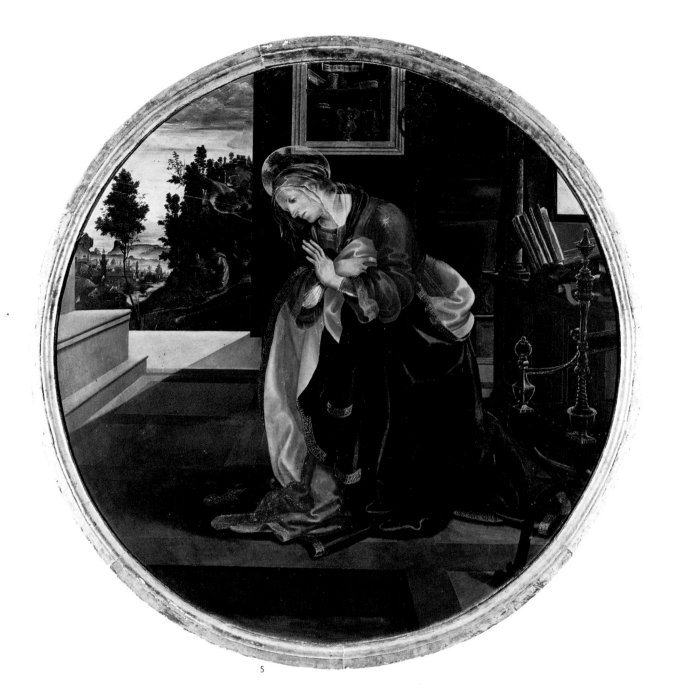

5

even ceramic (see Fig. 44) acquired sacred status as relics or containers of relics and found their way into medieval European church treasuries. Precious metal and jeweled mountings added in Byzantium and Europe emphasized their beauty and their new Christian identity.[19]

During the fifteenth century, contemporary Islamic carpets, metalwork, glass, and ceramics and Chinese porcelain acquired widespread cachet in Italian secular society as leading elites in cities throughout the peninsula collected them in increasing quantities, and the bour-

geoisie proudly displayed the few they could afford— developments that are well documented in inventories and paintings.[20] For example, Valencian *albarelli* like that in Figure 4 appear in Florentine bedchamber settings, where they probably contained aromatics, medicinal herbs, or sweetmeats: on display shelves in Filippino Lippi's *Annunciation*, 1482 (Fig. 5), and on the bedstead in Domenico Ghirlandaio's *Birth of Saint John the Baptist*, painted in the 1480s, in Santa Maria Novella, Florence.[21] Patrons, artisans, and merchants of similar local articles

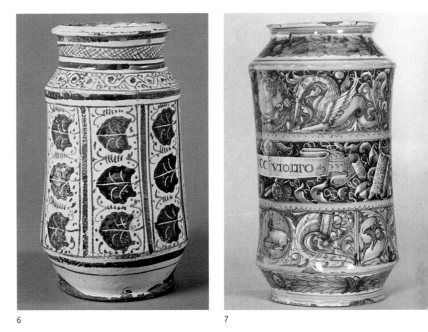

6 7

5 Filippino Lippi, *The Annunciation*, 1482.
Museo Civico, San Gimignano.

6 Drug jar painted in blue and purple,
Florence, Italy, second half of the fifteenth
century. Victoria and Albert Museum,
London (363-1889).

7 Drug jar with polychrome painted decora-
tion, Castel Durante, Italy, ca. 1550–1555.
British Museum, London (MLA 1855, 7-31, 1).

could not ignore the status and stylishness of imports among the rich and powerful.[22] Large numbers of imitations and adaptations followed. A Florentine drug jar of the second half of the fifteenth century (Fig. 6) is a modest example, in which the potter adjusted the ivy leaf and tendril ornament of a jar like those on the top shelf of Filippino's painting and in Figure 4 to a shorter, stouter shape, and substituted manganese purple for metallic luster, a technique unknown in Italy.

It is often said that the strikingly beautiful and, to Italian eyes, unusual materials, craftsmanship, and decoration of Oriental artifacts gave them a strong exotic appeal.[23] The cost, rarity, technique, and Eastern origin of some of the most admired Oriental luxury goods heightened their desirability. Fine Islamic carpets and Chinese porcelain remained expensive and rare throughout the Renaissance. Even the richest Italians had difficulty acquiring them in quantity, and efforts of powerful princes to establish local carpet and porcelain industries were short-lived or unsuccessful. In the Renaissance imagination, porcelain had magical properties, partly because the green-glazed celadon type was reputed to crackle and break upon contact with poison, but mainly because of its mysterious composition. Halfway between earthenware and glass in hardness and translucency, it was made, according to Marco Polo, from clay transformed by aging.[24] Some Islamic goods acquired special meanings in Italy because of their origin. For example,

Egyptian and Syrian textiles and brassware had a true connection with the Holy Land and an assumed association with biblical times that led to misinterpretations of the objects, especially their Arabic inscriptions. Italians, however, correctly linking the distinctive Islamic *albarello* to the exotic Oriental spices, medicines, and sweetmeats it contained in the pharmacy and the home, continued to evoke the Islamic imports in Renaissance maiolica. An example, inscribed "violet-flavored sugar candy," that was probably made in Castel Durante about 1550–1555 as part of a set for an apothecary (Fig. 7) retains the scale, shape, and banded composition of Hispano-Moresque *albarelli* like that in Figure 4, while the painted decoration is entirely in the classical Renaissance style.

Finally, some Oriental imports became so popular that exceptional efforts were made to imitate them as closely as possible. Confusion still exists between sixteenth-century Venetian orientalizing brassware and its Islamic models. The increasing ability of Venetian craftsmen to mimic intricate Ottoman ornament in various media—textiles, ceramics, leather, and lacquer—reflects a vigorous local market for art in an exotic style and indicates that patrons developed a sophisticated appreciation of Islamic art.

Each of the Italian decorative arts developed at its own pace, acquiring artistic sophistication in step with the taste of patrons, the skill of artisans, and profitability in the marketplace. These were internal, self-generating

factors. Oriental luxury goods had been arriving in Italy for some time before sufficient incentive and means arose to compete seriously with them. The stimuli for development originated in the Italian culture and economy. In general, Oriental imports had their greatest impact at the dynamic outset of a surge in development, when patrons and artisans were most open to new ideas and models for improvement were already available in the market-place. Thus the timing of Italy's own artistic development largely determined the contribution of foreign art objects. For example, in the fourteenth century textiles were the first Italian craft to bloom artistically and to compete internationally, inspired by luxury silks recently imported from Mongol Asia and the Islamic world. Italian ceramics and glass, in contrast, improved very slowly until the mid–fifteenth century, when soaring domestic demand stimulated rapid development. Artisans in these crafts drew upon earlier imports from Syria (and potters, from contemporary Valencia ware as well) for both techniques and ornamental concepts. The long period of development and its varying pace in the different decorative arts fostered diversity in the Italian production.

There is sufficient documentation of the movement of Oriental art objects to Italy to establish the principal points of contact and transfer in the decorative arts. Surviving objects with an Italian provenance between 1300 and 1600, paintings, inventories, commercial correspondence, diplomatic reports, and a few cargo lists identify the models—at least their types and styles. Unfortunately, much of the written evidence has limited value because contemporary Italian descriptive terminology was usually imprecise and sometimes misleading, partly because little was known about specific geographic origins and different foreign artistic styles. Nevertheless, the impact of the East-West luxury trade on various Italian craft industries can be assessed on the basis of evidence now available.

Comparatively little documentation, however, exists for Islamic elements in Venetian Gothic architecture. A shared architectural heritage—with Greco-Roman antiquity and Byzantium—as well as corporate patronage and anonymous designers obscure the lines of contact and transfer. Cross-cultural architectural transfer depends on the movement of people: often architects or craftsmen skilled in the building techniques and decoration of their native lands who bring that training to another culture

and/or travelers of the patron class who have admired foreign buildings in situ and brought home memories or sketches of them.[25] In Venice, transfer occurred during the early work on the new Saint Mark's, originally built as the state chapel and shrine for the saint's relics shortly after they were smuggled out of Alexandria aboard a Venetian merchant ship in 828/29 and reconstructed in the second half of the eleventh century after a fire. A Byzantine architect participated in designing its sophisticated plan, and Greek craftsmen worked on its early mosaic decorations.[26] Scholars agree that Venetian travelers must have affected the Islamic-style decoration on the facades of Saint Mark's and the Doge's Palace from the thirteenth to the fifteenth century, as well as various other Eastern elements in the medieval Venetian cityscape.[27] Much is known about the transfer process, and the types of—if not the particular—travelers, memories, and records involved. While the subject of Venetian Gothic architecture is beyond the scope of this book, the Oriental borrowings on these two facades relate to the subject of East-West luxury trade, and the consensus on their purposes and likely sources can be summarized.

Venetian Gothic, the last of several local Italian medieval architectural styles with a marked Islamic flavor, has significant historical analogies with styles of the Pisa region and Norman Sicily. Islamic elements—surface ornament in Pisa and Sicily and arch and vault forms in the latter—appear in important state buildings begun soon after the victories over Muslim powers that brought these Christian states honor and gave them commercial advantages in the competitive Mediterranean trade of the eleventh and twelfth centuries. The Pisan and Norman styles drew upon great past and present Mediterranean architectural traditions to express the shift in power. The cathedral of newly independant Pisa was begun in 1064 after a victory in Palermo, and the trade of the expanding diocese of Pisa increased rapidly as a result of further conquests in the western Mediterranean and participation in the First Crusade (1096–1099). The cathedral's fabric conspicuously incorporates antique Roman building and decorative material brought from Rome, Ostia, and expeditions to Tunisia.[28] The sumptuousness and variety of color and texture in the cathedral's exterior ornament, which encrusts its bichrome masonry, evoke the splendor of Islamic architecture in nearby Spain and North Africa,

such as the ninth-century cupola of the Zaytuna Mosque in Tunis.[29] Since the relationship is one of overall effect rather than specific motifs, the exterior decoration probably derives from travelers' impressions, conceivably assisted by sketches and/or looted architectural fragments.[30]

The Normans' more direct adoption of Islamic style reflects the cultural heritage of Sicily and the craftsmen employed.[31] For at least a century after the Normans completed the conquest of Muslim Sicily in 1091, the island remained a major Mediterranean entrepôt and transshipment point, and home to a diverse population. The Palatine Chapel in the Royal Palace at Palermo, begun by Roger II shortly after his coronation in 1130, juxtaposes some of the most outstanding features of Latin, Byzantine, and Islamic architecture. The Normans employed a mix of craftsmen: Greek and Muslim inhabitants of the island, and probably new Muslim recruits, drawn to Sicily by the regime's reputation for tolerance. A lost but documented mid-twelfth-century Islamic-style ceiling in the royal complex in Constantinople may have inspired Roger to undertake the elaborate painted wooden *muqarnas* (ceiling with stalagtite vaults) in his chapel, the only example in this medium that has survived, but the highly skilled carpenters and painters who executed it probably came from Egypt or Syria.[32]

By the end of the thirteenth century, Venice had also adopted a cosmopolitan Mediterranean architectural imagery as various European and a few Islamic elements were blended into Saint Mark's decoration in a unique and creative manner. Decorative forms of Islamic origin began to appear toward midcentury, several decades after Venice established commercial privileges in Alexandria and Aleppo, by which time Venetians were also buying and selling in Damascus, the most important market in the Holy Land.[33] Among the recognizably Islamic forms that contribute meaning to the structure are the geometric marble traceries screening windows in the lunette above the Porta Sant'Alippio (Fig. 8), at the extreme left of the facade. They are strikingly similar in form and function to the window grills of the Great Mosque in Damascus, completed under the Umayyads in 714/15, of which several marble examples survive (Fig. 9).[34] It is generally believed that the grills on Saint Mark's were modeled on those of the Damascus mosque.[35] Venetians

8 Window grills above Porta Sant'Alippio, Saint Mark's, Venice, thirteenth century.

9 Window grill, Great Mosque, Damascus, Syria, eighth century.

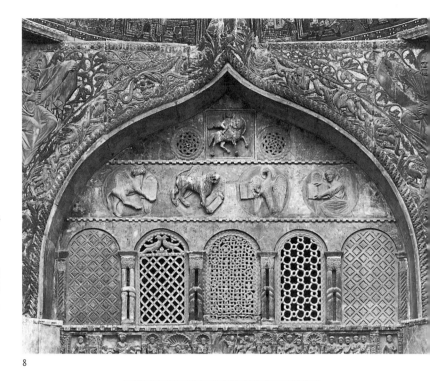

8

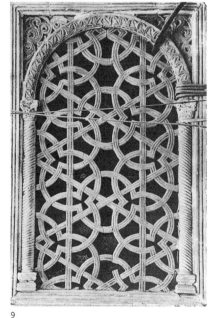

9

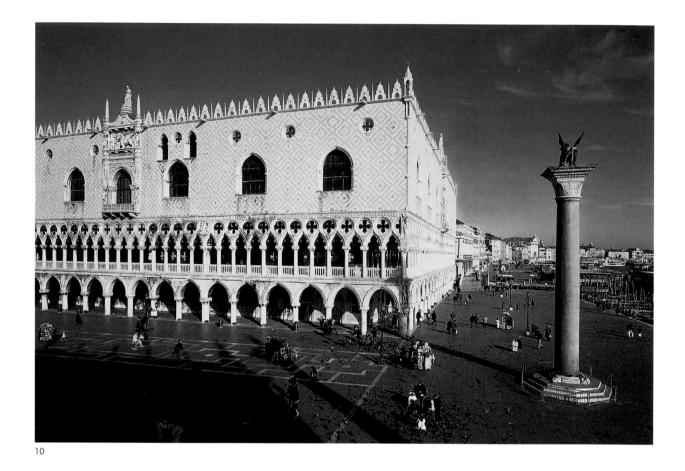

10

probably also associated these distinctive architectural forms with Egypt. Comparable grills appear on noteworthy medieval buildings in Cairo but do not survive in Alexandria.[36] As the chapter that follows explains, a sizable colony of Venetian merchants lived in Alexandria at the time the Porta Sant'Alippio was constructed, officially represented by a consul who could visit Cairo ten times a year to address the sultan.[37] Also at this time, mosaics installed in the lunettes above the four lateral portals of the facade commemorated the ninth-century translation of Saint Mark's relics from Alexandria to Venice, and mosaics set into the vault of the vestibule celebrated the Venetian legend of the saint.[38] In such an iconographic context the recognition of connections between the window grills and those of eastern Mediterranean monuments must have been intended as part of the "authentic" Alexandrian setting provided for Saint Mark's relics.[39]

The Porta Sant'Alippio grills may have been meant to confer a sense of the Early Christian era as well as of the eastern Mediterranean. From the eleventh into the fifteenth century, Europeans confused Umayyad buildings in Jerusalem with sacred Judeo-Christian monuments: the late-seventh-century Dome of the Rock with Solomon's and Herod's temple, and the early-eighth-century Al-Aqsa Mosque with Solomon's Palace.[40] Italian travelers also may have mistakenly believed that other old Islamic structures in Syria and Egypt dated from, or were representative of, much earlier times. Indeed, the strong early Byzantine component in Umayyad buildings such as the Dome of the Rock and Great Mosque of Damascus and the late antique origins of the Damascus window screens could have contributed to such confusion. As Chapter 3 shows, parallel interpretations of Arabic script, correct geographically and erroneous chronologically, cropped up frequently in Italian painting by the early fourteenth century. Gentile Bellini's painting *Saint Mark Preaching in Alexandria* (see Fig. 173) suggests that at least the geographical association of the window grills remained sufficiently strong among Venetians to be revived at the beginning of the sixteenth century: Bellini included an entire story of them on the church in his imaginatively "authentic" Alexandrian cityscape.

The facades of the Doge's Palace that face the Grand

Canal and the Piazzetta present an image of Venice as a
great trading nation and gateway to the Orient (Fig. 10).[41]
The facades were begun about 1340, precisely when Ven-
ice was preparing to increase trade with Syria and Egypt
to compensate for declining trade with Mongol-ruled
Persia and central Asia. By 1361, when the canal-side
facade was completed, Europeans were no longer active
in the Asian interior, and Venice was focusing on eastern
Mediterranean trade. By the second quarter of the fif-
teenth century, when the facade facing the Piazzetta was
completed, Venice had firmly established hegemony in
the eastern Mediterranean but sent few galleys to the
eastern Black Sea. The varied Oriental architectural
borrowings on the facades advertise the more extended
Venetian commercial network envisioned in the 1340s
and 1350s.[42]

 Most conspicuous is the pink-and-white lozenge pattern
of the walls, which evokes major monuments along the
Asian silk roads. A similar design is common in the tex-
tured monochrome brickwork on Seljuk minarets, such
as the twelfth-century example at the Kalyan Mosque in
Bukhara (Fig. 11).[43] In the third register above the base,
shadow fills recessed diamond-shaped outlines and cen-
terpieces, while light flickers over the raised intermediary
sections and the four headers forming open crosses at the
centers. The Venetian masonry's varied tones of pink and
bright white mimic this intricate shadow-and-light play
on a flat surface. The bichromy on the Doge's Palace may
also be indebted to contemporary ceramic tile and glazed
brick decorations like those on the huge octagonal tomb
built about 1305–1316 by the Mongol ruler Uljaitu in the
new capital of Sultaniyya (Fig. 12). Initially executed in
turquoise or cobalt blue against an unglazed buff ground,
but increasingly in completely glazed revetments, these
decorations commonly included zones of geometrical
motifs and diagonally aligned square script as on the
Sultaniyya dome.[44] Chapter 1 shows that Venetian mer-
chants were active during the Mongol period in the old
Persian capital of Tabriz and in the Sultaniyya and Bu-
khara regions farther east. Even though no travelers'
descriptions or drawings, which might have informed
the Venetian architects, have been found, such records

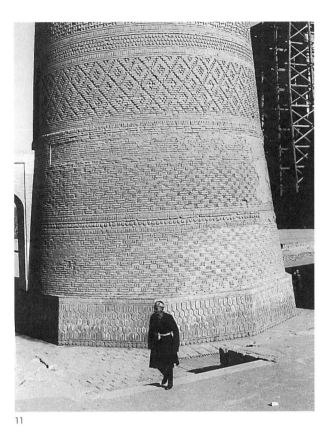

11

10 West and south facades, Doge's Palace,
Venice, begun ca. 1340.

11 Detail of the minaret of the Kalyan
Mosque, Bukhara, Uzbekistan, twelfth
century.

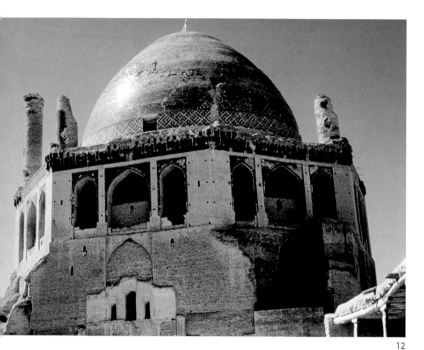

12

12 Mausoleum of Uljaitu, Sultaniyya, Iran, ca. 1305–1316.

13 Anonymous Italian, *Siege of a Fortress* (drawing inserted in a late-thirteenth–fourteenth-century Venetian manuscript), late thirteenth century. Staatsbibliothek zu Berlin–Preussischer Kulturbesitz, Berlin (MS. Hamilton 390, fol. 85r).

are at least implicit in a drawing of an octagonal Oriental building faced with geometric decoration similar to both the lozenge patterns in Seljuk brickwork and the square script on the dome of Uljaitu's tomb (Fig. 13). Together with the defenders' Tatar-style pointed hats, the decoration of the fortress places the siege represented in the drawing somewhere in the Mongol empire or Seljuk eastern Anatolia. On stylistic grounds, the drawing has been dated in the second half of the thirteenth century, when Anatolian tilework was at its peak, and Persian tilework presumably began to develop again after the Mongol conquest. The sheet was inserted in a volume of unrelated late-thirteenth- and early-fourteenth-century manuscripts in Old Venetian and Latin that has a fourteenth-century Venetian provenance.[45]

Other features of the Doge's Palace were probably inspired by Islamic architecture in Egypt and Syria. During the 1330s and 1340s, at least four Venetian embassies visited Cairo to negotiate resumption of trade.[46] Roofline crenellations, roughly drawn in Figure 13, were common and elaborate in Cairo, as in the courtyard of the Al-Azhar Mosque, 1131–1149, though no exact parallels for the Venetian versions survive.[47] The curved, bent, and pointed arches of the second-story arcade could also be graceful interpretations of urban Islamic windows and doors.[48] Unfortunately, little secular urban architecture survives in Egypt and Syria for comparison, and early travelers' information about it was undoubtedly imprecise. The designers who successfully adapted foreign forms to create an original Venetian imagery, however, ultimately bear responsibility and deserve credit for the vagueness of Islamic borrowings on the facades of the doge's and patricians' palaces. The cosmopolitanism of the Venetian Gothic architectural style so effectively expressed the values and culture of the ruling class—which during this same period developed a distinctive dialect borrowing many Arabic words—that it lingered in palaces into the sixteenth century, when patrician families ceased to accompany overseas trading ventures in large numbers.[49]

Italian painting from 1300 to 1600 reflects the movement of both objects and people. Paintings document the arrival of various imported luxury goods and show how Italians used and regarded them. Italian pictorial arts— paintings, drawings, prints, and sculpture—also reveal a

limited understanding of the cultures that produced the influential imports; religious and political divisions between East and West persisted throughout the period. Because the pictorial arts provide specific information on transcultural contacts and balance a discussion focused on cross-cultural artistic esteem and transfer, they are included in this study.

The chapters that follow respect the different stories told by the various decorative and pictorial arts. They describe important transfers that illustrate one or more of the propositions already introduced: (1) that Oriental trade and travel contributed to artistic development in Italy and made a permanent impression on Italian taste; (2) that the influential Oriental models varied according to what was admired at critical stages in the development of Italy's craft industries; (3) that Oriental art objects acquired an elite status in Italy that increased their influence there; and (4) that East-West trade, travel, and industrial competition continued to foster cosmopolitan taste and artistic exchange in the Mediterranean.

Chapter 1 summarizes the dynamic developments in international trade and travel, including diplomatic and missionary activity, that enabled cross-cultural artistic transfer. Subsequent chapters discuss the decorative arts in chronological order of greatest transfer, beginning with textiles. Chapter 2 focuses on the Islamic and Asian patterned silks that inspired revolutionary changes in fourteenth-century Italian textile designs and techniques. Chapters 3–4 consider other Islamic textiles represented conspicuously in paintings but not imitated industrially. Chapter 3 shows that Italians associated honorific garments bearing Arabic inscriptions, and the script itself, with the Holy Land and Early Christian era. Chapter 4 relates increasing Italian esteem for Oriental carpets to new types of imports and a surge in the demand for luxury household furnishings.

This new demand spurred rapid advances in other decorative arts during the second half of the fifteenth century. Chapter 5 shows that Syrian and Spanish imports inspired artistic improvements in Italian ceramics, and that Chinese porcelain and new Ottoman types influenced Renaissance maiolica through the sixteenth century. Such

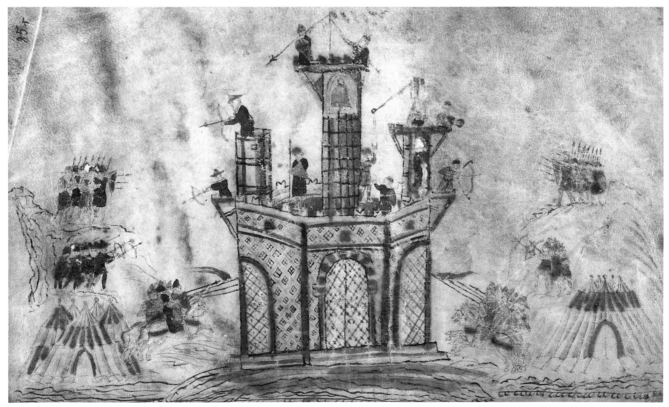

continuing relationships contrast with the brief but potent impact of imported models on Venetian glassware, discussed in Chapter 6. The bookbindings and lacquer considered in Chapter 7 present a richly documented example of Italian patronage of sophisticated Islamicizing styles. Chapter 8 links the late emergence of Italian metalwork in an Islamic style to particular circumstances of supply and demand.

The final chapters take broader measure of the impact of international trade, travel, and artistic transfer on cross-cultural understanding and enrichment. The representa-tions of Oriental people and places in Italian paintings, medals, and prints, discussed in Chapter 9, reveal that continuous commercial and diplomatic contacts during the period contributed little to the Italian understanding of the Oriental world. The success of Italian decorative arts in Islamic lands and the fierce competition between Italian and Ottoman textiles described in Chapter 10, however, indicate that Christian and Muslim peoples around the Mediterranean had acquired common tastes and, for practical reasons, accepted their need for industrial and artistic exchange.

::::::::::::::::::::::::::::::::::::::

TRADE, TRAVEL,
AND DIPLOMACY

UNTIL THE PORTUGUESE DISCOVERED THE SEA ROUTE around Africa at the end of the fifteenth century, the crossroads of East-West trade were in the eastern Mediterranean. Since antiquity, the Arabs at the hub of the known world had been intermediaries in the flow of spices, silks, and raw materials between Asia and the Mediterranean. From the eighth century the Muslim rulers of Syria and Egypt controlled the western ends of the network of caravan routes converging on Aleppo, Damascus, and Alexandria from Persia, Mesopotamia, Arabia, the Red Sea, the Persian Gulf, and the Indian Ocean (Map).[1]

Trade between Asia and Europe increased steadily during the Crusades (1096–1271) as more Europeans discovered the rich culture of the East and established trading bases in the Latin crusader states of Antioch, Tripoli, and Jerusalem along the coast near Aleppo and Damascus. Venetian, Genoese, Pisan, Catalan, and French merchants who served the crusaders received permission to open operations in conquered towns. Italian mercantile states appointed consuls to organize and protect their citizens abroad.[2] Emulating the privileges Venice had obtained from Byzantium in 1082,[3] numerous European governments also dispatched ambassadors to negotiate commercial treaties with the Muslim rulers of the principal ports and markets of the eastern Mediterranean and North Africa. Italian coastal city-states, which willingly used naval power to intimidate the land-based Arab rulers and promote the interests of their prominent merchant classes, led the rush. When they could extract customs

privileges and consular protection for their citizens in important Muslim ports, they accepted restrictions on inland travel. Venice obtained privileges in Aleppo in 1207, having had them earlier in Alexandria. Genoa and Pisa soon negotiated similar privileges, as did Barcelona, Montpellier, and others.[4] The main exports to the Orient were wood and iron from central Europe, to which Venice had the best access via the Brenner Pass; woolen and linen textiles; and hard currency. Imports included spices, raw silk, finished silk and silk brocades, sugar and other agricultural products, ceramics, glass, metalwork, and precious stones.[5] Europeans living in the crusader states also may have been involved in production— merchants as owners of silk looms, and rich crusaders as patrons of some of the surviving thirteenth-century glass and metalwork decorated with Christian themes. From the late eleventh century Pisa had favorable concessions in Tunis, a source of many of the ceramic *bacini* in the region (see Fig. 2), as well as raw wool, hides, furs, and gold dust from the African interior. Venice negotiated privileges with Tunis in 1231, and Florence, about 1252.[6]

In 1259 the Mamluks, a military caste of Turkish former slaves who served Saladin (d. 1193) and his Ayyubid successors, seized from their employers control over Egypt and Syria and quickly consolidated an empire from their base in Cairo. The early Mamluk sultans successfully maximized the revenue-producing potential of their territory and the trade flowing through it to maintain themselves; to continue the supply, and elicit the loyalty, of new slave trainees; and to patronize art and architecture.[7]

They organized an efficient administration, halted the Mongol advance into Syria, dominated Arabian ports and caravan routes, and gradually overran the crusader states in Syria and the Holy Land. Though the Mamluks encouraged European commerce, they tightened restrictions on merchants and constantly changed, or forced the renegotiation of, their privileges. Metalwork, glass, textile, and ceramics industries blossomed under lavish patronage by the Mamluk court and contributed a modest volume to exports. European profits and Mamluk taxes from trade steadily increased until 1291, when the fall of Acre completed the Muslim reconquest of the Holy Land, and Pope Nicholas IV decreed a general embargo on Christian trade in Mamluk territories.

Until 1345 European trade with Egypt and Syria was seriously impeded, though it never stopped.[8] The papal embargo specified war matériel—arms, horses, iron, and wood—but broadly included all supplies and merchandise. Because exports of wood and iron were important to the European balance of trade with Mamluk territories, even a limited observance of the embargo reduced profits, and all the major trading states evaded it to some degree. Venice openly violated it by sending ambassadors to renew privileges in Alexandria in 1302 and in Syria in 1304, incurring a fine. In addition, many privately owned Venetian vessels, operating under less scrutiny than state-organized convoys, defied the embargo. Venetians and others used Cyprus as an intermediary station to conceal the origin and ultimate destination of goods. That Mamluk brassware was slipping through the embargo is evident in halos painted by Giotto and his followers during the 1330s (see Fig. 56). Nonetheless, even Venetian trade diminished. When the pope reaffirmed the embargo in 1322, the Senate prohibited state convoys to Egypt and Syria, and in 1345 the sultan complained—less than honestly—that Venetian ships had been absent from his ports for twenty-five years.

Meanwhile, the Mongol domination of Asia from the 1240s to the 1360s provided new opportunities for East-West trade. During the Crusades, European merchants had rarely penetrated into Muslim territories beyond the Christian-occupied lands along the Syrian coast and Byzantine outposts on the Black Sea. The Mongols who conquered China, central Asia, the Caucasus, Persia, and Mesopotamia to the upper Tigris and Euphrates Rivers, however, were tolerant of other cultures and trade that could benefit them. For nearly a century, the great khans in China and successors to the conquerors in other parts of the empire kept the network of trans-Asian caravan routes known as the Silk Road open and safe for merchants and travelers of any religion or origin. Though the Il-Khanid rulers of Persia and Mesopotamia, who descended from the conqueror Hulegu (d. 1265), adopted Islam in the 1280s, both the northern overland routes to central Asia and China, and the sea route to India and China from the port of Hormuz at the mouth of the Persian Gulf (see Map) remained accessible to Europeans into the 1340s.

The period of openness between East and West that has come to be called the *Pax Mongolica* offered European merchants an opportunity to offset disruptions in commerce with Syria and Egypt resulting from the papal embargo. In addition, the elimination of Arab middlemen increased the profitability of the most valuable, easily transportable Asian imports. These included pearls, precious stones, the most exotic spices and aromatics, and especially silk. The Mongols' enormous consumption of luxury textiles boosted production in existing silk-weaving centers and spurred the development of new ones across their vast empire.[9] European demand for the finest central Asian and Persian fabrics soared despite the development of a silk industry in Italy. The weavers in Lucca, who could not yet equal the quality and variety of Oriental cloth, also needed supplies of fine raw silk from the Caspian region, for which the major emporiums were Tabriz and, for several decades at least, the new capital of Sultaniyya built by Uljaitu between 1305 and 1313, southeast of Tabriz (see Map).[10] Italian capital investment in East-West trade shifted significantly from the eastern Mediterranean to the Black Sea and Persia. The Genoese and Venetians, who had the largest commercial fleets on the Mediterranean as well as the biggest and most influential merchant colonies in Asian ports and entrepôts, competed for predominance. Pisan, Catalan, and French merchants also were active, at least at the ports of entry and exchange.

The principal routes to Persia and central Asia and customary trading practices along them were described

about 1339—when they were rapidly becoming obsolete—in the *Praticha della mercatura* by Francesco Pegolotti, a Florentine employee of the Bardi banking firm.[11] Ports in Christian-ruled principalities provided safe access to the Mongol hinterland into the 1340s.[12] Until the Mamluk rulers of Egypt and Syria captured Lajazzo (Ayas), on the Gulf of Alexandretta, from the kingdom of Lesser Armenia in 1347, that city was an important departure point for Tabriz and the Caspian region via eastern Anatolia. For example, the brothers Niccolò and Maffeo Polo purportedly returned from China via Lajazzo in 1269 and departed from there with Marco, Niccolò's son, in 1270. In the early 1300s Venice maintained a consul in Lajazzo, and sent an average of six state merchant galleys there each year.[13] Shipping between Lajazzo and Europe regularly passed through Cyprus, which was also under Christian rule.

For those sailing east from Constantinople on the Black Sea, there were two ports of exchange and entry: Trebizond to the south and Tana to the north. Byzantine-ruled Trebizond served Tabriz and beyond until 1341, when a Turkish attack and local uprising initiated a decline. Genoese and Venetian merchants were conducting business in Tabriz during the 1260s, Marco Polo reported leaving Asia via Tabriz and Trebizond in about 1294, and Venice maintained a consulate in Tabriz during the 1320s. European colonies in Persia diminished rapidly during decades of anarchy following the death of Sultan Abu Said in 1336.[14] Tana, a great emporium on the Sea of Azov, provided the principal entry to central Asia and China via Bukhara and Samarkand until the 1340s, when the Khan of the Golden Horde expelled the Italian merchant colony from the port (1343) and disintegrating Mongol control made connecting land routes dangerous. There were

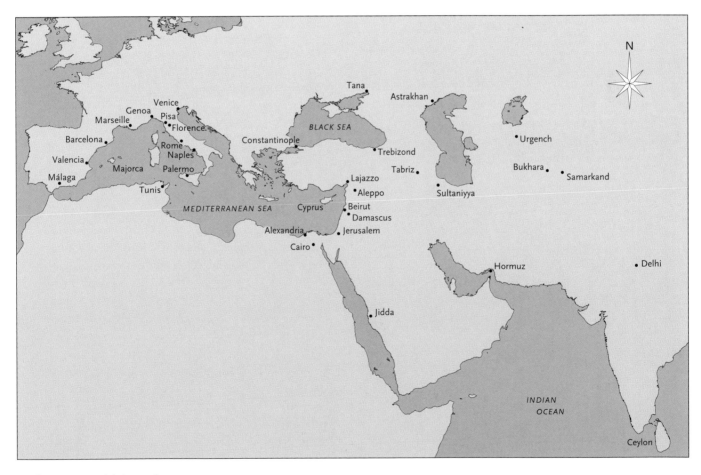

Mediterranean and Asian trade centers
in the fourteenth century.

Europeans in China from at least 1246, when Friar John of Plano Carpini reached the camp of the great khan near Karakorum, to 1371, when the emperor of the new Ming dynasty (1368–1644) dispatched an unidentified European to the West to announce his accession, soon thereafter closing the door to China behind him.[15] The *Pax* Mongolica brought an influx of influential "Tatar" textiles into Italy about 1300 (see, for example, Figs. 22, 25, 32) and left its mark on fourteenth-century Italian art in Mongol figures, costumes (see Fig. 160), and script (see Figs. 43, 49) in paintings and in references to monuments along the caravan routes on the facades of the Doge's Palace in Venice (see Fig. 10). Various travelers—merchants, diplomats, missionaries, and adventurers—contributed to the era's transcultural exchange.

Between 1265 and 1308 the Il-Khanid rulers of Persia in Tabriz sent at least nine embassies to the Holy See and to several European kings; the pope sent two embassies to Tabriz, and the English, one.[16] The Il-Khanids proposed an alliance against the Mamluks, offering European Christians possession of Jerusalem under Mongol suzerainty and hinting to the popes that they might convert to Christianity. The Persian embassies brought a considerable number of Orientals to Italy—certainly to Rome, Genoa, and Naples—and Italian adventurers and missionary friars who had attached themselves to the Persian court often participated as envoys, translators, and guides. Contemporary chroniclers recorded the appearance of Guiscardo de' Bastari, a Florentine serving as ambassador, and one hundred companions, all in Mongol dress, at the Jubliee of 1300 in Rome,[17] and other encounters with the Persian embassies provided Italians with views of Oriental peoples and costumes. Ambassadors customarily carried letters and gifts, at that time principally luxury textiles. In 1288, for example, Pope Nicholas IV sent the Persian ambassador back with gifts for the Nestorian Christian partriarch in Mesopotamia: ecclesiastical vestments in precious materials and a tiara and ring.[18] Though it is not known what the Persian envoys presented, some among the scores of "panni tartarici" (Tatar cloths) listed in the papal inventory of 1295 must have been diplomatic gifts.[19]

The Church had dual interests in Asia: to convert the Mongol rulers and the peoples of their empire and to restore wayward Eastern Christians—such as the numerous Nestorians who lived by trade in cities and caravan centers from Syria to China—to the true Catholic faith.[20] The first Franciscan and Dominican friars in Asia were primarily diplomats and adventurers, sent by the Holy See to gather information. Efforts to send friars who could teach the faith increased as a result of events that occurred at the Council of Lyons in 1274, when a Persian embassy unexpectedly appeared. The embassy's Dominican guide testified to the mercy shown toward Christians during conquests, and three Mongol envoys were baptized. In 1278 Pope Nicholas III established Franciscan friaries in the Crimea and sent five or six Italian Franciscans to Khan Abaga of Persia (r. 1265–82), who had his son baptized Nicholas in honor of the pope. Several Franciscans were martyred in Persia in 1282–1284 when, after Abagha's death, that same son embraced Islam and began persecuting Christians.[21] The most celebrated mission was that of the Italian Franciscan John of Montecorvino (d. 1328 in Beijing), sent to the great khan in 1289 by Nicholas IV, the first Franciscan pope (1288–92). The Holy See was unaware of Friar John's success, however, until letters describing his church and thousands of baptisms in Beijing arrived in Avignon in 1307 by way of the Franciscan missionary network and Italy. Pope Clement V immediately ordained Friar John "Archbishop and Patriarch of the Whole East" and ordered the Franciscan Minister-General to dispatch brothers to China, seven to be suffragan (assistant) bishops.[22] Until the 1350s there were sufficient numbers of missionary friars to maintain houses and bishoprics in important cities and trading centers of Persia and China: the Franciscans had at least nine houses in Persia, and in 1318 an archbishopric with six suffragan bishops, all Dominicans, was established in Sultaniyya.[23] The accomplishments of the missionary friars—some of them martyrs—significantly affected the imagery in contemporary Franciscan and Dominican churches in Italy (see Figs. 159, 160).

Thanks to a dispute over profits that forced the disclosure of details Italian merchants would have preferred to keep secret, a colorful account of an Asian trading venture led by members of the Loredan family in 1338 survives in the archives of Venice. The organization of this joint venture, though it is among the few recorded to Delhi, the second largest city in Asia, was typical of the

time.[24] Joining the company's founder, Giovanni Loredan, who had already made a profitable trip to China, were his brother Paolo and and another relative, Andrea Loredan, together with Marco Soranzo, Marino Contarini, and Baldovino Querini, all from noble families active in trade and government. It was widely known along the caravan routes that Delhi's Muslim ruler, Sultan Muhammad ibn-Tughluk (r. 1325–51), generously rewarded foreigners who brought him rare and valuable gifts,[25] and the six Venetians anticipated additional profits from trade on the outbound and homeward journeys. Each partner contributed to a common fund to purchase exotic items in Venice that might appeal to the sultan: a clock, probably made in Germany or France, and a mechanical fountain. The group bringing such complex mechanisms, presumably requiring reassembly, must have known that the Muslim elite had long been fascinated with them as well as with automata.[26] Each partner also brought money and merchandise to trade on his own account. Giovanni Loredan carried 1,030 ducats (their gold worth about $38,000 today),[27] a little amber, and many fine fabrics from Florence and Milan—probably including fine English wool dyed and woven in Florence and linen from Lombardy and Germany.[28] Giovanni took no Venetian glass imitations of precious stones, which the Chinese readily traded for merchandise, because the rulers along his Asian route were accustomed to receiving real gems as tribute.[29]

Setting out in the summer of 1338, the six partners stopped first in Constantinople, the customary gateway to Asia and terminus of regular convoys of Venetian merchant galleys. There Giovanni Loredan sold some of his fabric to settle previously incurred debts. The group then followed the route recommended by Pegolotti as the safest to central Asia, taking another Venetian galley to Tana and traveling by camel caravan to Astrakhan on the Volga River northwest of the Caspian Sea. Delayed by ice on the Volga, Giovanni sold more textiles; he also encountered another Venetian, Andrea Giustiniani, who was returning from Urgench. The partners took the customary overland route east of the Caspian to reach Urgench, a caravan center south of the Aral Sea, where Pegolotti recommended trading remaining linens for currencies that would be needed to hire pack mules and

camels and to purchase goods for the return journey. Before the group reached India, Giovanni Loredan died and his partners divided his assets to preclude their confiscation by local authorities, something Pegolotti had warned could happen.

In Delhi the sultan paid the survivors far more for their "gifts" than they had originally invested. They reinvested a little over half this sum in pearls, probably those of the highest quality from the Persian Gulf or Ceylon that would bring great profits in Venice and Europe. Such high-value, low-volume, and lightweight merchandise was most suitable for the long return journey. Pearls, moreover, were exempt from customs duties in much of Asia and the eastern Mediterranean.[30] The partners spent the remainder of the sultan's payment on local taxes and gratuities—a hefty sixteen percent of the total—precious metals and local currency for expenses on the return, and individual investments. At Urgench they dissolved the company and divided the pearls; they also made a loan to another Venetian, Francesco Barbarigo. When Querini too died, his goods (and probably also the four survivors) returned by a different route through Persia, perhaps because of disruptions along the previously "safe" route through Astrakhan and Tana. In Venice, Paolo and Andrea Loredan and Marino Contarini sold their pearls and goods for a little more than double their original investment. Marco Soranzo profited even more by exporting some of his merchandise to France. The survivors handsomely exceeded the average profit of twelve to twenty percent on an overseas venture, beating the odds during years of turmoil in Asia.

When the Mongol empire unraveled along the silk roads, Venice restructured her trade with Egypt and Syria.[31] In 1344 the Republic negotiated a five-year dispensation from the papal embargo that permitted five state galleys and five other merchant vessels to sail annually to Mamluk ports so long as they carried no weapons or war matériel. The Senate, which directed the Republic's trade and diplomacy, immediately dispatched an ambassador to Cairo and in 1345 opened regular service to Alexandria and sent a consul to represent the merchant colony still operating there. Both the papal dispensation and the treaty were renewed, and in 1366 state merchant galleys also sailed to Beirut. Between 1344 and 1382 the Venetian

Senate sent at least eleven special embassies to Cairo to build and maintain this trade, which was frequently interrupted by new papal embargoes, wars with Genoa, and Mamluk reprisals for raids by the Christian king of Cyprus and European pirates. From the 1370s, when the new native Ming dynasty limited access to China, until the early 1500s, when the Portuguese established the sea route to India around the Cape of Good Hope, most Asian goods reaching Europe passed through the Mamluk empire and Venice.[32] Contacts with Mamluk territories advertised in the Islamicizing decoration of the Doge's Palace proved very profitable.

During the first half of the fourteenth century the Venetian Senate had created a shipping system that encouraged East-West trade and effectively guaranteed a price advantage.[33] From 1314 the state built large merchant galleys (equipped with oars and sails), at first under contract but soon at the Arsenal, from 1329 auctioning concessions publicly in the Rialto for each voyage to Venetian citizens, who could bid individually or in consortia. For security and efficiency, the state merchant galleys sailed fixed routes in convoys, on a regular schedule of spring and fall voyages that coincided with optimal weather conditions at sea and with fairs and the arrival of caravans at their ports of call. The state merchant galleys could be armed, and escorted by state war galleys if necessary. The Senate appointed a noble to command a voyage and issued him written orders; controlled the rates; and added, suspended, or diverted voyages according to political and economic conditions. Galleys taking the route to Constantinople, called the *viaggio di Romania,* continued to Black Sea ports when possible. The route to Syria terminated in Beirut, and the one to Egypt, in Alexandria. Voyages to Flanders included a stop in England. During the fifteenth century regular routes were added in the western Mediterranean: the Aque Morte (named after Aiges Mortes in Languedoc) stopped at Naples, Pisa, French ports, Barcelona, and the Balearic Islands, and the southwestern Barbaria followed the North African coast from Tunis to Morocco, with voyages *di traffego* extending this route from Tunis to Alexandria; local merchants and travelers could join the return and reach Constantinople or Damascus via Venice. While the state merchant fleet specialized in luxury goods (spices, silks, precious stones, medicinal herbs, aromatics, cotton, dyes, alum, and manufactured items such as glass, ceramics, metalwork, and carpets) private merchant vessels carried bulky merchandise (cereals, salt, sugar, wood, and minerals) as well as some luxury goods. Private vessels, which could join the state convoys, replaced them entirely on some routes for long periods.

Venice early on established good relations with the rising Ottomans to protect the route to Constantinople and the Black Sea and to compete with the Genoese, who were well established there. Treaties guaranteeing freedom of navigation beyond the Dardanelles and conceding trading privileges were signed with Sultan Murad I (r. 1359–89) in 1365, 1368, 1376, and 1384 and then with Bayezid I (r. 1389–1402) in 1390.[34] Meanwhile, Genoa lost possessions along the Black Sea route to the Ottomans and yielded access to the Adriatic to the Venetians.[35] By the end of the fourteenth century, Venice dominated the now flourishing eastern Mediterranean trade. This dominance provided advantages to state-protected Venetian craft industries: reliable supplies of raw silk for textiles and alum for glass and a potentially significant market for the finished products.

Alexandria and Venice offered similar facilities for visiting merchants: the *funduq* (*fondaco* in Venice) as an institution evolved from antique precedents, its combined purpose to accommodate foreigners and control their activities and payment of taxes.[36] The *funduq* as a building housed the merchandise, officials, and visitors, as well as the business and social life, of a substantial foreign merchant community. A share of local customs receipts supported its operations. Typically built around a courtyard, the building had a ground floor consisting of storerooms and shops where goods and transactions could be regulated. Above were consular offices, private rooms, dormitories, and facilities for religious and community activities. The staff of the Venetian *funduq* in Alexandria included a consul who was appointed by the Senate for a two-year term, a customs agent and an interpreter who were usually non-Egyptians living in the country, a physician, a barber-surgeon, and a chaplain. Inside the *funduq,* laws and customs of the home country prevailed. For example, the Venetian *funduq* in Alexandria was administered by a council of twelve elected merchants headed by the consul, an administrative structure similar to that of the Republic. The doors of the *funduq* were locked from the

outside at night—and during Friday prayers in Mamluk territory. Venetians had the largest *funduqs* in Egypt and the largest colonies in Syria. In Damascus, Europeans seem to have been restricted to a commercial district, the "Bazaar of the Franks," rather than to *funduqs*.[37]

In Venice the first *fondaco* was provided for the Germans in the early thirteenth century; it was lavishly rebuilt after a fire in the early sixteenth century. A *fondaco* for Turks was established only in 1621, after decades of discussion focused on the desirability of segregating them from the local population. The Venetians designated distinguished quarters for the Turks: the former state guest palace once allocated to the dukes of Ferrara.[38] While the institution of the *funduq* in the hubs of East-West exchange facilitated trade, it limited contacts between people and perpetuated cultural divisions.

Other commercial practices in Venice and the Mamluk empire further restricted cross-cultural contacts.[39] Both Venice and the Mamluks taxed exported goods or goods in transit, usually exacting in addition a share of the export merchandise and a head tax on visiting merchants. In Venice the rates were the same for everyone, but in Mamluk territories they varied and were negotiable. Venice normally required that entering goods be carried on Venetian ships, but the Mamluks depended on European shipping in the Mediterranean. As a result, few Egyptians or Syrians accompanied their goods to Venice, and Venetians conducted most of the necessary diplomatic and business negotiations on Mamluk soil. In Egypt, foreign merchants dealt mostly with Jewish and other minority intermediaries rather than directly with Egyptian Muslims or Mamluk officials. The sultans governing Egypt restricted travel to Cairo and the Red Sea to control overland transport and the supply of spices, the principal export. Ambassadors, consuls, and eminent travelers visited Cairo, but ordinary merchants did not. Damascus, however, a major source for raw silk and cotton as well as a variety of manufactured goods, was accessible. European merchants and pilgrims flocked to its markets and were impressed by its architecture and crafts. Trade was freer in Damascus than in Alexandria because distance and the division of administrative authority between two local emirs weakened the sultan's control. It is no accident that the most accurate Italian image of the Mamluk world came from Damascus (see

Fig. 169). During the fifteenth century Venetians living in numerous other Syrian cities were represented by vice-consuls in Beirut, Acre, Hama, and Latakia. The loose Syrian control over trade and travel, however, exposed foreign merchants to extortion and confiscation.[40]

The luxury trade in Mediterranean countries changed after the great international epidemics of the 1340s, when the wealth and industries of Egypt and Syria declined while those of Italy grew. Whereas Europe successfully adjusted to economic changes, the Mamluk empire suffered a series of calamities. Decades of political instability followed the Circassian Burji faction's takeover in Cairo in 1382 and Tamerlane's invasion of Syria in 1400.[41] Rapid and violent successions, diminishing tax receipts, increasing military expenses, inflation, the famine of 1403/4, and depopulation greatly weakened the economies of Egypt and Syria. Decreased Mamluk buying power affected all classes. In the early fifteenth century, the Egyptian historian al-Maqrizi lamented that even the rich were now wearing clothing previously used only in the rain, by the urban poor, or foreigners—made from cheap European fabrics "dumped" in huge quantities in Alexandria.[42] Meanwhile, Mamluk industry failed to maintain quality or offer variety. The elite Egyptian royal textile workshops closed in 1341, and subsequently the industry suffered from the sultans' efforts to control it and from the lack of technical innovation. The number of looms in Alexandria plummeted from fourteen thousand in 1388 to eight hundred in 1433.[43] The Spaniard Clavijo, who led an embassy to Tamerlane in 1403–1406, observed many silk weavers captured in Damascus at work in Samarkand.[44] The production of inlaid metalwork fell because of decreasing court patronage and the costliness of materials.[45] Syrian glass declined technically, and the industry never recovered from Tamerlane's destruction of Damascus and the Mamluk elite's rising taste for Chinese porcelain.[46] Competition from porcelain and Spanish lusterware interfered with the recovery of the Syrian ceramics industry. To extract more revenue from trade, Sultan Barsbay (r. 1421–28) abolished traditional privileges of the local Jewish intermediaries and required foreigners to buy pepper and sugar—the principal Egyptian exports—from his own appointed agents at high fixed prices. His successors somewhat mitigated but sustained the monopolies.[47] Though Sultan Qaitbay (r. 1468–96) increased

trade, by granting new privileges to foreign merchants and excepting local merchants from some taxes, and lavishly patronized the arts—spurring a significant revival in metalwork and a new carpet industry, both of which contributed to exports—he could not reverse the general decline.[48]

In Europe, despite the reduction of population and the drain on money—Venice was said to be carrying off the treasury of England—the consumption of luxury goods continued to grow.[49] During the fifteenth century, Italian demand for luxury textiles and household furnishings accelerated rapidly, fueled by the urban elite's desire for public display and the private enjoyment of their steadily accumulating wealth.[50] To satisfy local consumers, Italians, certainly watching their balance of trade, expanded their already sophisticated silk production and swiftly developed their glass and ceramics industries. The Florentine Signoria officially linked industrial development and export trade when in 1422 it assigned the promotion of new arts and crafts to the officials responsible for the new state galley line to Alexandria that would compete with that of Venice.[51] Luxury goods previously imported from the eastern Mediterranean increasingly were made in Italy and exported east as well as north. The Spanish ambassador Clavijo noted that his escort from Tamerlane's court presented a Florentine textile to a Persian lord,[52] and in 1449 a German pilgrim found the Damascus market full of silk imported from Venice, much of it probably destined for markets farther east.[53] Northern Europeans and the Mamluk elite bought Venetian glass. Everyone was also buying Spanish lusterware, Turkish carpets, and Chinese porcelain. By the end of the fifteenth century, major manufacturing centers of luxury goods had developed in Europe, trade in these objects had become multidirectional, and there was a community of taste in Mediterranean lands.[54]

To maintain their eastern Mediterranean commerce during changes and setbacks in the Mamluk empire and Turkey, Venetians continued to rely on diplomacy. With the early Burji Mamluks, it was a question of constantly negotiating with new sultans for relief from mounting taxes and fees, arrests, confiscations, and general interference in trade. Consuls in Alexandria and embassies to Cairo protested in vain until 1415, when a favorable treaty exempted Venetians from punishments and residence restrictions imposed on other Europeans. But in 1421 the succeeding sultan, a religious fanatic, annulled these privileges and decreed all foreigners henceforth limited to a four-month stay. The Venetian Senate promptly dispatched two ambassadors to negotiate; before they arrived, however, the sultan died. The following year, Sultan Barsbay renewed the concessions of 1415. In his final oration in 1423 Doge Tommaso Mocenigo boasted that the city was receiving a forty-percent return on its investment in foreign trade, having earned 750,000 ducats (more than $28 million in gold today). He urged the Senate to pursue a policy of peace and accommodation to assure continuing prosperity.[55] In 1428 Barsbay instituted a state monopoly on pepper, the mainstay of East-West trade: it could be bought and sold only in the sultan's warehouses at his price, which was double the previous rate. The consul's protests were ignored. Sultan Jaqmaq (r. 1438–53) retained the monopoly but granted some relief. His successors replaced the monopoly with a requirement that each departing ship purchase a fixed quantity of pepper from state warehouses at the official price; more could be bought from local merchants at market rates. The quantity and price of the mandatory pepper purchases became the principal issue in Venetian-Mamluk relations, with prices tending to fall until 1500.[56] Merchants' grievances also remained a constant concern of Venetian envoys.

Though Venice could not avoid hostilities with the Ottomans, the Senate was ever quick to swallow losses and resume relations. Treaties with Suleyman (r. 1403–11) from 1403, and with Mehmed I (r. 1413–21) in 1415 prohibited Turkish commercial shipping in the Aegean but obliged Venice to pay an annual fee to maintain her colonies and guarantee free trade in Ottoman territory. When the Turks ventured beyond the Dardanelles, however, and a peace mission failed, Venice engaged and defeated them at Gallipoli in 1416.[57] Venice participated in the defense of Constantinople reluctantly and sent ambassadors soon after the city fell in 1453. In the ensuing treaty with Mehmed II (r. 1451–81) Venice, to retain commercial privileges, acquiesced to a downgraded status for the Republic's *bailo,* the consul in Constantinople whose perquisites dated from 1261. These privileges, renewed at

the beginning of each new sultan's rule, were gradually reduced after the late fifteenth century.[58]

Venice lost control of important colonies after Ottoman victories in Salonika (1430), Negropont (1470), Tana (1475), and Scutari (1479) and even suffered Turkish incursions in the Friuli on her mainland territory (in 1472, 1477, and 1479).[59] Seeking an ally capable of diverting or at least containing the Ottomans, the Senate sent ambassadors with years of experience in the eastern Mediterranean to the Turkoman sultan Uzun Hasan in Tabriz in 1471 and 1474, but no common front emerged.[60] Finally, ambassadors who were experts in Turkish affairs went to Istanbul with instructions to agree to anything that would maintain commercial privileges, and in January 1479 they signed a humiliating peace treaty that relinquished all claim to the lost colonies. In August the Senate received a request from Mehmed II for artists and immediately dispatched Venice's senior painter, Gentile Bellini.[61] The portrait medals that he and other Italian artists executed for Mehmed (for example, see Fig. 165) disseminated the sultan's image in Europe. Despite frequent interruptions, Venetian trade with the Ottomans continued, supplying carpets for all of Europe and a market for Venetian textiles and glass. Venice's acquisition of Cyprus in 1489 helped prolong the Republic's hegemony in East-West trade.[62]

Florence, after acquiring the ports of Pisa in 1407 and Livorno in 1421, sought to expand its overseas trade by establishing a state galley line.[63] Ambassadors concluded a treaty with the Hafsid ruler of Tunisia, Sultan Abu Faris, in 1421. The following year the Signoria sent Felice Brancacci and Carlo Federighi on the first new galley to negotiate with Sultan Barsbay in Cairo. A public holiday, procession, and Mass in the cathedral celebrated their successful return in 1423. Because of war with Milan, however, traffic began only in 1445 and was light. In 1487 Sultan Qaitbay sent one of his rare foreign embassies to renegotiate. The treaties of 1489, 1496, and 1497 increased privileges, following Venetian precedents.[64] Partly to promote trade with Constantinople, the Signoria hosted the concluding sessions of the Council of Eastern and Western Churches in 1439, and upon his departure the Byzantine emperor John VIII Paleologus granted Florence customs privileges and the use of the former Pisan consulate.[65] During the 1460s and 1470s, Mehmed II pursued good relations with Florence to the detriment of Venice, with whom he was at war. Florentine galleys sailed to Istanbul, where resident agents actively purchased luxury goods, notably carpets.[66] In 1478 Mehmed extradited the fugitive assassin of Giuliano de' Medici upon Lorenzo de' Medici's request, leading to the public hanging that ended the infamous Pazzi conspiracy. Lorenzo expressed his gratitude by commissioning a flattering medal of the sultan.[67] Nonetheless, Florence's trade with the eastern Mediterranean remained limited: the city had a small market for imported spices and could export only textiles and ceramics in quantity.[68] Characteristically, Mehmed II expressed interest in Florentine artists.[69]

Diplomatic gifts were an internationally accepted form of princely tribute, and during the fifteenth and sixteenth centuries they also played a role in promoting trade in the most profitable luxury exports. In 1473, after discussing the usual issues regarding pepper with a Venetian ambassador, Sultan Qaitbay sent Doge Nicolò Tron twenty pieces of porcelain, muslin, rare aromatics and medicinal herbs, sweetmeats, fine sugar, and a civet horn.[70] When Qaitbay's ambassadors arrived in Florence in 1487, they gave Lorenzo de' Medici "finer porcelain than seen hitherto"; Valencian vases; rich textiles, including a magnificent striped ceremonial tent; sweetmeats; spices; aromatics; medicinal herbs; and a giraffe, lion, bay horse, and fat-tailed sheep. The presentation of the gift is represented in a mid-sixteenth-century cycle of paintings by Giorgio Vasari in the Palazzo Vecchio, Florence, celebrating noteworthy achievements of the Medici family.[71] The Chinese porcelain presented by Qaitbay and the Mamluk sultans who preceded him are some of the earliest documented pieces in Italy.[72] At the time, most luxury ceramics were imported from Spain, and fine glass was no longer made in the Mamluk empire. By sending porcelain to Italian tastemakers, the Mamluks were promoting a costly new product beginning to arrive in their territory in sufficient quantity for export.[73] Exotic animals, long a tradition among Oriental princes, were an appropriate gift for Lorenzo de' Medici, who had a menagerie—also an Oriental tradition—at his villa in Poggio a Caiano.[74] While the rare giraffe brought to Florence was intended

as a token of highest honor, Arabian horses were increasingly brought to Italy, which offered a rising market for them. Diplomatic gifts also undoubtedly included exotic antiques from the East, such as the famous Tazza Farnese, a Ptolemaic sardonyx cameo now in the Museo Nazionale di Capodimonte, Naples. It was in the royal Timurid treasury several decades before 1471, when Lorenzo de' Medici acquired it in Rome, perhaps from the estate of Pope Paul II (d. 1471).[75]

Italian commercial states sought to impress Eastern rulers and their emissaries with locally produced luxury goods of the type and quality formerly imported from the Orient. In 1415 the Venetian ambassadors Lorenzo Capello and Santo Vernier presented textiles and several glass objects to Sultan Shaykh in Cairo.[76] In 1474 the Venetian ambassador Giosafat Barbaro gave Sultan Uzun Hasan of Persia brocades and silks worth 2,500 ducats, and other fine fabrics worth 300 ducats (all together about $105,500 in gold today).[77] In 1488/89 Florence sent Sultan Qaitbay silks brocaded with gold, small coffers and chests, and mirrors set in ivory and bone.[78] In 1480 a French pilgrim passing through Venice noted that the Ottoman ambassador Hasan Bey, who had come to negotiate frontiers, appeared in public wearing a robe of crimson velvet brocaded in gold with a floral design, probably one of the garments customarily presented by the Senate, and on the Feast of Pentecost the ambassador was given a cloth-of-gold and the rest of his delegation scarlet robes, garments normally reserved for the doge and patrician officeholders.[79] The senators' flattering promotion of their most elite textiles met with great success: the Ottoman court purchased huge quantities of Venetian silks and velvets, and sultans often had them made into ceremonial kaftans (Fig. 184).[80] Numerous Ottoman miniatures show Sultan Suleyman the Magnificent (r. 1520–66) and his attendants wearing Italian textiles.[81] In 1512 Venetian envoys presented the Mamluk sultan Qansuh al-Ghuri with glass, velvets, brocades, damasks, woolens, furs, and Parmesan cheeses.[82] Conversely, in 1483 Sultan Bayezid II (r. 1481–1512) presented the Venetian ambassador Bendriye with three types of velvet beginning to be produced locally at Bursa in competition with the Italian textile industry, a rivalry that soon became fierce.[83]

The new Portuguese pepper route to Europe, around the Cape of Good Hope, and political instability in Mamluk territory diminished Venetian trade with Egypt and Syria as the sixteenth century opened.[84] Violence in Cairo accompanying the accession of six sultans between 1496 and 1501 spread to the European merchant communities in Alexandria. By the time Sultan Qansuh al-Ghuri (r. 1501–16) took firm control and attempted to renew the state monopoly on pepper and compel more purchases at higher prices, Portuguese pepper was arriving in the Netherlands. It probably reached Genoa in 1503 and England in 1504. Venetian ships found little pepper in Alexandria or Beirut in 1502, and none in 1504 and 1506. Though active trade continued in Damascus and northern Syria, Venetians there were incurring huge debts, bankruptcies, and seizures that followed upon excessive interest, taxation and levies of merchandise, local hostility, and increased competition with other Europeans. Venice, to protect the lucrative German market for Oriental spices and the city's own industries, acted both at home and abroad, closing mainland frontiers to spices and luxury goods from Genoa and elsewhere in 1503.[85] After several embassies to Cairo failed to win concessions from Sultan Qansuh al-Ghuri, the Senate courted his ambassador, Taghri-Birdi, from September 1506 to July 1507. A treaty signed in March 1507 granted Venice privileges without requiring that the city supply the sultan with arms he wanted to confront the Portuguese in the Red Sea. In 1514, reversing traditional protectionist practice, the Senate permitted any vessel to unload spices from the eastern Mediterranean in Venice.

Venetian trade with Egypt and Syria improved following the Ottoman conquest of Mamluk territory in 1516–1517. The Ottomans revived the caravan routes and even began a Suez canal.[86] Complaints about the quality of Portuguese pepper and other difficulties with the long sea voyage around Africa favored a revival of the older, shorter eastern Mediterranean route. By 1550 the Venetian spice trade was thriving again; only after about 1625 would spices bound for Europe mostly travel the Atlantic route. Other trade also prospered.[87] The Ottomans permitted the Venetians to establish consulates in Cairo and Aleppo, the first, the principal market for spices, the second, for cotton and silk arriving by caravan. In 1520 the Venetian ambassador in London concluded negotiations for the entry of Cypriot wine only after he was able to present Cardinal Wolsey, his interlocutor,

with fine, newly fashionable "Damascene" carpets worth more than 1,000 ducats (about $37,700 in gold today).[88] Eastbound cargoes included copper in bars, manufactured copper—probably brass vessels shipped for decoration, woolen and silk cloth, coarse English woolens, coral, amber, glass, paper, and coin. In 1596 exports to Syria were valued at two million ducats (more than $75 million). Returning cargoes of spices, fine Persian silks, and raw cotton and silk had an even higher value.

Venice dominated trade with Turkey as well during the sixteenth century, though profits tended to decline.[89] The Ottoman court spent lavishly on velvets, silks, and fine woolens until about 1550, when the aging Sultan Suleyman the Magnificent adopted pious ways and simple dress. Several consortia of Venetian merchants had sold him gem-encrusted regalia reputedly worth over 300,000 ducats (about $11 million) in 1532 (see Fig. 175),[90] but in 1560 Venetian exports to the Ottomans totaled only 150,000 ducats, mostly fabrics and glass. Fluctuations in supply and demand and high overhead costs in Istanbul, including a fifty percent commission to increasingly active Jewish intermediaries, discouraged resident merchants. In 1553 only two Venetian nobles lived in Istanbul; middle-class agents handled most trade. The Ottomans soon developed their own luxury textiles and ceramics, with which Italian imitations competed in the European market. Northern European woolens and cottons, cheaper and lower in quality than Italian textiles, took an increasing share of the Turkish market. Though the Ottoman court imported more Venetian textiles and jewels toward the end of the century, and overland trade through the Balkans spurred Venice in 1590 to develop Split, trading patterns were shifting to Italy's disadvantage. By the 1630s English merchants outnumbered Venetians in Istanbul.

In 1600 as in 1300, Italy still imported luxury manufactured goods, notably fabrics, carpets, and ceramics. But Italian industries were now producing imitations that closely followed Oriental designs and, in far greater quantities, Europeanized versions of most of these items. Genuine porcelain and fine carpets continued to be imported exclusively, but Italy was now the primary producer of glass, and Italian textiles, ceramics, and inlaid metalwork had an international market. While Italians collected Greek and Arabic manuscripts from the East, they were also printing books in Arabic and other Eastern languages for export.[91] The luxury trade had become truly international and competitive, and through innovative design, technology, and marketing, Europe had become the industrial leader and Italy the most diversified producer.

▪▪▪ ▪

PATTERNED SILKS

TEXTILES WERE THE FIRST ITALIAN DECORATIVE ART that developed to a high standard, and the first to follow Oriental models as these reached their peak period of development. Luxury textiles were staples of the international luxury trade during the Middle Ages and the Renaissance, the demand for them so universal that they served as a common currency and became the primary agents of artistic transfer, all the more effective because they played parallel roles and bore comparable symbolic meanings in Islamic, Mongol, and European cultures.

In both East and West, the wearing and display of luxury textiles signified authority and rank and marked religious rituals and milestones in secular life.[1] It was international custom to seize luxury textiles as prizes of war and present them as tokens of honor. Their materials and color bore significant meaning in all cultures. For example, the protocol for honorific garments bestowed by Mamluk and Ottoman sultans and the Mongol great khan and for robes worn by Venetian doges was based on the actual value of materials used in the fabrics. Everywhere the most prestigious fabrics were silks woven or embroidered with gold and silver thread, or appliquéd with pearls and gems. The meaning of colors differed according to culture: the dynastic color for the Byzantine emperors was purple; for Venetian patricians, red; for the Fatimid sultans, white; and for the Mamluk sultans, yellow. Various colors marked Christian feast days, the Muslim *haj,* and Mongol holidays. Ornamental patterns woven into or embroidered onto luxury fabrics, in con-

trast, were highly subject to fashion. Because the finest fabrics had universal prestige, textile fashions were closely watched and imitated all along the routes of trade, conquest, and diplomacy. Europeans readily adapted the essentially ornamental motifs in Asian and Islamic textiles, few of which bore culturally restricted meanings.

An ecclesiastical vestment in the treasury of the cathedral of Fermo (Fig. 14) illustrates how even textiles whose Islamic imagery and inscription did have meaning were prized and adapted to new uses.[2] Supposedly owned by Thomas à Becket, archbishop of Canterbury (murdered in 1170), this chasuble (the outer garment worn by a priest celebrating the Eucharist) was made from worn pieces of a gold-embroidered silk produced in Almería, the principal textile center of Almoravid Spain, in 1116. The fabric probably came from a canopy or tent seized in war and presented as a diplomatic gift. For example, the Genoese sent textiles taken in Almería in 1143 to Emperor Frederick I Barbarossa, and Alfonso VIII of Castile sent the pope a tent of silk and gold after his victory at Navas de Tolsa in 1212.[3] Such was the prestige of the embroidered textile that it was reshaped for Christian use despite the traditional Islamic royal and cosmological imagery in its compartmented design.[4] Moreover, the textile's Arabic inscription invoking Allah's blessing on the owner was turned into an orphrey (an ornamental band, usually embroidered), centered on the back of the vestment, where it would face the congregation during Mass.

Unfortunately, few surviving medieval Islamic, Asian, and Italian textiles have documented histories. Most come from European church vestments and furnishings and royal and ecclesiastical tombs. Technical analysis, paintings, and inventories provide most of the evidence of the origins, dates, and diffusion of luxury textiles between about 1300 and 1600. Examples from central Asia that have recently come to light in Tibetan religious institutions, probably gifts from Mongol rulers, contribute new information on the spread of silk weaving in the Mongol empire.[5] It is clear that silk-weaving techniques and designs traveled rapidly, but mystery surrounds the production of individual textile centers from Spain to Mongolia and the beginnings of the Italian industry.

It is still uncertain what role the kingdoms of Sicily and South Italy played in transmitting Islamic and Byzantine silk-weaving traditions to the great northern Italian production centers.[6] Nothing survives to verify reports in Arab literature and Jewish documents in Cairo that silk fabrics were produced and exported during the Arab rule of Sicily,[7] which began with the Tunisian Fatimid conquest in 837 and continued under the dominion of the Egyptian Fatimids until the Norman conquest at the end of the eleventh century. Furthermore, little is known about the expertise Norman manufactories inherited from the Arab regime and possible refinements brought

back by Greek weavers from the Norman campaign in Corinth, Thebes, and Athens in 1147.[8]

Elaborate embroidery in an Islamic style was certainly produced for Norman rulers in Palermo. The earliest identifiable Sicilian textile is the red silk cape embroidered with gold and set with pearls, gems, and enamels that was made for King Roger II (see Fig. 52).[9] The Hohenstaufen successors to the Normans took the cape to Germany, where Holy Roman Emperors wore it for centuries at coronations. The clearly legible Arabic inscription running along the hem states that it was "made in the royal *kizanah* [treasury or household] for him in whom dwell good fortune and honor, prosperity and perfection . . . in Palermo in 1133/34." Though the Palermo *kizanah* may not have been the usual Islamic royal *tiraz* (weaving establishment), this inscription is so like those on textiles made in a *tiraz* that the craftsmen employed by the Normans must have been Muslims familiar with its traditions. The cape's embroidery technique relates to contemporary Spanish textiles such as that shown in Figure 14,[10] and the traditional Islamic design of addorsed animals flanking a tree shows strong Spanish influence in its graceful, precise drawing and the shape of the tree—a marked vertical topped by stylized leaves. The unusual representation of lions subduing camels, which must symbolize the Norman conquest of Arab Sicily, shows that its makers

14

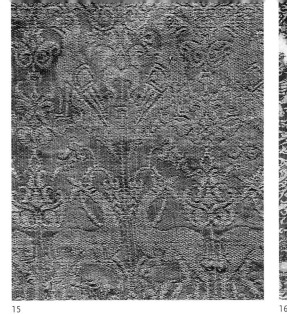

15 16 17

readily accommodated needs of the new regime. The
cape's red silk ground fabric may have been imported
from Byzantium, where King Roger soon captured skilled
silk weavers.[11] Roger's successors employed Muslim em-
broiderers until at least the 1180s to make bands for
imperial vestments.[12]

Large silks with allover embroidery made in Sicily or
South Italy under the Hohenstaufen were highly regarded
in northern Italy during the thirteenth century. According
to local tradition, an exceptional piece over five meters
long in the treasury of San Francesco, Assisi, draped the
funeral cart of Saint Francis, either during the obsequies
of 1226 or the ceremonial translation of the saint's re-
mains to the newly completed lower church in 1230. An
inventory of the treasury in 1338 describes this and two
other long altar cloths, also associated with the funeral
cart, as gifts of a Greek emperor.[13] Silks embroidered as
copes (the long outer capes worn in liturgical proces-
sions) were given to churches in Vicenza and Anagni,
the latter by Pope Boniface VIII (1294–1303).[14] The ani-
mal patterns on these fabrics, more Byzantine than Is-
lamic in style, offered nothing new to northern Italian
textile centers, which did not adopt the allover embroi-
dery technique.

Sicilian patterned silks may have had an impact on
the Italian industry. The only surviving example certainly
woven in Palermo is a damaged fragment in the Kestner
Museum, Hanover, that is inscribed OPERATIUM IN REGIO
ERGAST[IUM] (made in the royal workshop). It shows
weakly rendered Byzantine-style paired animals in a
roundel. A small group of Islamic-style textiles closely
related to burial cloths from the tomb of Henry VI
(d. 1197) are probably Sicilian.[15] Henry, of the German

14 Chasuble associated with Saint Thomas à
Becket, silk embroidered with gold thread,
Almería, Spain, 1116. Treasury, cathedral of Fermo.

15 Detail of a fragment from the shroud of King
Henry VI (d. 1197), silk, lampas weave, silk and
gold threads, Sicily (?), late twelfth–early thirteenth
century. British Museum, London (MLA 1878, 9-7, 4).

16 Detail of a fragment of a tunic, compound
weave, silk thread, Iran, thirteenth–fourteenth
century. Museum of Fine Arts, Boston, Denman
Waldo Ross Collection (31.11).

17 Detail of a chasuble, samite, silk thread, Spain,
thirteenth century. Staatliche Museen zu
Berlin–Preussischer Kulturbesitz, Kunstgewerbe-
museum, Berlin (85,20).

Hohenstaufen, acquired the kingdom of Sicily and South
Italy through his wife, Constance of Sicily; the textiles
presumably date from 1215, when Frederick II transferred
his father's remains to a new family mausoleum in the
cathedral of Palermo. A fragment from Henry VI's shroud
(Fig. 15),[16] a lampas weave (different sets of warps and
wefts in the background and pattern, producing varia-
tions in texture and sheen) with a pattern of horizontal
rows of paired animals separated by long vertically
aligned stems and palmettes, is so similar to thirteenth-
century Spanish and other Islamic silks that it is impos-
sible to be sure of its origin. Quality currently weighs
heavily in attributions. The weaving and drawing of
Henry VI's shroud are coarser than in Egyptian, Syrian,
or Persian silks such as the fragment in Figure 16,[17] as
well as Spanish examples such as that in the chasuble
in Figure 17.[18] Fine twelfth- or thirteenth-century com-
pound weaves (different sets of weft—or warp—threads

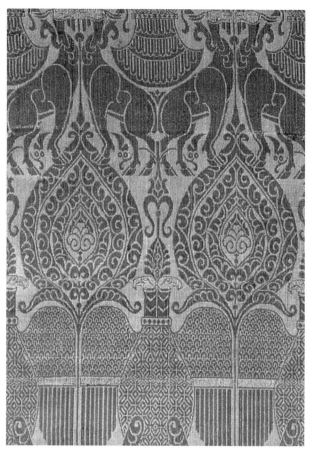

18

18 Fragment of silk, compound weave, silk
and gold thread, Spain, twelfth century. Saint
Servatius, Siegburg (D 22d).

19 Fragment of silk, lampas weave, silk and
gold thread, Italy, first half of the fourteenth
century. The Cleveland Museum of Art,
purchase from the J. H. Wade Fund
(1926.507).

bound to create a uniform texture) with gold threads
accenting the heads and feet of animals, as in Figure 18,
that used to be attributed to Sicily are now thought to
be Spanish.[19] Sicilian textile production—and its offshoots
in South Italy—declined in the decades preceding the
collapse of the Hohenstaufen empire in 1266, and it is
believed that disorder and civil war under Angevin rule
drove many textile workers north, especially to Lucca.
Their knowledge of sophisticated Islamic weaving tech-
niques and new uncompartmentalized Islamic designs
presumably contributed to the blossoming of the main-
land industry, specifically to a group of early-fourteenth-
century lampas weaves with gold accents exemplified in
Figure 19.

By 1300 silk weaving had been established in Lucca,
Venice, and Genoa, and Italian textiles were arriving in
Spain and the eastern Mediterranean.[20] The Lucchese
industry dates from the twelfth century, when the city
became a prosperous independent republic. Treaties with
Genoa in 1153, allowing free passage of goods to the fairs
of Champagne, and in 1166, permitting Lucchese to par-
ticipate in maritime commerce on equal terms with
Genoese citizens, helped assure the supply of raw silk
from the eastern Mediterranean and facilitated the mar-
keting of finished products in Europe.[21] Records indicate
that Lucca rarely used Venetian shipping, and only when
under the rule of Pisa, between 1342 and 1364, did Lucca
use the ships of that nearby rival. Specializing in luxury
silks demanded by the Church, royalty, and the very rich,
Lucca became the foremost textile center in Europe.
Genoa, with its strong position in the Black Sea and in
Syria, enabled Lucca to obtain the finest raw silk from the
Caspian region and northwest Persia—and cheaper Chi-
nese silk about the 1330s—as well as models of finished
central Asian, Persian, and Syrian fabrics. During the
twelfth and thirteenth centuries, Genoa also had good
commercial relations with Muslim Spain, whose textiles
were an important source of inspiration for the Lucchese
industry about 1300. An Italian silk in the Metropolitan
Museum of Art, New York, that is closely related to
twelfth-century Spanish silks matches the description in a
papal inventory of 1295 of "a Lucchese diaper [historical
term for a textured weave] with red birds in roundels,
with heads in gold."[22]

The same papal inventory also lists some Venetian silks
with animal designs.[23] Venetian statutes of 1265 establish-

ing minimum thread counts and sizes for different fabrics
and prohibiting the combination of linen or cotton with
silk threads indicate that the local industry was producing
and marketing enough silk fabric to warrant regulation.
Emigrants from Lucca fleeing civil war between the
Guelfs and Ghibellines that broke out there in 1307 pro-
vided a welcome boost to the Venetian industry. In 1314
the normally protectionist Venetian government awarded
privileges to thirty-two families of Lucchese artisans,
about three hundred persons, and established a silk district
near the Rialto. The encouragment given to these presum-
ably skilled craftsmen suggests an early beginning for the
diffusion of technology and copying in northern Italy.

Since Italian silk weavers used the same raw materials
as well as similar patterns and techniques, one meticulous
scholar has concluded that evidence is insufficient to attrib-
ute fourteenth- and fifteenth-century silks to specific
Italian weaving centers.[24] In both Lucca and Venice, the
silk-weaving industry was poised for the great surge in
development that occurred about the second quarter of
the fourteenth century. Paintings, inventories, and datable
vestments and burial cloths document the tremendous
demand for luxury fabrics that fueled this development,
as well as elite taste for new Oriental fabric designs that
the traditional compartmented animal patterns could no
longer satisfy.

The first Italian paintings to reflect a massive influx of
Islamic textiles are those that narrate the stories of Saint
Francis on the walls of the Upper Church of San Fran-
cesco, Assisi, executed sometime between the early to
mid-1290s and 1308. A long debate over the attribution
of these paintings continues. They may have been painted
under Giotto's direction as traditionally believed. Or they
may have been executed by unknown (perhaps Roman)
artists exploring naturalistic representation and expression
in ways similar to Giotto in his Arena Chapel paintings
in Padua, his earliest certain work, datable about 1304–
1312/13 (see Figs. 49, 158).[25] I treat the Assisi paintings
as anonymous works to avoid exaggerating Giotto's
responsibility for the various Oriental elements discussed
in this chapter and the one that follows.

The Assisi frecoes and paintings by a number of Tuscan
artists—Duccio (see Fig. 48), Giotto (see Fig. 158), Simone
Martini, Ambrogio and Pietro Lorenzetti, Taddeo Gaddi,
Bernardo Daddi—show many textiles with Islamic-style
geometric patterns that are closely related to thirteenth-

19

20 Master of the Stories of Saint Francis, *Saint Francis Appears to Pope Gregory IX in a Dream*, ca. 1296–1305. Upper Church of San Francesco, Assisi.

21 Fragment of the burial tunic of Don Felipe (d. 1274), compound weave, silk and gold thread, Spain, second half of the thirteenth century. Abegg-Stiftung, Riggisberg (212).

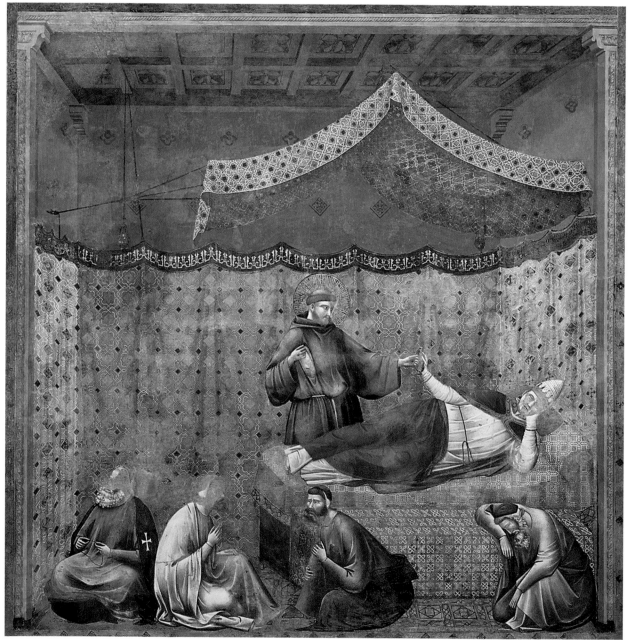

century Spanish silks.[26] The textiles in stories of Saint Francis suggest that at least their painters had Spanish models or sketches of them before their eyes.[27]

In the fresco *Saint Francis Appears to Pope Gregory IX in a Dream* (Fig. 20), the canopy, curtain, and covers on the bed and bench have similar overall patterns of fine geometric interlace. Such intricate geometric designs, developed to a high art in Mediterranean Islamic lands, are also hallmarks of textiles made in the Nasrid kingdom of Granada during the thirteenth century.[28] The canopy's alternating polygonal stars and lobed medallions, a pattern filled with overlapping and interlaced lines and tiny foliate forms, closely matches the upper and lower bands of a fragment of the Islamic-style tunic (*aljuba*) in which Don Felipe (d. 1274), brother of King Alfonso X of Castile, was buried (Fig. 21).[29] The curtain has a similar pattern, while the bench cover's medallion pattern resembles that of the band in the middle of the fragment. Closer matches for the interlacery of the bench cover and curtain are found on the burial mantle of Don Felipe's wife, Leonor.[30] The band running along the top of the curtain has repeated mirror-image upright and clef forms imitating highly ornamental Arabic inscriptions in *kufic*-style script that were common on Spanish textiles. Don Felipe's tunic illustrates the contemporary fashion for short repeated inscriptions—here the word *baraka,* blessing—arranged in four-square patterns. There are close parallels for the curtain's interlacery in other Spanish fabrics.[31]

No examples survive, however, of large Islamic furnishing fabrics with allover geometric patterns or with bands of script only along the top, like those represented in Figure 20 and many other late-thirteenth- and early-fourteenth-century Italian paintings. Drawlooms with mechanical patterning devices used in the Islamic world at this time favored banded layouts with small mirror-image repeats, as in Figure 21.[32] In Egypt and Syria geometric elements were combined with animal, vegetal, and epigraphic ones, but in Spain purely geometric and epigraphic elements predominated. The repeats on thirteenth-century Spanish silks are usually much smaller than those shown in Italian paintings,[33] about five centimeters or less, as in Don Felipe's tunic, and most of the Spanish fabrics listed in the 1295 papal inventory are described as *virgato,* striped or banded.[34] This does not mean that the fabrics represented by Italian painters did not exist. Great quantities of luxurious furnishing fabrics

21

were produced in the Islamic world, where it was customary for the elite to receive guests and conduct official business in curtained and draped surroundings, and documents indicate that hangings of different weights were made in Spain.[35] A traditional Islamic layout must be reflected in two large mid-thirteenth-century central Asian fabrics recently found in Tibet, perhaps from tents, that have bands of inscription at the top and allover patterns in the scale of the Assisi paintings but very different designs, blending Islamic and Chinese motifs.[36]

Differences between the painted textiles and surviving examples of their presumed visual sources, however, could result from artistic license and contemporary painting style, in which accurate representation was just beginning. The painters who executed the Saint Francis series had a varied understanding of Islamic geometric patterns and interlace: the textiles in Figure 20 and in *The Vision of Pope Innocent III* closely imitate the presumed Spanish models, but those in *Pope Honorius III Approves the Franciscan Rule* and *Saint Francis Preaching before Pope Honorius* scarcely resemble them.[37] Fabrics with Islamic-style geometric patterns, some with top bands of imitation Arabic script, appear in a number of late-thirteenth-century paintings by Tuscan artists, but the patterns bear only a distant resemblance to Spanish silks.[38] A noteworthy example covers the back of the throne in Duccio's *Madonna and Child Enthroned with Angels* (the Rucellai Madonna) (see Fig. 48), painted in 1285 for Santa Maria Novella.[39] During this period in Italian painting, textile patterns often passed from masters to pupils, part of the style of a workshop and eventually a region.[40] The exceptional ability of the painter of *Saint Francis Appears to Pope Gregory IX in a Dream* (Fig. 20)—and also of Giotto in *The Mocking of Christ* in Padua (see Fig. 158)—to describe Oriental patterns in detail permits the identification of the ultimate source for what had probably become an artistic convention. Though painters may have preferred geometric patterns because they could be rendered more clearly in fresco and tempera than figured designs, the textiles that inspired them must have been present in large numbers and admired for decades.

The paintings in the upper church illustrate contemporary use of luxury textiles in both the papal court in Rome and San Francesco itself, which was a papal basilica. In addition to furnishing papal bedchambers and audience halls, the geometric fabrics appear as altar cloths, garments of the Church hierarchy, a vestment worn by Saint Francis at Christmas Eve Mass in the town of Greccio (see Fig. 45), his funeral cloths, and fictive hangings along the lower walls of the nave. Lavish ceremonials at San Francesco began in 1228, when Pope Gregory IX laid the cornerstone in full papal regalia and immediately thereafter sent precious liturgical objects and textiles from Rome.[41] In 1253 Pope Innocent IV permitted the church to use the luxury articles flowing to it, an exception to regulations of the Franciscan order prohibiting costly decorations; he himself sent luxury textiles there in 1288. The conspicuous display of foreign, specifically Islamic-style, textiles in the church's painted decoration may also refer symbolically to the contemporary international program of the Church and the order. Nicholas IV, the first Franciscan pope, in 1288 ordered that the church be decorated. The execution of that decoration was administered from Rome during the next two decades, when the order was the papacy's principal partner in the new missions to the Mongol empire. Saint Francis's exemplary mission to Egypt in 1219 during the Fifth Crusade is commemorated in *Saint Francis Proposing the Trial by Fire to the Sultan*. The textiles could intentionally have been included in the carefully programmed decorations to underscore the increasing contacts of the Church and the order with the non-Christian world.

Despite the evident popularity of the Spanish geometric fabrics, Italian textile designers preferred figured designs. About 1300 they briefly imitated closely related Spanish patterns with geometric interlace enclosing traditional animals.[42] But the Italian industry's first major step away from conventional layouts, beginning by the second decade of the fourteenth century, was inspired by uncompartmentalized Islamic figured designs. The lampas weave in Figure 19 illustrates the popular Italian silks for which the earliest notice is the inventory of Canterbury cathedral in 1315.[43] Alternating horizontal rows of vertically aligned paired birds and animals flank concentric palmettes; gold threads accent the heads and hooves of the quadrupeds and the heads, wings, and claws of the birds. The ultimate source for the composition, the motifs—most tellingly the oval palmette filled with concentric rows of vegetal elements—and the gold accents was undoubtedly twelfth-century Spanish silks such as

those in Figures 17 and 18. As has been noted, Sicily may have played a role in transmitting uncompartmentalized designs and the lampas weaving technique to northern Italy. Inventories mention such designs in silks from Antioch, but little is known about production there. Though the Italian composition remained constant into the second half of the century, designers varied the traditional birds and animals and blended new motifs into the design—fantastic Chinese-inspired beasts like those on contemporary central Asian and Persian textiles, European heraldic emblems, and the Christian Lamb of God. Over time, designers also relaxed the composition's stiff verticality, opened up its crowded space, and enlivened the animals.[44] The passage from selective imitation to blending to Italianization of designs, which kept them fresh, is typical of fourteenth-century Italian silks.

The fabrics that revolutionized Italian textile design beginning about the 1330s were the Tatar cloths arriving from central Asia, Persia, and Syria during the *Pax Mongolica*. Though they were foremost among imports in the papal collection by 1295,[45] probably thanks to diplomatic gifts from the Il-Khanids of Persia, the new imports attracted no attention from Italian painters for two more decades and from local textile designers for three. Once Italian consumers and craftsmen grew accustomed to the new Oriental patterns, however, the industry made rapid progress, creatively reinterpreting a variety of these patterns concurrently during the second half of the fourteenth century, when the Italianized versions are identifiable in paintings and inventories.[46] The Tatar cloths offered Italian designers, who had already begun looking for new ideas, an unprecedented variety of them.

Tatar cloths were themselves products of transcultural exchange. As the nomadic Mongol warriors became imperial rulers, they adopted many aspects of the sophisticated textile culture in conquered Islamic lands and developed a preference for silks lavishly ornamented with gold threads. Customarily, the Mongols spared skilled weavers—both Muslim and Chinese—from the sword, distributed them as booty, and transported them to new workshops scattered across the empire. Captive artisans served royal courts, the military, and government officials, who were often recruited from the conquered. For example, it is known that Herati and Chinese craftsmen worked together in Mongolia, and some Herati were sent back to their home in eastern Persia (now Afghanistan). The cultural mix among the imperial elite and the craftsmen working for them resulted in a rich and distinctive blend of Islamic and Chinese techniques and patterns.[47]

A well-documented example of a delayed but creative Italian response to the new Tatar cloths is that of the tiny-pattern design, in which small leaves or plants and animals are rhythmically organized in a dense, allover composition. Examples survive from the tomb of the local ruler Cangrande della Scala in Verona (d. 1329) and in ecclesiastical vestments associated with Pope Benedict XI (1303–04) but probably sewn at a later date, such as a fragment from a cope (Fig. 22).[48] The design and its technique, a weaving of flat strips of gilded animal substrate commonly called strap gold, are characteristically Chinese. Such gold strips were used in various central Asian patterns and locations.[49] The description of this pattern as "tiny" and "curious" in papal inventories of 1311 and 1361 shows that it was considered strange.[50] Simone Martini, who was interested in contemporary fashions in costume, depicted such silk several times, as in the chair cover with a red ground in his *Saint Louis of Toulouse Crowning Robert of Anjou, King of Naples,* of about 1316–1319 (see Fig. 65), the main panel of the earliest painting representing Tatar cloths.[51] In two of its predella panels, Saint Louis wears a cope that was probably made from a Persian velvet: the textile matches a red velvet with gold discs listed in the papal inventory of 1295 and a surviving example in the Cleveland Museum of Art.[52] During the early fourteenth century, the Angevins of Naples donated numerous Tatar cloths, including velvets, to San Francesco at Assisi.[53] Since Simone executed his painting in Naples, the Tatar cloths, as well as the Oriental carpet—also the earliest in Italian painting—and a peculiar crozier in Figure 65 probably represent prized artifacts at King Robert's court. Later Simone brilliantly captured the vibrant shimmering effect of the tiny pattern on a white ground in the archangel Gabriel's robe in the *Annunciation* painted for the cathedral of Siena in 1333 (Fig. 23).[54] Italian versions of the tiny pattern, such as a fragment with the design in rose on an undyed ground (Fig. 24), also imitate the general visual effect but clarify the individual motifs and organize the clutter that papal cataloguers found so puzzling.[55] This designer drew upon an Islamic pattern such as that in Figure 16 to create

22 Detail of a fragment of a cope, lampas weave, silk and gold thread. Central Asia, late thirteenth to mid–fourteenth century. The Metropolitan Museum of Art, New York. Rogers Fund, 1919 (19.191.3).

23 Simone Martini, detail of *The Annunciation*, 1333. Gallerie Nazionali degli Uffizi, Florence.

22

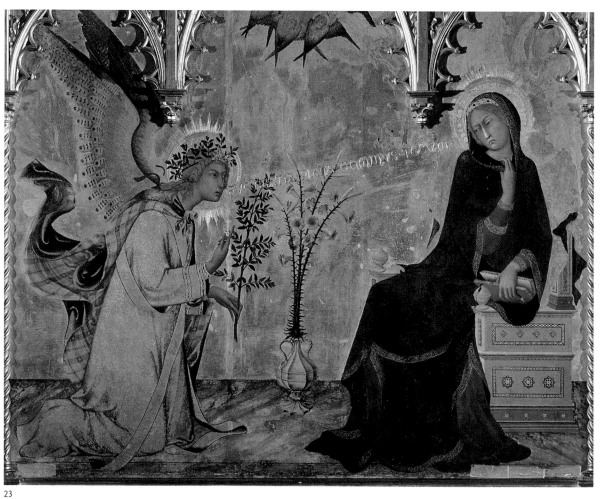

23

24

25

26

a familiar form of order. The earliest notice of Italian versions of the tiny pattern is 1338; inventories and paintings suggest that production peaked from 1360 to 1390 but continued until about 1400.[56]

The most influential Tatar cloths had bolder, more readable designs: ogival, banded, or energetic asymmetrical layouts, with naturalistically drawn flowers and vines, lively and often fantastic animals, and graceful Arabic inscriptions. Only rarely is it possible to identify the exact origin of the imported models because these designs moved quickly along trade routes, from central Asia through Persia and into Mamluk Syria and Egypt. Examples using strap gold (see Figs. 25, 27) were probably made in central Asia. The fragment in Figure 25 illustrates one of the Chinese asymmetrical designs: fantastic winged fonghuongs with swooping tails fly up and swoop down between undulating lotus flower scrolls.[57] A close Italian imitation using the same lampas weave but substituting European phoenixes for the Chinese birds was probably made early in the assimilation process (Fig. 26).[58] The fantastic confrontations between real and imaginary animals, the staggered repeats, and the restless motion throughout the pattern continued to fascinate Italian designers through the second half of the fifteenth century (see Fig. 35). The earliest depiction of the imported models, which is very accurate, is the curtain in Giotto's *Coronation of the Virgin*, datable about 1330 (see Fig. 56);

24 Detail of a fragment of silk, tabby weave, silk thread, Italy, second half of the fourteenth century. Victoria and Albert Museum, London (313-1894).

25 Fragment of silk, lampas weave, silk and gold thread, central Asia, thirteenth–fourteenth century. The Metropolitan Museum of Art, New York, Gift of Mrs. Howard J. Sachs, 1973 (1973.269).

26 Fragment of silk, lampas weave, silk and gold thread, Italy, second half of the fourteenth century. The Detroit Institute of Arts (41.88).

Italian textile designers were probably imitating them by the 1330s.[59] Giotto's observant departure from his usual geometric textile patterns offers a pointed example of the delayed artistic response to the new designs: a document of 1307 indicates that he rented out a loom—a common form of capital investment in Florence—so he must have been attentive to textile fashion.[60]

Other Chinese asymmetrical designs also had great influence in Italy. A dalmatic (a shin-length tunic with rectangular sleeves worn in liturgical services) made from a central Asian silk that has markings indicating its origin in the East and arrival in Stralsund, on the Baltic Sea (Fig. 27), illustrates the floral variant with large lotus and peony blossoms swinging in opposite directions between

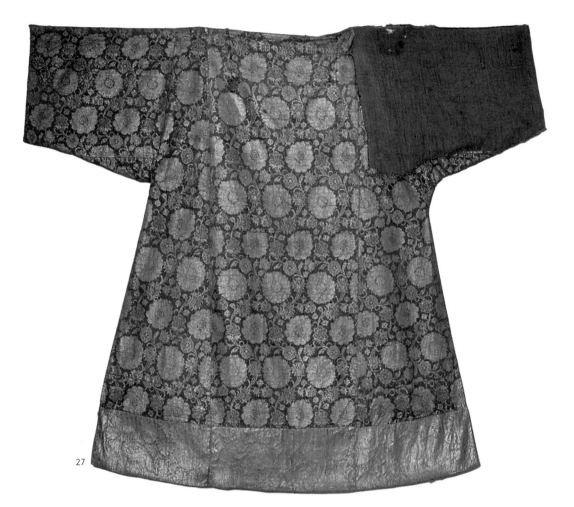

27

undulating flowering vines, naturalistically described.[61] Several Venetian painters represented this design in the middle of the fourteenth century, Paolo Veneziano often. In the mantles of Christ and Mary in his *Coronation of the Virgin* of about 1350 in the Accademia, Venice (Fig. 28), Paolo imaginatively embellished the contemporary imports with bands of imitation Arabic.[62] The undulating vertical-stem layout and its large floral motifs emphasizing the oblique rhythms had their greatest impact on Italian textiles about 1400, when designers were developing bold new Renaissance patterns (see Fig. 38). Many Italian fabrics of the second half of the fourteenth and the early fifteenth century reflect rather stiff compressed Persian interpretations of the asymmetrical Chinese designs that combine alternating rows of traditional Islamic animals with flowering vines (see Figs. 36, 37).

The ogival pattern (Figs. 29–31) was extremely popular along the fourteenth-century trade routes. It varied greatly but was basically a symmetrical design in which

vines frame a stylized floral motif or oval medallion, usually with paired animals in or around the centerpiece or its ogival frame. Because this textile pattern became international during the second half of the fourteenth century, even the regional origin of many Oriental examples is difficult to determine. Scholars have shown a web of close connections running from Chinese to central Asian fabrics, the probable origin of examples from the tomb of Cangrande in Verona and those associated with Pope Benedict XI in San Domenico, Perugia, and from central Asian fabrics to the Persian, Syrian, Egyptian, and Italian variations.[63] Silks produced along the trade routes from central Asia to Italy use a similar repertory of motifs and compositions. An altar frontal with a lampas weave in gold on a beige ground to which embroidery was added in Christian Spain (Fig. 29) illustrates the blend of elements common in western Asian versions.[64] The delicately rendered lotus blossom vines scrolling around the ogival centerpiece and the trailing

27 Dalmatic, lampas and compound weaves, silk and gold thread, central Asia, first half of the fourteenth century. Kulturhistorisches Museum der Hansestadt Stralsund (1862.16).

28 Paolo Veneziano, *The Coronation of the Virgin*, ca. 1350. Gallerie dell'Accademia, Venice.

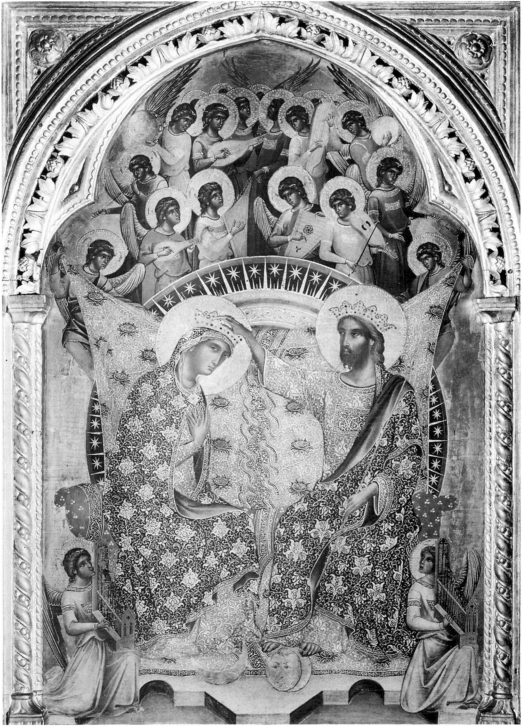

29

30

29 Detail of an altar frontal, lampas weave, silk and gold thread, Syria or Iraq (?), second half of the fourteenth century (with Spanish embroidery). Victoria and Albert Museum, London (792-1893).

30 Detail of a fragment of silk, lampas weave, silk thread, Italy, second half of the fourteenth century. Staatliche Museen zu Berlin–Preussischer Kulturbesitz, Kunstgewerbemuseum, Berlin (1921,17).

31 Detail of an orphrey, plain and satin weaves, silk and gold thread, Egypt, fourteenth–fifteenth century. Victoria and Albert Museum, London (753-1904).

tails on the birds within it were inspired by Chinese designs, while the central motif of stiffly confronted birds with discs on their wings flanking a stylized floral motif follows Islamic tradition, suggesting the fabric is from Syria or Iraq. The grape leaf springing from a heart-shaped vine between the ogival centerpieces is borrowed from a distinctively Italian grape-leaf-and-vine motif invented during the second and third decades of the fourteenth century.[65] Though some Islamic and Asian fabrics imitate complete Italian grape-leaf compositions, these are exceptional.[66] The few such transfers that have been identified prove that Italian textiles began to travel east over the silk roads and influence international textile design about the middle of the century. The Italian lampas in Figure 30 has a similarly light and graceful composition, though all the details differ.[67] The lotus blossoms as well as the palmettes and the animals within them show strong Chinese influence, while the crisp descriptive drawing is characteristically Italian. Bold naturalistic Italian renditions of the ogival pattern begin to appear in Andrea Orcagna's paintings in the 1350s, and several artists depicted the lighter designs like that of Figure 30 in the 1370s and 1380s.[68]

The Mamluk version of the ogival pattern had a narrow range of variation during the fourteenth and fifteenth centuries. A richly woven example made into an orphrey (Fig. 31) was accurately depicted by the Master of the Bambino Vispo about 1430—as the Madonna's robe.[69] The pattern includes two forms of Arabic inscription that were fashionable royal Mamluk emblems: the large teardrop medallions with conventional phrases honoring the sultan (here "Glory to our master the sultan al-Malik") and the smaller medallions with the sultan's title (here the name al-Ashraf used by Qaitbay and other sultans, including four who ruled before 1430).[70] Italians certainly imported this version of the pattern or lighter-weight versions in damask after trade resumed with Egypt and Syria in the 1340s, because imitations of both the large and small inscribed medallions of Figure 31 appear in Italian textiles during the second half of the century (see Figs. 33, 34).[71]

By the third quarter of the fourteenth century, Italian designers were imitating silks with alternating bands of varied width filled with a rich blend of Islamic and Chinese floral, animal, epigraphic, and abstract motifs. As in the Spanish versions of the banded designs (see Fig. 21), Arabic inscriptions usually play a prominent role because they signaled status and allegiance in the Mamluk empire, where this layout had been developed.[72] An Egyptian example imported before the embargo of 1291 was probably the model for an early representation in Cimabue's *Madonna and Child Enthroned with Angels* of about 1285 in the Louvre.[73] Technical differences in the banded Tatar cloths that survive from the tomb of Cangrande della Scala and in many ecclesiastical vestments, such as the dalmatic in Figure 32, suggest that the banded designs came from several regions of central Asia.[74] The Arabic inscriptions on this typical example accurately follow the contemporary Mamluk fashion for repeating short conventional honorific phrases and titles—here "the sultan the wise" and "the sultan"—indicating the likelihood that such fabrics were made principally for export to Egypt and Syria. Errors in the inscriptions of some examples, however, that imply the weavers' unfamiliarity with Arabic could mean the textiles were destined for Europe. Italian designers appreciated the rhythmic alternation and contrasts of the banded layout and its exotic blend of ornament, and they reduced the role of inscriptions. An

31

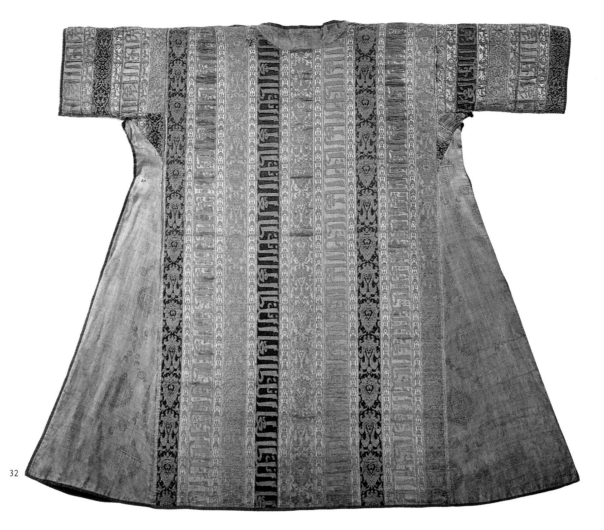

32

example in the Victoria and Albert Museum that closely imitates the scale and density of the models and includes narrow stripes with imitation inscriptions is probably early.[75] A presumably later example (Fig. 33) shows the bands opening up, so that the animals—fantastic Chinese-inspired birds, Persian-style cheetahs wearing collars, and courtly European dogs—move more freely and contrasts in the design are accentuated.[76] The small medallions with imitation inscriptions derive from contemporary Mamluk textiles (see Fig. 31). Italian textile designers captured the repeated and mirror-image patterns and various shapes of contemporary Arabic calligraphy, but their illegible inscriptions are only ornamental. Here such pseudo-Arabic plays a minor role in the rich potpourri of motifs. Painters represented Italian versions of the pattern into the fifteenth century.[77]

During the last third of the fourteenth century, Italian designers carried the international textile style to an unprecedented peak of spirited inventiveness. Drawing upon an accumulated wealth of Islamic, Chinese, and Gothic themes and motifs, they combined them in ingenious artistic ways and created new ones as well. The silk lampas in Figure 34 reinvents the old animal roundels, enclosing lively versions of heraldic beasts in twisted cords with knotted ends.[78] Woven in gold, these roundels stand out spatially against an airy ogive of pinecones and pseudo-Arabic medallions in red on red. The epigraphic motif and its position in the ogive were certainly borrowed from a Mamluk textile such as Figure 31, and the sprouting pinecone looks like an imaginative transformation of the Mamluk palmette. The clear references to tradition underscore the novelty of the design. Some of the patterns are so expressive that individual personalities can be recognized. Ingenuity, subtle humor, grace, and energy mark the work of the designer of the compound weave in a fragment of a chasuble (Fig. 35).[79] Chinese-

32 Dalmatic, silks with gold thread from central Asia and Italy, second half of the fourteenth century. Museum für Kunst und Kulturgeschichte der Hansestadt Lübeck (M 111).

33 Detail of a fragment of silk, lampas weave, silk and gold thread, Italy, second half of the fourteenth century. Museo Nazionale del Bargello, Florence (Coll. Franchetti, no. 632).

34 Detail of a fragment of silk, lampas weave, silk and gold thread, Italy, second half of the fourteenth century. Musée des Tissus de Lyon (28492).

35 Detail of a fragmentary back of a chasuble, compound weave, silk and gold thread, Italy, second half of the fourteenth century. The Cleveland Museum of Art, purchase from the J. H. Wade Fund (1928.653).

33

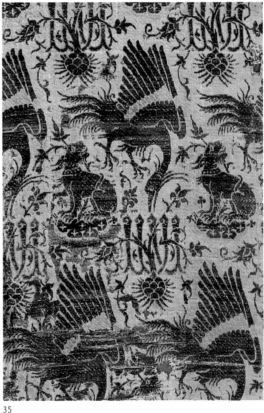

34 35

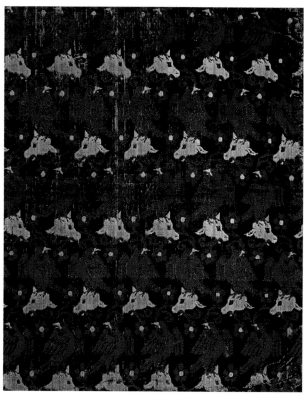

36

36 Panel, silk, plain weave, cut solid velvet,
49 × 59.7 cm., Italy, early fifteenth century.
The Art Institute of Chicago, Kate S.
Buckingham Endowment (1954.12).

37 Dalmatic, lampas weave, silk and gold
thread, Persia, second half of the fourteenth
century. Victoria and Albert Museum,
London (8361-1863).

style phoenixes dive toward shrubs entwining a pseudo-
Arabic fence; they are observed by dogs sitting on a bit of
turf protecting another shrub. It is easy to identify such
singular patterns in inventories and paintings. The fantasy
in the designs appealed particularly to northern European
painters, who were more willing than Italian artists of
that time to render the fine detail.[80] This whimsical play
with the whole international textile repertory ran out
of energy in the early fifteenth century, when the most
creative designers were developing the new Renaissance
style.

Luxurious patterned velvets among the Tatar cloths,
such as the gold disc design recorded in the papal inven-
tory of 1295, also inspired the Italian industry. Beginning
with plain fabrics in uniform pile, an example of which
survives from the tomb of Cangrande della Scala, Italians
gradually developed entirely new techniques and patterns
for weaving velvet, producing figured designs in several
colors (see Fig. 36) and various textures by the end of the
fourteenth century.[81] Because very few of the early ex-
amples survive and contemporary painting techniques
did not render textures well, most of the evidence for this
development comes from documents. Velvet weaving was
practiced in Lucca by 1311 and in Venice by 1337, when
the weavers of velvets and silks were divided into two
separate guilds. Like the Oriental disc design, the earliest
Italian velvet patterns were simple: stripes, checks, and
tartans. Though they may be slightly later in date, frag-
ments of checked and tartan velvets in the Victoria and
Albert Museum match patterns that Simone Martini
represented in the garments of courtiers in his fresco
The Knighting of Saint Martin in the Lower Church of San
Francesco, Assisi, executed in the second or third decade
of the fourteenth century, and the lining of Gabriel's cape
in the *Annunciation* tempera panel of 1333 (see Fig. 23).[82]
But it is impossible to judge from Simone's paintings
whether these fabrics have pile.

A velvet with a uniform pile in red, white, and blue

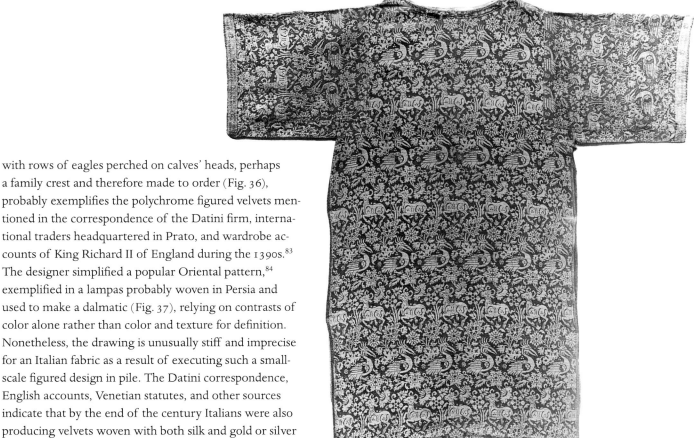

37

with rows of eagles perched on calves' heads, perhaps a family crest and therefore made to order (Fig. 36), probably exemplifies the polychrome figured velvets mentioned in the correspondence of the Datini firm, international traders headquartered in Prato, and wardrobe accounts of King Richard II of England during the 1390s.[83] The designer simplified a popular Oriental pattern,[84] exemplified in a lampas probably woven in Persia and used to make a dalmatic (Fig. 37), relying on contrasts of color alone rather than color and texture for definition. Nonetheless, the drawing is unusually stiff and imprecise for an Italian fabric as a result of executing such a small-scale figured design in pile. The Datini correspondence, English accounts, Venetian statutes, and other sources indicate that by the end of the century Italians were also producing velvets woven with both silk and gold or silver threads, and velvets with various types of pile. Velvets with different heights of pile are mentioned as well as cut and uncut velvets (in the uncut some of the loops of thread remain intact) and voided velvets (in which some areas of pile are invisibly woven into the ground). Voided velvets with a satin ground are specifically mentioned. These innovative techniques allowed, and presumably encouraged the development of, designs that exploited qualities inherent in the medium, with its contrasts in texture and sheen and palpable contrasts in material. To be clear in pile, forms needed crisp lines and smooth shapes. Because the most dramatic effects in texture, luster, and touch required bold patterns, the new Renaissance textile designs are believed to reflect available velvet-weaving technology as well as changes in artistic taste.[85] In textiles, ceramics, and glass, the sensitivity of Italian craftsmen to the possibilities of their medium enabled them to achieve an unprecedented level of artistry.

By 1400 a fortuitous coincidence of internal and international developments positioned the Italian industry to dominate luxury textile trade in the Mediterranean. In quality and variety, Italian production began to compete with the Tatar cloths just as the central Asian and Persian routes over which they had traveled became unsafe and control over them fragmented among competing regional powers, and shortly before Tamerlane's destructive advance from central Asia to Damascus. The new Italian fabrics benefited from innovative technology and artistic creativity that were increasingly lacking in the Mamluk industry. Furthermore, technology, commercial infrastructure, and internal competition gave Italy's luxury textiles a price advantage. Copying at lower cost was a standard practice.[86] Venice supposedly introduced velvets with the elaborate technique and design shown in Figure 39, but Florence and Genoa were imitating them by the second half of the fifteenth century. Both Venice and Florence attempted to protect their textiles with trademark thread counts, widths, and selvedges (the closed longitudinal edges of a loom width), but these too were imitated as quickly as they were introduced or modified.

38 Loom-width silk, lampas weave, silk and gold thread, Italy, early fifteenth century. Musée des Tissus de Lyon (25929).

39 Fragment of gold-ground voided silk velvet, Italy, second half of the fifteenth century. The Minneapolis Institute of Arts (35.7.152).

40 Altar frontal, silk, twill weave, with twill interfacings of secondary binding warps and gilt-metal-strip wrapped silk facing wefts forming weft loops in areas, cut, pile-on-pile voided velvet, 100.8 × 203.4 cm., Florence or Venice, second half of the fifteenth century. The Art Institute of Chicago, Kate S. Buckingham Endowment (1944.403).

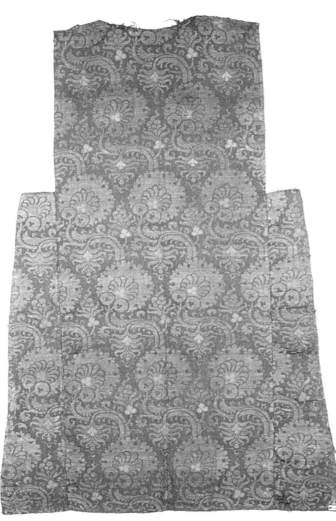

Though such measures doubtless originated to protect fabrics in the domestic market, competition for the expanding international market soon became significant. Even in the early fifteenth century Venice exported large quantities of its own fabrics with selvedges *alla fiorentina* to the Orient. Italy's luxury textiles predominated in Mediterranean trade for a century. As Chapter 10 shows, about 1500 they began to face serious competition from the rising Ottoman industry, leading to reciprocal influence and copying on a massive scale.

The most successful Italian Renaissance textile patterns descended from the Oriental ogival and undulating vertical stem designs, reinterpreted with new monumentality and focus on distinctive floral motifs. Gentile da Fabriano's *Adoration of the Magi,* dated 1423 (see Fig. 58), reflects changing Italian taste: characteristically Islamic banded fabrics with imitation inscriptions appear in several turbans and in the shawls of the Virgin and the female attendant at the far left, but at center stage the Oriental kings wear the new Italian textiles. Their ogival and undulating stem patterns are rendered with the naturalistically described motifs popular during the first half of the century.[87] A piece of early-fifteenth-century silk lampas (Fig. 38), preserved in its full loom width of about thirty-three and three-quarters inches, almost eighty-six centimeters, demonstrates the visual impact of the new textiles in a way that the usual surviving fragments and painted representations fail to do, though the latter provide an accurate sense of scale.[88] Italian designers enlarged the scale, diminished the detail, and enhanced the diagonal rhythms of asymmetrical Chinese-style floral fabrics imported as much as a century earlier (see Fig. 27). Though it is possible that this generation of designers took a fresh look at examples in churches and in the homes of the rich, their ideas evolve logically from the work of their predecessors, who had completely absorbed Oriental compositions and motifs and become accustomed to manipulating them inventively. By the late 1420s, the undulating vertical-stem pattern was being rendered in voided velvet: the sculptors Donatello and

Michelozzo clearly rendered the contrast between raised velvet pile and its smooth silk backing on the canopy of the tomb of Pope John XXIII (d. 1427) in the Baptistery, Florence.[89] A midcentury painting by Piero della Francesca (see Fig. 163) illustrates the continuing enlargement of the pattern as designers further developed contrasts in texture. A late-fifteenth-century voided velvet (Fig. 39) shows the pattern near its peak of elaboration: the dark red silk pile is set against a luxurious gold ground (a cloth-of-gold), and details of the blossoms are accented with uncut loops of gold thread (bouclé).[90] Such velvets were also made with varied silk pile, cut in two lengths (pile-on-pile), or accented with uncut loops. The ogival pattern was developed comparably in these techniques. The background in an altar frontal (Fig. 40) is rendered in red silk pile-on-pile velvet, and bouclé loops enrich the floral motifs woven in gold. Venetian sumptuary laws restricted the wearing of similar crimson pile-on-pile velvets to government officeholders, and cloth-of-gold to the doge.[91]

The principal ornamental motif on Italian Renaissance textiles was the pomegranate. In Figure 40 it occupies the center of the ogives, framed by the outline of a rose similar to those between the ogives. Variants of the pomegranate resemble a thistle (see Fig. 39, upper left) or a pinecone (see Fig. 39, lower right). The pomegranate had symbolic meanings that made it a desirable alternative to the Oriental palmette (see Fig. 31) and lotus or peony blossom (see Fig. 27) in Italy's Christian humanist culture.[92] In the Greco-Roman myth of Persephone, pomegranate seeds symbolize nature's cycle of regeneration and resurrection from the underworld. In Christian iconography, the pomegranate's red fruit refers to Christ's sacrifice and resurrection, and it retains its ancient association with abundance and fertility in connection with the Virgin Mary. This hallmark motif and the bold compositions in which it appeared became part of the international textile repertory by the end of the fifteenth century.

The Islamic banded layout and some of its traditional motifs had a long life in Italy on "Perugia towels," named

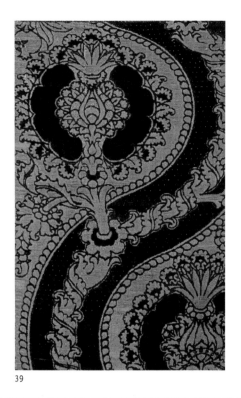

39

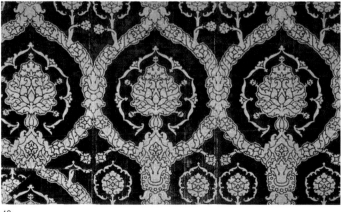

40

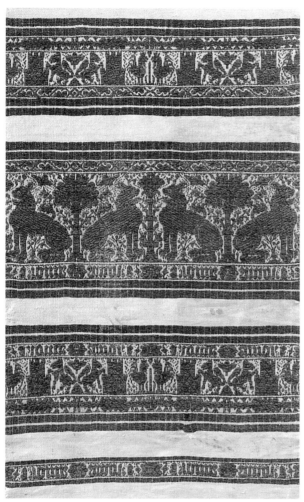

41

after the city that was a major production center beginning sometime in the late Middle Ages. A typical example in blue and white cotton (Fig. 41) from about 1500 has bands of varied width containing repeated paired animals separated by trees or castles, geometric motifs, and the word *amore*, love, separated by rosettes; it has lost its original long fringe.[93] Also made in linen, these long pieces of fabric had various uses. Paolo di Giovanni Fei's *Birth of the Virgin* of the 1380s (Fig. 42) represents them as towels presented at childbirth and as headcloths. Other Italian paintings show them as tablecloths.[94] Gentile da Fabriano's *Adoration of the Magi* (see Fig. 58) represents either an imported model or an Italian version as a shawl. As the imitation Arabic inscription on Gentile's shawl suggests, Perugia towels ultimately derive from Egyptian

linen towels and scarves with banded designs in indigo, though the means of transmission remain obscure.[95] On the Italian towel in Figure 41 the repetition of the word *amore* in reverse and upside down retains a close relationship with decorative Arabic inscriptions on Islamic fabrics woven on looms with mechanical patterning devices (see Fig. 21), which could include the presumed Egyptian models. The cosmopolitan style of the Italian versions lent prestige to utilitarian articles that were produced in quantity from simple materials.

In Italy textiles developed earlier than other decorative arts because of the international demand for luxury silks and the expertise and infrastructure of late medieval Italian weaving centers. The developmental surge of the fourteenth century, however, resulted directly from competition with contemporary Oriental imports favored by the European elite and competition among the northern Italian weaving centers. By 1300 they had begun to compete with contemporary imports from traditional sources of supply in the Mediterranean Islamic world. The novelty of central Asian textiles and their availability until about 1350 enhanced their appeal to Italian merchants and consumers alike. The unprecedented variety in the central Asian textile patterns, offering new Chinese and reinterpreted Islamic designs, stimulated the Italian industry's creative response. Fortuitously, Italian advances coincided with the closure of the Asian supply route and the decline in eastern Mediterranean production. Thus particular circumstances in East-West textile trade assisted the development and fostered the international success of Italian textiles.

In addition to the patterned fabrics, traditional Islamic royal honorific garments and knotted pile carpets also had an impact in Italy. Though the industry there made no effort to imitate the garments and little to compete in carpets, both play a significant role in Italian paintings, reflecting a special status and meaning in Italian material culture. The restricted representation of Islamic honorific garments strongly suggests that the Arabic script on them—and on other objects as well—was mistakenly associated with the Early Christian era. The misappropriation of Oriental scripts discussed in the chapter that follows explains further why imitation Arabic passed unchallenged into the Italian textile repertory, and why textiles with Arabic ornament were acceptable in ecclesiastical vestments.

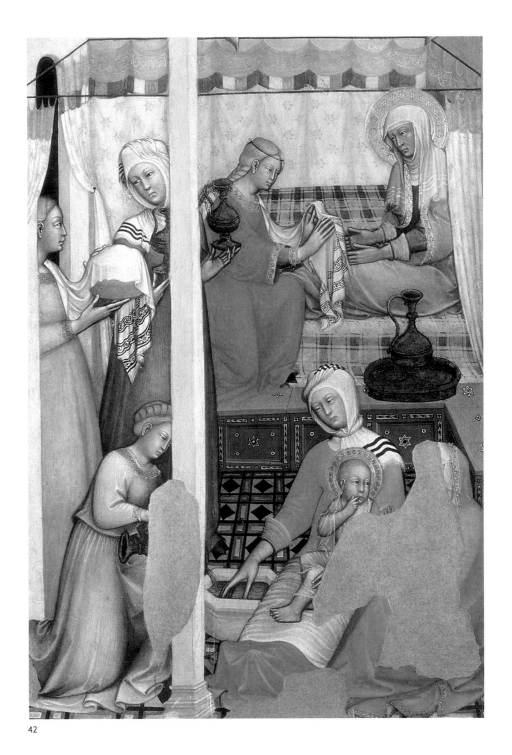

41 Detail of a "Perugia towel," self-patterned and tabby weave, cotton, Italy, ca. 1500. The Cleveland Museum of Art, gift of Miss Caroline E. Cort (1917.281).

42 Paolo di Giovanni Fei, *The Birth of the Virgin Mary*, 1380s, detail. Pinacoteca, Siena.

■ ■

ORIENTAL SCRIPT IN
ITALIAN PAINTINGS

DURING THE LATE MIDDLE AGES AND THE RENAISSANCE, Italian painters commonly used inscriptions in Latin or Italian to convey explanatory or commemorative information to the viewer. And occasionally they employed Greek or Hebrew in appropriate historical or theological contexts (see Fig. 46), though the writing is not always legible and few Italians knew either language. Such exotic inscriptions served principally as erudite accessories, meant to be recognized but not necessarily read. During the fourteenth and fifteenth centuries, totally factitious Oriental scripts now known to be unrelated to the Judeo-Christian tradition are more common in Italian religious paintings than Greek or Hebrew.[1] Most simulate Arabic. In addition, during the *Pax* Mongolica a few Italian painters imitated a Mongol script called 'Pags Pa.

Imitations of Arabic in European art are often described as pseudo-Kufic, borrowing the term for an Arabic script that emphasizes straight and angular strokes and is most common in Islamic architectural decoration. Ornament resembling *kufic* script in tenth- through thirteenth-century European art is justifiably called pseudo-Kufic (or kufesque). This term is misleading, however, when applied to Italian art between 1300 and 1600 because the only known imitations that derive from genuine *kufic* are painted representations of some Spanish textiles (see Fig. 20) and Turkish carpets (see, for example, Fig. 60). The cursive Arabic script normally imitated by Italian painters and textile designers is also often described as *naskh,* a term currently used for fine cursive script, derived from ordinary handwriting, in literary texts

and small Qurans.[2] The proper term for the bold cursive script used throughout the Islamic world during this period on most luxury goods imported by Italians is *thuluth* (or *thulth*). The fairest term for Italian imitations that are mostly fantastic and often blended with other elements is "pseudo-Arabic."[3]

Painters used the Oriental pseudo-scripts as writing, and as ornament on textiles, gilt halos, and frames for religious images. While these inscriptions are literally senseless, they convey symbolic meanings that differ somewhat according to their place in the paintings. Painters began to use the pseudo-scripts from the late thirteenth and early fourteenth centuries; examples can be seen in the decorations of the Upper Church of San Francesco at Assisi or in the works of Giotto. The most common and long-lasting use is in decorative bands on garments worn by the Holy Family and other sacred figures. The Islamic honorific textiles that inspired these garments are the principal source for the symbolism and misunderstanding of Oriental scripts in Italian painting. Though it requires some chronological backtracking, considering the uses by type helps to clarify their different but overlapping meanings.

Italians recognized these scripts as writing even though they usually used them as artistic ornament. *The Four Doctors of the Church,* vault frescoes in the Upper Church of San Francesco, probably executed toward 1300 by an unknown artist close to the Isaac Master, show these fourth- to early-seventh-century saints holding books written in imitation Oriental scripts.[4] The text of Saint

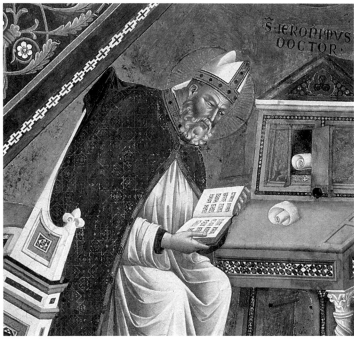

S·IERODIMVS
DOCTOR·

43

Ambrose is written in a cursive horizontal script that is pseudo-Arabic. The texts of Jerome (Fig. 43; destroyed in the 1997 earthquake), Augustine, and Pope Gregory I are written in squared units of vertical, horizontal, and curved strokes that can be called pseudo-Mongol.[5] Though the artist has aligned the units horizontally on the page in Western style, the script itself imitates 'Pags Pa, which is written vertically. 'Pags Pa (or hPags Pa, 'Phagspa) is a Tibetan script named after the monk who invented it for Kublai Khan (1216–1294); it is also now called "square" or "quadratic" script because of the outlines of its letters. Commissioned in 1260, the new alphabet transcribed the sounds of the Mongol language more precisely than Uighur, a cursive Turkic script adopted under Genghis Khan (1162–1227). In 1269 Kublai ordered that 'Pags Pa be used in documents bearing the royal seal, and in 1278 he decreed it should replace Uighur on the *pai-zu,* a passport identifying official envoys, giving them safe passage, and mandating that they be supplied with food, lodging, and transportation within the empire.[6] Made as gold or silver plates or tablets, these passports are mentioned by most of the Europeans who recorded their travels in the empire. Marco Polo reported that Kublai gave Niccolò and Maffeo such golden tablets for their first return

journey about 1267 and that the three Polos received them from the khan in Persia as well as the great khan for the return that ended in 1295.[7] The many envoys sent by or returning from the Il-Khanids in Tabriz to the Holy See in the decades before and after 1300 undoubtedly carried these passports. The only surviving examples of official letters to European rulers from Mongol rulers postdating 1269 are written in Uighur, which remained more popular than the new script; the seals of authority stamped on these documents are in Chinese.[8] 'Pags Pa was sometimes used in the seals of authority on paper money, which circulated throughout the Mongol empire, and on coins; it also appears on a few pieces of porcelain.[9] For Italian artists, the most likely visual sources of 'Pags Pa, which is considerably more decorative than Uighur, are *pai-zu* postdating 1278 or paper money, and the Assisi painter probably worked from a travel souvenir provided by his papal or Franciscan advisors. The Assisi painter— and Giotto, as is shown below—were imitating a Mongol script before 1307, when reports of Friar John of Montecorvino's success in Beijing arrived in the West, precipitating major missionary efforts in central Asia and China.[10]

The representation of these Eastern scripts at Assisi in texts studied by the Doctors of the Church shows that those responsible mistakenly associated the scripts with the Early Christian era. Italians correctly associated Arabic with the Holy Land but evidently did not know it arrived there in the seventh century as the language of Islam. From at least the thirteenth to the sixteenth century, Europeans commonly confused Arabic with ancient Eastern scripts, specifically one that was used in the eastern Mediterranean during New Testament times.[11] The crusaders' misidentification of the Dome of the Rock and Al-Aqsa Mosque in Jerusalem as Solomon's temple and palace provides a pointed analogy.[12]

It is not known exactly when or how such misidentification of Arabic occurred, but the history of an earthenware vase in the National Museum, Stockholm (Fig. 44), provides a paradigm for the process and factors involved.[13] In size and shape the vase is consistent with huge amphorae used for storage and shipping throughout the Mediterranean in antiquity and the Middle Ages, but its wing-shaped handles and elaborate painted decoration, which includes a handsome Arabic inscription, identify it

as one of the ornamental vases made in Muslim Spain during the fourteenth century, some of which decorated the Alhambra Palace in Granada. This example traveled to a church in Venetian-controlled Famagusta, Cyprus, where it was believed to be one of the six jars of water that Christ transformed into wine during the marriage at Cana (John 2:1–11). European pilgrims en route to the Holy Land, one a Spaniard, mentioned the purported relic between 1512 and 1566. After his conquest of Cyprus in 1571, the Ottoman commander Mustafa Pasha looted the vase and refused Cypriot requests to buy it back. The vase passed to Sultan Murad III (r. 1574–95), who probably gave it to the ambassador of Emperor Rudolph II of Germany (r. 1576–1612); it was among the imperial collections taken from Prague by the Swedish army in 1648. Both the ambassador and Rudolph II considered it a genuine relic, and the inscription was thought to be "Assyrian"—probably meaning Aramaic of Christ's time or its Syriac descendant then used by Assyrian and other West Asian Christians. Queen Christina of Sweden's inventories describe the vase as "a rare antiquity," but perhaps not the relic claimed.

No comparably detailed record of historical error, religious misassociation, and linguistic confusion, or of the travels of an object similarly plundered and presented, has yet emerged for the Islamic honorific garments that inspired most of the pseudo-Arabic inscriptions in Italian paintings. But available evidence suggests that Italians similarly misidentified these and other Islamic and Mongol objects, together with the script that appeared on them. Europeans knew very little about written Semitic languages other than Hebrew until the early sixteenth century. Though the Church approved the study of Arabic and other Eastern languages at the Council of Vienne in 1312, progress was slow until psalters, breviaries, and polyglot Bibles for the use of Eastern Christians were printed in Arabic, Aramaic, and Syriac between 1513 and 1517 under the patronage of Pope Leo X.[14]

Another object depicted in the Assisi decorations shows the association of Arabic writing with the Holy Land and the Christian tradition. Affixed to the front of the altar in *The Miracle at Greccio* in the stories of Saint Francis (Fig. 45) is a tablet that imitates a list in two columns written from right to left in Arabic. The object has not been identified, but comparable wooden tablets survive from old

Quranic schools, and its columns of thirteen lines correspond with a lunar calendar. The painting represents Christmas observances at the *praesepium* (Nativity scene) Saint Francis ordered prepared, complete with live ox and ass, in the town of Greccio in 1223. The artist probably depicted the altar as it might have been decorated for the occasion, following the example of the oldest *praesepium* in Italy at an altar in Santa Maria Maggiore in Rome that was adorned with wooden relics of Christ's manger in Bethlehem.[15] The painter or his advisors must have associated the tablet with Bethlehem and/or the Feast of the Nativity.

43 Anonymous, detail of *Saint Jerome* in lost section of the vault, ca. 1296–1300. Upper Church of San Francesco, Assisi.

44 "Alhambra vase," painted in golden luster and blue, Spain, third quarter of the fourteenth century. Nationalmuseum, Stockholm (NMKhv 47).

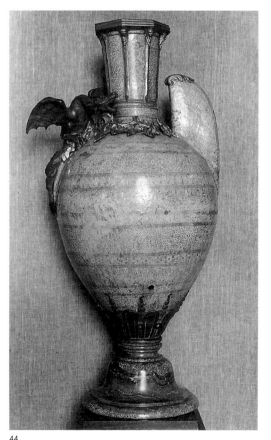

44

45

Italian painters also used pseudo-Arabic in works where Arabic was historically correct and theologically significant, such as *The Triumph of Saint Thomas Aquinas over Averroes* (Fig. 46), where the vanquished foe of the title bears the European name for Ibn Rushd (1126–1198). This eminent Spanish Muslim philosopher's interpretations of Aristotle were so valued in the West that the Church found it necessary to refute those conflicting with Christianity. In the painting, by an unknown Sienese artist about 1344, one of the books in the lap of Saint Thomas is written in pseudo-Arabic, certainly meant to represent the work of Averroes, the bearded figure in a turban who lies in submission at the saint's feet. Other depicted texts simulate Greek and Hebrew, indicating that Italians recognized a difference between Arabic and contemporary Hebrew.[16]

As is shown below, Giotto and his pupils often blended features of Arabic and 'Pags Pa in their ornamental orientalizing inscriptions. An unusual effort to make such an imaginative pseudo-script look legible to the Italian eye occurs on the frame of the Bologna polyptych, datable about 1330, that bears Giotto's name but is probably a late work of his shop (Fig. 47).[17] In the inscription above the center of the predella, dots like those in legible Latin

or Italian inscriptions separate groups of "letters." Below the side panels, delicate "letters" in the orientalizing script frame the Latin name of each saint, written in bold Gothic script. Though some of the "letter" forms are reminiscent of contemporary Arabic, Coptic, Armenian, and Georgian, they occur amid unrelated forms and make no sense.[18] This example suggests that contemporary painters associated even the most fantastic forms of Eastern pseudo-script with actual writing.

From the late thirteenth into the sixteenth century, painters throughout Italy ornamented garments worn by the Holy Family, angels, saints, and other biblical figures and textiles decorating the heavenly throne of Christ and the Madonna with bands of pseudo-Arabic (see, for example, Figs. 48, 56). Such textiles are less common in sculpture, though there are some exquisite fifteenth-century Florentine examples in bronze and marble.[19] The conventional form of these ornamental bands and their restriction to exalted persons of the Judeo-Christian tradition show that artists knew that in the East such textiles were elite. These were, in fact, Islamic textiles: robes of honor and *tiraz* fabrics woven for Muslim rulers in which bands of Arabic inscriptions were the distinctive ornament.[20] Italians wrongly associated recognizably Eastern textiles and some of their symbolic meaning in the contemporary Islamic world with an Early Christian context.

The term *tiraz,* derived from the Persian word for embroidery, originally designated the inscriptions on fabrics produced exclusively for the early Muslim caliphs but eventually referred to the official weaving establishments of rulers throughout the empire and to the ornamental inscriptions themselves.[21] According to the Arab historian Ibn Khaldun, the early caliphs inherited the custom from the Sasanian kings of Persia, who adorned the hems of their garments with royal portraits and other designs. The institution probably evolved from the imperial Byzantine workshop in Alexandria that the Umayyad conquerors took over in the seventh century. The caliphs adapted the fabrics to Muslim practices, including the prohibition on figurative representation. Arabic writing, the direct vehicle of God's revelations to the Prophet Muhammad, not only had sacred connotations in Islam but also became a powerful symbol of affirmation and of authority within the community of believers. The early caliphs' special status as successors to Muhammad, and

45 Master of the Stories of Saint Francis, detail of *The Miracle at Greccio,* ca. 1296–1305. Upper Church of San Francesco, Assisi.

46 Anonymous Sienese, *The Triumph of Saint Thomas Aquinas over Averroes,* ca. 1344. Santa Caterina, Pisa.

47 School of Giotto, detail of polyptych frame, ca. 1330. Pinacoteca Nazionale, Bologna.

46

47

subsequently the legitimacy and royal prerogatives of sultans from Iraq to Spain, were embodied in their names, written in Arabic on items only they could issue: coins, textiles, flags, and official documents. Writing, with all its significance, remained the principal ornament of the royal *tiraz* fabrics. Early inscriptions usually began with an affirmation of faith, followed by the name or honorific title of the ruler, and concluded with blessings or pious wishes for him and sometimes the place and date of manufacture; this is the formula adapted for the cape of Roger II (see Fig. 52). From about the twelfth century short conventional phrases and titles such as "blessing" (see Fig. 21), "the sultan," and "the sultan the wise" (see Fig. 32) predominated. The most prestigious garments in the Muslim world were the robes of honor made from these fabrics that rulers presented to officials upon promotion and at grand court events and to other rulers, including Europeans, as a sign of high esteem. In Islamic lands, recipients wore robes of honor to display status and loyalty. The practice of making and bestowing such garments eventually spread to the courts of petty princes, and by the fourteenth century commercial workshops supplying the public market were also producing fabrics with *tiraz* inscriptions. About 1340/41 the Mamluk sultan closed the royal workshops in Alexandria and Cairo, and thereafter royal titles customarily appeared on Mamluk textiles in standardized cartouches or medallions (see Fig. 31). By this time, however, the Italian artistic convention was already well established. Like the writing in other Islamic arts, *tiraz* inscriptions are often so ornate that they are difficult for even the educated to read.[22] The elaborate Arabic scripts developed in urban courts signified high taste and culture and gave visual pleasure that could be appreciated throughout the Muslim world. The decorative quality and social connotations of the writing further enhanced the prestige of the robe of honor and the status it conferred on the recipient. To the Muslim community, the real meaning of the inscription was borne by the lettering and the name of the ruler rather than the literal content of the words. Therefore it did not matter if the inscription was incomplete or senseless, or if the recipient of the message was illiterate.

Italian artists certainly knew part of the gestalt of *tiraz* textiles but not the whole. The painted imitations distinguish the sacred figures and throne and underline their honored status, but do not in any sense confer it. Italian painters, recognizing Arabic inscriptions as the most distinctive feature of these textiles, focused on the exotic sign that would communicate their symbolism to the Western spectator. Their response to the elegant, artful calligraphy, whatever the content, and their decorative transmutation of it into gibberish were not inconsistent with the values of the original, but they seem to have achieved such consistency innocently and accidentally as they imitated formal and sensory qualities.[23] Italians since the First Crusade would have correctly associated these honorific garments with the Holy Land and eastern Mediterranean royalty; they simply transferred them to an Early Christian context. They seem to have perceived the costume tradition of the eastern Mediterranean as very conservative. Fourteenth-century views were probably no more sophisticated than those of the Florentine bookseller and biographer Vespasiano da Bisticci (1421–1498), who, regarding the Eastern delegates at the conclusion of the Council of Eastern and Western Churches in Florence in 1439, asserted that Greek male dress had not changed in fifteen or more centuries.[24] Though misassociating *tiraz* textiles with the Holy Family and the saints reveals historical and cross-cultural ignorance, it also shows great reverence for the Eastern roots of Christianity. At the same time, the Italian practice of using Eastern inscriptions whose literal meaning was unknown and ignored reflects the West's tremendous confidence in its authority to sustain and interpret the Christian faith.

The visual sources for the early Italian representations of *tiraz* honorific garments are unknown. No extant Islamic examples in Italy remain from the time of the Crusades or later that could have served as models. By the first decades of the fourteenth century, Italian painters had developed a conventional garment, usually made of plain fabric, with narrow inscribed bands at the edges (see Figs. 50, 62) that has no parallel in the few Islamic examples surviving elsewhere. An early and strikingly beautiful example of such garments may, in fact, have been influential: Duccio's *Madonna and Child Enthroned with Angels* (the Rucellai Madonna), the largest surviving panel painting of its time, commissioned in 1285 by the Brotherhood of Saint Mary (known as the Laudesi) for the new Church of Santa Maria Novella, Florence (Fig. 48). Duccio imitated two different *tiraz* textiles. The

48

48 Duccio di Buoninsegna, *Madonna and Child Enthroned with Angels* (Rucellai Madonna), 1285. Galerie Nazionali degli Uffizi, Florence.

49 Giotto, detail of *The Crucifixion*,
1304–1312/13. Arena Chapel, Padua.

50 Giotto, *Madonna and Child*, ca. 1320–
1330. National Gallery of Art, Washington,
Samuel H. Kress Collection.

49

drapery on the back of the throne, with its top band of
pseudo-Kufic and allover star-and-cross pattern (which,
however, has Western filling ornament) reflects contem-
porary Islamic fabrics used to furnish palaces and tents.
The preceding chapter noted the close relation of the
geometric pattern to those in contemporary Spanish
banded textiles, and several central Asian furnishing
fabrics with allover patterns and inscribed top bands have
come to light in Tibet.[25] Subsequently, Italian painters
often represented other fashionable patterned fabrics
with a top band of pseudo-Arabic or geometric ornament
behind the Madonna as a cloth of honor (see Figs. 53, 56),
and as elite bed curtains (see Figs. 20, 42) and wall hang-
ings (see Fig. 159). The textiles on Duccio's figures, how-
ever, are garments made in solid color fabrics with promi-
nent though narrow inscribed bands. The Madonna's
mantle illustrates the typical Italian placement of the
band at the edge or hem of the garment, and the angels'
garments illustrate the next most common location, on
the neckband of a robe. Duccio's early, and therefore still
experimental, rendition of these garments includes place-
ments rare in later Italian art: on sleeves below the shoul-
ders on the angels, and falling vertically from the shoul-
ders on the Christ Child. The exceptional artistry of the
sinuously curving band on the Rucellai Madonna's man-
tle surely drew special attention to her garments during
subsequent decades.[26]

 Such garments do not appear in the stories of Saint
Francis at Assisi but are ubiquitous in Giotto's scenes
from the Life of Christ and vault figures in the Arena
Chapel, Padua, 1304–1312/13, where placements vary.
For example, in the *Crucifixion* (Fig. 49) the garments of
the Roman soldiers and the robe of Christ they hold are
unique in Italian art, while in the vault roundel of the
Madonna and Child (see Fig. 62), the bands falling from
the shoulders and on the sleeves below them are similar
to Duccio's. Giotto's *Madonna and Child* of about 1320–

1330, in Washington (Fig. 50), shows the standard Italian placement of the inscribed bands on hems, neckbands, and cuffs.

Because most of the surviving *tiraz* textiles are fragments or were made into European vestments and furnishings, little is known about the appearance of Islamic honorific garments, especially the placement of inscriptions. The most famous garment surviving in Europe is the "Veil of Saint Anne" in Apt, France, a tunic bearing the name of the Fatimid caliph al-Mustali (r. 1094–1101), the date 1096/97, and Damietta, Egypt, as the place of manufacture; it was probably brought back from the First Crusade.[27] Its three narrow woven inscribed bands fall vertically to the hem, two from the shoulders on the front, and one from the neck on the back. Duccio's Christ Child (see Fig. 48) and Giotto's Madonna and Child (see Fig. 62) indicate that this type of garment was known in Italy, though Giotto could have borrowed from Duccio. Islamic manuscript illuminations and ceramics show that in Iraq and Egypt *tiraz* inscriptions were common in turbans and on armbands just below the shoulders, as in the Iraqi artist Yahya al-Wasiti's *Abu Zayd Falsely Accusing His Son before the Governor of Rahba* in the copy of the *Maqamat* (Assemblies) by al-Hariri, 1237, in Paris (Fig. 51).[28] Though examples are rare, Italian artists knew of this practice as well. Pseudo-Arabic appears on armbands of Duccio's angels (see Fig. 48) and Giotto's Christ Child (see Fig. 62) and on the turbans of the sultan and his religious advisors in *Saint Francis Proposing the Trial by Fire to the Sultan* in the Upper Church of San Francesco at Assisi.[29] The usual Italian placement of the *tiraz* band at hems also appears in the *Maqamat* illustrations, as on the governor's robe in Figure 51. The illustrations in thirteenth- and fourteenth-century copies of this popular book, which originated in early-thirteenth-century Baghdad, have a standard imagery, intended to be understood by the contemporary urban bourgeoisie. Such garments,

50

therefore, must have been common in the Islamic world.[30] The only Italian representation of an identifiable *tiraz* garment is Pisanello's drawing of a robe worn by the Byzantine emperor John VIII Paleologus at the opening sessions of the Council of Eastern and Western Churches in Ferrara in 1438; it too shows the inscription at the hem (see Fig. 161). It seems likely that the generations of painters who established the Italian version of the Eastern honorific garment drew inspiration from Islamic images as well as textiles. The most readily available source of imagery would have been ceramics such as a Fatimid Egyptian bowl among the *bacini* of San Sisto, Pisa, that represents a seated youth with conspicuous *tiraz* arm-bands.[31] Manuscript illuminations such as those in the much copied *Maqamat* may also have traveled to Italy.

The twelfth-century Norman and Hohenstaufen kings of Sicily, to symbolize the magnificence and power of their particular regime, had solid color royal robes and ecclesiastical vestments embroidered with genuine Arabic inscriptions, sometimes accompanied by Latin ones, at hems and cuffs.[32] It has been argued that this practice legitimized the use of Islamic-style honorific garments in a Christian context, and that Italian painters may have used garments such as the cape of Roger II (Fig. 52) as models.[33] Though Frederick II wore this cape when Pope Honorius III crowned him emperor in Rome in 1220,

51

52

there is no evidence that Sicilian royal garments were well known on the Italian mainland.³⁴ Indeed, the Hohenstaufen were sending textiles from the royal treasury in Palermo to Germany by the first decades of the thirteenth century, and the cape had arrived there by 1246 at the latest.³⁵ Instead of inspiring later Italian painters, the royal Sicilian garments may thus provide an analogue for a similar adaptive process that occurred for different reasons. Altogether, current evidence suggests that early-fourteenth-century Italian painters drew upon a variety of visual sources for what soon became an artistic convention.

Italian pseudo-inscriptions differ in both their form and their resemblance to Arabic, and early on artists tended to develop a personal style. Giotto created a unique blend of Arabic and 'Pags Pa that acknowledges the fanciful nature of the imitation inscriptions. The two components are evident in the *Crucifixion* (see Fig. 49) in the Arena Chapel: the squared Mongol elements predominate on the soldiers' tunics and the cursive Arabic elements predominate on Christ's robe. Giotto's characteristic complete blend appears in the unusual frame around the *Madonna and Child* (see Fig. 62) on the vault of the chapel, and in typical locations on the garments in the Washington *Madonna and Child* (see Fig. 50). In these two examples from Giotto the regular punctuation of the pseudo-script by geometric forms imitates genuine inscriptions on Islamic textiles and other objects (for example, the dish in Fig. 57), where such forms separate repeated phrases—a pattern that subsequent Italian artists commonly followed.³⁶ Only Giotto's pupils and immediate successors adopted his hybrid script, and it disappeared in Italian painting before the end of the Mongol empire.

Simone Martini's *Annunciation* of 1333 (see Fig. 23) shows that the honorific garments the Italian painters conceived soon expanded to include other bands—with geometric or floral motifs, and legible Latin or Italian, as on Gabriel's cuffs and ribbon—in addition to the distinctive pseudo-Arabic ones. Through the fifteenth century, Italian painters often varied the ornamental textile bands in a single painting and sometimes counterbalanced nonsensical pseudo-Arabic with legibile inscriptions specific to the figure. For example, Simone showed the name of the archangel Gabriel on his cuff, opposite the Virgin's pseudo-Arabic cuffs, and Gentile da Fabriano, in his *Madonna and Child,* about 1422 (Fig. 53), represented the

51 Yahya al-Wasiti, *Abu Zayed Falsely Accusing His Son before the Governor of Rahba,* illumination in the *Maqamat* (Assemblies) of al-Hariri, Baghdad, Iraq, 1237. Bibliothèque Nationale de France, Paris (MS arabe 5847 [Schefer Hariri], fol. 26r).

52 Coronation cope of Roger II, silk, embroidered in gold thread and set with pearls, gems, and enamels, Palermo, 1133/34. Schatzkammer, Kunsthistorisches Museum, Vienna (SK XIII 14).

53 Gentile da Fabriano, *Madonna and Child,* ca. 1422. Museo Nazionale di San Matteo, Pisa.

53

54

54 Fra Angelico, detail of predella panel of *The Marriage of the Virgin*, ca. 1430. Museo Diocesano, Cortona.

55 Andrea Mantegna, *Judith with the Head of Holofernes*, ca. 1495. National Gallery of Art, Washington, Widener Collection.

repeated Latin invocation "Ave Mater Digna Dei" on the Madonna's mantle alongside the pseudo-Arabic on the Christ Child's blanket.[37]

Gentile's exceptionally bold form of pseudo-Arabic exemplifies the tendency of fifteenth-century artists to develop emphatically ornamental styles. His derives in part from late-fourteenth- and early-fifteenth-century Italian textiles such as the one in Figure 35, in which the wedge-shaped tops of the verticals and tapered curving downstrokes incorporate elements of contemporary Gothic script.[38] Gentile, who was also inspired by Islamic brassware, sparked renewed interest in orientalizing ornament in Florence. Probably in response to both his example and the rising interest in ancient languages, Fra Angelico selectively ornamented garments with recognizable pseudo-Hebrew. In the altarpiece with scenes from the life of the Virgin Mary painted about 1430 for San Domenico, Cortona, for example, he used pseudo-Arabic on the garments of the Virgin, Gabriel, and the Magi and their pages but pseudo-Hebrew on the vestment of the officiating rabbi in *The Marriage of the Virgin* (Fig. 54); Gabriel's salutation appears in Latin in the *Annunciation*.[39] The various inscriptions in Fra Angelico's paintings presumably reflect the highest contemporary level of linguistic knowledge of this painter, who was a Dominican friar at San Marco in Florence, which had a distinguished library, and often worked for secular patrons who encouraged humanist studies.[40] There can be no doubt that well into the fifteenth century learned Italians associated Arabic with the Early Christian era and interpreted garments bearing inscriptions in pseudo-Eastern languages as symbols of honored status.

Italians made limited personal use of *tiraz* textiles into the sixteenth century. Florentine tomb sculptures suggest that elaborate burial garments and furnishings included real or imitation *tiraz* bands as late as the 1420s.[41] Paintings represent some articles used in secular, courtly life. A predella panel, *The Adoration of the Magi*, attributed to Giovanni Toscani, who was active in Florence in the 1420s, shows elaborate horse trappings ornamented with pseudo-Arabic inscriptions.[42] Islamic rulers often presented horse trappings (as well as hunting equipment) along with robes of honor, and the painter certainly had seen an example.[43] *Judith with the Head of Holofernes* by Andrea Mantegna, about 1495 (Fig. 55), shows a ceremo-

nial tent with a prominent pseudo-Arabic inscription.[44] A late-fourteenth-century Lombard manuscript represents an elegantly dressed couple picnicking in a similar tent.[45] A striped tent that Sultan Qaitbay sent to Lorenzo de' Medici in 1487, praised by contemporary chroniclers, may have been in the Medici collection as late as 1553.[46] A *Portrait of Elisabetta Gonzaga, Duchess of Urbino* by Raphael, about 1505–1506, in the Uffizi, Florence, shows her in a contemporary dress with a pseudo-Arabic neckband; Baldassare Castiglione noted the fashion for foreign dress in Urbino in *The Book of the Courtier,* which he wrote there in the early sixteenth century while attached to the court.[47] The prestige of rare Islamic *tiraz* textiles in Italian secular society is consistent with their restricted appearance in religious art.

The decoration of gilt halos with pseudo-Arabic surprises modern spectators, but fourteenth- and fifteenth-century Italians who associated *tiraz* textiles with the Holy Family and the saints and admired brassware from Egypt and Syria must have considered them appropriate and sublimely beautiful. The earliest surviving example, in the Rucellai Madonna, is barely visible on the narrow outer band of the Madonna's halo (see Fig. 48). In scale and delicacy, this band echoes those on the garments of the other figures in the painting's subtly orchestrated arrangement of ornament.[48]

Halos with pseudo-Arabic next appear on the angels at the far left and right of *The Coronation of the Virgin,* painted under Giotto's direction about 1330 in the Baroncelli Chapel, Santa Croce, Florence (Fig. 56). Here such pseudo-Arabic ornament acquires salience and greater independence: the imitation writing, larger and bolder than that bordering the textile on the back of the throne, becomes the halos' principal decoration. When Giotto reconsidered how to adapt pseudo-Arabic decoration to the circular format of tooled gilt halos, he must have drawn inspiration from inlaid brass dishes in contemporary Mamluk style, such as that in Figure 57.[49] Bold circular *thuluth* inscriptions are the primary decoration on these shallow dishes. Another example datable in the first half of the fourteenth century, now in a private collection in Geneva, bears a coat of arms that is probably Venetian. Thus despite the papal embargo on trade with the Mamluk empire, such objects were certainly arriving in Italy.[50] Simone Sigoli, a Florentine pilgrim visiting Damascus in

1384, compared the inlaid brass vessels he saw there to goldsmiths' work: "Really they appear of gold . . . [and are] a very beautiful thing to see."[51] Their fine craftsmanship must also have intrigued Italian artists designing and executing incised giltwork. Giotto's *Madonna and Child* in Washington (see Fig. 50), with several arabesques inspired by the popular Spanish geometric textiles remaining on the abraded halo of the Virgin, confirms the artist's taste for Islamic-style halo ornament. Gilt halos filled with bold orientalizing inscriptions—mostly pseudo-Arabic but also a blend of pseudo-Arabic and pseudo-Mongol—commonly appear in the paintings of Giotto's close follower Bernardo Daddi.[52] Such halos seem to have

55

56

56 Giotto and assistants, *The Coronation of the Virgin*, ca. 1330, Baroncelli Chapel, Santa Croce, Florence.

57 Dish, brass incised and inlaid with silver and gold, Egypt or Syria, ca. 1300–1350. Aron Collection.

58 Gentile da Fabriano, detail of *The Adoration of the Magi*, 1423. Gallerie Nazionali degli Uffizi, Florence.

disappeared by 1350 but were revived about 1420 in Florence and spread to northern Italy about 1450.

These halos suddenly reappear in Gentile da Fabriano's first Florentine paintings, which are undated but stylistically precede the magnificent *Adoration of the Magi* altarpiece, commissioned by Palla Strozzi and completed in 1423 (Fig. 58). Probably shortly after his arrival from northern Italy about 1419 or 1420, Gentile, with his characteristic bold pseudo-Arabic, ornamented Mary's halo in the *Madonna and Child,* in the National Gallery of Art, Washington, and her halo and robe in the *Coronation of the Virgin,* in the J. Paul Getty Museum, Los Angeles.[53] In the *Adoration of the Magi,* as well as in the *Madonna and Child* in Pisa (Fig. 53) that Gentile probably painted during that work's beginning stages, the script on Mary's halo is clearly divided into four equal sections by rosettes like those of the Mamluk dish shown in Figure 57, strongly suggesting that Gentile studied contemporary or fourteenth-century brassware, adjusting the number of sections in inscriptions as on Mamluk plates and trays, where they vary from three or four to six or eight. The

57

58

whirling rosette on the page's sash is another borrowing from Mamluk brassware (see Fig. 148). Because none of Gentile's pre-Florentine paintings show pseudo-Arabic on textiles or halos, they must respond to the artistic environment of Florence. Gentile most likely took the idea of orientalizing halos from earlier paintings in Florence, consulting both Mamluk brassware and Italian textiles for the composition and form of the script. The pseudo-Arabic halos and textile bands, consistent in the Madonnas Gentile painted in Tuscany and Orvieto before departing for Rome in 1427, are often juxtaposed with Latin inscriptions from biblical or liturgical sources that relate specifically to the image.[54] The various inscribed objects and textiles contribute decorative richness and cosmopolitan sophistication to Gentile's painting style.

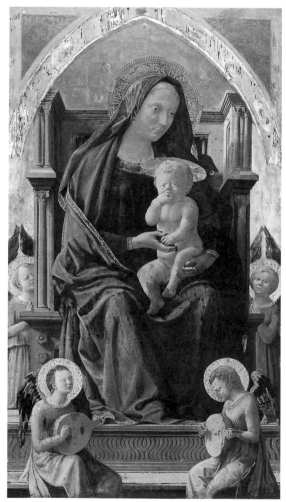

59

Masaccio as a young painter responded immediately to Gentile's halos. Indeed, the Madonna's pseudo-Arabic halo in Masaccio's earliest known work, the triptych dated April 23, 1422, painted for the Vanni Castellani family of Florence, long in San Giovenale a Cascia, Regello, is the first one documented in the 1420s.[55] Its quadripartite composition with whirling rosettes may have been inspired by Mamluk brassware as well as Gentile's paintings, but its jagged, clumsy script and asymmetrical blossoms are far removed from both. Masaccio used this type of halo only in traditional altarpieces of the Madonna and Child Enthroned with Angels: subsequent examples are on his Christ Child and an angel in one executed about 1424–1425, in collaboration with Masolino da Panicale, for Sant'Ambrogio, Florence (now in the Uffizi) and on the Madonna in another executed in 1426 for the Church of the Carmine in Pisa (Fig. 59).[56] In the two later paintings, the script and rosettes are more robust and carefully rendered, and the Gothic elements stronger. Similar script appears on the edge of the Madonna's mantle, neckband, and cuffs in the panel in London. Pseudo-Arabic script in another distinctive and Gothicizing hand appears on the halos of the Madonna in several paintings attributed to Giovanni Toscani, a follower of both Gentile and Masaccio who was active in Florence during the 1420s,[57] and in paintings by Fra Angelico probably completed before the early 1430s.[58] Orientalizing halos are rare in Tuscan painting thereafter. In this instance Gentile's contribution to the fast-breaking artistic developments of the 1420s proved minor and fleeting.

This short-lived fashion for pseudo-Arabic halos has been related to Florence's successful diplomatic missions: in 1421 to Tunis, then a source of critical grain supplies, and in 1422–1423 to Cairo, to open direct trade with Alexandria through the recently acquired ports of Pisa and Livorno.[59] The coincidence in time is intriguing but inconclusive. Public festivites celebrating the ambassadors' return from Cairo—including a business holiday and a procession and Mass in the cathedral—show an enthusiasm that might well have kindled a special interest in Islamic luxury goods, but the fashion had already been established by 1423. There is no known connection, moreover, between the paintings at issue and the principal participants in the missions to Tunis and Cairo, and Gentile

must have been completing the *Adoration of the Magi* by early 1423, when his patron Palla Strozzi went to Naples to negotiate alternative shipping arrangements in case of war with Milan.[60] Given the precedents of Duccio, Giotto, and Bernardo Daddi, and the strong ornamental component of Gentile's own style, there is no reason to look for a nonartistic motive for Gentile's Islamic-style halos and textiles. Nevertheless, the diplomatic triumphs and hope of increased trade with the Islamic world may well have enhanced their appeal to Florentine and Pisan patrons.

Elaborate pseudo-Arabic halos and textile bands appear among the varied ornamental accessories of northern Italian painting in the 1450s. No firm evidence supports suggestions that the Florentine sculptor Donatello introduced these halos in northern Italy during his stay in Padua, which ended in 1453.[61] Jacopo Bellini, the leading Venetian painter at the time, may have set the local standard about 1450 in his half-length *Madonna*s, in the Accademia, Venice, and Uffizi, Florence, but the dating of his works is too uncertain to be sure.[62] The absence of such halos in Jacopo's *Annunciation* of 1444, in Sant'Alessandro, Brescia, and other, probably earlier, paintings—which already show his distinctive finely drawn version of traditional pseudo-Arabic textile bands—suggests that his orientalizing halos did not result directly from a hypothetical Florentine sojourn with Gentile da Fabriano about 1423–1425.[63] The *Madonna and Child* attributed to Francesco Squarcione, in the Gemäldegalerie, Berlin, indicates that by about 1455 his decorative repertory, which greatly influenced the many young artists trained in his Paduan shop, included ornate pseudo-Arabic textile bands and halos.[64] His most important pupil, Andrea Mantegna (influenced also by his father-in-law, Jacopo Bellini), adopted orientalizing ornament in such early works as the altarpiece executed in Padua in 1456–1459 for San Zeno, Verona (Fig. 60). In addition to pseudo-Arabic halos and garment bands, Mantegna represented a Turkish carpet beneath the Madonna's throne and a Mamluk-style bookbinding—to which he imaginatively added a pseudo-Arabic border—in the hand of Saint Zeno (see Fig. 132). Mantegna and his patron Gregorio Correr, the eminent Venetian-born humanist abbot of the Benedictine monastery of San Zeno in Verona, certainly recognized the carpet and bookbinding as contemporary Islamic objects but evidently did not consider the ornament on them inap-

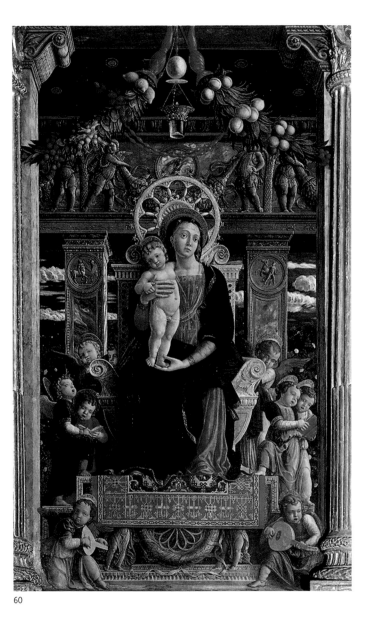

60

59 Masaccio, *Madonna and Child Enthroned with Angels*, 1426. National Gallery, London.

60 Andrea Mantegna, *Madonna and Child Enthroned with Angels and Saints* (central panel of the San Zeno Altarpiece), 1456–1459. San Zeno, Verona.

61 Filarete, *Christ* (detail from bronze doors), ca. 1450. Saint Peter's, Vatican City.

62 Giotto, *Madonna and Child* (detail from the vault), 1304–1312/13. Arena Chapel, Padua.

63 Donatello, *Madonna and Child with Angels* (Madonna Chellini), 1456. Victoria and Albert Museum, London (A. 1-1976).

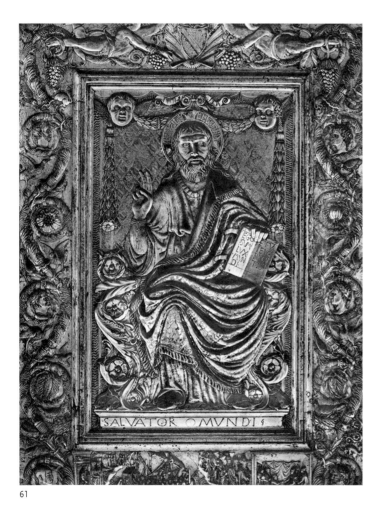

61

propriate for the garments and halos of sacred figures. The carpet and the bookbinding, rare at this date as well as costly, compliment the elite taste and status of Correr, who might well have owned such objects, and Mantegna, who must have had access to leading collections.[65] The imported carpet and orientalizing garments, halos, and bookbinding add exoticism to the painting's rich mix of ornamental accessories, but fantastic pseudo-Arabic elements did not last long in Mantegna's art.[66]

Pseudo-Arabic halos and textile bands have a unique significance on Filarete's bronze doors, about 1450, for Old Saint Peter's, Rome.[67] In the *Christ* (Fig. 61), *Saint Peter,* and *Saint Paul* panels, the bands along the outside edges of the cloths of honor are partly covered by classical festoons of garlands and seraphim heads. Latin inscriptions decorate the panels' frames, and strong Byzantine elements appear in the figures and their draperies. Other reliefs on the doors commemorate the Council of Eastern and Western Churches, which at its final session in Florence in 1439 issued a declaration uniting the Greek Orthodox and Roman Catholic Churches that never took effect. Evidently, Filarete attempted to blend the different artistic traditions of the elusive united Church as he understood them.

It is difficult to account for Giotto's use of his distinctive hybrid pseudo-script to frame religious images. It appears in the central band of the polychrome frames of *The Madonna and Child* (Fig. 62) and the saints on the vault of the Arena Chapel, Padua, and traces of it survive on incised bands edging the gilt background of the Washington *Madonna and Child* (see Fig. 50), and the *Stigmatization of Saint Francis* in the Louvre.[68] Comparable framing pseudo-script appears on other gilt panel paintings associated with Giotto.[69]

It was traditional Islamic practice to border important architectural forms and decorations—which are nonfigural—with Quranic or dedicatory inscriptions.[70] Bands of pseudo-Kufic are common in carved architectural decoration in Byzantine Greece from the early eleventh century to the mid-twelfth, and appear in numerous twelfth- and thirteenth-century French and German wall paintings, as frames around religious representations as well as architectural decoration. Pseudo-Kufic frames also appear in contemporary Byzantine, French, and German manuscript illuminations. Though in nu-

merous examples pseudo-Kufic is used as architectural decoration in thirteenth-century Byzantine-style wall paintings in South Italy, such ornament rarely appears in any medium in central and northern Italy.[71] Nevertheless, it seems likely that artists of Giotto's generation, instead of borrowing motifs anew from Byzantine illuminations or Islamic objects, modernized framing ornament inherited from the European wall- and miniature-painting traditions, so that it harmonized with contemporary Eastern script and their own style.[72] At the same time, it may not be accidental that Giotto's framing inscriptions distantly resemble Islamic metalwork. The quadripartite division of his unique circular vault frames in Padua (see Fig. 62) relates to the same Mamluk brassware (see Fig. 57) that probably inspired his orientalizing halos. Unlike the gilt halos and panel frames, however, these polychrome roundels bear no visual or material resemblance to brassware.

The meaning of Giotto's framing pseudo-script is as puzzling as its sources. It could be purely decorative, though the strong connection between contemporary orientalizing pseudo-script and real writing argues against this possibility. Because Arabic and 'Pags Pa were associated with the Holy Land and the Early Christian era, the frames could emphasize the origin and age of the images they surround. Perhaps they marked the imagery of a universal faith, an artistic intention consistent with the Church's contemporary international program.

Giotto's frames seem to have had no artistic impact beyond his close associates except, perhaps, in a unique fifteenth-century sculpture. In 1456 Donatello presented Giovanni Chellini, a Florentine physician who had recently cured him, with a roundel, *The Madonna and Child with Angels,* the size and shape of a platter (Fig. 63). Pseudo-Arabic in gold ornaments its flat rim, and traces of gilding remain in the background and the figures of the center. The back of the roundel is a negative replica of the front, intended to serve as a mold for making identical casts of the central image; those that survive, however, lack the framing inscription of the original.[73] Though the roundel resembles inlaid brassware and may have a symbolic association with trays presented at childbirth, the image has a low viewpoint, as if its figures were seen through an opening in a wall or vault above eye level. The style of the object suggests that Donatello

62

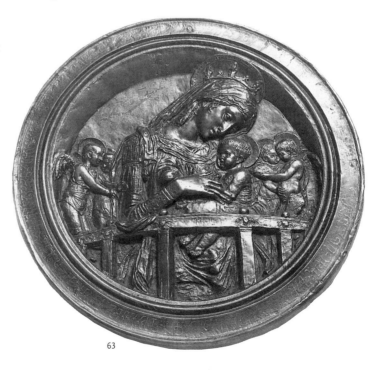

63

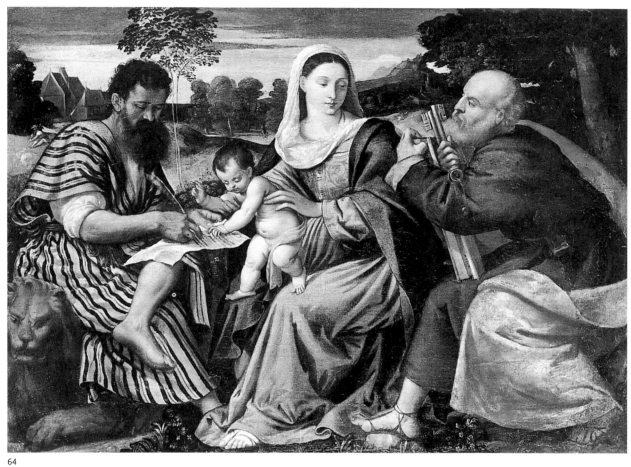

64

64 Attributed to Polidoro da Lanciano, *Madonna and Child with Saints Mark and Peter*, ca. 1535–1540. The Walters Art Museum, Baltimore.

made it in Padua during his stay from 1443 to 1453, and the particular combination of an orientalizing frame and figures seen above through a circular opening recalls Giotto's roundels with their sky-blue backgrounds in the vault of the Arena Chapel in Padua (see Fig. 62).

Pseudo-Arabic inscriptions are rare in Italian painting after the second decade of the sixteenth century. The artists of the High Renaissance preferred to dress the Early Christian era in a classical style and to inscribe legibly in Latin or Italian using antique Roman letters or the new script invented by humanist scribes. For example, although traditional orientalizing pseudo-script appears on some of the garments in Raphael's early paintings, such as the *Saint Sebastian* of about 1501–1503, in the Accademia Carrara, Bergamo, it soon disappears.[74] More was being learned about Eastern scripts, and even if ignorance persisted, fantastic pseudo-Arabic inscriptions were inconsistent with the high value sixteenth-century artists and patrons placed on demonstrating knowledge. A curious blend of earlier tradition and new learning appears in a rare example of pseudo-Arabic toward the mid–sixteenth century. In the *Madonna and Child with Saints Mark and Peter* attributed to the Venetian painter Polidoro da Lanciano (Fig. 64), Saint Mark wears a stereotypical eastern Mediterranean striped robe with a pseudo-Arabic neckband and writes pseudo-Arabic in the correct direction, from right to left.[75]

While the patterned textiles examined in Chapter 2 show that Italians admired the aesthetic qualities of Islamic calligraphy, Italian paintings reveal a complex perception of Arabic writing. Italians recognized Arabic writing as Eastern and, through objects such as *tiraz* textiles and Mamluk metalwork, realized that it had a highly honored status in the region where Christianity was born. Islamic objects, similar in style and technique, that were regarded as relics in the West abetted the European mis-

association of contemporary eastern Mediterranean material culture with that of the Early Christian era. But the misapprehension was driven by Western veneration of Christianity's Eastern roots and the desire to possess and preserve that sacred heritage. Compelling interest in the Christian Holy Land during the Crusades and immediately after the Muslim reconquest of Palestine, combined with ignorance about Islamic culture, led to confusion between the Eastern past and present. Honored elements of the contemporary East were misinterpreted and appropriated. The brief appearance of pseudo-Mongol in Italian painting was merely an offshoot of this phenomenon that highlights the misunderstanding of Eastern scripts. Artistic concerns also played an important role in the various adaptations of Arabic writing and the Islamic objects on which such writing appeared. Giotto and his contemporaries developed an immediately recognizable version of the Eastern honorific garment to make their representations more vivid and, in their view, more accurate. The imitation writing on halos and frames was ornamentally sophisticated, consistent with the Eastern garments, and perhaps also emphasized that these were images of a universal faith. In the fifteenth century, when Europe's connections with the Holy Land were more distant, artists who used orientalizing accessories usually made them more elaborate and stressed their exotic qualities. The Eastern scripts, garments, and halos disappeared when Italians viewed the Early Christian era in an antique Roman context.

Oriental luxury goods valued in Italy's secular culture continued to be used in religious life and represented in religious paintings, however—as marks of honor but not of time or place. The chapter that follows examines the rising status of contemporary imported carpets, including some that Italians realized might have special meaning in Muslim culture.

■ ■

CARPETS

FROM AT LEAST THE MID–FIFTEENTH CENTURY, FINE hand-knotted pile carpets have been the most prestigious Oriental textiles in international trade. Two market factors helped give them their status during the Renaissance: only the richest Europeans could afford them, and the supply of fashionable carpets was limited. Carpets cost much more than other contemporary Oriental manufactured goods. Late-fifteenth-century Italian inventories valued carpets at between 10 and 70 florins or ducats, most inlaid brassware at less than 10, and lusterware ceramics only in small coins.[1] Some sixty of the newly popular carpets shipped from Venice to London in 1520 were worth more than 1,000 ducats.[2] Furthermore, the best carpets were as valuable as the paintings and sculptures that the richest Italians displayed in their palaces. For example, the inventory of Lorenzo de' Medici's estate of 1492 lists table carpets with geometric patterns worth 70 and 30 florins, another geometric carpet worth 60 florins, geometric carpets with Medici arms worth 30 and 20 florins, six *spalliera* paintings (works custom-made for walls and furniture) by Pesellino and Uccello—including the three large panels of Uccello's *Battle of San Romano,* now in the Uffizi, Louvre, and National Gallery, London—worth a total of 300 florins, and three large *Hercules* paintings by Antonio Pollaiuolo worth 20 florins each.[3] Lorenzo's best table carpet was also worth more than two sculptures by Donatello owned by Luigi Martelli in 1493: a bronze *Saint John,* valued at 50 florins, and a marble *David,* at 25.[4] Even Italians who could pay the price, however, found some carpets difficult to acquire. In 1473 Lorenzo de' Medici's agent in Istanbul shipped a table carpet inferior to what his employer wanted because the production center for the best ones with custom-made coats of arms was so remote.[5] Large carpets were also in short supply.[6] Thus it is not surprising that royalty and the urban elite displayed their carpets as status symbols both in real life and in the art they commissioned.

Oriental carpets first appeared in Italian paintings in the early fourteenth century; both the quantity and quality of carpet representations rose significantly between the mid–fifteenth century and the sixteenth. This surge resulted from several overlapping developments: changes in painting style, the arrival of high-quality carpets with geometric patterns, and increased interest in acquiring and displaying luxury domestic furnishings. Though Italians made no sustained attempt to develop a competitive carpet industry, the painted images of Oriental carpets indicate the taste and demand that fueled the rapid growth of other Italian decorative arts. Indeed, paintings show how Italians changed their use of Oriental carpets, signaling new attitudes toward their household objects and environment.

Fifteenth- and sixteenth-century carpets that came to light in the twentieth century prove that the European painters who represented them in a descriptive style were remarkably accurate. Most of the field and border patterns in fifteenth- and sixteenth-century Italian images occur in surviving carpets, and the images and surviving examples show a comparable range of variations. There

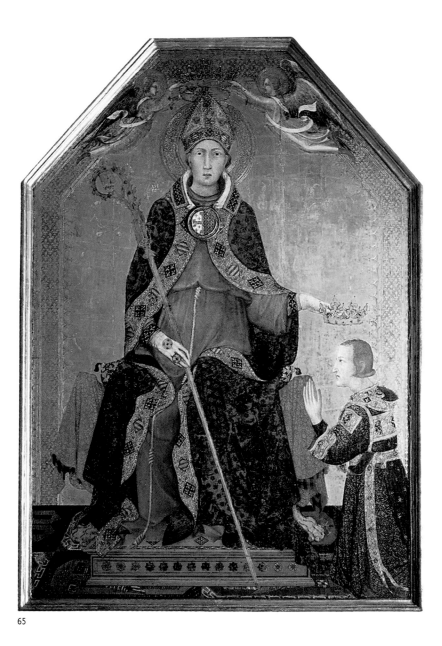

65

is little corroborative evidence, however, for fourteenth-century images. The types of Oriental carpets in European painting, their accuracy, and the documentary value of painted images for the history of early carpet making have been well studied and need only brief mention here. More important for this study is the response of Italian patrons and artists to the carpets.

Oriental carpets must have begun arriving in Italy at least several decades before the earliest surviving depiction of one, in the second decade of the fourteenth century. In 1220 Venice established commercial relations with the Seljuks of Rum ruling eastern Anatolia, where pile carpets with geometric designs were produced from the early thirteenth century. According to Marco Polo, the carpets produced around Konya were the best in the world.[7] Among the floor coverings listed in the papal inventory of 1295 is one with pile, described as old and worn.[8] But there are no certain depictions of pile carpets in thirteenth-century Italian paintings.[9]

Though it is often impossible to distinguish pile carpets from flat-woven kilims and other furnishing fabrics in fourteenth-century paintings, a significant number must represent carpets: series of parallel lines indicate rows of coarse knotted pile.[10] The earliest such representation is in

65 Simone Martini, *Saint Louis of Toulouse Crowning Robert of Anjou, King of Naples,* ca. 1316–1319. Gallerie Nazionali di Capodimonte, Naples.

66 Domenico di Bartolo, detail of *The Marriage of the Foundlings,* 1440. Spedale di Santa Maria della Scala, Siena.

67 Carpet with phoenix-and-dragon design, Anatolia, first half or middle of the fifteenth century. Staatliche Museen zu Berlin–Preussischer Kulturbesitz, Museum für Islamische Kunst, Berlin (I.4).

66

Simone Martini's *Saint Louise of Toulouse Crowning Robert of Anjou, King of Naples,* about 1316–1319 (Fig. 65); the function and design of this carpet are typical. Until about the mid–fifteenth century, all of these carpets cover the floor: before the dais of an important living person, in a festive religious ceremony, and beneath the Madonna's throne or in her bedchamber. The figures stand or kneel on, or sit above, the carpets, which signify their exalted status and distinguish a highly esteemed space. There are no representations of figures sitting directly on carpets, taking intimate visual and tactile pleasure in them as was the custom in the Islamic world.[11] Most paintings show only parts of the rugs' designs, and all the visible fields are geometric compartments containing stylized animals. No examples survive of the Byzantine-style designs shown in the majority of the representations, such as Simone's with addorsed birds. A few paintings, however, show a Chinese-inspired phoenix-and-dragon pattern verified by an increasing number of known examples. The large carpet in Domenico di Bartolo's *Marriage of the Foundlings,* 1440, for example (Fig. 66), closely resembles the contemporary example in Figure 67, which is probably a fragment of a larger repeat.[12] A small carpet in Jacopo Bellini's *Annunciation,* 1444, in Sant'Alessandro, Brescia, has the same main border as Figure 67, with the colors reversed. The partially visible field compartments are related to a later-fifteenth- or sixteenth-century example formerly in the Bernheimer Collection, Munich.[13]

It is believed that these early carpets were produced in several locations in western Anatolia because of relationships to Byzantine textile design and later Large Pattern Holbein carpets from this region. Because purely geo-

67

metric designs in the many thirteenth- to early-fifteenth-century Anatolian carpet fragments excavated in Fustat, the medieval section of Cairo, predominate over animal patterns like those in Italian pictures, Italians must have preferred the figured patterns.[14] Two paintings before 1450 by Sienese artists represent carpets—one with an animal design—known to have been in the possession of Avignon popes, in scenes set in the Papal Palace there.[15] It seems likely that carpets represented in contemporary Italian ceremonial scenes also belonged to the patrons or institutions, King Robert of Naples in the case of Simone's painting and the Hospital of Santa Maria della Scala in Siena in Domenico di Bartolo's. The carpets in some early-fifteenth-century *Annunciations*, however, seem to derive from fourteenth-century paintings of the same subject rather than actual examples.[16] The overwhelmingly Sienese provenance of painted images of animal carpets may reflect local taste and/or artistic style. These carpets disappear from Italian paintings in the 1470s, about two decades after high-quality geometric carpets began to arrive. The painted images of animal carpets suggest coarse, utilitarian articles that were admired less by Italian collectors and artists than subsequent imports. Like Simone Martini, Italian painters generally showed far more interest in the designs of contemporary silks and velvets than in the animal carpets.

After the new geometric carpets began to arrive in about the mid–fifteenth century, Italian painters rarely represented Oriental carpets on the floor except beneath the throne of the Madonna or a saint, or before the dais of a ruler. Otherwise, in the contemporary domestic settings of both religious and secular paintings, carpets appear above ground, protected from wear and displayed as works of art. Carpets are laid out mostly or entirely uncovered, draped or hung on furniture and architecture so that their intricate patterns of bright colors are clearly visible. Even the two earliest images of the new geometric carpets, which show them in traditional locations, strikingly emphasize their beauty by placing them so that their design, described in detail, is readily visible: one is stretched out before the kneeling patron in Piero della Francesca's *Sigismondo Malatesta before San Sigismondo*, 1451, in the Tempio Malatestiniano, Rimini,[17] and the other hangs over the dais of the Madonna in Mantegna's San Zeno altarpiece of 1456–1459 (see Fig. 60). The new

locations signal rising esteem for these carpets among collectors and artists alike. During the sixteenth century many Italians—most often in northern Italy but also in Florence and Rome—had themselves portrayed with their prized table carpets, symbols of their wealth, status, and taste.

The depiction of carpets in domestic settings increases rapidly after about 1475 and peaks during the first quarter of the sixteenth century, precisely when there was a tremendous surge in demand for luxurious household furnishings and conspicuous consumption became an expression of high culture.[18] During the fifteenth century individuals began to keep detailed accounts and inventories of furnishings in their sleeping and living quarters, which rarely exceeded one or two rooms. These records show a steady rise in both the quantity and variety of furnishings from the late fifteenth through the sixteenth century. The bedchamber and study, often combined in one room, were the focal points of the Italian Renaissance palace. Italians who could afford to do so furnished these rooms with fine art objects, including imported carpets. Although even the rich owned few pieces of furniture other than beds, they decorated their tables (see Fig. 81), benches (see Fig. 69), and chests with precious Oriental carpets. Paintings also show them on sumptuous dining tables, shielded by smaller white covers (see Fig. 78).[19] Lorenzo de' Medici kept his best carpets—including those for tables—in a chest outside his bedchamber, where they would be protected and readily available for special occasions. Carpets on that chest and a desk nearby, and on tables, desks, or the floor in other rooms of the palace were worn and/or of little value.[20] Fine bedside carpets seem to have been an extremely rare luxury. In 1545 Cosimo I de' Medici ordered two pairs of custom-made pile bedside carpets from Cairo; they arrived a year or two later. These are the only floor carpets not described as used or worn in his inventory of 1553, which lists eighty-six pile rugs.[21] A drawing by Lorenzo Lotto in the British Museum shows a small one beside the bed of a cleric portrayed as preoccupied with worldly pleasures.[22]

As indicated above, Lorenzo de' Medici's most valuable carpets all had geometric designs. Among the various carpets listed in the inventory of Cardinal Francesco Gonzaga's fabulous collection in 1483, at least ten were probably the new Anatolian geometric types.[23] Sixteenth-century

Florentine and Venetian inventories often list ten or more Oriental carpets and name different origins: "cagiarini" (Mamluk designs from Egypt), "damaschini" (either Mamluk or Turkish carpets sold in Damascus or the para-Mamluk type perhaps made in the Damascus region), "barbareschi" (North African), "rhodioti" (probably imported via Rhodes), "turcheschi" (Ottoman), and "simiscasa" (Circassian or Caucasian). Persian carpets are rarely mentioned before the early seventeenth century.[24]

Italians also displayed their carpets ostentatiously in public. On holidays or festivals, such lavish display celebrated communal as well as individual prosperity. Merchants and diplomats had certainly seen carpets ceremonially paving the route of sultans in the streets of Cairo,[25] but in Italy it was customary to hang them from windows, balconies, and parapets of private palaces and state buildings. A fresco of about 1300 in San Giovanni Laterano, Rome, that represents Pope Boniface VIII proclaiming the Jubilee from the palace balcony, indicates that the practice was an old and honored one, though in this instance the rug-size textile depicted was not a carpet because it has rounded rather than square corners.[26] Late-fifteenth-century Florentine *cassone* (storage chest often decorated with paintings) panels show rug-size textiles with geometric patterns and stylized animals that look like heraldic devices hanging from palace windows. These may have been locally made for personal display; they appear not to have competed with imported carpets in other functions.[27] In 1461, when Florentine galleys were sailing direct to Istanbul, the commune made the decoration of public buildings with carpets official policy: captains were required by law to pay twelve florins into a fund for the purchase of such carpets.[28]

Ostentatious public display of Oriental carpets was especially significant in Venice, where they were a highly profitable re-export commodity and symbolized the Republic's commercial power and connections.[29] The inventory of King Henry VIII of England of 1547 attests to the magnitude of the trade, for most of the approximately five hundred carpets listed are Turkish, usually acquired from Venice.[30] In a painting of 1496 commemorating a miracle that had taken place during the annual Procession of Saint Mark in Venice, Gentile Bellini shows a line of carpets on palace facades facing Saint Mark's Square (Fig. 68). The diaries of Marin Sanudo (1466–1536), secretary

68

68 Gentile Bellini, detail of *Procession in the Piazza San Marco*, 1496. Gallerie dell'Accademia, Venice.

to the Venetian Senate, confirm that government buildings around the square were lavishly decorated with carpets and tapestries for public processions. For example, on the Feast of the Madonna, September 8, 1515, Cairene, Circassian or Caucasian, and other carpets as well as tapestries and flags were hung across the facade of the Doge's Palace.[31] The most lavish displays described by Sanudo celebrated great alliances—the Holy League of 1511 with the pope and Spain against France and Germany and the 1526 League of Cognac with the pope, Milan, Florence, and France against Germany and Spain— apparently following a precedent set in 1495 honoring the coalition of the pope, Milan, Germany, and Spain to defeat the ongoing French invasion of Italy. For the procession of October 11, 1511, carpets and tapestries (or hangings) covered the Doge's Palace facing the square, the tapestries, at least, lent by a Maestro Stephano, who had a shop in the square and wanted to decorate the palace as in 1495.[32] On July 8, 1526, three rows of carpets hung at different levels, one row with twenty carpets, on the principal facade of the Doge's Palace alone, and the palaces in the Procuratie Nuove on the south side of Piazza San Marco were adorned like those in the Procuratie Vecchie on the north side in Bellini's painting—including a woman at every window.[33] Merchants decked the Rialto with carpets for the three-day holiday celebrating the Venetian victory over the Ottoman fleet at Lepanto in 1571, which offered prospects of increased trade.[34] The Venetian settings in Vittore Carpaccio's cycle of paintings representing stories of Saint Ursula of 1495 indicate that on ceremonial occasions carpets were also displayed on gondolas, docks, and bridges as well as private palaces.[35] Especially in paintings executed in Venice and northern Italy, cityscapes also show how in everyday life carpets were ostentatiously aired in public view (see Figs. 72, 74). The archives of the Scuola di San Rocco, a lay confraternity, record the omnipresence of carpets in Venetian civic life. In 1541 its officers considered buying two carpets for altars or the visits of ambassadors and other dignitaries but later decided to buy one magnificent carpet, as a striking status symbol. It has been proposed that a huge Mamluk carpet still in the *scuola* was the one purchased. To preserve this or another large Mamluk carpet, the officers in 1568 found it necessary to fine members who authorized its loan. Other Venetian documents indicate that renting carpets and hangings was a common practice.[36]

The Italian elite who commissioned paintings showing their costly carpets undoubtedly wanted them represented in detail. Late-fifteenth-century painters certainly discovered on their own, however, that they could both please their patrons and showcase their own skills by imitating the intricate patterns of the new carpets. Furthermore, given the contemporary passion for geometry, the designs of these carpets must have captivated artists: many of them went beyond mere imitation to integrate the carpets' aesthetic qualities into their art, while some responded to the material qualities and unique features of individual carpets.

Two outstanding depictions, one from the Veneto and the other from Tuscany, of the earliest type of Anatolian geometric carpet dramatize differences of sensibility and style (see Figs. 69–71). This type has been called the Small Pattern Holbein since the beginning of the twentieth century, when European painted images were better known than surviving examples of the early Oriental carpets themselves, and different carpet designs were named after artists who represented them. Though the German painter Hans Holbein represented this carpet pattern magnificently, it could just as reasonably bear other names, especially because Italian artists represented it first—Piero della Francesca and Mantegna—and more often.[37] The field consists of alternating octagonal and cross-shaped forms with intricate geometric and strapwork compositions, and the borders in early examples have pseudo-Kufic ornament. It is believed that the pattern, which is both sophisticated and easily adjusted to size, was conceived for commercial production in the Ushak region of Anatolia.

In *The Annunciation* by the Bergamese painter Andrea Previtali, about 1508 (Fig. 69), the carpet's display lengthwise on a bench gives the spectator full opportunity to appreciate its design and colors and to admire the artist's descriptive powers. The rich green ground of the field is common in Small Pattern Holbeins, and the octagons and medallions are closely related to the sixteenth-century carpet in Figure 70.[38] The painted carpet's "endless knot" kufesque border is similar to one on a late-fifteenth-century fragment in the Keir Collection, which provides an even closer match for the border in Mantegna's San Zeno altarpiece (see Fig. 60).[39] Previtali used the carpet to anchor a carefully balanced composition. In addition, the carpet bridges the still and quiet figures of Gabriel

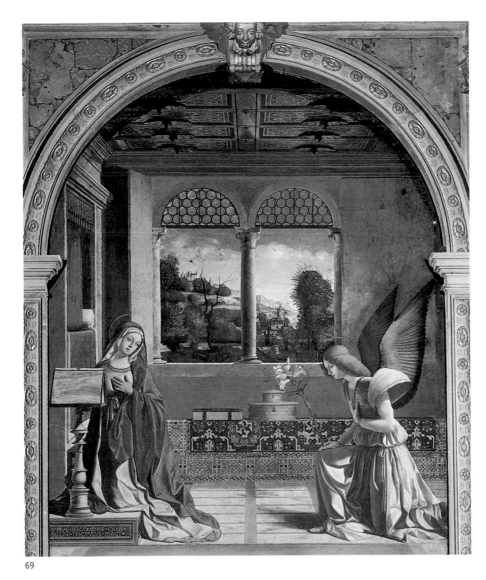

69

69 Andrea Previtali, *The Annunciation*, ca. 1508. Santa Maria del Meschio, Vittorio Veneto, Treviso.

70 "Small Pattern Holbein" carpet, Anatolia, sixteenth century. Staatliche Museen zu Berlin–Preussischer Kulturbesitz, Museum für Islamische Kunst, Berlin (82,894).

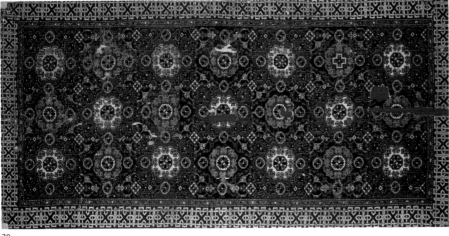

70

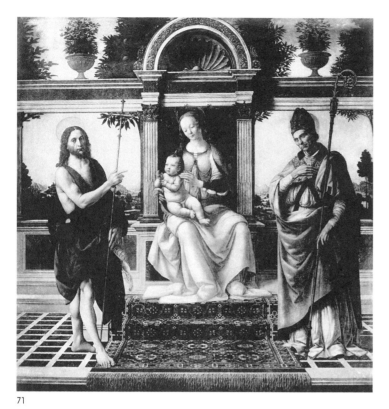

71

71 Lorenzo di Credi, *Madonna and Child Enthroned with Saints John the Baptist and Donato of Arezzo* (Madonna di Piazza), ca. 1475–1480. Cappella del Sacramento, cathedral of Pistoia.

and the Virgin, its interlacing lines and vibrant colors a metaphor for their dialogue. Previtali's artistic integration of the carpet into his chromatic composition is characteristic of contemporary Venetian painting style.

A Small Pattern Holbein provided the Florentine painter Lorenzo di Credi with a challenging vehicle for a remarkable feat of perspective foreshortening and trompe l'oeil illusionism in his *Madonna and Child Enthroned with Saints John the Baptist and Donato of Arezzo*, about 1475–1480 (Fig. 71). The risers of the steps provide the spectator with direct views of the carpet's pattern, which can be compared with the foreshortened views on the pavement and tread. The fringe crossing the fictive boundary between real and painted space and Saint John's bare foot on the corner of the carpet add tactile to visual excitement. Several Tuscan painters immediately imitated Credi's amazing stair carpet,[40] but artists in northern Italy did not indulge in this particular perspective trickery. The border on Credi's carpet matches one in a private European collection.[41]

Though its carpet images are tiny, Antonello da Messina's *Saint Sebastian*, 1478–1479 (Fig. 72), is remarkable for juxtaposing two variants of a carpet just beginning to arrive in Italy. Antonello had recently traveled from Sicily to northern Italy and evidently was impressed by the new imports. The pattern is known as the Large Pattern Holbein.[42] Formerly grouped with the Small Pattern Holbein carpets under the single term "Holbein," this type is now believed to have been produced in the Bergama region of western Anatolia and is considered a successor to the animal carpets. Its field of rectangular or square compartments with large octagons framing stars varies in the number and arrangement of compartments. Antonello's distant images capture the essential difference between the type's two basic formats: on the right, the centered arrangement of one or more compartments and, on the left, the staggered composition of two small and one large compartment. The composition, borders, and motifs of the carpet on the right seem similar to those of a sixteenth-century example in Figure 73, though the painted carpet probably had only two compartments.[43] The new rugs with three and five "wheels" listed in the inventory of Cardinal Gonzaga's collection of 1483 were probably Large Pattern Holbeins in centered and staggered formats.

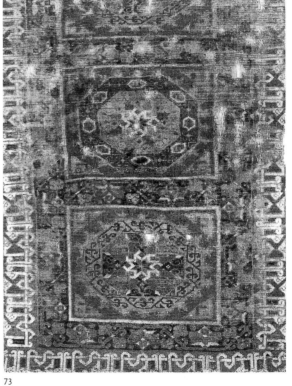

72

73

72 Antonello da Messina, *Saint Sebastian*, 1478–1479. Gemäldegalerie Alte Meister, Dresden.

73 "Large Pattern Holbein" carpet, Anatolia, sixteenth century. Staatliche Museen zu Berlin–Preussischer Kulturbesitz, Museum für Islamische Kunst, Berlin (83,522).

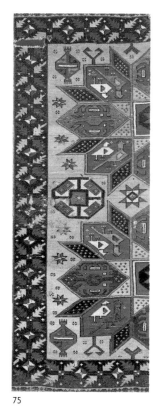

74

75

The type of carpet in Carlo Crivelli's *Virgin Mary Annunciate,* 1482 (Fig. 74), more justifiably bears his name because he was the only artist to represent it. A late-fifteenth- or early-sixteenth-century fragment verifies his image (Fig. 75).[44] Because we know that Crivelli did not travel outside the Marches, high-quality Oriental carpets were reaching the provinces. Crivelli was exceptionally sensitive to the visual and material qualities of luxury silks and velvets, and his careful rendition of the drape of hanging carpets is unique. In this painting he also distinguishes the pile of the carpet field from its flat-woven kilim end and notes the worn fringe.

Gentile Bellini's *Madonna and Child Enthroned,* painted in the last decades of the fifteenth century (Fig. 76), is probably the earliest of seven surviving traditional altar-

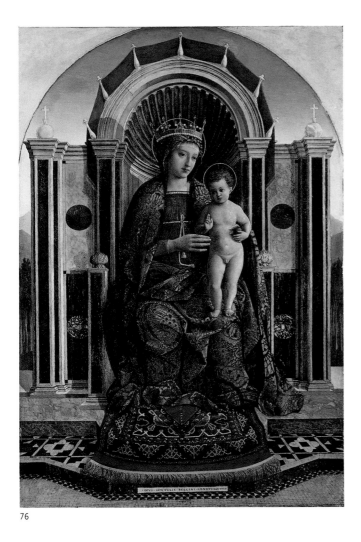

76

77

pieces showing a "prayer rug" beneath the Madonna's throne.[45] The export of these carpets to the West and their frequent representation in Italian paintings from about the 1490s to 1562 raises questions about their original meaning and subsequent interpretation in a Christian context. Bellini represented the top end of a carpet similar to an elaborate late-fifteenth- or early-sixteenth-century example from western Anatolia (Fig. 77) that has the same unusual main border and exemplifies the field containing a niche and various motifs selectively used to ornament it.[46] This pattern has been called Bellini, keyhole, or re-entrant, after a painting of 1507 by Giovanni Bellini that shows an entire carpet, and after the keyhole shape formed at the bottom where the band outlining the niche enters it.[47]

74 Carlo Crivelli, *The Virgin Mary Annunciate,* 1482. Städelsches Kunstinstitut, Frankfurt am Main.

75 "Crivelli" carpet, Anatolia, late fifteenth–early sixteenth century. Iparmüvészeti Múzeum, Budapest (14940).

76 Gentile Bellini, *Madonna and Child Enthroned,* late fifteenth century. National Gallery, London.

77 Re-entrant prayer rug, Anatolia, late fifteenth–early sixteenth century. Topkapi Sarayi Muzesi, Istanbul (13/2043).

The directional design of these and later related carpets and their standard portable size have become associated with the Muslim ritual of praying five times a day facing Mecca, and the practice from at least the fourteenth century of using one's own rug or mat for prayers at the mosque, *zawiya* (a religious foundation), or other location.[48] The characteristic niche is believed to symbolize both a doorway to paradise and the *mihrab,* the mosque niche orienting prayer toward Mecca, and the lamp commonly suspended in the niche refers to a verse in the Quran likening Allah to a lamp in a niche. The keyhole at the bottom of the niche has been interpreted variously as the basin for ablutions before prayer, a niche-within-a-niche, or a mountain providing elevated ground for prayer. Lamp, vase, or candlestick motifs that sometimes appear beside the keyhole may represent objects placed at a mosque's entrance or *mihrab.*[49] There is some basis for these interpretations in medieval Islamic art. Twelfth- and thirteenth-century manuscript illuminations depict mosques as arcaded halls with lamps hanging on chains, and thirteenth- and fourteenth-century Persian tile representations of *mihrab*s show a lamp hanging in a pointed niche that is sometimes also flanked by lamps or vases.[50] Nonetheless, the pre-Islamic origins of most, if not all, of the stylized forms that have been presumed to symbolize the niche, *mihrab,* and lamp in carpets raise questions about the validity of the term "prayer rug." Over time, as Islamic cultures adopted these forms and adapted them to new compositions, the motifs probably acquired new meanings. Individual weavers, merchants, and owners, however, undoubtedly understood designs differently, especially when new ones were being developed.[51]

Re-entrant prayer rugs seem to have been first produced in the second half of the fifteenth century. They share their ornamental repertory with earlier *safs,* large rugs with rows of niches that were made for mosques and for the use of the Muslim community during prayers, and with symmetrical re-entrant carpets with keyholes at both ends, that also emerged in the late fifteenth century and may have been wholly secular in use. For example, the multiple lamps on chains, the bottom medallion, and the triangular forms with hooked extensions above the keyhole in Figure 77 appear on a fifteenth-century *saf,* and

these triangular forms and central and keyhole medallions also appear on an early symmetrical re-entrant carpet.[52] Though in 1610 the highest Ottoman religious authority ruled against the use of such motifs as the *mihrab,* Kaaba (the Holy Shrine at Mecca), and any writing in carpets because so many were being sold to nonbelievers, there is no evidence that re-entrant carpets were made primarily for export to the West.[53] Re-entrant prayer rugs were produced in widespread locations by the early sixteenth century. In addition to examples from different regions of Anatolia, one made in Cairo in the Mamluk style survives, and para-Mamluk types associated with Damascus appear in Italian paintings.[54]

Italian estate inventories early on use the term "mosque carpet." Cardinal Francesco Gonzaga's of 1483 describes six: one "with four mosques" five and two-thirds *braccia* long must have been a *saf;* four "with the mosque" have typical prayer rug lengths averaging two and one-half *braccia* (about 1.5 meters); and one for which no measurements are given.[55] The inventory of Francesco Badoer of Venice in 1521 lists eight new "tapedi a moschetti," and the inventory of Lorenzo Correr of Venice in 1584 mentions ten "tapedi da cassa moschetti."[56] Thus to some extent Italians must have associated the prayer rug design with the Muslim religion.

Italian representations of re-entrant carpets with the Madonna and saints, which are mostly Venetian, are clustered in the last decade of the fifteenth and the first decade of the sixteenth century, when these imports were new, and decline noticeably thereafter. The last image of a re-entrant carpet beneath the Madonna's throne dates from about 1530, but Venetian painters continued to represent other carpets in this subject into the 1540s, after which changes in painting style led to a general decline in carpet depictions. Until they disappear from paintings in the 1560s, re-entrant carpets are shown in secular settings: hung over balconies, and on tables in portraits and dinner scenes. Prayer rugs last appear in religious subjects on feast tables in a context of excessive luxury in two paintings by Jacopo Bassano: *Lazarus and the Rich Man,* about 1554 (Fig. 78), and *The Beheading of the Baptist,* about 1555, Statens Museum fur Kunst, Stockholm.[57] Though there was no corresponding decline in the popularity of "mosque carpets" among Venetian

78

collectors between the 1520s and 1580s, artists and
patrons may have become more discriminating about this
particular Oriental carpet in paintings because of its
perceived connection to Islam.

The most ingenious depiction of a re-entrant prayer
rug is in Lorenzo Lotto's *Mystic Marriage of Saint Cather-
ine with the Patron, Niccolò Bonghi*, 1523 (Fig. 79).[58] Lotto
represented the top and bottom ends of a prayer rug,
draped over the window ledge (a view of Bergamo has
been cut out of the picture), that is similar to a late-
fifteenth- or early-sixteenth-century example from the
Ushak region of Anatolia (Fig. 80).[59] On the left, Lotto
positioned the top of the carpet's niche to frame the
Madonna's head; to balance his composition, he placed
the carpet's keyhole behind the angel's head on the right.
The black bands outlining the top of the niche and
keyhole are identical; its ivory motifs, which descend

78 Jacopo Bassano, *Lazarus and the Rich
Man*, ca. 1554. The Cleveland Museum of Art,
Delia E. and L. E. Holden Funds (1939.68).

79

from a stylized form of the Arabic word for God, appear on the prayer rug in Figure 77. Both ends have a pseudo-Kufic border, as in Figure 80, but there is a discreet discrepancy: on the left, the rectangular elements open outward, the normal direction, and on the right they open inward.[60] Paintings with more than one carpet customarily show different types or designs to emphasize the owner's wealth.[61] Directly beside Bonghi's head is a detail unique in Italian painting: the edge of the carpet is turned back and the fineness of the weave is indicated by the knots. Lotto's other representations of carpets show exceptional sensitivity to their particular qualities, and he is the only artist known to have owned an example of

the elite Turkish carpets he depicted.[62] Moreover, since Bonghi was Lotto's landlord, Lotto must have known his patron and his patron's carpets well. Perhaps the two men had examined the knots on this carpet together and collaborated on the details of its representation. Both the detail on the left and the discrepancy on the right may be highly inventive devices to please Bonghi and flatter his expertise.

A new Anatolian carpet pattern that has been named after Lorenzo Lotto first appears in Sebastiano del Piombo's magnificent portrait *Cardinal Bandinello Sauli, His Secretary, and Two Geographers,* 1516 (Fig. 81).[63] Along with the accessory figures, open text, and ready bell, the

80

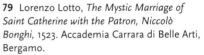

79 Lorenzo Lotto, *The Mystic Marriage of Saint Catherine with the Patron, Niccolò Bonghi*, 1523. Accademia Carrara di Belle Arti, Bergamo.

80 Re-entrant prayer rug, Anatolia, late fifteenth–early sixteenth century. Staatliche Museen zu Berlin–Preussischer Kulturbesitz, Museum für Islamische Kunst, Berlin (87,1368).

81 Sebastiano del Piombo, *Cardinal Bandinello Sauli, His Secretary, and Two Geographers*, 1516. National Gallery of Art, Washington, Samuel H. Kress Collection.

81

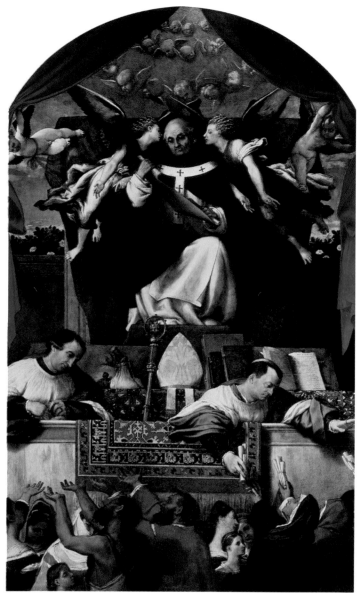

82

fine Oriental table carpet signifies the cardinal's status and sophistication. Indeed, his outstretched hand on the pile expresses the pride and pleasure of possession. The complex Lotto field pattern, composed of interconnecting octagonal and quatrefoil arabesques, is minutely described in that artist's *Saint Antoninus Giving Alms,* 1542 (Fig. 82). The sixteenth- or early-seventeenth-century carpet in Figure 83 has the identical arrangement, with the octagons in the center; it also has the open pseudo-Kufic main border that is typical of early Lottos, such as those in Sebastiano's and Lotto's paintings.[64] The Lotto field does not have a fixed beginning or ending, and carpets with this design were also made in large sizes with more than three horizontal elements; these were probably designed for commercial production in or near the Ushak region of Anatolia. In the *Saint Antoninus* altarpiece, Lotto represented a second carpet on the altar under the moneybags and bishop's miter (liturgical headdress). The two carpets play a pointed role in the theme: the rich furnishings underline the wealth of the Church as alms are dispensed to the poor.

The second carpet in Lotto's *Saint Antoninus Giving Alms* belongs to a group called para-Mamluk that shares design and technical features with contemporary Anatolian rugs, especially the Large Pattern Holbeins, and the Mamluk carpets made in Cairo that are discussed below.[65] Most scholars agree that they were made around Damascus, close to Turkey in the north of the Mamluk empire, where there is some evidence of carpet production. Lotto represented part of a compartmented field design similar to that in the sixteenth-century carpet in Figure 84. In both, inward-pointing cypress tree, floral, and geometric motifs derived from Mamluk carpets are arranged radially around rows of small interlacing stars. The more open composition of the painted rug resembles that of other surviving examples.[66]

Though sixteenth-century Italian inventories indicate that Mamluk rugs were popular, Italian painters rarely attempted to depict their subtle pattern.[67] The early-sixteenth-century example in Figure 85 illustrates the inimitable qualities.[68] The centralized composition is broken down into a multitude of small and intricate

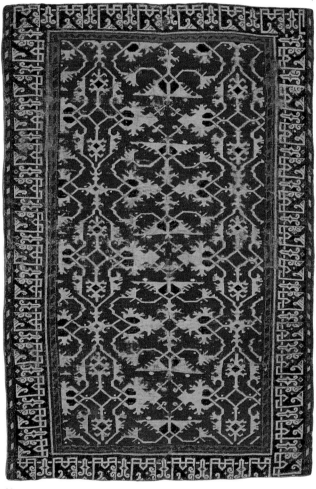

83

84

geometric forms, and the characteristic narrow range of colors and silky sheen of the wool pile enhance the effect of a shifting kaleidoscopic pattern. Both full and close views are required to appreciate the design and beauty of Mamluk carpets. They originated in Cairo during the second half of the fifteenth century, differ technically from Anatolian carpets, and were produced in many sizes and in shapes that included the cruciform and circular, destined for tables in Europe. The Medici grand dukes, in addition to the rare pair of bedside carpets mentioned above, owned one of the largest early Oriental carpets still in existence: a magnificent Mamluk nearly eleven

82 Lorenzo Lotto, *Saint Antoninus Giving Alms*, 1542. Santi Giovanni e Paolo, Venice.

83 "Lotto" carpet, Anatolia, sixteenth century. The Saint Louis Art Museum, Gift of James F. Ballard (104:1929).

84 Para-Mamluk carpet, Damascus region, Syria (?), first half of the sixteenth century. Private European collection.

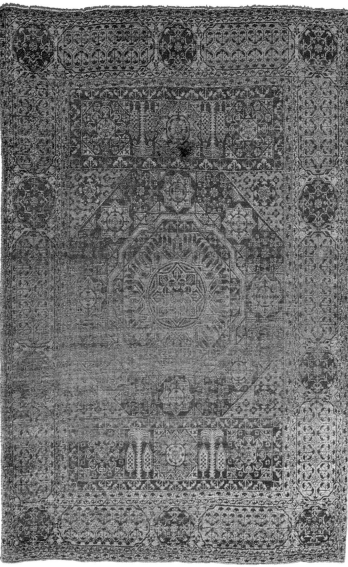

85

85 Mamluk carpet, Cairo, Egypt, beginning of the sixteenth century. Staatliche Museen zu Berlin–Preussischer Kulturbesitz, Museum für Islamische Kunst, Berlin (82,704).

86 School of Moretto, *Young Ladies of the House of Martinengo*, before 1543. Palazzo Martinengo-Salvadego, Brescia.

meters long, acquired sometime between the inventories of 1557 and 1571. It survived in almost perfect condition in the Palazzo Pitti because it was kept in reserve for special occasions.[69] The Martinengo di Podernello family of Brescia must have required artists of the Moretto School to portray them with their prized set of six Mamluk carpets. In the fresco decorations of a room in their palace, each of the three walls executed before 1543 shows two young ladies of the house of Martinengo and two carpets (Fig. 86); the fourth wall, painted after 1543, shows two more ladies but no carpets.[70] The painters were able to capture essential features of the set: the similar size and colors—yellow-green with red and light blue, as in Figure 85—and the variation in composition. But they were unable to convey the subtlety and beauty of the designs.

Paris Bordone's *Return of the Doge's Ring*, 1534 (Fig. 87), is one of the few Italian Renaissance paintings that represents carpets on the floor in a contemporary court setting. A series of new Ottoman carpets appear lined up on the steps before Doge Andrea Gritti (r. 1522–38) and the senators. In front of the doge is a large Star Ushak carpet comparable to an example from the first half of the seventeenth century (Fig 88).[71] Its centralized design of floral arabesques and loosely sprinkled blossoms and stems was inspired by Persian illumination, bookbinding, and carpet designs that strongly influenced Ottoman court art beginning about the 1460s. It has been proposed that the Star Ushak and closely related Medallion Ushak carpets were developed in the late fifteenth century as elite court objects. The carpet in front of the senator to the doge's left appears to be a Medallion Ushak, and the carpet between the two Ushaks has a geometric design similar to that of a sixteenth- or seventeenth-century fragment in the Museum für Islamische Kunst, Berlin.[72] This is the earliest representation of such carpets, and it seems likely that they had only recently arrived as diplomatic gifts.

Renaissance painters' diminishing interest in detailed description led to a rapid decline in carpet representations after the 1540s. Undoubtedly, the complex patterns of the Mamluk and the new Ottoman carpets also discouraged their representation. The inclusion of Oriental carpets in Christian subjects might have raised objections from Counter-Reformers concerned with historical accuracy

86

and appropriateness, but there is no evidence that the few carpets in late-sixteenth-century religious paintings were singled out for criticism.[73]

While Oriental-style carpets were made in Christian Spain, Flanders, and England, Italians made no sustained effort to develop a competitive industry. A few carpet-making workshops directed by immigrants were established in Italian courts when interest in luxury household furnishings blossomed, but nothing is known about their production.[74] Francisco da Perca, presumably a Spaniard, for example, worked for the royal household in Naples as a master of carpet making in 1456. And in 1473 Cardinal Francesco Gonzaga sent a servant named Barisano from Bologna to learn carpet weaving at the court of Ludovico Gonzaga and his wife, Barbara of Brandenberg, in Mantua; in 1494 Barbara sought a Turkish slave to make car-

87

87 Paris Bordone, detail of *The Return of the Doge's Ring*, 1534. Gallerie dell'Accademia, Venice.

88 Star Ushak carpet, Anatolia, first half of the seventeenth century. The Metropolitan Museum of Art, New York, Gift of Joseph V. McMullan, 1958 (58.63).

pets there. A craftsman from Cairo called Sabadino Moro or Sabadino Negro, moreover, managed a carpet work-shop for Ercole I d'Este in Ferrara between 1493 and 1530. Several silk table tapestries with Islamicizing designs were produced at the Medici court in the early 1550s.[75] But if such meager information is available on carpet making and substitute crafts in the courts of Italy, less is known about such production in the Italian mercantile republics. There is no evidence that the armorial textiles displayed in late-fifteenth-century Florentine *cassone* panels were made of knotted pile, and no examples survive of some forty Venetian carpets listed in the inventories of King Henry VIII of England of 1547.[76] Whatever was pro-duced locally did not reduce Italian demand for the imports.

The coincidence about 1450 of the arrival of new high-quality Turkish carpets with fascinating geometric designs and a rising local interest in accumulating and displaying luxury domestic furnishing assured the rapid success of the imports in the Italian market. The sus-tained quality and increasing variety of the Oriental pro-

88

duction, along with a few concessions to Italian taste,
such as formats for tables and custom orders with coats
of arms, certainly helped to sustain demand and discour-
age competition. As measured by the remarkable quantity
of painted representations, their fidelity to the originals,
and relish for details and variations, however, Oriental
carpets made too profound an impression on Italian taste
to allow a new industry much leeway for competition.
By the time the representation of carpets in paintings
went out of fashion in Italy, Oriental carpets had acquired
a unique position in Western material culture that persists
to this day.

As the demand for luxury domestic furnishings soared,
Italian craftsmen rushed to compete with other luxury
imports that they were better prepared to imitate: ceram-
ics, glass, bookbinding, and, somewhat later, inlaid brass.
The chapters that follow on ceramics and glass show that
Islamic imports first inspired technical and artistic im-
provements in utilitarian objects, then showpieces that
were ostentatiously displayed, much like carpets. Oriental
ceramics also left a permanent impression on Italian taste.

∎∎∎∎∎∎∎∎∎∎∎∎∎∎∎∎∎∎∎∎∎∎∎∎∎∎∎∎∎∎∎∎∎∎∎∎∎∎

CERAMICS

AMONG ITALY'S DECORATIVE ARTS, CERAMICS SHOW the most continuous contacts with Oriental imports.[1] The very idea that pottery can be more than utilitarian first took root in medieval Italy at the beginning of the eleventh century, when Islamic tin-glazed, painted bowls— the *bacini* mentioned in the Introduction—were set into church facades and towers, contributing color and sheen to the fabric at lower cost than marble and stone intarsia or mosaics. Nonetheless, Italian pottery remained crude and essentially utilitarian for the next four hundred years. Improvements in technique and decoration from about 1200 onward owe a great deal to Islamic sources, but only in the late fourteenth century and first half of the fifteenth did Italian earthenware begin to compete with luxury imports from Syria and Spain. Italian potters, though their techniques and materials were still inferior, raised wares produced in quantity to a new artistic level and created more one-of-a-kind pieces. During the second half of the fifteenth century, they rapidly developed a world-class pottery that expressed their own imagination and contemporary Italian Renaissance culture yet continued to draw ideas and motifs from Islamic art, Chinese porcelain, and Ottoman Iznikware.

The first Italian pottery manual, the *Arte del vasaio,* written about 1557 by Cavaliere Cipriano Piccolpasso of Urbino, reveals how completely Italian potters and patrons had absorbed Oriental concepts of artistic ceramics. Piccolpasso called the most luxurious Italian tin-glazed earthenware that was painted with metallic luster maiolica, borrowing the term for the popular fifteenth-century Spanish lusterware shipped to Italy via the island of Majorca.[2] The word derives from this transshipment point, or from the Spanish name for the Islamic luster technique adopted in Málaga, *obra de málequa.* Eventually Italians applied the term to all their tin-glazed wares. Furthermore, Piccolpasso listed and illustrated several Oriental designs among the decorations common on Italian ceramics: Islamic arabesques, strapwork, and knots and Chinese-inspired *porcellana.*[3]

In tin glazing, the clay vessel is covered with a white glaze containing tin oxide, which renders the glaze opaque and provides an optimal base for painted decoration. The technique, widely known in antiquity, disappeared in the western Mediterranean in the fifth century. It reappeared in Italy about 1150, perhaps before it arrived in Muslim Spain, and by 1300 spread to numerous pottery-making centers scattered throughout the peninsula. Scholars believe that Italian potters learned tin glazing from Islamic sources rather than rediscovered it independently, but little is known about the means of transmission. The regional—in some instances local— character of the early Italian production suggests that different sources and traditions were involved.[4] For example, the polychrome proto-maiolica of South Italy is more closely connected to the pottery of Sicily and North Africa than the predominantly green and brown archaic maiolica of central and northern Italy. Frederick II's forced resettlement of Sicilian Muslims in Lucera in 1223

89

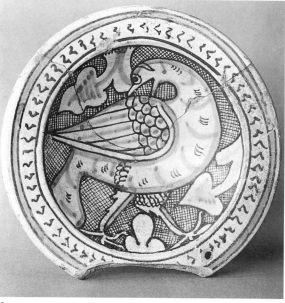

90

accounts for the style of that area, but the origins of various techniques and styles in archaic maiolica are obscure.

In the regions where archaic mailoica was produced and the main Renaissance production centers evolved, the *bacini* show that a similar range of Islamic imports were available as models and that the production of local wares increased during the thirteenth century and predominated in the fourteenth. From Genoa and Pavia to Pomposa, Pisa, and Rome, the types and dates of imports are comparable. Around Pisa, where they are most numerous, all the eleventh-century *bacini* were Islamic imports: eighty-five percent from North Africa—by far the largest category—Spain, and Sicily and fifteen percent from Egypt.[5] Most twelfth-century imports came from Tunisia (see Fig. 2) and Spain. A *bacino* with an interlaced-star design (Fig. 89) exemplifies the thirteenth- and early-fourteenth-century Pisan maiolica that imitates compositions, motifs, and simple filling ornament of these imports.[6] Like most archaic maiolica, such Pisan ware is painted in the primitive green and brown of the earliest ones rather than in cobalt blue and brown, like most of those that began to arrive at the end of the twelfth century, such as the one shown in Figure 2.

The dish in Figure 90 illustrates the more ambitious green-and-brown archaic maiolica produced in Orvieto toward the end of the fourteenth century that drew upon traditional Islamic and European Gothic themes.[7] This example echoes an Islamic bird-and-leaf-tendril design common on Egyptian and Syrian pottery.[8] Like the Pisan maker of Figure 89, Orvieto craftsmen adopted some of the decorative conventions of western Mediterranean Islamic pottery: brown outlines filled with green brushstrokes and brown lines in parallel, cross-hatched (see Fig. 2), or scale-and-dot patterns. These Italian potters, however, emphasized their principal forms by using both heavier outlines than most Islamic potters and stronger contrasts between areas left in reserve or painted green and areas filled with tight linear ornament. One of the distinctive features of the Orvieto painting style is that figural and plant elements are often silhouetted against a trelliswork background more dense than the painting of the elements themselves, the reverse of traditional Islamic practice (see Figs. 91, 92). Most archaic maiolica was economically made with tin glazing only under the painted decoration, which is usually stiff. A few surviving pieces have coats of arms or other personalized ornament.[9] For a brief period around the mid–fourteenth century, some potters in Florence and other production centers farther north enriched their archaic wares with blue, the dominant color in contemporary Islamic ceramics, but did not advance their decorative repertory.[10]

From about the later fourteenth century until after 1450 the Italian elite imported their finest earthenware from Syria and Spain. Records of the Datini firm of Prato indicate the heavy involvement of Italian merchants in both the international Mediterranean ceramics trade and the local market. In 1384 the firm shipped twenty-three cases of ceramics, glass, and textiles from Beirut to Barcelona, which was also an export center for the luster- and blue-painted pottery of Málaga and Valencia. The firm also shipped earthenware from Syria and Egypt to Spain in 1388 and 1391. In 1401–1402 the firm arranged for a large shipment of "maiolica" by a Moorish potter in Manises to Venice through its agent in Valencia.[11] Damascus pottery is listed in a Datini family villa in 1395–1396, and in Florentine estate inventories of 1389, 1390, 1413, 1429, 1465 (that of Piero de' Medici listed three *albarelli* [spice jars] and three bowls), 1493 (a vase), and 1511 (two *albarelli*). In 1462 a shop in Florence was selling both Damascene and Florentine pottery, and in 1492 another shop had a great deal of earthenware from Damascus in stock.[12] The supply of Syrian pottery was interrupted at least temporarily after Timurid invaders sacked and burned Damascus in 1400–1401 and took many of the city's master craftsmen to Samarkand. Though some production had resumed there by 1430, the Syrian industry never fully recovered.[13] It is thus surprising that Syrian pottery was sold in Florence into the 1490s.

Although no Syrian earthenware with a documented fourteenth- or fifteenth-century Italian mainland provenance survives, an *albarello* usually dated in the first half of the fifteenth century (Fig. 91) has one unusual feature indicating that it was probably destined for Florence. It bears the Florentine lily, here a geometrically stylized version of the emblem as it appears on the reverse of Florence's gold coin, the florin. Apothecary symbols appear on some Syrian drug jars, but European family coats of arms are unknown.[14] Since the florin was abundant in Syria and Egypt, this jar was not necessarily made-to-order, even though it was probably produced for the Florentine market. The rest of the decoration, in underglaze cobalt blue and black with floral scrolls and flying birds in horizontal bands, is typical of Syrian wares inspired by Persian pottery and Chinese porcelain, though its painting is not of the highest quality. In the century before the Timurid invasion, Syrian potters produced

89 Bowl painted in green and brown (*bacino* from San Martino, Pisa, 1280–1330), Pisa, Italy, late thirteenth–early fourteenth century. Museo Nazionale di San Matteo, Pisa.

90 Dish painted in green and brown, Orvieto, Italy, fourteenth century. Victoria and Albert Museum, London (C. 202-1928).

91 Drug jar painted in blue, Damascus (?), Syria, first half of the fifteenth century. Musée des Arts Décoratifs, Paris (4288).

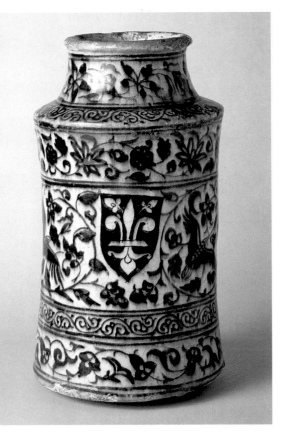

91

great quantities of *albarelli* and large ovoid vases with tra-
ditional animal, plant and epigraphic ornament painted
either in cobalt blue and black on white or in golden me-
tallic luster over a blue glaze.[15] The Sicilian provenance
of two magnificent ovoid vases in luster over blue in the
Victoria and Albert Museum proves that such wares were
exported to the West.[16] By the end of the fourteenth cen-
tury, however, a fashion for blue-and-white decoration in
the style of contemporary Ming porcelain had swept the
eastern Islamic world from Persia to Egypt.[17]

Bacini in Pisa that document the arrival of Spanish
tin-glazed pottery from the eleventh into the fourteenth
century include an early example of the golden luster-
ware for which Málaga, in the Muslim kingdom of Gra-
nada, became famous (see Fig. 44).[18] Italian imports
mounted after new potteries were established at Manises
in Christian-ruled Valencia, and especially after the Ti-
murid sack of Damascus. Valencian pottery is called
Hispano-Moresque because of its close ties to Islamic
tradition. For example, the jar in Figure 92 imitates the
ovoid shape and animal-and-plant-scroll decoration of
earlier Syrian examples but is executed in the refined
Malagan style of painting, with golden luster or luster
and blue on white.[19] The jar's light and airy scrolls of
leaves and blossoms are characteristic of the Hispano-
Moresque wares. Historical evidence suggests that the
de Buyl family, landlords of Manises, encouraged Muslim
craftsmen to leave increasingly unstable Granada and re-
settle on their lands during the 1350s and 1360s, and that
the de Buyl also used their positions as courtiers and
diplomats to promote the pottery—from which they
received ten percent of sales. The proximity of Manises
to Valencia, long a convenient port for Spanish trade
with Christian Europe, also contributed to the phenome-
nally rapid international success of Manises pottery.
Furthermore, early contracts between Italian merchants
and Manises potters show that vessels could be custom
ordered, a marketing inducement undoubtedly made
convenient through Valencian branches of several Flor-
entine commercial houses, such as the Datini.

Italian pharmacies commonly used *albarelli* and ovoid
vases like those in Figures 91 and 92 as storage containers.
An inventory of a Florentine pharmacy of 1424 lists "a
tall Damascene or maiolica spice jar," indicating that Flor-
entines were familiar with Syrian and Valencian luster-

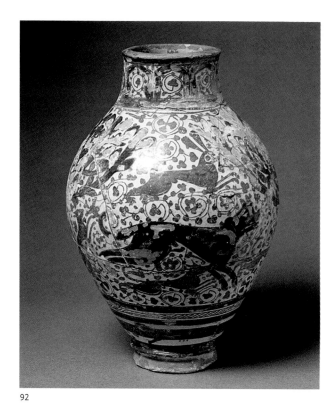

92

ware and considered them similar.[20] In 1420 a Milanese
merchant ordered a potter in Manises to make 720 "Dam-
ascene and golden luster" jars to match a presumably
older Syrian model; the quantity suggests that he was
supplying a hospital.[21] In this and some fifteenth-century
Florentine documents, the term "Damascene" implies
blue-and-white ware, so it probably had a range of
meanings—from various styles of pottery made in Da-
mascus or imported from Mamluk Syria and Egypt to
Islamic-style blue-and-white pottery in general.[22] The
style of early-fifteenth-century Florentine pharmacy jars
reflects the highly esteemed Syrian containers as well as
Spanish versions of them.

The first Italian ware made in conscious competition,
artistically and commercially, with imports was made
principally for pharmacies, but also as tableware, in and
near Florence during the first half of the fifteenth cen-
tury. Indeed, one of the largest orders the Hospital
of Santa Maria Nuova in Florence placed with a local
potter—for 588 vessels in 1426/27—specified a Dama-
scene style. Most surviving pieces are two-handled jars
or pitchers with animal and leaf designs in dark cobalt

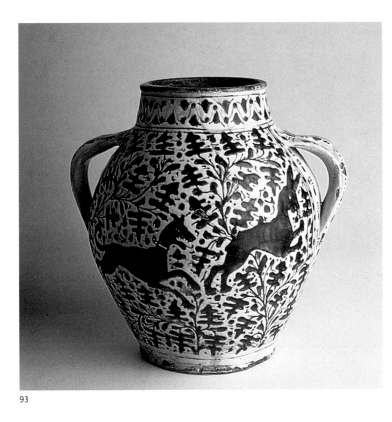

92 Jar painted in golden luster and blue, Spain, early fifteenth century. Instituto de Valencia de Don Juan, Madrid.

93 Jar painted in relief blue with the emblem of the Hospital of Santa Maria Nuova on the handles, Florence, second quarter of the fifteenth century. Gemeentemuseum, The Hague (OC-1933-0005).

93

blue on white. Some, like that in Figure 93, bear the emblem of Santa Maria Nuova, a green crutch, on their handles; others bear the mark, three asterisks, of the potter Giunta di Tugio, whose workshop made about a thousand vessels for the same hospital in 1430/31.[23] It is the first "signed" European pottery. The ware is called *zaffera,* the Italian word for the Asian cobalt in the pigment; or oak-leaf, after the stylized serrated leaves filling the background; or relief-blue, after the texture of the finish. The potters used an impure cobalt that rose from the tin-glazed body during firing, giving the vessels a rough but attractive finish. Cobalt has a tendency to move during firing, and the fine manganese purple outlines that Florentine potters used to stabilize it are analogous to the black outlines on Syrian ceramics painted with blue.[24] The oak-leaf motif, inherited from archaic maiolica,[25] has a different filling and framing function in *zaffera*'s painted compositions. The example in Figure 93 also shows a new sensitivity to contrasts and interpenetrations between the dark blue leaf forms and bright white background that relates to Islamic ceramics. The favorite central animal was a rampant lion, the emblematic Floren-

tine *marzocco,* but otherwise the birds, ducks, hares, fish, dogs, and leopards ultimately derive from Islamic art, appearing in similar poses and actions on Syrian pottery and metalwork. Original to the *zaffera* style are the fresh drawing of the animals, the spontaneous character of their movements, and the naturalistically haphazard spring of stylized leaves from their stems.

Because Italian textiles and archaic maiolica had previously absorbed the Islamic animal repertory, and because archaic maiolica and *zaffera* showed continuities in shape and other motifs—such as the oak leaf, heraldic emblems, and Gothic harpies—some scholars argue that *zaffera*'s dependence on Oriental ceramic models has been exaggerated.[26] Nevertheless, the quality and style of the *zaffera* decoration were new in Italian pottery, undeniably emulating contemporary Syrian and Hispano-Moresque imports in color and composition. For example, the composition on the *zaffera* jar in Figure 93 so closely resembles the one on the Syrian-inspired Valencian lusterware jar in Figure 92 that an imported model must have been used. Both the documents on *zaffera* ware and its style indicate response to a rapidly increasing demand for

94 Drug jar painted in blue, Florence, mid–fifteenth century. Victoria and Albert Museum, London (47-1907).

95 Drug jar painted in blue, Valencia, Spain, first half of the fifteenth century. Victoria and Albert Museum, London (488-1864).

96 Flower vase painted in golden luster and blue, with insignia of the Medici family, Valencia, Spain, ca. 1465–1475. British Museum, London (MLA Godman, G619).

97 Flower vase painted in blue and yellow, with the arms of the Medici and Orsini families, Florence, ca. 1470. The Detroit Institute of Arts (37.74).

94 95

pottery more sophisticated than archaic maiolica. The huge quantities of Valencian and *zaffera* vessels ordered by Italian hospitals and apothecaries suggest the sale of drugs and spices in such containers and underscore the role of pharmacies in spreading a taste for Oriental-style ceramics. While the quality of the decoration on *zaffera* declined after about 1435 and the use of green increased, the late pieces adopt more Islamic shapes and Hispano-Moresque painting conventions.[27]

Meanwhile, Italian demand for ceramics from Manises and offshoot production centers soared. The large body of surviving Valencian lusterware with European coats of arms (see Figs. 96, 98), religious inscriptions, or other emblems testifies to the tremendous appeal of personalized ceramic objects. Though these imports cost considerably more than local products, by the second decade of the fifteenth century Italian families bought whole services for display, a use paintings indicate was common by the 1480s.[28] For example, in Filippino Lippi's *Annunciation* in San Gimignano (see Fig. 5), 1482, three accurately depicted containers with the vine-leaf-and-stem pattern in cobalt blue and golden luster decorate shelves in the Virgin's chamber: an *albarello,* a wing-handled vase, and a footed pitcher; tightly tied covers (customarily of parchment) indicate that they contained spices or aromatics. Matched sets of Valencian plates and vases (or ewers) are set out on a table before guests at a wedding feast in a painting by Sandro Botticelli, Jacopo del Sellaio, and Bartolommeo di Giovanni that commemorates the marriage of Gianozzo Pucci to Lucrezia Bini in 1482.[29] About this time, Italian tin-glazed earthenware began to compete with the imports, but some of the very rich continued to prefer Valencian lusterware for their city palaces and used locally made pottery at their more informal country villas.[30]

About 1450, when Valencian lusterware was pouring through Pisa and Venice, potters in Florence and Faenza, the most innovative Italian production centers at the time, began to imitate its distinctive decoration in domestic and pharmacy wares.[31] Several Florentine examples illustrate the range in styles and types of objects. *Albarelli* in the traditional Islamic slender tapered shape, but smaller than the finest imports, were in great demand. Italians usually used only blue on *albarelli* with horizontal bands, drawing upon the extensive Hispano-Moresque repertory

96

97

of plant, geometric, and epigraphic motifs. The Floren-
tine potter who made the typical example shown in Fig-
ure 94 certainly had Valencian models in view for the
scroll of stylized leaves circling its waist,[32] the three bands
with imitation cursive Arabic script above and below its
shoulder, and the imitation *alafia* pattern at the bottom.[33]
Valencian potters frequently combined this pattern,
which is based on the Arabic word for "providence" or
"blessing," with bands of script, as on a blue-and-white
albarello from the first half of the fifteenth century (Fig.
95).[34] Another Florentine example (see Fig. 6) illustrates
the stout Italian version of the drug jar and the popular
ivy-leaf decoration, in which manganese purple substi-
tutes for metallic luster, which was not yet known in
Italy.[35] The alternating blue and purple leaves emulate
the shifting colors of Hispano-Moresque blue and golden
luster but cannot reproduce its fascinating changing re-
flections (see Fig. 4). Though the Florentine potter imi-
tated the Hispano-Moresque motifs in detail—ivy leaves
with incised veins, and stems with curling tendrils—he

did not comprehend the delicate balance of painted and
incised elements with each other and with the white
background.

One of the most elaborate personalized Valencian
showpieces is a large flower vase with winged handles,
in the style of the monumental "Alhambra vases," and a
pedestal foot (Fig. 96; see Fig. 44). The side illustrated in
Figure 96 features a Medici emblem, a diamond ring and
two feathers symbolizing eternity; the coat of arms on
the other side shows both the Medici balls and the lily
that Louis XI of France granted to Piero de' Medici in
1465. Since the style of the vase is datable about 1465–
1475, Piero (d. 1469) or his son Lorenzo must have com-
missioned it.[36] In Italy these vases graced altars and
shrines as well as private chambers (see Fig. 5), and docu-
ments indicate that the Medici displayed their Valencia
ware in festival decorations.[37] A Florentine imitation (Fig.
97) that bears combined Medici and Orsini arms was
probably made for the nuptials of Lorenzo and Clarice
Orsini in 1469.[38] It is decorated in the popular bryony

pattern (Fig. 98), with blossoms and leaves in blue and tendrils in orange-yellow that substitutes for luster. This was one of the standardized Valencian patterns developed toward 1450 that were well suited to the European export market.[39] Their small, airy floral repeats created resonating backgrounds for coats of arms and other emblems, and the patterns could be easily produced in quantity to meet demand. The arms of at least fifteen famous Italian families, such as the Guasconi of Florence (Fig. 98), have been identified on surviving examples.[40] The popularity of Valencia ware among the Italian elite enhanced the prestige of its style of ornament and fostered a taste for exotic display pieces.

During the half century, beginning about 1470, when the creative development of artistic maiolica occurred with phenomenal rapidity, Italian potters constantly drew inspiration from Oriental imports as well as other Italian art media. A vase made in Faenza about 1470–1480 (Fig. 99) illustrates the common adaptation of Hispano-Moresque floral ornament to fill sections of the composition and surround figured designs.[41] This vase also shows an Islamic painting convention that Florentine and Faenza potters adopted without modification: the contour panel, a reserved area that frames and follows the contours of figures and focal points, separating them from the background decoration. Persian in origin, contour panels are common on fourteenth-century Syrian ceramics, from which earlier Italian versions on Florentine *zaffera* ware probably derive.[42]

The "Persian palmette" motif on the deep sides of a bowl made in Tuscany or Faenza about 1490–1500 (Fig. 100) was probably inspired by alternating palmettes and rosettes (see Figs. 25, 27) and stylized forms (see Fig. 31) on fourteenth-century Oriental textiles, or Italian versions of them (see Fig. 30).[43] Faenza potters adapting these forms as border decoration gave them the aspect of pinecones seen in alternating vertical and horizontal sections, with spectacular chromatic shadings and contrasts. The transformed motifs were quickly adopted in Florentine ceramics. The development of color by Italian potters in this borrowed motif parallels the earlier development of texture in Oriental ogival and vertical stem patterns by Italian velvet weavers (see Figs. 39, 40), demonstrating how the sensitivity of craftsmen to the possibilities of their media contributed to the originality of Renaissance decorative arts.

98

99

Islamic geometric arabesques entered the Italian ceramic repertory about 1500 from a variety of sources. The two traditional Islamic types—interlacing bands or ribbons (strapwork) and lines (knots)—appear on Italian pottery as border or sectional ornament or as the principal design.[44] Though potters may have seen similar arabesques on fourteenth- and early-fifteenth-century Spanish ceramics, their immediate sources of inspiration must have been contemporary Italian books and prints and popular imported Islamic metalwork. Similar ornament distinguished the new Italian luxury gold-tooled leather bindings of the 1460s and 1470s (see Figs. 133, 135, 137) and related manuscript illuminations and early printed illustrations.[45] A plate probably made in Siena about 1525 (Fig. 101) derives its composition from prints—a common source for Renaissance ceramic decoration—after Leonardo da Vinci's endless knot designs, either the series of six copper engravings signed Accademia Leonardi (Fig. 102) or the woodcut copies Albrecht Dürer made during a visit to Venice in 1505–1506.[46] Moreover, this potter seems also to have studied Leonardo's presumed sources: fascinatingly intricate and perfectly balanced strapwork arabesques on Syrian inlaid metalwork, imported in large quantities through Venice during the late fifteenth century, such as the spherical incense burner in Figure 103.[47] The colors of his painted design, yellow against red, green, and black, reproduce the visual effects of bright silver inlay on a warm brass background, accentuated by black infilling. During the second quarter of the sixteenth century, prints and illustrated books of embroidery designs further popularized geometric and floral arabesque ornament in Europe, and Italian artists, including potters, often combined it with antique-inspired grotesques.[48] In 1557 Piccolpasso noted that knots were "a common fashion."[49]

When luster painting finally arrived in Italy, it became the specialty of the Umbrian pottery centers of Gubbio, perhaps from the 1480s, and Deruta, from about 1490; in 1498 a Deruta potter claimed that his lusterware had an international market.[50] It is not known how the metallic luster technique arrived, whether through Spanish émigrés, Italian spies, or independent experiments, but the distinctive Italian colors and visual effects suggest different recipes.[51] A large dish with an emblematic female figure holding a crowned toad and a cornucopia (Fig. 104) exemplifies the historiated Renaissance maiolica pro-

98 Serving plate painted in golden luster and blue, with the arms of the Guasconi family of Florence, Valencia, Spain, second half of the fifteenth century. Hispanic Society of America, New York (E 627).

99 Jar with polychrome painted decoration, Faenza, Italy, ca. 1470–1480. Victoria and Albert Museum, London (8389-1863).

100 Bowl with polychrome painted decoration, Tuscany or Faenza, ca. 1490–1500. National Gallery of Art, Washington, Widener Collection (1942.9.316 [C-41]).

100

101

101 Plate with polychrome painted decoration, Siena, ca. 1525. Rijksmuseum, Amsterdam (NM 13136).

102 After Leonardo da Vinci, *Fifth Knot*, engraving, ca. 1490–1500, detail. British Museum, London (P&D 1877-1-13-366).

103 Incense burner, brass incised and inlaid with silver, Syria, late fifteenth–early sixteenth century. Freer Gallery of Art, Washington (39.58).

duced in Deruta about 1510–1540 that was intended for display: two holes punched in the foot ring before firing permit it to hang correctly on a wall.[52] Brassy yellow luster is applied on elements already painted in blue to produce iridescent effects ranging from vivid beetle green to violet. Though Deruta potters inherited their characteristic radiating segmental border and some of its ornamental motifs, such as the scale-and-dot pattern in the three widest sections of Figure 104, from early-fifteenth-century Hispano-Moresque and medieval Islamic ceramics, their showpiece lusterware has its own style.

The prestige and scarcity of Chinese porcelain in Italy invited imitation. The few pieces that arrived during the fifteenth century were truly princely possessions. Mamluk sultans presented them as diplomatic gifts to doges of Venice from 1442 onward, and to Lorenzo de' Medici in 1487.[53] The Medici had the largest porcelain collection in Italy, growing from a few pieces owned by Piero in 1456 and 1463 to more than fifty at Lorenzo's death in 1492. Mostly blue-and-white but also plain white and monochrome green celadon, they were valued at more than 240 florins and kept in a cupboard in Lorenzo's bedchamber.[54] By 1475 the richest Italians were avidly seeking porcelain in Venice.[55] During the late fifteenth and early sixteenth century demand for it so exceeded supply that even Filippo Strozzi of Florence and Duke Ercole I d'Este of Ferrara bought "Damascene porcelain" and "counterfeit porcelain," probably meaning Islamic blue-and-white

102

103

earthenware in a Chinese style and Venetian opaque white glass.[56] "Porcelain" objects mentioned in documents of this period thus may not all have been Chinese.

No pieces of Chinese blue-and-white porcelain documented on the Italian mainland before the 1550s survive,[57] and paintings reveal little about the models available to earlier Italian potters. The earliest representation is a small bowl of the early-fifteenth-century lotus seed-pod type in a *Madonna and Child,* about 1460–1470, by the Veronese painter Francesco Benaglio, in the National Gallery of Art, Washington. An order of 1475 by Filippo Strozzi for small porcelain bowls, both plain white and decorated with blue leaves, indicates that Italians were familiar with the two versions of the early Ming dynasty type.[58] The atypical blue decoration on Benaglio's bowl suggests that his depiction is inaccurate or his model was an Islamic imitation, perhaps both.[59] In Andrea Mantegna's *Adoration of the Magi,* about 1495–1505, in the J. Paul Getty Museum, Los Angeles, one of the Magi offers the child gold coins in a small cup decorated in blue with the stems of flowers and leaves. The motif recalls flower scrolls on early-fifteenth-century Ming blue-and-white, such as the dish in Figure 105, but Mantegna may have altered the cup's shape and decoration to fit the Magus's grasp.[60]

The earliest certain Italian representations of Chinese porcelain are the two large bowls in Giovanni Bellini's *Feast of the Gods,* 1514 (Fig. 106). The similar shallow dish with attached European-style handles in the same painting is not described clearly enough for identification. The large, densely painted palmettes and blossoms framed by leaf scrolls and tendrils on Bellini's bowls correspond to the decoration of a late-fifteenth- and early-sixteenth-century Ming type that was exported in large quantities to Persia, Syria, and Egypt. Examples survive in both the depicted shapes: with tapering sides and a flared rim, and with steeper sides and a plain rim, like those of the bowl in Figure 107.[61] Bellini executed *The Feast of the Gods* for Duke Alfonso I d'Este, who tried to engage a Venetian to imitate porcelain in Ferrara in 1514, the same year in which he paid for the finished painting.[62] The d'Este certainly owned "counterfeit porcelain," that ordered by Ercole in 1504 and a sample bowl and plate sent to Alfonso by the Venetian imitator in 1514, but there is no record of their possessing Chinese porcelain

104

105

104 Display dish with luster and polychrome painted decoration, Deruta, Italy, ca. 1510–1540. National Gallery of Art, Washington, Widener Collection (1942.9.317 [C-42]).

105 Dish, blue-and-white porcelain, China, early fifteenth century. Asian Art Museum of San Francisco, The Avery Brundage Collection (B69 P5L, The Roy Leventritt Collection).

at this time. It seems likely that Alfonso, who was an exacting patron involved in the details of his commissions, suggested to Bellini that porcelain would be appropriate for the ideal feast, and that Bellini found models in Venice such as the diplomatic gifts from Mamluk sultans to Doge Barbarigo in 1490 and to the Signoria in 1498 and 1508.[63]

Italian potters responded creatively to the beauty of Ming blue-and-white and the demand for imitation porcelain with their own maiolica *alla porcellana*. Large quantities of earthenware with blue floral scrolls and sprays on a bright white background were produced in Faenza from about 1490, in Tuscany from about 1500, and soon after in Venice, where blue-and-white predominated through the sixteenth century.[64] Rarely merely imitative, Italian potters preferred to blend Chinese-inspired floral patterns with other ornament, creating variations that prolonged the life of the style and enabled it to compete with both Chinese imports and Renaissance historiated polychrome maiolica. Like other maiolica styles, *alla porcellana* spread because of the movement of craftsmen as well as objects. Some of the earliest pieces made in Faenza show that potters there were looking at the same contemporary Chinese imports as Giovanni Bellini.[65] In the floral scroll on the rim of a plate made in Siena about 1510 (Fig. 108), a Master Benedetto, who had emigrated from Faenza before 1503, freely blended this contemporary Ming ornament (see Fig. 107) and earlier floral scrolls (Fig. 105).[66] In the center he combined the idea of Chinese blue-and-white with Islamic strapwork and a Renaissance representation of Saint Jerome in the wilderness, where white highlights enrich the monochrome blue. In the early sixteenth century decoration *alla porcellana* commonly appeared on the backs as well as the fronts of maiolica from the prolific potteries at Montelupo in Tuscany and into the 1570s on the elite maiolica produced in a factory established by 1498 on Medici family property at Cafaggiolo with craftsmen from Montelupo. The numerous *alla porcellana* patterns in the small Cafaggiolo production bear witness to the style's popularity and exemplify its range, from close imitation of early-fifteenth-century Ming floral scrolls such as those in Figure 105 to imaginative blends of Chinese with Islamic, Ottoman, and Renaissance ornament.[67]

A characteristic Venetian maiolica of the first half of the sixteenth century is *berettino* ware, developed in Faenza, in which a little cobalt blue added to the thick

106

107

106 Giovanni Bellini, detail of *The Feast of the Gods*, 1514. National Gallery of Art, Washington, Widener Collection.

107 Bowl, blue-and-white porcelain, China, late fifteenth–early sixteenth century. Topkapi Sarayi Muzesi, Istanbul (15/9324).

108

109

110

white enamel produces a gray to lavender-blue background for the painted decoration, usually executed only in blue but sometimes also with white highlights and accents in other colors. The earliest dated Venetian example, a plate (Fig. 109) commissioned for a wedding in Augsburg in 1515, is one of many inspired by Chinese lotus designs such as that in Figure 105.[68] By the 1540s, when production flourished, the influence of contemporary Ottoman ornament is apparent. Floral arabesques in the Ottoman court style used in many media (see, for example, Figs. 138, 146) fill the center of a dish dated 1543 from the workshop of Jacopo da Pesaro (Fig. 110).[69] Venetian potters used Ottoman-style *rabesche* (arabesques of flowers, leaves, and stems) to decorate the bottoms of plates, as well as to frame and fill the front designs, and juggled the Oriental cobalt blue and white colors between the background and painted decoration. A letter of 1550 from Cosimo de' Medici's Venetian agent to Eleonora di Toledo illustrates that the contemporary definition of *alla porcellana* was broad: the agent reported that two kinds of pottery were made in Venice, "one with many colors, the other without, but both closely resemble porcelain."[70]

A technically and visually unique earthenware was developed in the late fifteenth century in Ottoman Turkey. Called Iznikware after its principal place of manufacture, it had a hard white frit-paste (fine clay) body that could be thin and elegant, a smooth white slip

108 Plate painted in blue-and-white *alla porcellana*, signed by Master Benedetto, Siena, ca. 1510. Victoria and Albert Museum, London (4487-1858).

109 Plate painted in blue-and-white *alla porcellana* with the arms of the Lamparter von Greiffenstein and Meuting families of Augsburg, Venice, 1515. Museum für Kunsthandwerk, Frankfurt am Main (6875).

110 Dish painted in blue on a tinted background, workshop of Jacopo da Pesaro, Venice, 1543. Victoria and Albert Museum, London (8389-1863).

111

112

111 Plate painted in the *tugra* spiral style, Iznik, Turkey, ca. 1535–1545. Ashmolean Museum, Oxford (X. 3274).

112 Drug jar with Ottoman-style painted decoration, Liguria (Genoa or Savona ?), ca. 1575. British Museum, London (MLA 1990, 5-2, 1).

113 Plate with Ottoman-style polychrome decoration, Padua, 1633. Musée National de Céramique, Sèvres (4617).

114 Plate with polychrome painted decoration, Iznik, Turkey, last quarter of the sixteenth century. Staatliche Museen zu Berlin–Preussischer Kulturbesitz, Kunstgewerbemuseum, Berlin (82/130).

under clearly drawn, brilliantly colored designs, and a pellucid, even glaze. No early-sixteenth-century notices of Ottoman pottery in Italy have yet come to light, but the "imitation porcelain" then available in Venice could have included Iznikware with Chinese-style shapes and blue-and-white decoration. The two Iznik patterns that late-sixteenth- and early-seventeenth-century Italian potters imitated most closely were new, indicating that Italians particularly admired original elements of Ottoman ceramics.

An Iznikware plate of about 1535–1545 (Fig. 111) illustrates an Ottoman pattern in cobalt blue on white that seems to be reflected in Venetian *alla porcellana* by the 1540s and was imitated in Liguria by the 1570s (Fig. 112);[71] it is also one of the few surviving early Iznik pieces adopting a distinctively Italian shape. In this and a similar plate, the broad flat rim of the Italian *tondino* provides a congenial compositional field for the spiral scrolls of the new pattern.[72] Traditionally known as the Golden Horn style, the pattern is currently called the *tugra* spiral style because of its affinity to the background of the imperial monogram (*tugra*) of Sultan Suleyman the Magnificent, invented at the court scriptorium and datable 1526–1532.[73] The ceramic design, originally only in blue but

later accented with other colors, consists of thin, concentrically scrolling stems that sprout tiny stylized leaves and blossoms at regular intervals in a set sequence. Like the typical Ligurian piece in Figure 112,[74] the Italian imitations ignore the regular sequence of stem ornaments, and several are in the old Islamic *albarello* shape for which there are no Ottoman examples. The imitations produced in Savona and perhaps other nearby centers are usually assigned to the 1570s because one example is dated 1572, but some excavated fragments may date from the 1540s, and a Cafaggiolo *albarello* that was probably inspired by the Ligurian imitations is dated 1566.[75]

European imports of Iznikware seem to have increased as a result of improved commercial and diplomatic contacts following the battle of Lepanto in 1571. The only surviving personalized pieces commissioned by Europeans date from about 1575; these include thirteen pieces, ten in the *tondino* shape, from a dinner service bearing a coat of arms that is probably Italo-Dalmatian.[76] Between 1573 and 1577, the Hapsburg ambassador in Istanbul sent 100 ducats' worth of Iznik tiles to Venice, and in 1577 he recommended them to the bishop of Salzburg, Wolf Dietrich von Raitenau.[77] A Venetian inventory of 1587 lists thirty pieces of "maiolica from Constantinople."[78] Polychrome Iznikware in the style of the Italo-Dalmatian dinner service was so admired in the region around Venice that it was copied almost to the point of counterfeit in Padua from at least 1601 to 1697, dates appearing on surviving examples. This large production acquired the name Candian ware (from the island of Candia) through misinterpretation of the inscription "S. Chandiana 1633" on the bottom of the plate in Figure 113.[79] The Iznikware models feature naturalistically described bunches of tulips, carnations, roses, hyacinths, and other flowers gracefully springing from tufts of leaves. An example such as Figure 114, with a distinctive Ottoman motif, a long feathery *saz* leaf, in the center of the bouquet, was imitated in Figure 113.[80] Because the controlled naturalism and brilliant colors of this style of Iznikware were completely consistent with Italian Renaissance taste, Paduan potters copied all but the distinctively Ottoman crimson red, which they replaced with brownish orange, lacking the Armenian bole from which the red was made.

The Medici grand dukes epitomize Italy's continuing

113

114

fascination with exotic ceramics. Cosimo I (r. 1537–74) increased his collection of Chinese porcelain from the eighty-seven pieces inventoried in 1531 to nearly four hundred by 1553, acquiring one hundred twenty new pieces, mostly blue-and-white, in the year 1547 alone. By about 1590, under Ferdinand I (r. 1587–1609), the collection surpassed one thousand pieces.[81] In the 1550s Cosimo I initiated an effort to manufacture porcelain in palace workshops that was far more sustained and successful than other Italian attempts. Documents report several earlier claims of success by Venetian glassmakers and recount that an alchemist from a family of potters in Castel Durante produced a few pieces of porcelain in Ferrara for Duke Alfonso II d'Este between 1561/62 and 1567; the d'Este family's experiments ended shortly after the craftsman's death, and nothing survives of his work.[82] Cosimo's son Francesco, intrigued by nature's wonders and the processes of discovering and replicating them, built new workshops in the Boboli Gardens and Casino di San Marco, where he worked alongside lapidaries, potters, and alchemists trying to make rock crystal and porcelain. In the 1568 edition of his *Lives of the Most Famous Painters, Sculptors, and Architects,* Giorgio Vasari predicted that his pupil Bernardo Buontalenti, director

of the workshops, would soon be producing porcelain vessels. But success came only in 1575, shortly after Francesco became grand duke (Francesco I, r. 1574–87), when the Venetian ambassador Andrea Grissoni reported that after a decade of effort Francesco had produced "Indian porcelain" with the help of a "Levantine." The following year several large pieces were shown to the d'Estes' ambassador. Some seventy pieces of "Medici porcelain" survive. Most were made at the Casino di San Marco during Francesco's lifetime, but production continued sporadically at factories at Cafaggiolo and Pisa under Ferdinand I and Cosimo II (r. 1609–20).[83]

Recent technical analysis of Medici porcelain supports Ambassador Grissoni's report of Oriental expertise and suggests a connection with Iznikware.[84] The Medici produced a soft-paste porcelain, different in composition and fired at lower temperatures than true, or hard-paste, porcelain. Both Iznik fine white frit-paste pottery and Medici soft-paste porcelain have a high silica content, obtained by mixing quartz or sand with clay, which distinguishes them from regular earthenware. Turkey was then the closest and largest producer of wares in the originally Persian frit-paste technique. Peculiar to Medici porcelain is the clay, from Vicenza, which contains some kaolin, an essential ingredient in true Chinese porcelain.[85] The only additional information on Francesco's advisor comes from a late-eighteenth-century source that describes him as a Greek who had traveled in the Indies, a notice which is too distant and too much like a garbled version of the Venetian ambassador's report to be reliable.[86] Nonetheless, a suggested connection with "earthenware from Saloniki resembling porcelain" listed in contemporary Medici inventories merits further study. Two large Ottoman jars (Fig. 115 is one), decorated in the wheat-sheaf style that inspired numerous pieces of Medici porcelain, have a unique shape and a pitted, uneven glaze uncharacteristic of Iznik products.[87] Their shape could be the *kupa* known only from the "*kupa* from Salonike" (kupa-i Selânik) listed in the inventory of the royal palace in Istanbul of 1555/56; their glaze could indicate such a secondary production center.

The style of Medici soft-paste porcelain is eclectic and emphatically exotic. Both the shapes and the decoration vary tremendously, but most pieces blend Chinese, Islamic—predominantly Iznik—and Italian Renaissance elements, and Oriental-inspired floral sprigs and scrolls are the most common ornaments. A flask (Fig. 116)[88] exemplifies the group inspired by the wheat-sheaf–style Iznikware of the last quarter of the sixteenth century (see Fig. 115). The Medici craftsmen adopted the style's bold scrolls of large, fleshy peony blossoms and palmettes and elongated lotus palmettes but ignored the spiky wheat-sheaf motif, an Ottoman invention, after which the style is now named.[89] The technical faults of almost all the surviving Medici production did not mar the family's pride in their wondrous achievement. Francesco presented at least twenty pieces to the d'Este of Ferrara and King Philip II of Spain, rulers of discerning taste.[90] The bases of most pieces are conspicuously marked with the letter "F" and a recognizable rendition of Brunelleschi's dome on the cathedral of Florence, regarded locally as the first artistic miracle of the Renaissance.[91]

When the demand for more artistic pottery began to rise, Italian craftsmen first turned to recent Syrian and contemporary Spanish imports for inspiration. The rapid development of polychrome and figured decoration resulted in an earlier and more marked departure from the models than had occurred in textiles. Still, some Islamic shapes, ornament, and the luster technique were retained, and orientalizing styles emerged to compete with Chinese porcelain and Iznikware. Princely taste for imported ceramics, epitomized by the Medicis' acquisition of Valencia ware and porcelain and their patronage of imitations, certainly promoted continuing interest in new Oriental ceramic styles.

The chapters that follow look at the role of elite taste in Italian glass, bookbinding, and metalwork. Like ceramics, glass developed rapidly during the last decades of the fifteenth century after centuries of slow improvement, but technological innovations soon led to a complete break with Islamic tradition.

116

115 Jar painted in the wheat-sheaf style, Turkey (?), ca. 1575–1580. Victoria and Albert Museum, London (627-1902).

116 Flask, Medici blue-and-white soft-paste porcelain, Florence, ca. 1575–1587. National Gallery of Art, Washington, Widener Collection (1942.9.354).

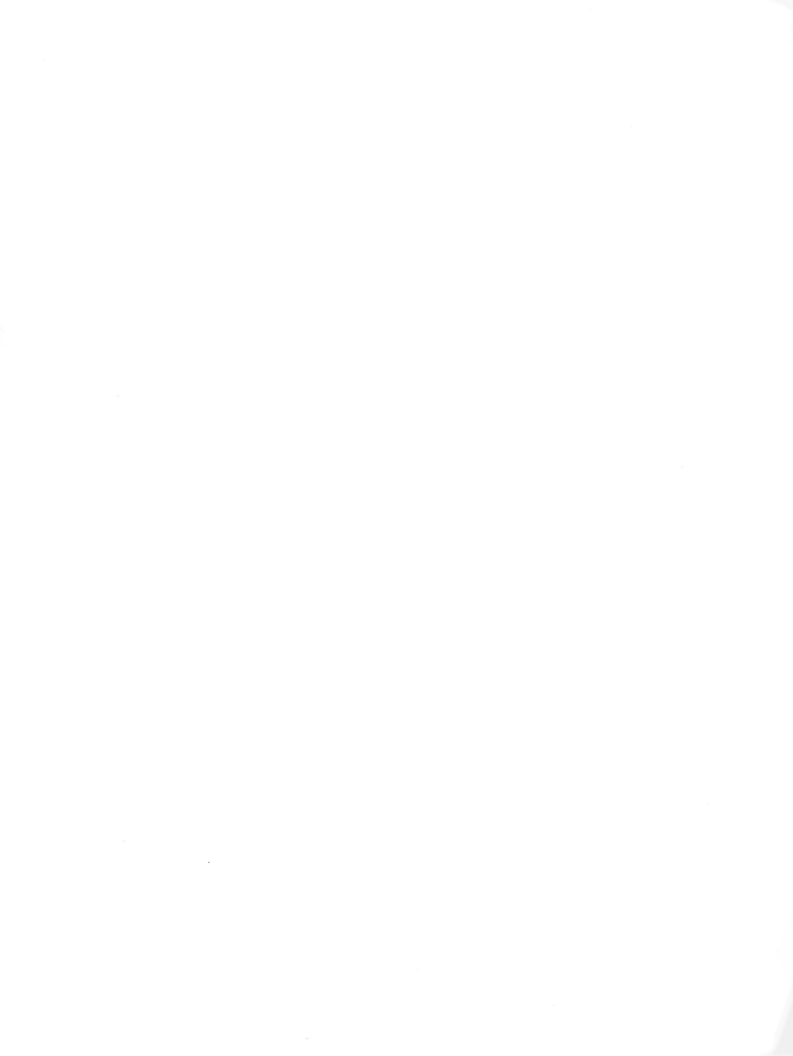

▪▪▪▪▪▪▪▪▪▪▪▪▪▪▪▪▪▪▪▪▪▪▪▪▪▪▪▪▪▪▪▪▪▪▪▪▪▪▪ ▪ ▪ ▪

GLASS

UNLIKE THEIR COMPATRIOT WEAVERS AND POTTERS, Venetian glassmakers had virtually no foreign or Italian industrial competition during their period of rapid development, beginning about 1460. The Syrian industry, which had been the world leader for two hundred years, suffered from technological stagnation in the late fourteenth century and never recovered from the Timurid devastation of 1401, when the glass furnaces of Damascus were burned and master craftsmen taken to Samarkand.[1] The contemporary Barcelona industry had a later start than Venice and did not develop apace.[2] Protectionist legislation in force since 1300 effectively confined the Venetian industry's secrets to the island of Murano until the mid–sixteenth century.[3] As a result, there was no superior contemporary artistic glass to stimulate or limit the imagination of Venetian glassmakers. Until its invention of crystal changed the art about 1550, the Murano industry continued to develop techniques and decorative styles inherited from Byzantine and Syrian glass, of which fine examples had become rare collectors' items, and increasingly explored new directions suggested by technical experiments and its own tradition of imitating gems. Venetian glassmakers also adapted some ornament from contemporary maiolica and responded ingeniously to the passion of the Italian elite for porcelain and "antique" artifacts, many of which came from the East. The impact of Oriental luxury trade on Renaissance Venetian glass was brief but potent.

By 1300 Venetian glassmaking had developed from obscure beginnings into a profitable industry that merited protection. It is not known how much of the ancient Roman glassmaking tradition survived in the northern Adriatic.[4] There is documentary evidence of glassblowing in Venice before the Crusades, and Byzantine craftsmen employed in the mosaic decoration of Saint Mark's from 1078 certainly contributed to local expertise.[5] In addition, Venice had access to alkali, an essential ingredient, from Syria and to the Syrian glass industry through its merchant colonies in the crusader states. A treaty of 1277 between Doge Giacomo Contarini and Bohemond VII, prince of Antioch, mentions duties on broken glass loaded at Tripoli that served as raw material in Venice.[6] Production and markets were varied by the end of the Crusades: "water-bottles and scent flasks and other such graceful objects of glass" were proudly borne in the inaugural procession for Doge Lorenzo Tiepolo in 1268, the Polo brothers opened the Oriental market for Venetian glass beads in jewel-like colors in the 1260s, and by 1275 German merchants were carrying Venetian glass beyond the Alps.[7] On November 8, 1291, the Great Council of the Venetian Republic decreed the removal of all glassmaking furnaces to the island of Murano, where many glassblowers lived, to contain a dangerous source of fires. The new isolated location also safeguarded technical secrets and facilitated the enforcement of other laws passed between 1271 and 1303 to regulate production and marketing and prohibit the emigration of craftsmen and the export of raw materials.[8] A secret worth protecting was the knowledge of two Syrian techniques: for making colorless glass and for painting it with enamel

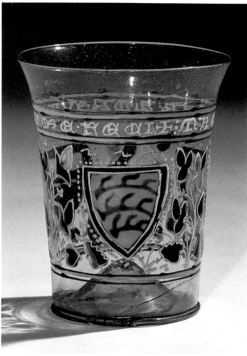

117

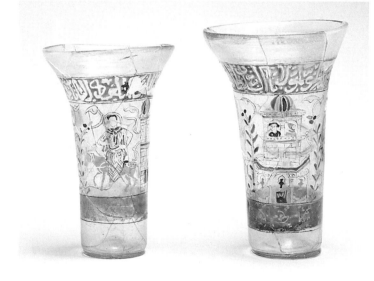

118

117 Beaker signed by Magister Aldrevandin, enameled colorless grayish glass, Venice, early fourteenth century. British Museum, London (MLA 1876.11-4.3).

118 Pair of beakers, enameled and gilt colorless honey-tinted glass, Syria, ca. 1260. The Walters Art Museum, Baltimore (47.18 and 47.17).

119 Bowl, enameled and gilt dark red glass, Byzantium, ca. eleventh–twelfth century. Treasury of Saint Mark's, Venice (109).

colors. Fragments of undecorated colorless glass excavated in thirteenth- and fourteenth-century contexts near Venice, a late-thirteenth-century treatise describing the use of decolorizers imported from Spain, and a decree of April 1300 prohibiting trade in imitation rock crystal suggest that glassblowers had begun to compete with the *cristalleri* (or *cristallai*), who made eyeglasses and other objects in clear rock crystal.[9] Venetian documents mention painters of drinking glasses from 1280 to 1351, and a fragment of their work has recently been found in Venice itself.

The earliest surviving Venetian colorless enameled glass, the "Aldrevandin group" of the late thirteenth and the fourteenth century consisting mainly of drinking glasses, is closely related to Islamic Syrian glass. Indeed, the object after which the group is named, a beaker bearing the Latin signature "Magister Aldrevandin Me Feci[t]" (Made by Master Aldrevandin) and a European, probably Swabian, coat of arms (Fig. 117), was long believed to be Syrian.[10] The distinctive Islamic technique of painting nearly colorless or deeply colored blown glass with enamel colors and gold, which are then fused with the glass by refiring, probably emerged in Syria toward the end of the twelfth and the beginning of the thirteenth century, though the earliest datable piece is from the mid-1200s, and the industry was soon centered in Damascus.[11] The imagery on a small group often described as Syro-Frankish strongly suggests that some of this glassware was made for Christians.[12] For example, the painted decoration on a pair of beakers, usually dated about 1260, includes, beneath typical Mamluk honorific inscriptions in legible Arabic, a "Christ Entering Jerusalem" (Fig. 118,

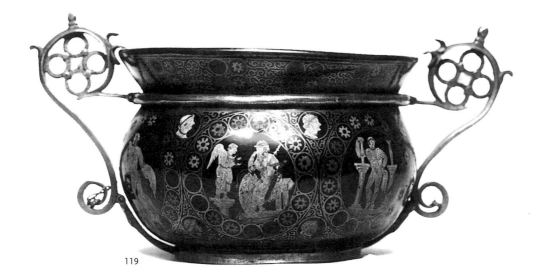

119

left), men in ecclesiastical robes, and representations of the principal shrines in Jerusalem—the Church of the Holy Sepulchre (Fig. 118, right) and the Dome of the Rock, which crusaders believed to be Solomon's temple.[13] Such objects may have been intended to commemorate a European or Eastern Christian's pilgrimage. The hybrid iconography, however, like that of elaborate inlaid metalwork in the same style, some of it bearing the names of Ayyubid and early Mamluk sultans, also accommodated the mixed local population: Muslims, Arabic-speaking native Christians—numerous in Syria, the Holy Land, and parts of Egypt—and crusaders. A number of the sophisticated pieces of enameled Syrian glass in English, German, and French collections, including a beaker found in the ruins of a church in Orvieto, Italy, were probably carried back carefully by crusaders or pilgrims.[14]

The Latin signatures, technique, and decoration of the Aldrevandin group, however, argue for a Venetian rather than a Syrian origin. Signatures are unknown on Syrian drinking glasses, and there is no record of European glassmakers working in the Holy Land or Syria before the fall of Acre in 1291. Signatures on Figure 117 and fragments of similar beakers excavated in London and various continental European cities, moreover, match the names of craftsmen mentioned in Venetian documents between 1291 and 1331: Aldrovandino Fiolario, recorded in Murano in 1331, perhaps from a Venetian glassmaking family, and two "drinking glass painters" (*tintor de majolis*), Bartolomeus from Zara, who decorated a drinking glass with three figures surrounded by foliage before November 21, 1291, and Petrus, probably a Venetian, mentioned in 1348. Though it cannot be certain that these were the craftsmen who signed the beakers, only Venetian documents name specialists in glass painting, an indication of high regard also expressed in the signatures. The technique of Aldrevandin's stout beaker and fragments of other vessels with European shapes and decoration—Christian and secular figured scenes, heraldry, and Latin inscriptions—also point to a Venetian origin. Though the composition of the glass and the enamel colors used are similar to those of Syrian glass, it is distinctive and also closely related to later Venetian glass. The enamel colors are partly painted on the interior and fused with the blown glass in the Islamic manner and partly cold-painted (not fused with the glass) on the exterior in the Byzantine manner. The largest known stout beaker in this mixed technique, signed Magister Batolameus Fecitetee, features a motif of Roman and Byzantine origin that is closely related to contemporary relief sculptures on Saint Mark's. Recently excavated in Stralsund on the Baltic Sea, this luxurious beaker is now in the Kunsthistorisches Museum der Hansestadt Stralsund.[15] Some other beakers decorated in the style of the Aldrevandin group, but blown in a tapered shape similar to that of Islamic examples, as in Figure 118, are painted only on the exterior, and some also have gold-leaf decoration. The technique of fourteenth-century Venetian enameling is crude and experimental, however, compared with that evidenced in typical Syrian pieces (see Figs. 118, 124, 125) and high-quality Byzantine models available in Venice, such as a bowl in the treasury of Saint Mark's that was probably looted from Constantinople in 1204 (Fig. 119).[16] Venice's longstanding ties to the Byzantine glassmaking tradition were undoubtedly reinforced by the presence of immigrants

from former Byzantine territories among the drinking glass painters recorded between 1280 and 1348: a Greek from Morea in the Peloponnisos, and Bartolomeus and his brother Donino from Dalmatia. Immigrant craftsmen arriving before the fall of Acre in 1291 and early European purchasers of the painted glassware might even have had direct knowledge of the Syrian industry.[17]

Though the market for enameled glass of the Aldrevandin group extended to the Baltic and the western and eastern termini of Venetian galleys—London, the Black Sea, and Alexandria[18]—Italians continued to import Syrian glass for the European elite. Pegolotti listed glass vessels (*vetro lavorato*) among the goods imported in quantity via Cyprus during the papal embargo on trade with Mamluk Egypt and Syria, and enameled Damascene glass is occasionally mentioned in princely inventories after the embargo was lifted in the 1340s.[19] Syrian glass was still in demand at the end of the century, when its

120

quality was declining. In 1386 the Venetian agent of the Datini firm advised headquarters in Prato that no Islamic lamps were currently available and he would send notice when some arrived.[20] The same firm loaded cases of glass in Beirut in 1384, and in Caffa, on the Black Sea, in 1394.[21] For the most part, however, it is impossible to identify the origin of glassware marketed in Europe, such as the glasses unloaded from Venetian ships in Flanders in 1394 and London in 1399.[22] Four phials or flasks from Damascus, presumably glass, are listed in a Florentine household inventory of 1390.[23] Of the fifteen glass items listed in the inventory of Piero de' Medici of 1456, eleven were described as "Damascene" or "Syrian": two *infreschatoio* (footed bowls or wine coolers?), three *ghuastade* (pilgrim flasks?), three *ghozzi* (flasks), two *orciuolo* (pitchers), and one drinking glass. Elite collectors were also acquiring some Venetian glass. For example, imitations of Damascene glass, mentioned together with authentic Damascene glass in the inventory of King Charles V of France (d. 1380), were probably Venetian, as were the colored vessels owned by Piero de' Medici.[24] The glass called Venetian was evidently held in less esteem, for unlike the Damascence glass objects described in European inventories, few of those called Venetian had gold or silver mounts.[25]

The availability of Syrian imports may have been partly responsible for the slow development of Venetian enameled glass from the early fourteenth to the mid–fifteenth century. Another factor was European preference for luxury drinking and eating vessels of gold and silver, graphically illustrated in a Swiss Dominican pilgrim's memoir of his visit to Murano on January 14, 1484. Friar Felix Fabri of Ulm saw glassware being made that was more elegant than even gem-encrusted vessels of silver and gold and would be even more costly than such vessels were it not so fragile. To emphasize his point, he recounts a possibly apocryphal anecdote concerning the visit of Emperor Frederick III to Venice in 1468. After the doge and Senate presented him with a glass vase (or vessel), the emperor examined it and praised its craftsmanship, then dropped it; picking up the pieces, he commented that gold and silver were superior since even fragments had value.[26] Another visitor's comments suggest that once esteem for fine glass began to rise, the fragility of the most artistic and costly pieces may have

enhanced their status among the rich, who could afford the risk of breakage. In 1484 Canon Pietro Casola of Milan saw a chalice being made in Murano for which the asking price was 10 ducats, but he did not dare touch it, fearing it might break in his hand.[27]

The creative surge in artistic Venetian glass coincided with the development of maiolica and rising Italian demand for luxury household furnishings. A goblet of about 1475 (Fig. 120) represents a group of pieces associated with the famous Barovier family that reputedly elevated Venetian glassmaking to a new level.[28] Produced from about 1460 to 1490, the group shows great advances in artistry and in enameling and gilding techniques but cannot be attributed to particular craftsmen. Tradition credits Angelo Barovier, who was active in 1424 and died in 1461, with inventing crystal and *lattimo* (milk glass) and learning enameling from an alchemist in the Marches. He was eulogized as "the best Venetian maker of crystalline vases [or vessels]" and permitted to travel to Milan, Florence, and Constantinople.

This goblet illustrates the new blend of various Oriental and European elements. Its painted decoration is fused with the glass in the Syrian manner, but the enamel is much thicker. Furthermore, while Syrian glassmakers painted gold onto their vessels, the Barovier and subsequent Venetian glassmakers always applied gold leaf. Its use may be of Byzantine origin.[29] Most of the Barovier group is deeply colored glass—blue, green, or red. Though Venetian glassmakers had long produced beads and molded medallions and plaques in varied gem-like colors,[30] the new combination of richly colored blown glass with enameled and gilt decoration may have been inspired by Oriental examples such as the red Byzantine bowl in the treasury of Saint Mark's (Fig. 119) and the thirteenth-century blue Syrian or Egyptian perfume bottle in Figure 121.[31] The range of shapes and insignia of patronage on the few surviving colored Islamic pieces evidence a large and distinguished production. Favored colors were a dark lapis lazuli blue and various shades of manganese violet-purple. There is no proof that examples of this type of Islamic glass were available as models in Venice, but a connection seems likely.[32]

The only decorative motif derived from Syrian glass that appears frequently on these Venetian pieces is the pearl-shaped white or colored enamel dot, lined up in

121

120 Goblet, enameled and gold-leaf decoration representing *The Triumph of Fame* on dark blue and colorless glass (restored foot), Venice, ca. 1475. The Toledo Museum of Art, Ohio (1940.119).

121 Perfume bottle, enameled and gilt dark blue glass (later wood base and metal collar), Syria or Egypt, thirteenth century. Museo Civico d'Arte Medievale, Bologna.

122

122 Shallow footed bowl, enamelel and gold-leaf decoration on colorless glass, Venice, late fifteenth–early sixteenth century. The Corning Museum of Glass, Corning, N.Y. (60.3.88).

123 Pilgrim flask, enameled and gold-leaf decoration on colorless grayish glass, Venice, first quarter of the sixteenth century. Rijksmuseum, Amsterdam (R.B.K. 1957-14).

124 Pilgrim flask, enameled and gilt colorless honey-tinted glass, Syria, ca. 1325–1350. British Museum, London (OA 1869.1-20.3).

125 Bottle made for Sultan al-Malik al-Mujahid Saif al-Din of Yemen (1322–1363), enameled and gilt colorless honey-tinted glass, Syria, mid–fourteenth century. Freer Gallery of Art, Washington (34.20).

rows, as on the goblet in Figure 120, or clustered like rosettes.[33] Such dots constitute a primary decorative element of Syrian glass from the late twelfth to the mid–thirteenth century but thereafter serve as accessories and accents (see Fig. 125). Conversely, they play a minor role on early Venetian enameled glass (see Figs. 117, 120) and become a principal ornament on later pieces (see Fig. 122). Although the scale-and-dot pattern on the Barovier group (see Fig. 120) and other Venetian enameled glass (see Fig. 122) is often ascribed to Islamic models, it is rare on Syrian glass and instead appears to be an enameler's interpretation of popular contemporary maiolica ornament (see Fig. 104), which derives from Islamic ceramics.[34] Also related to maiolica are the pictorial themes that are this glassware's principal decoration—nuptial portrait busts, religious and secular scenes, heraldry, fruit and flowers—and the strong contrast between the background and the dense painted decoration. Most of the shapes of the Barovier group derive from European Gothic metalwork, and both the fine detail in the enameling and the shimmering effect of gilt speckling on feet and knobs emulates that of objects in gold.[35] Oriental techniques and models certainly contributed to this type of Venetian glass, but objects such as the goblet in Figure 120 were made for Western taste.

Toward the end of the fifteenth century, the enameled and gold-leaf decoration on elegant pieces of colorless Venetian glass, such as the *tazza* (shallow footed bowl) in Figure 122, became very delicate. Islamic dots predominated, but they were newly arranged in clusters that accent scale patterns or form buds, lily-of-the-valley blossoms, and hexafoils (see Figs. 128, 129). Applied or mold-blown forms often enrich the shapes (see Figs. 128, 129). Several scholars suggest that this style evolved to emphasize the transparency of colorless glass, though it also appears on colored vessels.[36]

Late-fifteenth- and early-sixteenth-century Venetian glass responded even more strongly than contemporary maiolica to elite taste for exotic Oriental-style display objects. Perhaps the most popular was the *guastada* or pilgrim flask, a bottle with two flattened sides, a long neck, and looped handles on the curved sides (Fig. 123), presumably modeled after an Islamic flask that had leather straps attached to the handles for carrying.[37] Though no Islamic glass precedents in the shape and size

of the late-fifteenth-century Italian version have been cited, these objects have a long history. In late antiquity and the Middle Ages, small lead or pottery flasks in similar shapes, often stamped with images related to a religious shrine and containing earth or sanctified oil from it, had been common souvenirs of a pilgrimage to the Holy Land. For example, in 1384 several Florentines bought tiny phials of oil, said to come from the tombs of Abraham, Jacob, and Isaac in Hebron, that was revered by Jewish, Christian, and Muslim pilgrims alike.[38] Unglazed pottery water flasks with two flattened sides, a short neck, and looped handles between the curved sides and mouth were produced in quantity for secular use in Syria during the thirteenth and fourteenth centuries.[39] Also different in shape from the Italian pilgrim flasks are two thirteenth-century Syrian enameled glass flasks, purportedly containing earth stained by the blood of the innocents of Bethlehem, that probably arrived in the treasury of the Cathedral of Saint Stephen, Vienna, in 1363.[40]

Comparable reliquaries do not survive in Venice, however. Larger flasks with only one flattened side, a short neck, and a variety of handles exist in Islamic enameled glass and inlaid brass and also in Ming porcelain—all objects of princely display.[41] A Syrian glass example shaped like a leather flask (Fig. 124) probably dates from about the second quarter of the fourteenth century.[42] It is not known whether the three Damascene glass *"ghuastade"* listed in the inventory of Piero de' Medici of 1456 had the pilgrim flask shape or the typical Syrian tall-necked bulbous shape, made with either a ring or a pedestal foot like that of the mid-fourteenth-century bottle in Figure 125.[43] Such rare collectors' items certainly contributed to the popularity and general style of the Venetian glass pilgrim flask, if not its details.

Most surviving Venetian pilgrim flasks are in colorless glass with enameled and gold-leaf decoration. While some are decorated with European figured scenes, arabesque medallions are the principal ornament on many,

123 124 125

such as an early-sixteenth-century example in Figure 123.[44] Though the Venetian medallions are only distantly related to those on Syrian flasks (see Fig. 124) and bottles (see Fig. 125), they emphasize the Eastern character of the objects. This Venetian flask also illustrates a subgroup with gilt bands simulating leather carrying straps that further link them to prized artifacts from the Holy Land. Indeed, the earliest datable examples, a pair in the Museo Civico, Bologna, with the arms of the Bentivoglio and Sforza families, suggest that the Venetian glass pilgrim flask was originally conceived as—or very soon evolved into—an elite orientalizing display object. The pair were probably made for the marriage of Alessandro Benti-voglio and Ippolita Sforza in 1492 rather than that of Giovanni II Bentivoglio to another Sforza in 1464, which would be early for such sophisticated glassware.[45] They are ornamented in Islamic style, with the coats of arms in the center of gold-leaf medallions decorated with incised arabesques and concentric rows of enameled dots similar to those in Figure 123. Produced during most or all of the sixteenth century, the pilgrim flask was one of the most enduring forms of Venetian enameled and gilt glass, and the shape appears in other types of Venetian glass, Renaissance maiolica, incised brass, and Medici porcelain.[46]

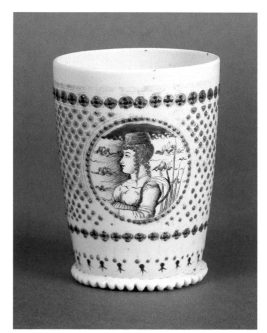

126

Most of the literature states that Venetian *lattimo,* or milk glass, was inspired by porcelain, but it is doubtful that the Murano artistic glass industry ever attempted to imitate Chinese plain or blue-and-white vessels. By the fourteenth century Venetian mosaicists knew a recipe for making opaque white glass, and Angelo Barovier's purported experiments with it would have coincided with or postdated the arrival of the first documented porcelain in Venice in 1442.[47] The earliest notice of actual production concerns a legal dispute in 1492 between Giovanni Maria Obizzo (active 1488–1525), who special-ized in enameling and gilding *lattimo,* and Bernardino Ferro, who allegedly fired over a thousand of Obizzo's vessels illegally.[48] By that date the Italian elite had been seeking Chinese and imitation porcelain in Venice for some twenty years.[49] Yet Western shapes and decoration predominate in the rare surviving examples of late-fifteenth- and early-sixteenth-century milk glass (see Fig. 126), and there is little evidence of floral ornament in blue *alla porcellana.*[50] In his *De Situ Urbis Venetae,* written about 1500, Marc Antonio Sebellico lauds the inventive-ness and mimetic skills of Murano glassmakers; he mentions imitations of (rock) crystal, precious stones, and flowers (*millefiori* glass) but is silent regarding *lattimo* and porcelain.[51] Many scholars have proposed that the counterfeit porcelain recorded in Venice—such as the seven bowls Duke Ercole I d'Este acquired there in 1504 and the small bowl and plate a Venetian counterfeiter sent to his successor, Alfonso I, in 1514—was milk glass. But Leonardo Peringer, who informed the Senate in 1518 that he could make porcelain "like that called Levantine," was a mirror maker, and others experimenting with por-celain making were alchemists.[52] Thus, it seems likely that Murano milk glass and counterfeit porcelain were separate crafts using different recipes.

The milk-glass tumbler in Figure 126 belongs to a small group painted in the style of Carpaccio, probably by a single distinguished enameler such as Giovanni Maria Obizzo, who decorated *lattimo* for Giovanni Barovier.[53] Typical of vessels commemorating a betrothal, it bears separate portrait busts of the couple; her profile is closely related to Carpaccio's *Two Venetian Ladies,* about 1490–1495, in the Museo Correr, Venice, which celebrates feminine virtues.[54] The framing and filling dotted orna-ment is characteristic of Venetian enameling, and, except

for the lustrous opaque white material, the tumbler has no connection with Chinese porcelain. Nonetheless, the material's resemblance to porcelain undoubtedly enhanced the status of milk glass and encouraged its use in the highest quality Murano glassware, such as this tumbler.

The Murano industry responded to the rising passion among the richest Italians for antiquities and objects in exotic materials by experimenting with a wide range of glassmaking techniques, including ancient ones. The results were ingenious.[55] For example, late-fifteenth-century glassblowers developed *calcedonio,* a marbled glass that simulates semiprecious stone (Fig. 127). "Antique" vessels carved from semiprecious stone were among the most highly valued items in Lorenzo de' Medici's palace treasury: a sardonyx ewer, probaby made in Sasanian Persia; an Islamic vase, probably from Fatimid Egypt; two Egyptian or Byzantine bowls of red jasper; and other items of diasper and agate.[56] In a letter written in 1502 to one of her agents, Isabella d'Este confessed an "insatiable desire" for both antiques and modern reproductions or counterparts, and some seventy-two contemporary vessels in *pietro dure* (semiprecious stone) are listed in the inventory of her museum, the Grotta, of 1542.[57] The market for the new versions was extensive: the inventory of Charles the Bold of 1497 lists a jasper goblet of Venetian work.[58] The Venetian glass imitations accommodated the budget of the middle class as well as the taste of the elite. *Calcedonio* was produced in a variety of colors and marbled effects, both imitative and inventive, and in Eastern and Western, old and modern shapes. Many pieces, such as the bottle in Figure 127, copy distinctive medieval Islamic shapes (see Fig. 125). Since the "antiques" valued by elite collectors included both genuine Greco-Roman antiquities that came from the Islamic East, such as the Tazza Farnese,[59] and Sasanian and Islamic objects, Italians undoubtedly came to prize glass versions in a recognizably old and Eastern style.

Some Venetian experiments may have been assisted by old glass objects from the East, because various elaborate ancient Roman techniques—mold blowing, trailed and pinched decoration in relief, polychrome trailed and splashed glass, and *millefiori* glass, in which slices from different-colored rods are fused together—survived in Sasanian Persian glass, from which several passed into

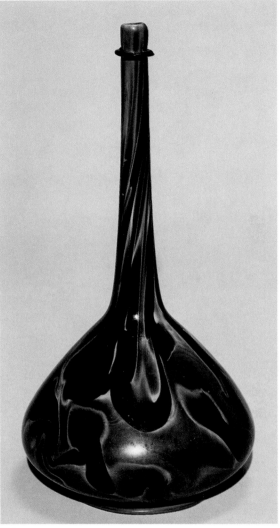

127

126 Marriage beaker, enameled and gold-leaf decoration on milk glass, Venice, late fifteenth century. The Cleveland Museum of Art, purchase from the J. H. Wade Fund (1955.70).

127 Bottle, marbleized glass, Venice, late fifteenth century. Victoria and Albert Museum, London (5301-1901).

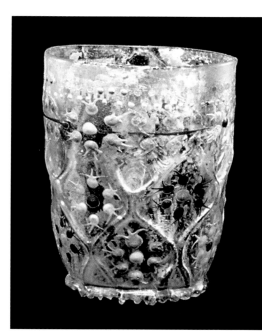

128

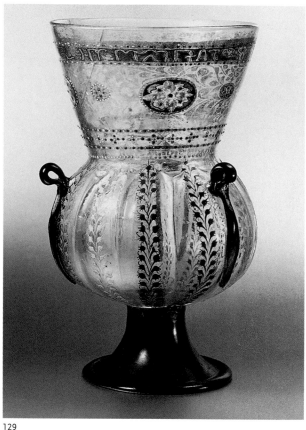

129

128 Tumbler, enameled and gold-leaf
decoration on colorless mold-blown glass,
Venice, late fifteenth–early sixteenth century.
The Corning Museum of Glass, Corning, N.Y.
(55.3.12).

129 Vase in the shape of a mosque lamp,
enameled and gold-leaf decoration on
colorless mold-blown glass (purple foot and
handles later additions?), Venice, about
1500. Kunstmuseum Düsseldorf (P. 1978-1).

Islamic glass.[60] An ancient technique that Venetians
probably revived from Islamic or Persian examples was
mold-blown geometric decoration in relief. The lozenge
pattern adopted in Italy has long been described in
English as "nipt diamond waes" after one method of
execution, also of antique origin, in which vertically
applied glass threads are pinched into diamond shapes
before they harden. The most common Venetian version
is mold blown in colorless glass, then decorated with
enamel and gold leaf (Fig. 128). Because these lozenges
are usually combined with the colorless, enameled, and
gilt glass that was closely linked to Islamic glass, Italians
may have associated this relief decoration with the East.
Such Venetian glassware was made in a variety of shapes
and was popular in both Europe and the Islamic world.
The tumbler in Figure 128 and several others like it that
bear a patina resulting from long burial were purportedly
excavated in a Jewish cemetery in Damascus.[61]

The taste of collectors permeated late-fifteenth- and

early-sixteenth-century Murano glassware. A unique vase was made about 1500 as a modern version of the Islamic Syrian lamp (Fig. 129).[62] Such objects are called mosque lamps because most survived in mosques and madrasas, to which they had been donated in huge numbers by Mamluk sultans and functionaries. By the end of the thirteenth century, the Syrian lamp had acquired a standard shape: a tall neck angled inward to a body that sloped outward, then turned inward above either a ring (see Fig. 179) or pedestal base. Handles on the body provided attachments for chains when the lamps were hung; they were also used standing.[63] The neck of the piece in Figure 129 and its purple handles and foot, which may be later additions, are consistent with the Syrian shape, but its globular body with mold-blown ribs updates typical late antique and Byzantine lamp forms. The awkward pseudo-Arabic inscription in its hybrid enameled and gilt decoration points to a European rather than an Oriental patron. As Chapter 10 will show, there is little evidence that Muslim patrons demanded Islamic-style decoration on custom-ordered Venetian glassware, or that the Murano industry developed an export production for the eastern Mediterranean marketplace. Pieces like this vase catered to esoteric European taste.

The Murano industry's success with new glassmaking techniques and imaginative ways of combining them soon rendered Oriental concepts of artistic glass obsolete. Enameled decoration declined sharply in the mid–

sixteenth century when the invention of crystal confirmed new directions that had been evolving for fifty years. Inventive glassmakers could blow and manipulate this ductile material into shapes of unprecedented elaboration and could complement its brilliance, thinness, and hardness with fine diamond-point engraving. Even pieces decorated with gold leaf or cold-painted on the underside strike the eye as original works, in a style independent of the Oriental glassmaking tradition.

By the time Venetian glassmakers had mastered sophisticated Syrian techniques and begun responding to rising demand, they no longer needed to compete with Islamic glass. Western pictorial themes and ornament predominated on the most distinguished pieces of enameled and gilt glass, while technical experiments rapidly led in new directions. Still, for several decades there was a significant European market for orientalizing pieces that recalled such earlier Syrian types as the pilgrim flasks and resembled such exotic Eastern antiques as *calcedonio* in Islamic shapes.

Few pieces of late-fifteenth- and early-sixteenth-century Venetian glassware can be traced to individual Italian collectors or patrons. By contrast, there is a great deal of information about the patronage of the Islamic-style bookbinding, described in the chapter that follows, which reveals how a new borrowed art spread to members of the Italian elite, some of whom required increasingly sophisticated orientalizing craftsmanship.

■ ■

BOOKBINDING
AND LACQUER

ITALIAN TOOLED, STAMPED, GILT, AND LACQUERED leatherwork descends from fifteenth- and sixteenth-century Islamic bookbindings. It has been shown that tooled leather bookbinding originated in Italy as an elite style, and many of the individuals who promoted and patronized the style have been identified.[1] The objects themselves provide detailed evidence for the history of this new craft: the books that are bound yield particulars on the purpose, patrons, and makers of these volumes that are rarely available in textiles, ceramics, and glass surviving from the period. The new Islamic-style book-bindings emerged in Florence and Padua in the mid–fifteenth century and remained an elite style through the sixteenth century in Venice. Their technical and artistic sophistication steadily increased, peaking toward the second quarter of the sixteenth century. Venetian crafts-men mastered exacting Mamluk and Ottoman techniques and became proficient in arabesque ornament. Among the various media, bookbinding best illustrates the gradual Italian mastery of sophisticated Islamicizing ornament. For the most part, detailed evidence for Italian bookbinding corroborates trends in other decorative arts whose patronage and sources are less well known.

During the second quarter of the fifteenth century, an elite group of humanist scholars, scribes, and booksellers in Florence, then the center for manuscript production and marketing, introduced and promoted a new style of bookbinding that broke completely with Italian medieval tradition. Customarily manuscripts had been bound in thick wooden boards covered with cloth or plain leather,

often ornamented with heavy metal clasps and closures. Those who owned enough books to form a library, such as Piero de' Medici, often coordinated the colors of cloth bindings with the disciplines of their texts.[2] By the 1430s, however, preparers of important manuscript copies of new and ancient texts began to use decorated leather bindings, which had no Italian precedent, to distinguish their volumes, especially those presented or dedicated to eminent patrons. The idea probably arose from the recent successful introduction, in such manuscripts, for analogous purposes, of a new style of handwriting, the so-called humanist script. Because of its connection with the revival of classical literature and learning, the new binding style has aptly been called humanistic bookbinding.[3]

Unconventional bindings complemented the novel texts, and the beautiful craftsmanship was intended to impress current or potential patrons of humanist scholarship. For example, in 1453 and 1454, the scholar Niccolò Perotti, then working in Bologna, commissioned the Florentine bookseller Vespasiano da Bisticci to bind several of his manuscripts in the new style. Perotti asked that one be "tooled as magnificently as possible," and expressed hope that the leather binding on a Homer destined for Pope Nicholas V would surprise and please him.[4] Like Perotti's Homer, all the manuscripts in the Vatican Library bound in tooled leather between about 1441 and 1476 were dedicated or presented to popes.[5] The scholars and book preparers modeled the new bindings after the most elegant contemporary examples: Mamluk

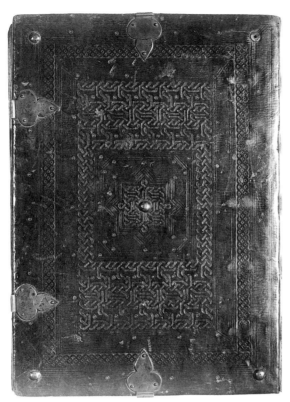

130

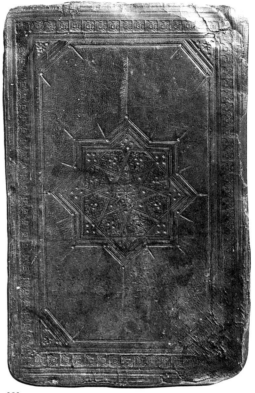

131

130 Leonardo Bruni, *Historia Fiorentina* (ms., Florence), ca. 1440–1450, lower cover, leather with blind tooling and gilt and colored punchwork dots, Florence. The Bodleian Library, University of Oxford (MS Buchanan c.1).

131 Cover of a bookbinding, blind-tooled leather, Egypt or Syria, fourteenth–fifteenth century. Victoria and Albert Museum, London (366/9-1888).

132 Andrea Mantegna, *Saints John the Baptist and Zeno* (detail of the San Zeno Altarpiece), 1456–1459. San Zeno, Verona.

bindings with blind (impressed without gilding) and gilt tooling on fine tanned leather over thin pasteboard cores. Though they might have preferred antique models, none existed, and any incongruity between the Muslim origin of the new covers and the humanist or Christian texts inside apparently did not concern them.

The binding on an early copy, about 1440–1450, of Leonardo Bruni's *Historia Fiorentina* (Fig. 130), illustrates the first Florentine style.[6] It imitates Egyptian or Syrian covers on which blind tooling is accented with gold dots (Fig. 131).[7] A reduced version of a common Mamluk center-and-cornerpiece design—an eight-pointed star outlined by several fillets and a border with four triangular cornerpieces—occupies the center of the *Historia* cover, whose continuous outer border composed of repeated impressions of simple geometric tools also closely follows its models. The plaited ropework on the *Historia* often appears on Mamluk bindings, but in different locations.[8] A Renaissance sense of balance and proportion refines the Florentine compositions: normally zones of ropework mediate between the rectangular borders and regular centerpieces, or the centerpieces

themselves are rectangular. The technique of the dots—gilt and colored punchwork, apparently attached with stucco—also differs from that of the models, as does the continued use of European wooden cores and metal clasps and bosses. The metalwork on the new bindings has minimal ornamental significance, however, serving chiefly to protect the covers of books that were customarily stored flat. Italian binders never adopted the characteristic Islamic pentagonal flap that is part of the lower cover and folds over the top cover to protect the pages inside (see, for example, the inside of such a cover and flap in Fig. 136); differently shaped flaps on Italian account books fold under the front cover. No models among surviving imported bindings have been identified, nor is there evidence of how such models might have arrived in Florence—whether through ordinary commerce or the diplomatic missions to Tunis and Cairo in the early 1420s. Though the new style soon spread to other Italian centers, contemporaries associated it with Florence: the inventory of Pope Eugenius IV (1431–47) describes it as "the Florentine style" (modo fiorentino).[9] Most of the texts bound in this style date from the second quarter of the fifteenth century. The style itself did not develop beyond a narrow range of variations in its motifs and compositions.

Meanwhile, craftsmen in several parts of Italy began to experiment with pressing gold leaf into leather with heated metal dies, an Islamic technique that was magnificently combined with blind tooling and painting in gold on fifteenth-century Mamluk bindings. Italian craftsmen did not develop gold tooling artistically, however, until the third quarter of the century, by which time both imported and local models were available to bibliophiles. Owners were sending some manuscripts to Egypt or Syria for binding, and Italian experiments were circulating among scholars and binders.[10] For example, a volume in the Biblioteca Marciana, Venice, consisting of two Latin manuscripts, one dated 1453, that once belonged to the Venetian diarist Marin Sanudo has a Mamluk binding with a typical interlaced star design and Islamic flap.[11] A comparable Mamluk example inspired an Italian, probably Venetian, binding with traces of gold tooling and painting on a copy made in 1433 of Saint Augustine's De civitate Dei in the Royal Library, Stockholm.[12] About 1454 Niccolò Perotti had a Bolognese binder imitate contemporary Florentine bindings with some gold tooling for

his new Latin translation of Polybius's Historiae, now in the Biblioteca Malatestiniana, Cesena. The more accomplished binding Perotti showed his local binder as a model was probably that of his own Florentine copy, made in 1454, of Leonardo Bruni's Latin translation of Aristotle's Politica, now in the Vatican Library.[13] By such means binders in Florence, Venice, Bologna, Ancona, Milan, and Padua learned how to tool in gold by 1460. While the movement of craftsmen facilitated the diffusion of new textile and ceramic styles and techniques in Italy, the new bookbindings spread through the activities of the intellectual elite.

Gold tooling developed rapidly during the next two decades in Padua, where eminent scribes promoted the style and the rich and powerful, many of whom had scholarly interests, patronized it.[14] Indeed, gilt leather bindings first appear in Italian paintings in Padua, proving that they had begun to attract the attention of artists and the patron class. The earliest representation is in Andrea Mantegna's San Zeno Altarpiece, painted in Padua in 1456–1459 for the humanist abbot of San Zeno, Gregorio Correr (Fig. 132).[15] The covers on books held by Saints John the Baptist and Zeno have Mamluk-style center-

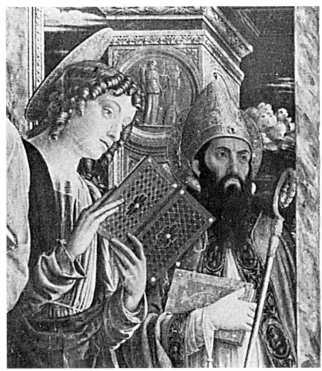

132

133 Suetonius, *Vitae XII Caesarum* (ms., Padua, scribe Bartolomeo Sanvito), 1461, front cover, leather with gilt tooling, Padua. Biblioteca Apostolica Vaticana, Vatican City (Barb. lat. 98).

134 Lower cover on a work by al-Dimyati (ms., Egypt or Syria, copied for Sultan Qaitbay), 1473, leather with gilt tooling and gold paint, Egypt or Syria. Topkapi Palace Library, Istanbul (MS. A. 649/1).

135 Leonardo Bruni, *Commentarius rerum in Italia suo tempore gestorum* (ms., Bologna, contributions from the scribe Felice Feliciano), ca. 1464–1465, doublure on back cover, dark olive brown goatskin with gilt and silver tooling and filigree over blue and green painted grounds sprinkled with red glass beads, Padua. Biblioteca Marciana, Venice (cod. marc. Lat. X, 117 [= 3844]).

pieces that reflect contemporary Italian bindings, but Mantegna seems to have invented the surrounding ornament, which includes pseudo-Arabic borders. These bindings are consistent with Mantegna's taste for exotic Oriental accessories as well as the learned culture of his patron.

Two miniatures in a copy of Strabo's *Geography* now in the Bibliothèque Rochegude, Albi, show that by 1459 the Paduan intellectual and artistic elite expected deluxe manuscripts to be bound in gilt leather.[16] The humanist Guarino da Verona had begun the Strabo for Pope Nicholas V; after the pope's death, its completion was sponsored by Jacopo Antonio Marcello, a noble Venetian army captain who was then governor of Padua. In 1459 Marcello presented the volume to René of Anjou, a significant figure in Italy's politics and a bibliophile whose goodwill Marcello sought to retain through gifts of manuscripts. The high-quality Paduan-style miniatures in the Strabo show Marcello receiving the manuscript from Guarino and presenting it to René, in both instances in a gold-decorated red binding that has to be leather. Because

133

134

the miniatures predate the binding, they predict rather
than illustrate it. The original binding does not survive,
but an old photograph indicates that it closely imitated
a Mamluk model.

The most important promoters of the new artistic gold
tooling were the scribes Bartolomeo Sanvito and Felice
Feliciano. An early example of the bindings associated
with Sanvito appears on a manuscript of Suetonius's *Vitae
XII Caesarum* that Sanvito copied in Padua in 1461 for
Marcantonio Morosini of Venice (Fig. 133).[17] More ambi-
tious than the Strabo cover, it has a border, composed of
continuous knotwork framed by interlocking S-stamps
and fillets, and a center-and-cornerpiece design derived
from contemporary Mamluk covers. A later cover on a
manuscript copied for Sultan Qaitbay in 1473 (Fig. 134)
shows similar outer borders and a more elaborate oval
centerpiece with fleur-de-lis–shaped pendants filled with
fine arabesques.[18] Though the Paduan binder's center-
piece is crude, with stiff un-Islamic cusped outlines and
floral forms, he has understood the horizontal and ver-
tical symmetry of an arabesque centerpiece and, to a
lesser degree, the basic intertwining split-leaf pattern.
Two more manuscripts in Sanvito's hand have similar
bindings, as do other manuscripts and printed books
in which he was probably involved, both in Padua until
1469 and in Rome into the 1490s.[19] Among them are the
earliest surviving European bindings with pasteboard
rather than wooden cores. The Roman bindings associ-
ated with Sanvito show a gradual shift away from Islamic
knotwork and center-and-cornerpiece designs toward
Renaissance motifs and compositions, which predomi-
nated in sixteenth-century Italian bindings.

A small group of elaborate, inventive bindings inspired
by the most luxurious Mamluk examples have been
attributed to the Padua-based scribe and antiquarian
Felice Feliciano, who was directly involved in preparing
several of the bound texts.[20] The bindings include the
first made in Europe with ornamented doublures (linings
on the covers) and filigree (cut leather interlace against
a colored background), elements that soon spread to
Venice. The doublure on the back cover on a manuscript
of Leonardo Bruni's *Commentarius rerum in Italia suo
tempore gestorum* (Fig. 135), to which Feliciano contributed
while in Bologna in 1464–1465, illustrates the style.[21] The
composition combines a traditional Mamluk cover border

135

of segmented knotwork, tooled alternately in silver and
gold, with a contemporary Persian-inspired center-and-
cornerpiece design similar to that of Figure 134. Like the
doublure of that same Mamluk binding (Fig. 136), the
Bruni's center and cornerpieces are executed in filigree:
parts of the gilt arabesque ornament are cut away to
reveal a blue-painted ground. Alternatively, Mamluk
filigree has green silk backgrounds and appears on covers
rather than on better-protected doublures.[22] The Bruni's
filigree has green painted accents in the centerpiece, and
tiny red, presumably Venetian, glass beads sprinkled on
the background enrich the optical effect and add local
flavor. The same binder used a green silk background
in the cornerpieces of the filigree cover on the Codex

Lippomani—a volume of Latin poems by Jacopo Tiraboschi copied in Padua about 1471 and dedicated to Niccolò Lippomano of Venice—proof that his models were Mamluk since they are the only Islamic bindings with filigree covers.[23] In addition to red glass beads, the Codex Lippomani centerpiece has a raised profile portrait of Antinoüs, derived from an antique gem, that makes it the earliest surviving Renaissance plaquette binding. These bindings all have accomplished filigree, and despite stiff, heavy arabesques, the craftsmanship they exhibit is fine enough for the work to have been attributed to Orientals working in Venice.[24] The inventiveness, skillfulness, and antiquarian touches, however, are consistent with the personality of Feliciano, well known for his bindings, who embellished his manuscripts and illustrations for printed books with Islamic-style strapwork and clarified ancient inscriptions as he copied them.[25]

The Paduan filigree bindings had greatest impact in Venice, where patrons continued to esteem close imitations of the most elaborate contemporary Islamic bindings.[26] The evidence indicates that Peter Ugelheimer, a German businessman and bibliophile residing in Venice, instigated high-quality filigree work there.[27] Ugelheimer, who owned the Deutsches Haus inn, invested heavily in the leading printing firms of Nicholas Jenson (d. 1480), John of Cologne, and their successors, and collected unique impressions on parchment of their books. He had been having these parchment volumes bound in gold-tooled leather in Padua.[28] In 1475 he ordered a filigree binding from a Venetian binder that proved unsatisfactory. Evidently, he soon found a satisfactory local craftsman: six parchment copies with Venetian bindings whose sumptuousness was unprecedented in Italy survive as proof. They all probably came from the same shop, and four—made between 1477 and 1481 for law books now in the Forschungsbibliothek, Gotha—were certainly done for Ugelheimer. Scholars long accounted for the success of the filigree by arguing that Persian craftsmen must have come to Venice as a result of diplomatic contacts with Uzun Hasan between 1471 and 1474.[29]

136 Doublure of Figure 134, leather with gilt tooling and filigree over blue painted ground.

137 Gratian, *Decretum* (printed on parchment, Venice, Nicholas Jenson), 1477, front cover, leather with blind and gilt tooling and filigree over blue painted ground, Venice. Forschungs- und Landesbibliothek, Gotha (Mon. typ. 1477, 2, 12).

138 Lower doublure on a binding, leather with gilt tooling and filigree over gilt and blue painted ground, Istanbul, ca. 1480. Topkapi Palace Library, Istanbul (MS. A. 1921).

The cover on Gratian's *Decretum* (Fig. 137), published in 1477 and therefore one of the earliest of the group, shows that the binders must have been Italian and that they drew inspiration from varied sources, none of them Persian.[30] The combination of Islamic filigree with stamps copied from ancient Roman coins certainly derives from Paduan bindings associated with Feliciano. The application of filigree to the outside covers ultimately derives from Mamluk bindings, perhaps by way of the Paduan imitations. Several features point to contemporary Ottoman models, which at this time were strongly influenced by Persian bindings: pressure-molded borders, Chinese lotus palmettes in the arabesques, escutcheon-shaped cutouts radiating diagonally in a round centerpiece, and the sections of varied fine arabesques in the centerpiece.[31] For example, the narrow bands outlining the sections and insets on the axes resemble the filigree doublure on an Ottoman binding of about 1480 (Fig. 138).[32] Ottoman exemplars were certainly arriving in Italy. A Florentine manuscript of Petrarch's *Canzoniere e Trionfi*

of about 1460 to 1470 in the Bodleian Library, Oxford, was bound in Istanbul with pressure-molded covers and doublures in contemporary Ottoman style but no flap, and the practice of ordering bindings in Istanbul continued with printed texts into the sixteenth century.[33] Because of his involvement with the German merchant community and book production in Venice, Ugelheimer was undoubtedly well informed about the latest imported bindings. The composition of the Gratian cover also suggests a connection with contemporary Mamluk inlaid metalwork (see Fig. 152), as do the knotted stems linking some of the floral arabesques within the oval.[34] Awkwardness in the arabesques and an Italian sense of proportion in the composition of the six covers, each of which is different, offer further evidence that the craftsman was Italian.

Though Oriental-style bindings constitute only a fraction of Venice's large and varied production, they had an elite patronage through the sixteenth century. They are most common on certificates of appointment

137

138

to public office that included pertinent laws, duties, and special instructions. These bound documents, ceremoniously presented by the doge—or to a new doge—were personal showpieces.[35] Because there is considerable variation in the style of the bindings, even on certificates issued in the same year, the appointees must have been responsible for them. Those who preferred and could afford the luxury Islamic-style bindings patronized a few specialists who were extraordinary interpreters of Ottoman techniques and ornament. These objects show that among Venetian patricians, whose direct participation in overseas ventures was generally diminishing, some continued to value the eastern Mediterranean ties.

The *promissione* containing the oath of office administered publicly to Doge Leonardo Loredan upon his accession in 1502 (Fig. 139) combines outstanding features of bindings from the reign of Sultan Bayezid II in an Italian format.[36] Because this *promissione* includes an entry dated 1508, the volume was probably bound several years after Loredan's accession, certainly at great expense. Loredan's centerpiece, like that on an Ottoman cover datable about 1511 (Fig. 140),[37] is composed of airy arabesques impressed in relief using a block stamp: the lavishly gilt background accentuates the relief of the arabesques, which have gold only on some impressed interior details. Emulating the pressure-molded edges and sunken fields of Ottoman bindings such as that in Figure 140, the Venetian field lies slightly below a narrow, separately cut border, and the raised rim around the center creates the impression that the medallion there is also sunken. Usually bindings from Bayezid's reign delicately calibrate increased gilding and contrasts in texture against sparser overall decoration. The Venetian binder, however combined his large stamped and gilt centerpiece with other ornament that completely reverses the restrained opulence of his models. He surrounds the centerpiece with floral scrolls painted in gold in which some of the lotus and leaf forms are also impressed and parts of the stems incised. His intricate filigree cornerpieces have exceptionally rich particolored silk backgrounds of red, blue, green, and gold.

Venetian craftsmen also produced a few bindings in pure Ottoman style, without any Italian embellishments. One example was made about 1520–1530 for a then rare manuscript of Fra Giocondo's *Sylloge* copied by Barto-

139 *Promissione* for Leonardo Loredan's accession as doge, 1502–1508, lower cover, pressure-molded leather with gilt tooling, stamping, gold paint, and filigree over particolored silk ground, Venice. The Walters Art Museum, Baltimore (MS W 486).

140

141

lomeo Sanvito. The covers of pressure-molded black
leather with a stamped and gilt centerpiece are similar
to those of Figure 140, and only minute details in the
arabesques on its filigree doublures (Fig. 141) betray an
Italian hand.[38] Among this group is a filigree doublure
with an allover arabesque design that was common on
Ottoman bindings but rarely attempted in Venice.[39] The
quality of these bindings and their arabesques indicate
that by the 1520s some Venetian craftsmen were accom-
plished practitioners of Islamicizing ornament. Their
mastery of Ottoman ornament predates the pattern
books of arabesques that enabled the style to spread
across Europe during the following decades.[40]

During the second half of the sixteenth century,
Venetian binders mastered the technique of coating
painted and gilt decoration with lacquer. The technique
derives from Persian bindings, but Venetians were
undoubtedly inspired by Turkish versions such as one
on a manuscript of 1530/31 (Fig. 142).[41] An Ottoman
Quran with lacquered covers, dated 1536, in the Biblioteca
Marciana, Venice, suggests that exemplars were arriving

140 Lower cover of a work on politics and
morals (ms., Istanbul, copied by Muham-
mad ibn al-Shaykh Ibrahim al-Halabi for
Sultan Bayezid II), 1511, pressure-molded
leather with gilt tooling and stamping,
Istanbul. Topkapi Palace Library, Istanbul
(MS. A. 2493).

141 Fra Giocondo, *Sylloge* (ms., scribe
Bartolomeo Sanvito), not after 1511, doublure
on front cover, brown leather with gilt tooling
and filigree over blue and turquoise painted
grounds, Venice, ca. 1520–1530. Devonshire
Collection, Chatsworth, Bakewell, Derbyshire.

142

143

142 Cover on a *Hamse-i Nevai* (ms., Istanbul, transcribed by Piri Ahmed bin Iskendar in 1530/31), ca. 1540, lacquered leather, Istanbul. Topkapi Sarayi Muzesi, Istanbul (H. 802).

143 *Commissione* of Girolamo da Mula as procurator of Saint Mark's, 1572, front cover, lacquered leather with sunken compartments and stamping, Venice. The Newberry Library, Chicago (Wing MS. ZW 1.575).

144 Ceremonial shield, painted and lacquered leather over wood, Venice, late sixteenth century. Armory of the Doge's Palace, Venice (122).

at least a decade before they were imitated.[42] Almost all surviving Venetian lacquered bindings are on appointment documents. Like Girolamo da Mula's *commissione* as procurator of Saint Mark's (Fig. 143), probably bound shortly after his election in 1570, many of the covers feature stamped and gilt sunken centerpieces of the Lion of Saint Mark on the front and the appointee's coat of arms on the back.[43] Da Mula's binder adopted a standard Ottoman composition and added a Renaissance-style border. Around the centerpiece, he expertly imitated the *saz* style arabesques exemplified in Figure 142—scrolls sprouting bold, naturalistic blossoms, and feathery single and compound *saz* leaves that energetically bend across and twine around the stems. He may have copied the fine linear details from manuscript illuminations.[44] The remarkable artistry and luxuriousness of such late-sixteenth-century Venetian lacquered bindings bear witness to their high status. Da Mula's binding also has

144

filigree doublures, and a few of the lacquered covers have mother-of-pearl accents inspired by Ottoman inlay.[45] The styles of binding used for sixteenth-century appointment documents—Italian Renaissance, Mamluk knotwork, Ottoman, and French "fanfare" (in which small tools are used over the whole surface)—vividly demonstrate the range in both Venetian taste and the skill of Venetian craftsmen.[46]

Craftsmen soon applied techniques and styles used in bindings to other leather objects. The *cuoridoro* (gilt leather) industry expanded from the few artisans first documented in 1484 to some seventy shops earning 100,000 ducats annually by 1569, when the Venetian government noted large shipments to Istanbul and introduced protectionist measures. The principal product was leather wall coverings in various combinations of gold, silver, painted, stamped, and etched decoration that were finished with gilt lacquer or transparent red varnish.

Popular through the seventeenth century, some of the surviving middle- to late-sixteenth-century examples have designs inspired by Ottoman textiles.[47]

Venetian craftsmen also produced small custom-made leather objects in an Ottoman style. An example descending directly from bookbinding is a gilt and lacquered case in the guise of a bookbinding that was made about 1563 for King Philip II of Spain's portable panel of *The Crucifixion* by Titian.[48] The panel in its case recently came to light in the Escorial on a reading desk in the room that Philip used as his private chamber. A group of late-sixteenth-century painted and gilt leather shields (Fig. 144) and quivers ingeniously competed with popular Turkish objects produced in other techniques.[49] Elaborate armor and archery, hunting, and riding equipment were made in the sultan's workshops for court ceremonies, games, and diplomatic gifts as well as battle.[50] European royalty collected them, and numerous examples undoubt-

145

edly reached Venice. Ottoman ceremonial shields were made of tough wicker, decorated with a gold boss and silk embroidery. Bow cases and quivers were usually made of richly embroidered velvet, like a mid-sixteenth-century example in Figure 145, but they were also made in painted and embroidered leather appliquéd on leather.[51] Venetian leatherworkers cleverly used their existing technical and ornamental skills to imitate the style of these objects. Some of the shields, like that in Figure 144, have wooden cores; others have a metal spike in the center, a pasteboard core, and a wire rim. Many are decorated with the Lion of Saint Mark, a coat of arms, or initials in addition to standard Ottoman ornament, which is executed in fragile relief covered with gold leaf and silver or

red varnish to resemble the gold embroidery in Figure 145. They were certainly intended only for ceremonial use.

The showy Venetian imitations were successful in Europe. Toward the end of the century, Wolf Dietrich von Raitenau, archbishop of Salzburg (1587–1611), ordered shields, bow cases, and quivers from Venice for his Turkish-style mounted guard.[52] Surviving shields in the Museum Carolino-Augusteum, Salzburg, are even flimsier than their counterparts in the Doge's Palace. Made of varnished parchment over wood, they are completely covered with delicate Ottoman arabesques, skillfully rendered, that are raised and painted in various colors. Darkening of the parchment has diminished the brilliance of the colors and finish, but originally the ornament must have resembled the finest Ottoman embroidery that uses colored silk threads on a background of gold threads, as in the trim on the velvet bow case in Figure 145.[53]

The fashion for Turkish-style furnishings culminated in the last decades of the sixteenth century and first decades of the seventeenth, during the peace following the battle of Lepanto, in Venetian painted and varnished wood inspired by Ottoman inlaid furniture.[54] Though true lacquer from China and Japan may have begun to arrive in Italy at this time, it was rare and was not imitated until after about 1600. A throne associated with Sultan Suleyman the Magnificent (Fig. 146) illustrates the mid-sixteenth-century Ottoman technique of inlaying walnut or ebony with other woods, ivory, and mother-of-pearl; silver and tortoiseshell were also used.[55] Though this throne, which can be disassembled for carrying on pack animals, was probably made for use on military campaigns and is believed to have accompanied Suleyman in Asia and Europe, such luxury furniture was certainly seen by European diplomats at the Sublime Porte. Some of the characteristic small inlaid objects—covered Quran boxes, bookstands, caskets, and writing boxes—undoubtedly reached Venice. Venetian craftsmen produced a comparable range of items that catered to European taste: containers for toilet and other personal articles, caskets, mirror frames, tables, chests, cabinets, and musical instruments. Venetian decoration was painted in black-and-white or polychrome and gold, sometimes accented with inlay, and varnished. A polychrome and gilt casket of about 1580 (Fig. 147) shows a typical Italian composition

of orientalizing ornament, which in this case is Ottoman. Europeanized arabesques, Renaissance ornament, and representational scenes are common, and combinations can be very eclectic. Some of the late tables feature landscapes with birds and animals that were inspired by Persian miniatures and carpets, which were beginning to arrive in Italy in greater numbers. Produced when the European market for luxury domestic furniture was just beginning to rise, these exotic Venetian objects underscore the cachet of orientalizing styles among the rich.

The sophistication of the early models and interaction among discriminating patrons and ingenious craftsmen sparked the rapid rise of Italy's completely new artistic leather industry. It originated among a few humanist scholars and scribes as a device for marking the novelty and importance of their texts and enhancing their patrons' enjoyment of such books. Promoted by the intellectual elite, the new tooled and gilt leather bookbindings soon caught the attention of the patron class, at first those with scholarly interests and bibliophiles, then the ever increasing numbers of the rich and powerful who sponsored, acquired, and displayed beautiful objects in general. From blind-tooled Mamluk geometric and knotwork compositions that Italians could readily appreciate and imitate during the second quarter of the fifteenth century, the ornamental repertory of Italian bookbindings gradually increased to encompass complex Persian-inspired Mamluk and Ottoman techniques and styles. Though Renaissance ornament predominated after

146

1500, sophisticated Ottoman-style bindings retained an elite patronage in Venice through the century.

It is not surprising that the most elaborate Islamic-style bookbindings were produced in Venice, where craftsmen had best access to the latest imported models. The mastery of arabesque ornament that leatherworkers acquired between the 1470s and the 1520s in Venice provides a parallel for the sudden emergence of sophisticated Islamic-style metalwork there about 1500, the subject of the chapter that follows.

145 Bow case, embroidered velvet, Istanbul, mid–sixteenth century. Topkapi Sarayi Muzesi, Istanbul (1/10989).

146 Throne, inlaid wood, Istanbul, mid–sixteenth century. Topkapi Sarayi Muzesi, Istanbul (2/2879).

147 Left end of casket, painted and varnished wood, Venice, ca. 1580. The Metropolitan Museum of Art, New York, Rogers Fund, 1957 (57.25ab).

147

▪▪▪

INLAID BRASS

IN THE MID–SIXTEENTH CENTURY, THE ARTIST AND ART historian Giorgio Vasari justly credited recent improvements in Italian metalwork to Islamic brassware imported from the eastern Mediterranean.[1] A few decades earlier, Venice had suddenly begun producing incised and inlaid brass that competed with contemporary imports. Although scholars long believed that Persian or Arab immigrants had established the new industry, most scholars now believe that the brassware attributed to the immigrants was made in the eastern Mediterranean, much of it probably the last phase of a Mamluk export production. For more than a hundred years the Mamluk industry and Italian—principally Venetian—merchants had profited from trade in this brassware. Undoubtedly, the steady supply of high-quality pieces increasingly adapted to European taste delayed the establishment in Europe of a competing industry, which would have required great technical skill and costly materials, and also ensured a firmly established market niche there for Islamic inlaid brassware even after an Italian production emerged. Because Italian textiles and ceramics drew inspiration from a variety of models, and Murano glassware benefited from the lack of international competition during its developmental surge, these Italian crafts soon showed diversity and inventiveness. Early Venetian inlaid brassware, however, originating to compete with a particular and highly esteemed import, remained remarkably imitative into the later Renaissance.

During the second half of the thirteenth and most of the fourteenth century, when inlaid metalwork flourished in Damascus and Cairo under Mamluk patronage, the European market had little impact on the industry, Islamicizing halos in Italian paintings (see Fig. 56) and Pegolotti's *Praticha della mercatura* indicate that in the early 1300s these costly vessels were slipping through the papal embargo on trade with the Mamluks via Cyprus.[2] The embargo, however, did limit individual European commissions. The only known examples datable during the first half of the century were made for royalty such as Hugh IV of Lusignan, king of Cyprus (r. 1324–59), and Elisabeth of Hapsburg-Corinthia, wife of Peter II of Sicily (r. 1337–42), living close to Mamluk territory and tolerant, at least, of the commerce officially prohibited by the papacy. Their coats of arms and names—Hugh's in Arabic and French and Elisabeth's in Latin—appear amid customary Mamluk decoration.[3] Because undated early-fourteenth-century examples with an Italian provenance have typical Mamluk decoration, brassware probably intended for the Mamluk elite and the wider Islamic luxury market during this period must have found its way to European merchants. A dish in the Dauphin collection, Geneva, to which arms, perhaps of the Pallavicini family of Venice, were added in Italy, is similar to that in Figure 57 except that the roundels dividing the inscription and occupying the center contain late-thirteenth-century–style figures rather than early-fourteen-century–style floral motifs.[4] A bucket used for holy water (Fig. 148) exemplifies the allover banded style of decoration: large medallions containing, alternately, Chinese-inspired lotus palmettes and attacking animals

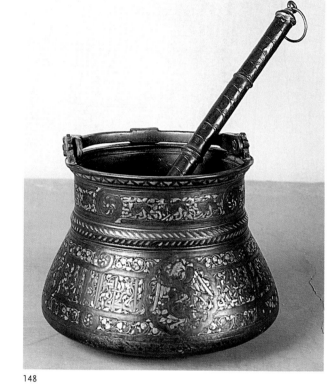

148

148 Bucket (shown with a holy water sprinkler), brass incised and inlaid with silver and gold, Syria or Egypt, first half of the fourteenth century. Museo Diocesano d'Arte Sacra, Treviso.

149 Candlestick with the arms of the Boldù (?) family of Venice, brass incised and inlaid with silver and gold, Damascus, Syria, ca. 1400. British Museum, London (OA 1878.12-30.721).

divide the inscription, and whirling rosettes divide the narrower bands of floral scrolls and running animals. The prominent Arabic inscriptions on these pieces repeat standard phrases and titles honoring the owner or his high-ranking patron.[5]

After the 1340s, when the papal embargo was lifted and Venice instituted regular voyages to Mamluk ports, Italian merchants could place special orders, especially in Damascus. Some surviving pieces from the second half of the fourteenth century were made with European coats of arms in the positions customary for personal Mamluk blazons—badges consisting of medallions or roundels containing symbols of emiral office, such as a goblet for a cupbearer, a penbox for a scribe, or a sultan's written title. The existence of three Mamluk brasses with the same unidentified European coat of arms indicates that such commissions were becoming profitable to both the craftsmen and the merchant intermediaries, probably Venetian. One of these objects, a wine cup in the British Museum, London, that is cast in a distinctively Islamic shape and decorated with the customary titles of a

Mamluk emir, may date from the period of Sultan Hassan (r. 1347–51 and 1354–61), shortly after the end of the embargo.[6]

European, principally Italian, coats of arms or blank shields for their later addition are more common on late-fourteenth- and early-fifteenth-century Mamluk inlaid brassware. Italian inventories also indicate that imports soared: a Florentine inventory of 1390 mentions "Damascene" candlesticks and a large bowl, all probably brass, and Piero de' Medici's inventory of 1463 lists thirty-six pieces, including basins, ewers, pitchers, candlesticks, a lamp, and both a standing and a spherical incense burner.[7] An example of a popular export candlestick probably made in Damascus about 1400 (Fig. 149) shows that the Mamluk industry was making significant concessions to European taste.[8] Though the base and enlarged drip pan have a characteristic Mamluk form, the neck is proportionally taller and the piece one-third to one-half the size of the candlesticks customarily made for the Mamluk elite. Whereas those ostentatious display pieces were commissioned for donation to religious institutions and

149

celain for use in their households. Furthermore, silver became scarce as it drained eastward to pay for spices and porcelain, especially from Egypt, whose principal export was Europe-bound spices. Copper and brass too were in short supply. In 1374 inlaid brassware from houses and public buildings in Damascus was melted down for copper—the main ingredient in brass—needed for the roof of a madrasa being built by the sultan in Cairo. According to the Egyptian historian al-Maqrizi, writing in about 1420, the shortage of gold and silver was so severe that people were picking out inlay, and some patrons obliged inlayers to work in their palaces to prevent fraud; because only a few could afford inlaid copper, little was being made. Evidence from a ship wrecked off the Syrian coast in 1404/5, probably en route to Alexandria, supports al-Maqrizi: there were no inlaid brasses on board, and only one of the many engraved copper vessels had inlay.

Europe was both the principal market for expensive metalwork and an important supplier of materials. Venice exported huge quantities of copper ingots to the eastern Mediterranean during the fourteenth and fifteenth centuries, and fifteenth-century shipping documents, which usually lump copper and brass together, mention copper wire and formed vessels that probably served advanced stages of the Oriental manufacturing process. *Tole* (copper plates) were shipped from Venice to Alexandria in 1410 and *zerti lavori di rame* (certain works of copper), in 1441.[12] Fifteenth-century trade in raw copper, formed copper and brass, and fine inlaid metalwork illustrates the growing economic interdependence of Mediterranean lands.

During the rule of Sultan Qaitbay, the sultan's own patronage and moderate economic improvement sparked a revival of inlaid brassware in a traditional style. Inlay is sparse, however, even on the fine pieces bearing the sultan's name, and patronage probably did not extend beyond court circles.[13] From Qaitbay's time into the early sixteenth century, the Mamluk industry and economy probably benefited more from the new shapes and decorative styles developed for the European market. Indeed, objects popular in Europe constitute most of the Islamic inlaid brass surviving from this period. Many of the pieces are signed in Arabic, and the only signed and dated piece was made in 1505.[14] Long called Venetian-Saracenic because of its close relationship to later Venetian brass-

probably also for use in ceremonial processions, the typical export candlestick was appropriate for domestic use.[9] Like the silver and gold inlay on earlier elite Mamluk brassware with blazons, that on Figure 149 is lavish, especially on the personal insignia; the coat of arms, which appears to be Oriental work, may be of the Boldù family of Venice. The decoration, however, consists of animal battles and contemporary sylized floral motifs rather than the Arabic inscriptions that asserted the status of the owner or donor in Mamluk society. Though inscriptions appear on some exported brassware into the sixteenth century, they tend to be bland: repetitions of a word such as "the possessor," the name of the craftsman (see Figs. 150, 151), a blessing, or a poem (see Fig. 152).[10]

In the late fourteenth century, when Mamluk patrons could no longer afford inlaid metalwork, because of the severe economic decline described in Chapter 1, the export market became essential for the survival of the craft.[11] The Mamluk elite interested in artistic patronage gradually turned to less costly illuminated Qurans and bought vessels of copper without inlay or Chinese por-

ware, this new type of brassware has controversial origins. Currently most scholars believe that much of it was made in Damascus, but there is disagreement about the origin of the most innovative pieces and little is known about the extent of European input.

Because of the various Western shapes and many European coats of arms in this metalwork, its resemblance to sixteenth-century Venetian inlaid brass, and signatures on two pieces, scholars long believed all of it was made in Venice, at first by Muslim immigrants.[15] The theory, which arose in the mid–nineteenth century, was based on sixteenth-century Italian use of the term *agemina* (*azzimina* in Venetian dialect) for the inlaid metalwork technique. The term, derived from the Arabic words *al adjem,* meaning a person of Persian rather than Arab origin, appears in a signature, PAULUS AGEMINUS FACIEBAT, on an inlaid coffer decorated with the Europeanized arabesques common in Venetian decorative arts about 1570; in contemporary Venetian documents mentioning the craft of inlaid metal; and in late-sixteenth- and seventeenth-century Florentine inventories referring to the style of objects earlier called Damascene.[16] When the name of one of the most accomplished craftsmen, Mahmud al-Kurdi, came to light in both Arabic and Latin on one of the most popular new objects, a flat-lidded box decorated in the style of Figure 150, it was concluded that he and others signing similar works in Arabic worked in Venice.[17] The Persian roots of their style and the possibility that Mahmud al-Kurdi ("the Kurd") was of Persian origin bolstered the theory of immigrant *azzimini.* Furthermore, it was conjectured that the first craftsmen arrived from Persia in the 1470s, when Venice opened diplomatic relations with Uzun Hasan, and inferred from the varied style of the pieces that eventually Syrians or Egyptians joined them. Historians of such arts as bookbinding adopted the theory to account for Venetian examples in a sophisticated orientalizing style. But in 1970 the theory was demolished.[18] The evidence was shown to be weak or open to alternative explanation, and it was pointed out that contemporary Venetian documents mention neither craftsmen with Arab or Persian names nor any Muslim community. Moreover, the protectionist Venetian guild system of the time would scarcely have tolerated the presence of a significant flourishing group of foreign craftsmen.

The most detailed recent studies of the new brassware have distinguished two groups on the basis of style.[19] All the craftsmen who signed their pieces worked in the more innovative style, which was quite different from that of earlier Mamluk metalwork. Some of these craftsmen, however, also signed pieces in a style that blends innovative elements with Mamluk tradition. Differences between the two groups suggest that there may have been two production centers. Overlaps, however—especially among the signed pieces—indicate that the production centers must have been closely linked artistically and geographically, with equally good access to Venetian and perhaps other Western merchant intermediaries and shipping.

Typical of the more innovative style are a box signed by Zayn al-Din 'Umar (Fig. 150) and a tray signed by Mahmud al-Kurdi, who was perhaps the most outstanding craftsman (Fig. 151). The box has an exceptionally well documented provenance: it is described in the inventory of 1589 listing precious objects displayed in the Tribuna of the Uffizi Palace, a treasury built under Francesco I de' Medici.[20] The tray was made with a blank shield in the center, where a European craftsman has added a griffin's head. The distinctive feature of the innovative style is its extremely refined layered ornament. The exterior surfaces are completely covered with an intricate network of minute ornament: linear elements incised into a blackened ground, and floral arabesques in slight relief. Superimposed on this layer is another, of arabesques that enlarge the lines of the background, as on the box, or of interlaced medallions, pendants, and cartouches that geometrically organize the composition, as on the tray. Silver-wire inlay accents the principal divisions, shapes, and connections as well as geometric arabesques and signatures filling some of the shapes. Though the inlay is more conspicuous than on contemporary brassware made for Sultan Qaitbay, the use of wire requires less silver than traditional flat inlay. There are close parallels between the superimposed wire inlay and silver or white outlines that highlight fine Persian-inspired arabesques on fourteenth- and fifteenth-century Mamluk Quran illuminations. The metalwork arabesque forms also relate to sculptural decoration on buildings in Cairo that date from the 1470s. It has been argued, therefore, that metalworkers drew inspiration from the

Qurans to develop a style that required less silver, and that they probably developed it in Cairo, where the Qurans were plentiful and influential, during the last quarter of the fifteenth century, when Qaitbay encouraged the revival of the industry.[21] But this theory of a second Cairene production different from, and more prosperous than, that patronized by the court has not been generally accepted.[22]

There is more agreement that the new shapes, unprecedented in Islamic metalwork, were intended for the European market. The box with a nearly hemispherical bowl and flat lid, as in Figure 150, was the most popular. Some shapes decorated in the innovative style, such as an elaborate ewer with a turned foot, flared spout, and S-shaped handle, are so characteristically Italian that they were probably cast in Venice and shipped to the eastern Mediterranean for decoration.[23] The flat-lidded boxes also may have been cast in Venice.

Most scholars now agree on a Syrian, probably Damascene, origin for the larger group of export brassware, though some believe it dates from the first rather than the second half of the fifteenth century.[24] The incense burner in Figure 103 and a wine cup with a blank shield for a European coat of arms (Fig. 152) illustrate its links to earlier Mamluk inlaid brassware with allover banded decoration (see Fig. 148).[25] The pieces, rarely signed, use silver inlay lavishly; their ornament includes horizontal bands, often geometrically divided by roundels and cartouches that are outlined by strapwork. The floral motifs also relate to Mamluk tradition, but instead of honorific inscriptions, the principal decorations are intricate strapwork arabesques that incorporate some highly stylized, barely recognizable plaited *kufic* elements at their edges. Other features overlap those of the more innovative style: blackened backgrounds decorated with minute incisions, shapes such as flat-lidded boxes and spherical incense burners, and a few of the signatures. For example, a box in the Museo Correr, Venice, is signed by the same Zayn al-Din 'Umar who made the box shown in Figure 150.[26] Easy European access to Damascus and the city's preeminence as an international entrepôt for finished goods presumably favored a continuing supply of silver and the consequent productivity of the Damascene metalwork industry. Indeed, during the first years of the sixteenth century, the Bolognese traveler Ludovico de

150 Covered box signed by Zayn al-Din 'Umar, brass incised and inlaid with silver, Egypt (?), ca. 1500. Museo Nazionale del Bargello, Florence (317).

151 Tray signed by Mu'allim Mahmud al-Kurdi, brass incised and inlaid with silver, Egypt (?), last quarter of the fifteenth century. The Walters Art Museum, Baltimore (54.527).

150

151

152 Wine cup (arms of the Priuli family of Venice in the interior, handles later additions), brass incised and inlaid with silver, foot formed in Venice (?), probably decorated in Damascus, Syria, second half of the fifteenth century. Victoria and Albert Museum, London (311-1854).

153 Bucket, brass incised and inlaid with silver, Venice (?), first half of the sixteenth century. Staatliche Museen zu Berlin–Preussischer Kulturbesitz, Museum für Islamische Kunst, Berlin (B 72).

154 Pair of candlesticks, cast brass inlaid with silver, Venice, early sixteenth century. Aron Collection.

152

Varthema noted that the warehouses of Christian merchants there were filled with "silk, satin, velvets, and brass, and all the merchandise required [for profitable trade]."[27] In Figure 152, the shape and Arabic inscription on the bowl are traditional, and the inscription quotes two verses from a poem that appears on other Mamluk brasses. The turned foot, which is a separate piece, however, may have been shaped in Venice, then decorated in the same shop as the bowl. The handles and the arms of the Priuli family of Venice on the inside bottom of the bowl were added later in Italy.

Incense burners like that in Figure 103 derive from smaller seventh- to ninth-century Chinese perforated metal balls that were equipped with a hook for suspension from the ceiling. The Islamic version, introduced by the end of the twelfth century, was cleverly designed in two hemispherical sections that fit together. Inside are gimbals that hold aromatics (incense, sandalwood, or musk) level as the object was swung or, according to Arabic literature, rolled on carpets to perfume the air.[28] Today these objects are often called hand warmers, as old northern European inventories describe them.[29] Inventories of the Medici from 1463 through the sixteenth century and from other Italian cities, however, specifically describe them as perfume dispersers.[30] Many surviving

examples still have hooks attached, and two in the Museo Nazionale del Bargello that were probably acquired by Cosimo I de' Medici also have chains, though their date is uncertain.[31] The Oriental aromatics used in the spherical incense burners, like the spices stored in ceramic *albarelli,* undoubtedly enhanced the status of the objects.

Records of Lorenzo de' Medici's collection suggest that the Italian elite's tremendous response to late-fifteenth-century export brassware finally spurred Venice to imitate it. The inventory of his estate of 1492 lists fifty-seven pieces described as *domaschini* and about fifty more *alla domaschina*—terms that may refer to different styles or origins, such as Italian imitations—for a total value of more than 967 gold florins.[32] The valuations on some pieces, far higher than the average value of about 10 florins, are remarkable. For example, the three fashionable though small spherical incense burners are valued together at 100 florins. When the contents of Lorenzo's residence (the Medici-Riccardi Palace) were dispersed following the French invasion and Piero di Lorenzo's expulsion from Florence in 1494–1495, "one hundred sixty Damascene vessels of various types" (160 *vaxi domaschini di più sorta*) were bought for 793 florins by Michelangelo Viviano, who may have been acting for Lorenzo's heirs.[33] The average cost of nearly 5 florins

indicates that this group consisted mostly, if not entirely, of metalwork. The huge quantities of metalwork in the collections of Lorenzo and his father, Piero, undoubtedly reflect the traditional princely practice of accumulating, in personal and state treasuries, objects whose materials have intrinsic value.[34] But more significant, the data of the 1490s show European demand for Islamic metalwork reaching a peak that offered irresistible incentives for imitation. Records of the grand-ducal collection, acquired mostly after 1537 when Cosimo I became duke on the extinction of Lorenzo's branch of the family (all descended from Giovanni di Bicci de' Medici [1360–1429]), mention only a few pieces of Islamic metalwork, suggesting that supply and demand diminished rapidly. The late export brassware seems to have maintained its status and value through the sixteenth century, however. Among the five pieces of inlaid brass exhibited in the Tribuna of the Uffizi Palace in 1589 were the covered box in Figure 150 and the two Syrian spherical incense burners in the Bargello mentioned above.[35] Thus it is not surprising that this style of brassware was influential until at least the mid–sixteenth century.

The imitations vary, from counterfeits that blur dividing lines between models and imitations to sensitive artistic reinterpretations. The bucket in Figure 153 exemplifies a small group made to replicate signed pieces in the style of Figure 150.[36] Though the bucket's shape could pass for Islamic, its decoration falls short. The inscriptions are pseudo-Arabic gibberish, and the negative shapes between the silver-outlined pendants and medallions are awkward, especially on the lower section of the piece. The existence of such an object proves that this style of metalwork had a high value in Europe, and that there were Western craftsmen with sufficient technical skill to fake it.

What seems the largest group of early-sixteenth-century Venetian inlaid brass is imitative, but most objects have some Italian features. For example, a pair of candlesticks (Fig. 154) update the popular Syrian export version (see Fig. 149) with a taller turned neck and a slightly concave drip pan consistent with the other curved forms.[37] The banded decoration, which includes the arms of the Belegno family of Venice, closely imitates that of contemporary export ware (see Figs. 152, 103),

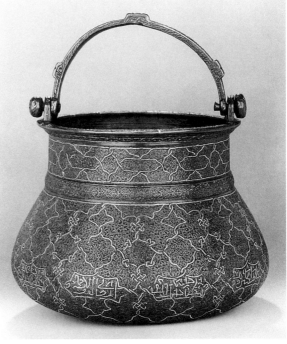

153

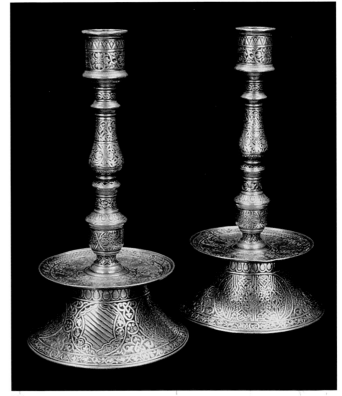

154

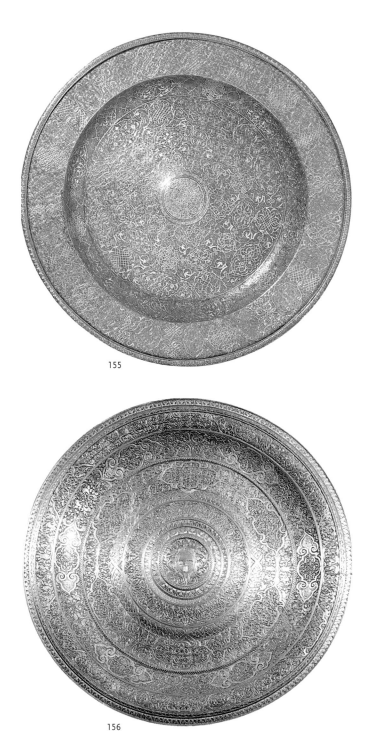

155

156

though the craftsman has not understood the outward development of the strapwork, or the stylized forms, connections, and repeats of floral arabesques on his models. The technique of the piece, like that of many other imitations, requires less labor than Islamic practice: the decoration is cast rather than incised, and the sparing silver inlay is attached in a different manner. The background is blackened like the Syrian models.

An engraved and inlaid plate of about 1540–1550 (Fig. 155) imitates the style of Figure 151 with considerable technical and artistic sophistication.[38] Rather than attempt to reproduce intricate Islamic motifs he did not fully understand, the craftsman covered the plate with Europeanized versions of such ornament common in other Italian crafts (for example, Figs. 101, 137), prints (Fig. 102), and illustrated books.[39] The craftsman did understand the geometric arrangement of the various motifs on his Islamic models but not their connection or the interplay of positive and negative shapes. The absence of blackening on the background, however, and an un-Islamic profusion of motifs effectively conceal the awkwardness.

A mid-sixteenth-century tray with the arms of the Giustiniani or Sagredo families of Venice (Fig. 156) translates the still prestigious imports like that shown in Figure 151 into Renaissance style.[40] The sections of the object and its surface ornament have greater plastic definition, and more naturalistic floral motifs are blended with antique classical motifs. Renaissance shapes and decoration—historiated themes and grotesques as on contemporary maiolica—became common on Venetian sixteenth-century inlaid or engraved brassware.[41] Nevertheless, many objects retain the Islamic idea of allover surface ornament and imitate the variations and arrangements common on late export brassware. For example, a mid-sixteenth-century candlestick (Fig. 157), covered with bands of fine ornament like that of the plate in Figure 155, echoes the old Syrian export shape (see Fig. 149).

Although it has often been suggested that production centers in Venice's overseas colonies and territories may have contributed to the sudden success of her inlaid brass industry, the only evidence concerns two craftsmen who signed trays in the 1550s and 1560s.[42] Horatio Fortezza's signature indicates that he was a "pupil of Master Stefano

the goldsmith" and worked "in Sibenik" on the Dalmatian coast. Nicolo Rugino was a "Greek from Corfu." Figured decoration predominates over Islamicizing arabesques on Fortezza'a trays, and Rugino's imitations of the style of ornament in Figure 150 show Ottoman influence. Though such craftsmen eventually produced high-quality work for the Venetian and other markets, it is not necessary to postulate offshore beginnings for the Venetian industry earlier in the century. As the preceding chapter has shown, from the 1470s to the 1520s Venetian bookbinders also acquired competence in technically and artistically sophisticated Islamicizing ornament (see, for example, Figs. 137, 141). Venetian metalworkers, given decades of familiarity with Islamic brassware in the Venetian marketplace and numerous local models of arabesque-style ornament, undoubtedly required little practice to approximate Islamic style.

Though the most innovative late-fifteenth-century Islamic brassware may not be of Mamluk origin and certainly shows some marked departures from Egyptian and Syrian tradition—the new shapes and style of decoration, and the number of signed pieces—it is consistent with the trend in the Mamluk metalwork industry from the mid–fourteenth century onward to accommodate the European market. The apparent reasons for this accommodation were economic. The only other contemporary eastern Mediterranean craft to develop a noteworthy export production was one with costlier products: the carpet industry in Turkey and Egypt. When Venice finally developed a competitive metalwork industry in the early sixteenth century, it was initially highly imitative. Metalworkers, more rapidly than workers in other Italian crafts with earlier starts, such as ceramics and gilt and tooled leather, updated their production in keeping with contemporary Ottoman and Renaissance styles. Nevertheless, the earlier Islamic imports left an enduring mark on Italian taste.

Despite the constructive effects of Oriental imports on various Italian craft industries over three centuries and the continuing interest in new imports, Italians remained quite ignorant of the cultures that produced them. Evidence in Italian painting of how geographical distances and religious and political differences continued to separate the Italian and Islamic peoples is the subject of the chapter that follows.

155 Plate, bronze engraved and inlaid with silver, Venice, ca. 1540–1550. Victoria and Albert Museum, London (259-1854).

156 Tray with the arms of the Giustiniani or Sagredo family of Venice, brass engraved and inlaid with silver, Venice, ca. first half of the sixteenth century. The Courtauld Gallery, London (Gambier-Parry Collection 102).

157 Candlestick, cast brass (?), Venice, mid–sixteenth century. Victoria and Albert Museum, London (M.2-1953).

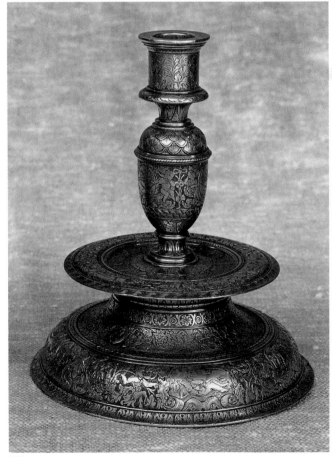

157

■ ■

THE PICTORIAL ARTS

PRECEDING CHAPTERS HAVE DEMONSTRATED THAT paintings provide important evidence for the impact of East-West luxury trade on the decorative arts in Italy. Paintings document both the arrival of imports that served as models and the emergence of the new Italian products they inspired. Paintings also show how Italians regarded and used the imports. In addition, representations of foreign people and places in paintings—as well as drawings, prints, and medals—reflect Italian perceptions of the outside world, revealing a limited vision of the Orient. Though significant numbers of Italians traveled to the East between 1300 and 1600, and commercial and diplomatic interaction was constant, such contacts contributed little over time to popular understanding of the appearance and character of Orientals and their environment.

For example, few Italian representations of Oriental physiognomies, costumes, and settings are accurate, and these derive from a surprisingly tiny number of direct contacts and studies from life. Italian artists and patrons, moreover, generally seem to have been satisfied with stereotypical imagery available at home. Although some northern European artists traveled overseas to acquire Oriental imagery, there is little evidence that Italians did; those known to have worked in Turkey had Ottoman patrons. Finally, artists tended to adapt a small repertory of authentic images to a variety of representational uses. The iconography changed in response to contacts and interests, but its range was narrow until new imagery

arrived during the later sixteenth century in northern European prints and illustrated books.

The earliest realistic Italian representations of foreigners are by Giotto, the first artist to individualize his figures' appearance and actions to make his narratives more vivid. For example, in the *Mocking of Christ* of about 1304–1312/13, Pontius Pilate is clean shaven and has classical features, Christ and the Pharisees have beards and Semitic features, and one of the torturers is a black African (Fig. 158), whose head has been studied from life. Undoubtedly the model was a domestic slave, the role the African plays in the scene.[1] Few records of slaves in Tuscany and other regions of Italy predate the second quarter of the fourteenth century, when their numbers soared, partly as a result of depopulation from the plague of 1348. The use of foreign slaves must date from the abolition of indigenous serfdom in the thirteenth century; Pisa and especially Genoa participated in the slave trade from the twelfth century. Most of the slaves traded were white and black Muslims from North Africa and Spain until the fourteenth century; blacks—the majority of them male—constituted a small percentage of slaves in Italy through the fifteenth century.[2] The immediate recognition by Giotto's viewers that the African was a slave would have made the narrative concrete.

Local slaves may also have served as Giotto's models for the individualized Muslims in *Saint Francis Proposing the Trial by Fire to the Sultan* in the Franciscan church of Santa Croce, Florence, painted in the second or third

149

158

158 Giotto, *The Mocking of Christ,*
1304–1312/13. Arena Chapel, Padua.

159 Giotto, *Saint Francis Proposing the Trial
by Fire to the Sultan,* ca. 1310–1326. Bardi
Chapel, Santa Croce, Florence.

decade of the fourteenth century (Fig. 159).[3] The event
represented occurred in 1219, during the Fifth Crusade,
when the Ayyubid sultan al-Adil received Saint Francis in
Damietta, Egypt. Francis, to prove his Christian faith and
the falseness of Islam, challenged the sultan's religious
advisors to follow him into martyrdom by fire; the sultan
excused his Muslim advisors and forbade Francis to enter
the fire alone. The sultan and the two advisors at far left
echo the standard late Byzantine type for both Jews and
Muslims but are described with considerable naturalistic
detail.[4] The sultan is characterized by his rich garments
and a turban surmounted by a crown, a fantastic creation

but appropriate from an Italian perspective. The two advisors closest to the sultan have quite different physiognomies and headdresses. Furthermore, the exceptionally large, originally sumptuous Spanish-style textile in the background of the painting establishes a plausible setting in a luxurious Islamic court.

The realistic portrayals of Muslims in Giotto's *Saint Francis Proposing the Trial by Fire to the Sultan,* the great exemplar for daring witness overseas, resounded in other Tuscan paintings celebrating Franciscan and Dominican missions.[5] The most noteworthy is Ambrogio Lorenzetti's *Martyrdom of Seven Franciscans,* now in the Church of San Francesco, Siena (Fig. 160), the only complete episode of martyrdom remaining from Franciscan histories frescoed in the adjacent monastery toward 1330. These seven friars were tortured and beheaded in Ceuta, Morocco, in 1227, but Lorenzetti's other figures place the event in a contemporary Asian context. A small fragment surviving from the background of another episode, representing a thunderstorm in the Bay of Bengal, identifies its subject as the execution of four Franciscans, including a Demetrio from Siena, in Thanah (present Bombay),

India, on their way to China in 1321, though the figures themselves are lost. While this episode must also have had a contemporary Asian setting, it is not known whether the series was consistent in this regard.[6] Like Giotto, Lorenzetti probably modeled the individualized foreign physiognomies in the surviving martyrdom on local slaves, in this instance from the area around the Black Sea, the chief source of supply from the early fourteenth into the fifteenth century. These Asian slaves were ethnically varied, ranging from Tatars to Circassians.[7] Young redhaired and blonde Caucasian women, like those at the lower right, were highly valued in Italy. The Mongol physiognomies of the ruler and two warriors wearing tall pointed hats, however, were probably observed among emissaries whom the Il-Khanids sent to Italy during the first decades of the fourteenth century.[8] This hat with a neck-covering flap and feather on top accurately depicts the headgear of commanders of one thousand men in the Mongol army.[9] Such headgear might even have been seen in Siena: perhaps Tommaso Ugi, a Sienese who had taken the name Tümen, had visited Siena when he accompanied the Il-Khanid emissaries in 1301. The hats are con-

160

sistent with the style of Lorenzetti, who like his Sienese contemporary Simone Martini was exceptionally attentive to contemporary costume.[10] The fierce aspects and weapons of these two attendants echo Marco Polo's description of Mongols as the most furious warriors and best archers in the world, who also had very good swords.[11] The Asian setting, though historically incorrect, does underscore the continuing tradition of Franciscan missionary activity, the principal theme of the cycle, and its contemporary focus on Mongol Asia.

The curiosity, fascination with exotic details, and straightforward description in Giotto's and Lorenzetti's images have well-recognized parallels in the travelogues of the first Europeans to visit Asia.[12] This enthusiasm for discovery among the first generation of artists to take a

fresh look at their visible world waned in later-fourteenth-century Italian painting. In general, realism diminished and the use of stock figures increased. Despite the disappearance of the Mongol empire, the Mongol type persisted, marked by a pointed hat and pigtail, therefore often viewed from the rear. Increasing Italian activity in the Islamic world after the end of the embargo produced no fresh imagery. A bearded figure with a covered or turbaned head sufficed for Muslims, and blackness for Africans and Moors. Such figures play standard roles as infidels or convey traditional perceptions of the East: its exoticism and wealth in *Adoration of the Magi* corteges, its learning in *The Triumph of Saint Thomas Aquinas over Averroes* (see Fig. 46), and its cruelty in the *Crucifixion*.

The next fresh images of Orientals, postdating the

development of Early Renaissance naturalism, result from Pisanello's observations of foreign delegations in Italy. The most striking is a remarkably direct study, now in the Louvre, of a Central Asian holding a bow and arrow, probably after a groom belonging either to the retinue King Sigismund of Hungary brought to Rome in 1432–1433 or to the Eastern delegation to the Council of Eastern and Western Churches, which convened in Ferrara in March 1438.[13] Sometime in the 1430s Pisanello used the figure as a picturesque accessory, lost amid Western imagery, in his *Saint George and the Princess* in the Church of Sant'Anastasia, Verona. This authentic Oriental figure then passed into obscurity.

More relevant to contemporary Italian interests in the East and Italian artistic subject matter was Pisanello's portrayal of the Byzantine emperor John VIII Paleologus, who headed the Eastern delegation to the Council of Eastern and Western Churches. Pisanello's famous medal (see Fig. 162) is based on studies made in Ferrara between March 1438 and January 1439, when the council moved to Florence because of plague.[14] The Eastern delegation numbered some seven hundred persons, including Patriarch Joseph II, ecclesiastics from the Egyptian Coptic Church and Jacobite sect of Mesopotamia, Abyssinian Monophysites of Jerusalem, Russian and Armenian prelates, and various attendants. Their exotic aspects fascinated Pisanello, especially the emperor's costume and horse and some of the other delegates' headgear.

The emperor appears in two outfits on the recto of a sheet in the Louvre (Fig. 161).[15] At the center bottom of the sheet, he wears an Islamic *tiraz* textile; its banded hem ornament is drawn in detail at the top and left of the sheet. According to Pisanello's slightly incorrect copy of the Arabic inscription ("al-Muayyad Abu Nasr Shaykh"), the garment was made for the Mamluk sultan Shaykh (r. 1412–21). The emperor, however, probably received it from Sultan Barsbay (r. 1422–38), who had sent a letter and a gift shortly before the council.[16] The emperor also appears mounted, dressed for hunting, an activity that occupied much of his time and undoubtedly followed ceremonial protocol. He wears hunting gear, a sword, and a Tatar-style hat with a pointed top, turned-up brim, and long pointed visor. Pisanello noted their colors as if he were anticipating a painted portrait: "The hat of the emperor should be white on top and red underneath, the profile black all around. The doublet of green damask

160 Ambrogio Lorenzetti, *Martyrdom of Seven Franciscans*, ca. 1330. San Francesco, Siena.

161 Pisanello, *Studies of Costume Worn by the Emperor John VIII Paleologus and Eastern Delegates at the Council of Eastern and Western Churches in Ferrara*, 1438. Département des Arts Graphiques, Musée du Louvre, Paris (MS MI. fol. 1062r).

161

and the mantle on top crimson. . . . The boots of pale yellow leather; the sheath of the bow brown and grained, and also that of the quiver and scimitar."[17] Pisanello drew the scabbard in detail on the recto of a sheet now in the Art Institute of Chicago, and the bow and quiver on its verso.[18] The elaborate Turkish-style ornament on the archery equipment suggests it was among the gifts recently sent by the emir of Karaman, whom the emperor in 1437 had advised of the upcoming conference. In these and other drawings Pisanello also studied the emperor's horse, an unusual small breed the emperor may have purchased from the Russian delegation in late August 1438.[19] Pisanello recorded additional exotic headgear on the Louvre and Chicago sheets, some on figures who are certainly ecclesiastics and some possibly on the

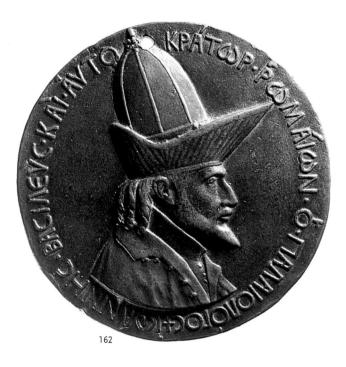

162

emperor; several of the heads show the forked beard and long hair then fashionable among Greeks.[20]

John VIII Paleologus dressed to project the image of a potent Oriental ruler, conspicuously displaying Islamic attire and accoutrements that signified power and prestige: the *tiraz* garment and the archery equipment probably received recently as diplomatic gifts. Such gifts demonstrated that contemporary Mamluk and Turcoman rulers recognized his authority over Byzantium, which in fact was rapidly crumbling. Thus the emperor's costume served as propaganda in his campaign for the Western support desperately needed to save his empire from the advancing Ottomans. Italians, however, long remembered the Byzantine or "Greek" elements of his aspect that corresponded with their perception of Constantinople's ruler and culture.

Pisanello's distillation of the emperor's appearance on his medal, which is datable 1438–1439, instantly became an archetype. The naturalistic profile on the obverse (Fig. 162) strikingly portrays the emperor's sharp features, pointed beard, and coiled hair. The element of his costume singled out for notice is the pointed hat in Figure 161, crowned, however, not by the white top noted in the drawing, but by the ruby that Vespasiano da Bisticci observed at the ceremonious signing of the union be-

tween Eastern and Western churches in Florence on July 6, 1439: "a Greek-style hat with a very beautiful gem on the peak."[21] The equestrian portrait on the reverse of the medal shows the emperor dressed for hunting and riding the small horse, as in the drawing, but piously visiting a roadside shrine. The numerous casts that were struck circulated widely and provided images for artists throughout Italy.

The earliest borrowing was straightforward. In Filarete's two reliefs of 1439–1445 on bronze doors at Saint Peter's, Rome, that commemorate the council, the emperor appears both seated and mounted with the profile and an exaggerated version of the hat on Pisanello's medal.[22] To differentiate the various particpants at the council, Filarete relied primarily on headgear: this hat distinguishes the emperor, whereas most of the other Eastern delegates wear turbans or tall shovel hats, and a few wear shawls or pointed caps. Since elements of costume from the council that are not on Pisanello's medal, such as shovel hats, are widespread in Italian painting, other artists must also have studied it.

From about the time of the Ottoman conquest of Constantinople in 1453 to the end of the century artists adopted the visage and/or the pointed hat on Pisanello's medal to render various figures concretely: ancient and modern Greeks, Roman emperors, and other Oriental rulers. The visual connection with the authoritative image of John VIII Paleologus is usually clear enough for sophisticated spectators to recognize and correctly interpret the imagery. Some images reflect the rising interest in ancient Greek culture and literature that some of the council delegates helped foster through scholarly discussion and the texts they brought with them.[23] For example, Pisanello's profile bust—including the hat—served as a pattern for classical-style fictive portraits of such ancient Greeks as Theseus, Phocion, and Polybius in manuscript illuminations.[24] Such transfers resulted primarily from the enduring Gothic tradition of representing the past in contemporary terms, coupled with the common acceptance, given voice by Vespasiano da Bisticci, that the hat was "Greek." Vespasiano's misbelief that attire worn by the Eastern delegation to the council had not changed since ancient times was probably less widely shared during this period of increasing antiquarian study.[25]

Other borrowings result from the need for historical accuracy in representing past and contemporary events. The image of one of the last of the Byzantine emperors—heirs to the Roman imperial house—was topical in the years immediately following the fall of Constantinople in 1453. Outstanding examples of its adaptation to past events appear in the works of Piero della Francesca. In his frecoes in San Francesco, Arezzo, about 1454–1458, Piero rendered Constantine, the Roman founder of the Byzantine empire, in the guise of John VIII Paleologus—a straightforward analogy. Piero drew directly upon Pisanello's medal for the profile equestrian image of Constantine in *The Battle of the Milvian Bridge* even though he had himself seen the emperor in Florence in 1439 or learned about his appearance from sources other than the medal.[26] The innermost figure in the foreground of his *Flagellation of Christ,* also painted about the 1450s (Fig. 163), wears the yellow boots and crimson cloak described

162 Pisanello, Medal of the Byzantine Emperor John VIII Paleologus (obverse), bronze, 1438–1439. Staatliche Museen zu Berlin–Preussischer Kulturbesitz, Münzkabinett, Berlin (Coll. Benoni Friedländer 1861).

163 Piero della Francesca, *The Flagellation,* ca. 1450s. Museo Nazionale di Palazzo Ducale, Urbino.

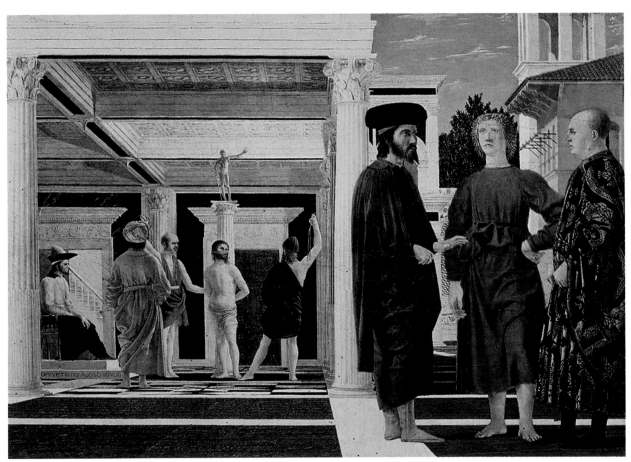

163

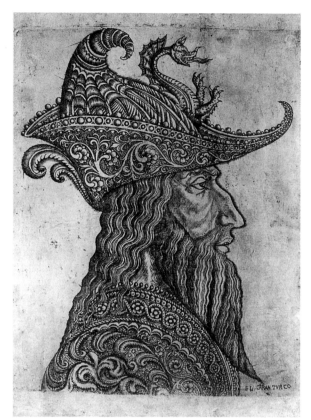

164

in Pisanello's study of John VIII on horseback (see Fig. 161), and the headgear on this figure as well as others in Piero's midcentury paintings presumably derives from that of the council's Eastern delegation.[27] In the *Flagellation,* the image of Pontius Pilate, the Roman governor of Palestine, also quotes Pisanello's medal, and likewise seems intended as historically accurate. Curiously, on both Constantine and Pontius Pilate, Piero colored the pointed hat rose and green rather than white, red, and black as noted by Pisanello. Aside from designating eastern Mediterranean places or persons, the meaning of other exotic costume from the council in Piero's paintings seems inconsistent today, inviting a variety of interpretations.

The medal's imagery proliferated in paintings dealing directly or indirectly with the momentous fall of Constantinople and the ongoing Ottoman conquest, such as several *cassone* panels by the Florentine workshop of Maso del Buono Giamberti and Apollonio di Giovanni.[28] In the *Conquest of Trebizond,* about 1461–1465, in the Metropolitan Museum of Art, New York, the emperor's hat marks King David Comnenus, who surrendered without a fight in 1461. In *Xerxes' Invasion of Greece,* Allen Memorial Art Museum, Oberlin, Ohio, about 1463, Byzantine costumes on the ancient Greeks—the Persian invaders are in fantastic Oriental dress—clarify an optimistic historical analogy with the failed campaign of 483–479 B.C.; the lost companion panel represented the triumphal procession of the victorious Greeks. In addition, Pisanello's august profile bust was converted into satirical images of the Ottoman sultan Mehmed II, whom Europeans called the Conqueror, Great Turk, and Terror of Christendom. These range from the sophisticated Florentine engraving entitled *El Gran Turco,* usually dated about 1475 (Fig. 164), to crude woodcuts in printed books.[29]

After 1453 there was an increasing need for authentic Ottoman imagery, both for cogent stereotypical Orientals and for programs referring specifically to the ongoing threat. Detailed images did not emerge, however, for nearly thirty years. Opportunities for observation, such as the Ottoman embassies to Venice in 1474 and 1479 that numbered about twenty persons each, contributed little if anything to the visual record. Representations remained

fantastic (as in Fig. 164) or relied on the *taj*—the small
white turban wound around a red cap with vertical
ribbing, introduced by Mehmed II—until Italian artists
invited to Istanbul brought home new visual documents
about 1481.[30] Though other Italian artists presumably
observed Ottoman visitors and a few worked in Istanbul
during the reign of Suleyman I, studies from life of Turks
and other Orientals are rare through the sixteenth century.

To pacify Mehmed the Conqueror when he requested
portraitists, Italian statesmen sent leading artists. Despite
the Muslim prohibition against human imagery, Mehmed
II had had a childhood interest in drawing caricatures and
busts; from it he developed the fifteenth century's most
active patronage of medals, undoubtedly to advertise his
dominion over a great eastern Mediterranean empire in
a traditional Mediterranean manner for a Western audi-
ence.[31] Indeed, he regarded himself as a new Alexander
the Great and dreamed of capturing Rome. In 1461 Si-
gismondo Malatesta of Rimini sent the Veronese artist
Matteo de' Pasti, but Venetians arrested him near Crete
on suspicion of carrying a map of the Adriatic and forced
him to return.[32] Ferrante I of Naples, when asked for a
painter, sent Costanzo da Ferrara, an itinerant artist.[33]
Costanzo arrived in Istanbul by 1475 and probably re-
turned to Naples after Mehmed's death on May 3, 1481.
Asked for "a good painter," sculptor, and bronze caster,
the Venetian Signoria sent Gentile Bellini and a sculptor,
both with assistants.[34] Gentile worked in Istanbul from
the fall of 1479 to late 1480 or early 1481. The sultan
probably employed other, unknown, Italian artists and
architects. It is clear that a number of artists contributed
to the late-fifteenth- and early-sixteenth-century vision
of the Ottomans, though their particular roles are not
yet fully understood.

Until recently, Costanzo da Ferrara's contribution
has been undervalued. He designed a portrait medal of
Mehmed II whose portrayal of a vigorous Oriental ruler
suited the intention to disseminate it internationally. It
exists in two versions, one dated 1481 that circulated,
and the other a unique undated piece (Fig. 165).[35] In the
profile bust, echoing the style of Pisanello, Mehmed
wears the characteristic *taj* and appears more robust than
in other portraits, notably the painting by Gentile Bellini
(mentioned below) that the sultan kept. Costanzo either

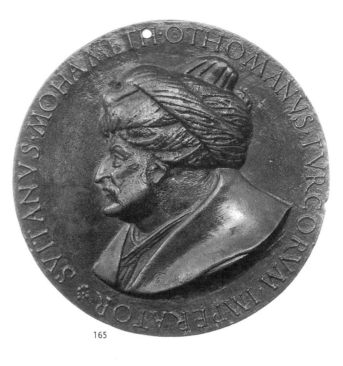

165

showed him younger or substantially idealized the image,
in accord with its purpose. The equestrian portrait on the
reverse represents him with a sword and a Western-style
baton.

Costanzo is currently considered the most likely author
of a group of exceptionally objective detailed images of
persons seen at court or on the streets of Istanbul that
have traditionally been attributed to Gentile. At least one,
a miniature of a seated scribe (see Fig. 183), long re-
mained in the royal collection in Istanbul and was often
copied by Turkish and Persian artists at the court.[36] The
miniaturist's fascination with the scribe's facial features
and his *taj* and belted robe—a *dolman* made from an
Italian-style brocade—distinguishes a series of seven
forthright studies of men and women in different ethnic
and official costumes that accurately record the mixed
population of Istanbul. Five of these drawings (Fig. 166
is one) are considered close European copies after Cos-
tanzo, indicating that his images circulated.[37] As a group
these drawings foreshadow popular sixteenth-century
costume books, which are, however, artistically inferior.
Some of Costanzo's figure studies certainly circulated in
Italy because three were used by Pintoricchio in the 1490s
and early 1500s.

166

166 After Costanzo da Ferrara (?), *Standing Oriental*, ca. 1470s–1480s. Städelsches Kunstinstitut, Frankfurt am Main (3957).

167 Pintoricchio, *The Disputation of Saint Catherine of Alexandria before Emperor Maximilian*, 1492–1494. Sala dei Santi, Borgia Apartments, Vatican Palace, Vatican City.

Pintoricchio used these authentic Turkish figures in two paintings about the Ottoman threat to Christendom.[38] The more noteworthy work artistically is *The Disputation of Saint Catherine of Alexandria before Emperor Maximilian* (Fig. 167). It occupies a prominent position in the decorations of the Sala dei Santi in the Borgia Apartments at the Vatican, executed by Pintoricchio and his shop between the end of 1492 and the beginning of 1494 for Pope Alexander VI (Rodrigo Borgia, 1492–1503).[39] The paintings represent saints receiving divine assistance in times of great need. Pope Alexander's patron saint was Catherine of Alexandria, on whose feast day, in 1492, the Muslim kingdom of Granada in his native Spain had fallen. The painting expressed the hope that God and Saint Catherine would give the pope, facing the Ottoman advance (against which he had long advocated a crusade), the same assistance. Pintoricchio's three exceptionally realistic Ottomans, conspicuously located in front of a cosmopolitan crowd representing the fifty philosophers who attended Saint Catherine's disputation, epitomize the Ottoman threat and would have drawn the contemporary viewer's attention to it. Flanking Maximilian's throne at left are two standing figures copied from Costanzo; Figure 166 shows one of them.[40] By slightly altering the faces and substituting luxurious patterned silks for simpler striped and plain fabrics in the kaftans and cloaks, Pintoricchio elevated Costanzo's street figures to court status, undoubtedly to balance the elegant equestrian figure at the right. He is probably Prince Cem Sultan, the fugitive son of Mehmed II who lived in Rome under papal supervision beginning in 1489.[41] Pintoricchio also used Costanzo's study of a seated janissary guard for an accessory figure in the *Martyrdom of Saint Sebastian* across the room.[42]

The diplomatic importance of Gentile Bellini's artistic mission to Mehmed II and the prestige he derived from it generated a myth about his contribution to orientalism in Renaissance art. Scarcely five weeks after the Venetian Signoria received the sultan's request for "a good painter" (August 1, 1479), the Republic's senior artist embarked on the perilous journey (September 3). Gentile's own diplomatic gift to the sultan was his father Jacopo's sketchbook now in the Louvre. After his return, Gentile publicly vaunted his mission in paintings celebrating Venice's history. He included a self-portrait with the gold

chain presented to him by Mehmed in his first story of Saint Mark for the Scuola di San Marco (see Fig. 173) and commemorated his contribution to Venice's great diplomatic tradition in a signature on a painting in the Great Council Hall.[43] Nevertheless, Ottoman imagery in Venetian painting did not significantly increase following Gentile's return, nor is there any evidence that he brought back views of Istanbul or extensive studies of its inhabitants.[44]

The only works that survive from Gentile's visit are two portraits of the sultan: a medal, and a painting dated November 25, 1480, now in the National Gallery, London. The bust on the obverse of the medal emphasizes Mehmed II's deep-set eyes, long hooked nose, and receding chin more than Costanzo's medal. The reverse bears three crowns symbolizing the sultan's rapidly expanding empire and a signature referring to honors the sultan reputedly conferred on Gentile.[45] Gentile's bust was the model for a medal Lorenzo de' Medici had the sculptor Bertoldo di Giovanni design as a gift to Mehmed in 1480/81, in appreciation for the sultan's extradition

in 1479 of Giuliano de' Medici's fugitive assassin.[46] In Gentile's painting, Mehmed appears thinner and less vigorous than on the medals, probably an accurate reflection of his poor health, which he tried to conceal by retreating to his new palace after January 1479.[47] The painting remained in the royal collection until Bayezid II sold some of his father's Western-style art. Though a Venetian merchant supposedly bought it at the bazaar in the European quarter of Pera, this portrait had no impact on Italian art. Most scholars, while accepting the report of Giovan Maria Angiolello, an Italian then living at court, that Mehmed wanted Gentile to draw Venice and do many portraits, and that he executed portraits of courtiers and some lascivious images,[48] discount seventeenth-century reports of other works.[49] Three Turkish figures Gentile painted after his return survive in the tiny, sketchily rendered Ottoman bystanders in the background of his *Procession in the Piazza San Marco*, finished in 1496. Authentic and fresh, they attracted Albrecht Dürer's attention during a visit to Venice in 1494–1495, while the work was in progress.[50] But there is no evidence

168 Giovanni Mansueti, *The Arrest and Trial of Saint Mark,* 1499. Princely Collections, Vaduz Castle, Vaduz, Liechtenstein.

169 Anonymous Venetian, *The Reception of the Ambassadors in Damascus,* ca. 1488–1495. Musée du Louvre, Paris.

that Gentile provided more varied or detailed information on Ottomans to contemporary artists.

Although fifteenth-century painters commonly represented local landmarks in religious as well as historical paintings, and even though many patrons were interested in geography, realistic foreign settings are rare in Italian art until the end of the fifteenth century. By the 1460s a few painters were drawing upon maps, views, and historical sources for details in background representations of the Byzantine world, Constantinople, and Jerusalem.[51] Toward 1500 such interest in geographical

168

169

accuracy coincided with the Venetian narrative painting style, a revival of the cult of Saint Mark, and new visual information on the Mamluk world to inspire the most detailed representations of a contemporary Eastern locale in Italian Renaissance art.

Syrian, Palestinian, and Egyptian costumes and settings play such an important role in a group of Venetian paintings dating from about the mid-1490s to the early 1520s that the term "orientalism" is legitimate. The marked shift from Byzantine or Ottoman to Mamluk imagery was purposeful, constituting a distinct iconography that has been called the Mamluk mode.[52] It fulfilled a need for authentic contemporary imagery for historical events that had taken place in the eastern Mediterranean. Recent paintings commissioned by the Republic's guilds and lay confraternities (scuole), such as Gentile Bellini's Procession in the Piazza San Marco for the Scuola Grande di San Giovanni Evangelista (see Fig. 68), reenacted local history and legend as a series of events unfolding in the midst of everyday contemporary life. The Venetian settings, events, and surrounding activities are depicted in minute detail, with numbers of citizen observers present, so as

to authenticate the events. Aptly called the eyewitness style, it has often been likened to contemporary Venetian chronicles and diaries that record history in a string of personally observed, graphically described anecdotes.[53] The Mamluk iconography first appeared in a new cycle of the story of Saint Mark in the chapel of the silk weavers' guild in Santa Maria dei Crociferi that postdates 1495 (Fig. 168). A Mamluk context was geographically appropriate for events in the Venetian legend of Saint Mark, set principally in Alexandria. Furthermore, because of their long close commercial and diplomatic relationship with the Mamluk empire, which was tightly woven into Venice's history and fame, many Venetians could recognize and appreciate this foreign context. The recent arrival of authentic images of Syria and the Holy Land enabled painters to represent stories of Saint Mark—and soon other Eastern Mediterranean saints—in the style Venetian patrons expected.

The most important painted source was The Reception of the Ambassadors in Damascus (Fig. 169).[54] It probably appeared in Venice after Dürer's first visit, about 1495, since he did not begin to use its imagery until after his

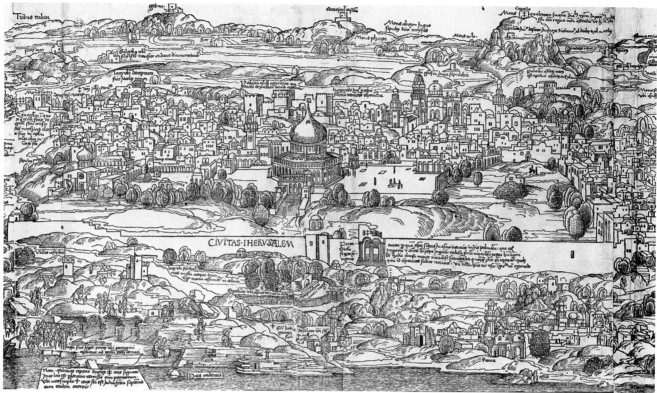

CIVITAS·IHERVSALEM

170

second visit in 1505–1507, and it was certainly available to Giovanni Mansueti by 1499, the date of his *Arrest and Trial of Saint Mark* (Fig. 168). Traditionally attributed to the circle of Gentile Bellini, the *Reception* is by a still unidentified artist who was familiar with contemporary Venetian style. His recognizable representation of the dome, facade, and three minarets of the Great Mosque of Damascus postdates 1488, when the western minaret appearing on the left was completed. The composite view of the city contains so much knowledgeable detail that it must have been painted in Damascus or put together elsewhere from detailed studies as well as personal visual experience. It shows both characteristic architectural components of an Islamic city—the mosque, market, bathhouse, and walled garden—and distinctive architectural details, such as window screens and rooftop terraces on private houses, and bichrome masonry and blazons typical of Qaitbay's time. The costumes, furniture, and protocol of the diplomatic reception in the center have been studied from life and correspond so closely to the

written description of a Venetian embassy to Cairo in 1512 that that embassy was once thought the subject of the painting.[55] Instead, the picture must commemorate a reception in the courtyard of the *naib* of the citadel, the emir who represented the person of the sultan in Damascus,[56] and was probably commissioned by a Venetian who attended it. Surviving copies of the image indicate that the painting was well known.[57]

The *Reception of the Ambassadors* provided a compendium of the Mamluk urban milieu from which Venetian painters selected authenticating details. Perhaps most appreciative of the richness of its imagery was Giovanni Mansueti, whose *Arrest and Trial of Saint Mark* is probably the earliest surviving work to draw upon it (see Fig. 168).[58] Various male headgear, the robes worn with long white stoles, and the blazon—misunderstood—establish the Alexandrian locus of Mansueti's totally fabricated late antique setting. He used the same costumes and blazon, plus several entire figures from the *Reception,* for other scenes in the life of Saint Mark executed for the Scuola

Grande di San Marco between 1505 and 1526, and some of the headgear for the *Adoration of the Magi* in the Civico Museo Castelvecchio, about 1500.[59] Mansueti's repetition of the robe and stole from the street scene with all types of headgear betrays the superficiality of his borrowings.[60]

The other major source of authentic imagery was the first illustrated travel book: the *Peregrinationes* by Bernhard von Breydenbach, bishop of Mainz, with woodcuts by Erhard Reeuwich, printed in Mainz, Germany, in 1486. Reeuwich, a Dutchman who accompanied Breydenbach on his pilgrimage to the Holy Land and Egypt, drew views of Jerusalem (Fig. 170), Mamluk landmarks, Mediterranean stopovers, and also various ethnic male and female costumes (for example, that shown in Fig. 171). Although imagery from the *Reception of the Ambassadors* is rare outside Venice, artists throughout Europe drew figurative and topographic information from Reeuwich's woodcuts.

Apparently the first Venetian to use them was Vittore Carpaccio, who interpreted them imaginatively.[61] Characteristically, he took considerable license with geography and detail in his painstakingly constructed settings, as in the stories of Saint George executed for the Scuola di San Giorgio degli Schiavoni between 1502 and 1508. The saint was associated with sites in both Syria and Palestine,[62] and Carpaccio marked his backgrounds with various monuments in Mamluk territory. The *Triumph of Saint George* (Fig. 172) features several selected from Reeuwich's woodcut of Jerusalem (see Fig. 170). The two

170 Erhard Reeuwich, *View of Jerusalem*, detail of a woodcut in Breydenbach's *Peregrinationes*, 1486.

171 Erhard Reeuwich, *Saracens*, woodcut in Breydenbach's *Peregrinationes*, 1486.

172 Vittore Carpaccio, *The Triumph of Saint George*, 1502–1508. Scuola di San Giorgio degli Schiavoni, Venice.

171

172

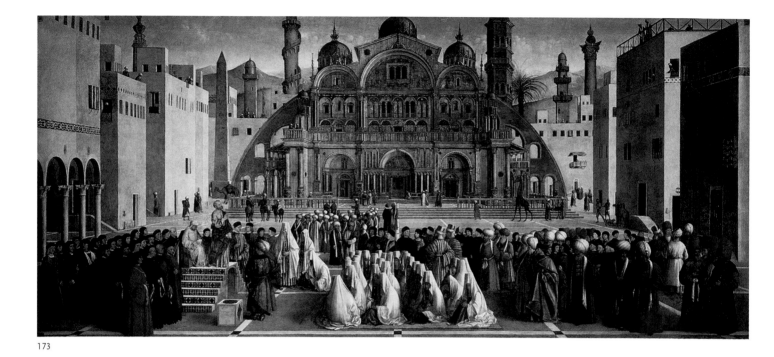

173

173 Gentile Bellini, *Saint Mark Preaching in Alexandria,* 1504–after 1506. Pinacoteca di Brera, Milan.

separate towers at the left of the painting derive from the tower and facade of the Holy Sepulchre (at upper right in the woodcut). Carpaccio copied the tower quite closely at the far left, but perhaps misinterpreting the facade as another tower, he detached it and crowned it with the minaret of the mosque in Reeuwich's view of the nearby port of Rama (at lower right in the woodcut). The Dome of the Rock, the Islamic shrine Europeans associated with the Temple of Solomon, and its paved platform appear in the center of Carpaccio's Jerusalem just as they do in the woodcut. Although the dome in the painting has the correct hemispherical shape rather than a pointed one, it is not known whether Carpaccio imaginatively remodeled the building in a classical style or relied upon another visual source. He did use an unidentified visual source for a fortified gate, modeled on the Bab al-Futuh in Cairo, in the background of his *Saint George Fighting the Dragon.*[63] Costumes in his paintings draw heavily upon those in Reeuwich's *Saracens* woodcut (see Fig. 171)—for example, the veiled woman on the left and the man on the extreme right in the *Triumph of Saint George* (see Fig. 172)—and upon those in the *Reception of the Ambassadors* more generally for the headgear in *Saint George Baptizing*

the Pagans.[64] Carpaccio's exceptional ability to interweave fact and fantasy made him Venice's most successful orientalist painter. That he offered a large view of Jerusalem to Marquis Francesco Gonzaga of Mantua in 1511 has misled some scholars into believing that Carpaccio actually traveled there.

Gentile Bellini's travel to Istanbul was irrelevant to the Mamluk mode, but he nonetheless reminded his contemporaries about his expertise in his only surviving painting with Mamluk iconography, the *Saint Mark Preaching in Alexandria,* begun in 1504 for the Scuola di San Marco (Fig. 173).[65] His conspicuous self-portrait, with the gold chain awarded by Sultan Mehmed, faces the only figure in Ottoman dress. Otherwise, the Eastern costumes derive directly from the *Reception of the Ambassadors* and Reeuwich's woodcuts, or indirectly, from Carpaccio's and Mansueti's versions of them.[66]

With remarkable resourcefulness, Gentile constructed a specifically Alexandrian equivalent for Piazza San Marco. The church facade blends elements of Saint Mark's and the Scuola di San Marco in Venice with arcaded buttresses, probably remembered from Hagia Sophia in Istanbul, that remove it from the Venetian context.[67] That Gentile extended the Islamic-style window grills of the Porta Sant'Alippio (Fig. 8) across the entire second story supports the theory that earlier Venetians considered them authentically Alexandrian.[68] Gentile imaginatively constructed Alexandria's famous antique monuments: the Pharos lighthouse at the far left; the obelisk from Heliopolis; and the Column of Diocletian, also known as the Pillar of Pompey, on the far right. His immediate sources were undoubtedly reports from Italians who had recently traveled overseas, such as Cyriacus of Ancona.[69] Cyriacus visited Alexandria in 1412–1414 and again in 1435–1436, when he continued up the Nile to Cairo and Upper Egypt, a journey Europeans rarely made. A letter written to Pope Eugenius IV about his second trip mentioned these Alexandrian monuments and exotic animals seen in Upper Egypt; another letter, to Filippo Maria Visconti of Milan, included drawings of a white elephant, giraffe, dromedary, and crocodile. These letters and other reports of Cyriacus's travels in the Greek East, principally in search of antiquities, were widely copied and circulated. Gentile's awkward giraffe is almost certainly taken

from a copy of the letter to Filippo Maria Visconti, such as that in the Biblioteca Medicea-Laurenziana, Florence.[70] This manuscript also contains drawings from Cyriacus's trip to Samothrace that were used by Gentile's brother-in-law, Andrea Mantegna, suggesting that Gentile had access to Cyriacus either through his relative or their mutual patrons, the Gonzagas in Mantua. In 1493 Gentile drew a view of Cairo for Francesco Gonzaga, perhaps utilizing a view owned by Francesco Teldi that Gentile told the marquis was unique in Venice.[71] Gentile must have derived his minaret with a spiral staircase, modeled on the Mosque of lbn Tulun in Cairo, from such a lost visual source, which may also have provided Carpaccio with an image of the Islamic Bab al-Futuh. From the *Reception of the Ambassadors* (see Fig. 169), Gentile selected the urban palm tree and rooftop balcony on the right. The plethora of detail suggests that Gentile was defending his status as a true orientalist.

The Ottoman conquest of the Mamluk empire in 1517, the deaths of Gentile in 1507 and Carpaccio and Mansueti in the 1520s, and the new style of Giorgione and Titian doomed the Mamluk mode in Venetian history painting.[72] Focusing on grand themes and dramatic climax, Titian avoided detailed settings and costumes, and his rare Oriental figures are generic.[73] For example, a highlighted *taj,* seen from the rear, suffices to identify an Ottoman prisoner appearing in deep shadow at the extreme left of the *Madonna of the Pesaro Family,* 1519–1526, in the Chiesa dei Frari, Venice.[74] The figure refers to the family's participation in the defeat of Ottoman forces off Santa Maura in 1502 that is incidental to the Madonna's miraculous presence before the family. Typical of Orientals in later-sixteenth-century Venetian narrative painting are the faceless Turks in Tintoretto's *Miracle of the Slave,* painted for the Scuola di San Marco in 1548 and now in the Accademia, Venice.[75] From the Italian perspective, the eastern Mediterranean now appeared so monolithic and threatening that it was neither necessary nor desirable to go beyond stereotypes.

There was a need for images of eminent Turks and others serving the Ottomans, however, both for the fashionable galleries of famous men and women and for prints commemorating events of interest to Italians. Their authenticity and objectivity varied. An example of

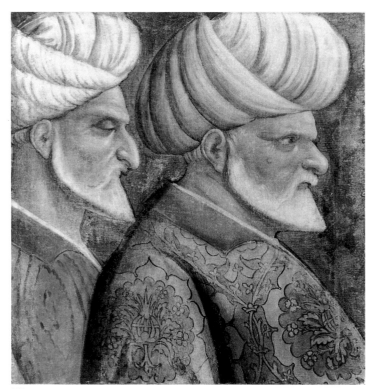

174

the most realistic, by an unknown, probably Venetian copyist, is the dual portrait *Sinan the Jew and Haireddin Barbarossa* (Fig. 174).[76] The likenesses of these notorious corsairs—captain Yahud Sinan on the left, and Barbarossa, an Algerian of Greek origin who became the grand admiral of Sultan Suleyman's fleet, on the right— probably derive from drawings or paintings executed by Venetian artists known to have worked in Istanbul during the 1530s for cosmopolitan courtiers such as Grand Vizier Ibrahim Pasha (d. 1536). Both Barbarossa and Sinan were in Istanbul between November 1533 and June 1534. The copy was probably made in Italy for Paolo Giovio (1483– 1552), a historian and portrait collector who maintained close ties with Italians trading at the Ottoman court. The fragmentary double portrait may have belonged to a series decorating the walls of the Sala de' Turchi in Giovio's villa at Como from 1543. Among Turkish objects

displayed in the room were a Quran owned by Barbarossa, a velvet kaftan, and vessels for eating and washing. These images acquired authority and circulated widely through copies offered by Giovio and illustrations in the posthumous publication of his portrait gallery in 1571.

Among the famous men and woman that Titian painted for eminent European collectors were Sultan Suleyman, his official wife, and her daughter or lady-in-waiting.[77] The lost originals are known only through later versions, which vary. The female images were certainly fictional, with ideal heads and exotic headdresses and costumes.[78] The images of the sultan, four of which are mentioned in contemporary sources, were certainly idealized and featured the standard *taj*.[79] The earliest, painted for Duke Federigo Gonzaga of Mantua in 1538, was said to have been done from a medal. Indeed, later versions are profile busts with facial features that are distantly related to a medal, and an Italian print of about 1532 (see Fig. 175) but much more regular. Evidently, there was a significant demand for Ottoman imagery of the highest artistic quality that was dignified though not particularly accurate.

The Venetian engraving *Sultan Suleyman I Wearing the Jewel-Studded Helmet* (Fig. 175) records a helmet made for the sultan in Venice and exhibited at the Doge's Palace before it was shipped in 1532 and a likeness of the sultan that would have been recognizable.[80] The anonymous artist's portrayal of a weak-chinned Suleyman in large headgear that from an Italian perspective has an outrageously pretentious resemblance to the papal tiara, however, descends from the fantastic and satirical images of Mehmed II (see Fig. 164), based on Pisanello's pattern for the profile bust of an Oriental ruler (see Fig. 162). For his woodcuts of 1535 commemorating Charles V's recent victory over Barbarossa in Tunis, Agostino Veneziano copied this image of Sultan Suleyman, giving him a fiercer expression.[81]

The first objective images of the sixteenth-century Ottoman ambient that circulated in the West came from northern Europe rather than Italy. After a consortium of merchants in Antwerp, Venice, and Istanbul failed to sell Ibrahim Pasha, Suleyman's grand vizier, a series of Brussels tapestries representing contemporary Ottoman scenes, the unused designs were published in 1553 in eight engravings entitled *Customs and Fashions of the*

Turks.[82] The designs, prepared in Istanbul about 1533 by the Flemish artist Pieter Coecke van Aelst, provide composite views of the Istanbul cityscape and Ottoman costumes that are comparable to the earlier Italian *Reception of the Ambassadors* painting of Damascus (see Fig. 169). Some 120 engravings issued from about 1562 after drawings by the Danish artist Melchior Lorck, who accompanied the Hapsburg ambassador Ogier Ghiselin de Busbecq to Istanbul in 1557–1561, furnished Europeans with more architectural views and ordinary costumes plus full-length portraits of Ottoman dignitaries in their surroundings.[83] The most influential of these midcentury European publications was an illustrated travel book by Nicolas de Nicolay, geographer to the king of France, first printed in 1568 in Lyons as *Les quatres premiers livres de navigations et pérégrinations orientales.* Its text and woodcuts provided the first systematic guide to the vast Ottoman empire's inhabitants, male and female, each identified by region and occupation, from the multiethnic janissaries to the "woman of Caramania who sells eggs, chickens, milk, and cheese on the city streets" (Fig. 176). Nicolay's illustrations emphasize the picturesque but give the enemy a less menacing, more human image. The book, reissued in several editions and translations, spawned an international industry.[84] By the 1590s locally produced versions were available in Italy and Istanbul.[85]

In Italy too commercial publishers of books and prints were ahead of elite artistic patronage in seeking out new information on the East. Despite centuries of commercial and diplomatic contacts, most Italians, until well into the sixteenth century, knew little about the history and culture of the Islamic world. Memoirs of diplomats and other travelers who had overcome language barriers and restrictive commercial practices were not published in quantity until the 1540s, when curiosity about foreign places, peoples, and nations was rising throughout Europe. Thereafter publications proliferated in Venice, which had exceptional documentary evidence and printing resources.[86] Numerous citizens' manuscripts were published for the first time together with reprints of noteworthy earlier publications. For example, in 1543 Antonio Manuzio printed a collection of travelers' accounts ranging from Giosafat Barbaro's voyage to Tana in 1437–1438 to Benedetto Ramberti's visit to Istanbul in 1533. Giovanni Battista Ramusio's anthology of inter-

174 Anonymous, probably Venetian (traditionally attributed to Giovanni Bellini, Venetian, ca. 1430–1516), *Sinan the Jew and Haireddin Barbarossa*, tempera on canvas, 66.5 × 63.7 cm., ca. 1535. The Art Institute of Chicago, Charles H. and Mary F. S. Worcester Collection (1947.53).

175 Anonymous Venetian, *Sultan Suleyman I Wearing the Jewel-Studded Helmet*, engraving, 1532. British Museum, London (P&D 1845-8-9-1726).

175

national voyages was printed four times, beginning in
1550. It included Ludovico de Varthema's lively narrative
of his experiences, disguised as a Muslim, in Mecca, Aden,
and India that had already been printed six times in Italy
between 1510 and 1535. Giovan Maria Angiolello's *His-
toria Turchesca,* which covered the period from 1300 to
1514 and included an eyewitness account of the court of
Mehmed II, was finally published in 1559. The admiration
Francesco Sansovino expressed for the organization and
prosperity of the Ottoman empire in a history published
in 1564 had to be toned down when a new edition was
issued in 1582, by order of the Inquisition.

The publication of visual information advanced more
slowly. The first Italian illustrated costume book was
printed in Venice in 1563 with engravings by Enea Vico
that also belong to the history of caricature. His images
included a Turkish servant boy, male and female Ethiopi-
ans, Tatars, and three African women—labeled virgin,
married, and widowed. Giacomo Franco's factual engrav-
ings in a book about Venetian costumes and festivals,
published in Venice about 1570, show Turks, French,
English, and Greeks among the crowds at outdoor
spectacles. Franco's illustrations advertised the city's
cosmopolitan character and the book's practical function
as a tourist guide. Leading artists commemorated the
victory at Lepanto in 1571 in numerous battle scenes
and votive paintings that contributed no new information
on the Ottoman locale.[87]

The tolerable if uneasy status quo and increased trade
and travel following Lepanto finally spurred Italian
publishers to seek out new visual information. In 1580
an Italian version of Nicolay's book of Turkish costumes
was printed by Ziletti in Venice with five new illustrations
from an unknown source at the end. About 1580 a book
of European and Oriental costumes, with engravings by
Martino Rota, was published in Rome; a second edition
followed in 1585. Rota also engraved a series, *The Battle
of Lepanto.*[88] The most successful Italian costume book
was Cesare Vecellio's encyclopedic *Habiti antichi e moderni
di tutto il mondo* (Ancient and modern costumes from all
over the world), first published in Venice in 1590 and
reprinted many times (see Fig. 178). Vecellio assembled
his Oriental images from a tangle of sources including
Mansueti, Gentile Bellini, and Nicolay, whose book was

Femme de Caramanie.

176

also the model for his captions.[89] Though the costumes emphasize geographical and historical differences, similarities in occupation and social status unite these persons as human beings. The costume book format and Vecellio's sources limited the scope and veracity of the information but evidently gave the public what it wanted.

A group of twenty miniatures of Ottoman figures by the Florentine artist Jacopo Ligozzi, now in the Uffizi, elevated the artistic level of the printed illustrations and show how late-sixteenth-century images of Orientals continued to propagandize as well as inform.[90] Closely related to Ligozzi's drawings of plants and animals for Francesco I de' Medici and his brother Ferdinand I, they were probably prepared for a luxury costume book between about 1577 and 1580. Ligozzi accompanied the figures with animals, many of them exotic, that allude to the person's character or occupation. Most of the representations derive from Nicolay and are intended to be picturesque but factual. For example, in *The Woman of Caramania* (Fig. 177), Ligozzi plausibly upgrades Nicolay's street vendor (see Fig. 176), giving her a more elegant pose and headscarf, and substituting a duck and an "Egyptian turkey" (*[tac]hina di Egitto*) for chickens. His least realistic image is *Mufti, the Pope of the Turks*.[91] The figure is the only one in the group with a profile head, which belongs to the tradition of exaggerated Oriental stereotypes (see Figs. 164, 175). Though the Ottoman mufti and other Muslim dignitaries reportedly wore larger-than-normal turbans about this time,[92] the one on Ligozzi's figure is enormous, and he is paired with an awesome "Monster," who wields a horrific cudgel and a huge key. The contrast with the Christian pope could not be more obvious. Vecellio's caption, however, describes this personage straightforwardly in keeping with the factual tone of the book: "The Mufti, who administers and manages all spiritual matters and is supreme over religious Turks, always dresses in watered green mohair" (Fig. 178). Nonetheless, the scowling visage beneath the huge turban perpetuates the sinister image of Islam. In matters of faith, Italian perceptions had not changed since the late Middle Ages and imagery, in comparison with that of Giotto (see Fig. 159), had even regressed.

Until the end of the fifteenth century, Italians' visual knowledge of Orientals essentially depended on visitors

176 *Woman of Caramania Who Sells Eggs, Chickens, Milk, and Cheese on the City Streets,* woodcut in Nicolas de Nicolay's *Quatres premiers livres de navigations et pérégrinations orientales,* 1568.

177 Jacopo Ligozzi, *Woman of Caramania,* ca. 1566/67–1580. Gabinetto di Disegni, Gallerie Nazionali degli Uffizi, Florence (2950F).

177

178

178 *Mufti,* woodcut in Cesare Vecellio's
Habiti antichi e moderni di tutto il mondo,
1590.

seen in Italy, and artists adaptively reused a small reper-
tory of authentic data, supplemented by fantasy. Since
Italians had a narrow understanding of Islamic and
Mongol cultures and great respect for Byzantine links
to the Greco-Roman tradition, with some artistic inge-
nuity the available imagery was adequate for visual and
historical accuracy in contemporary subject matter.
Though Italian artists working for Mehmed II in Istanbul
brought home some fresh high-quality Ottoman imagery
about 1480, it seems to have been limited. Furthermore,
there was little change in representational needs and
artistic practices until Venetian taste in narrative painting
and the arrival of authentic images of the Mamluk
ambience converged to produce a detailed vision of
the contemporary eastern Mediterranean toward 1500.
Venetian orientalism raised the traditional mix of fact
and fantasy to a peak of sophistication. There was no
comparable expansion of Turkish imagery then or in
subsequent decades, however, and the repertory con-
tinued to be adapted to a traditional range of realistic,
standardized, and satirical representations that reflect
Italian ambivalence toward the Ottoman world. In the
second half of the century, a rising European interest
in Turkish history and culture fed by printed books
and northern European prints as well as relaxation of
strategic tension slowly encouraged more varied, human,
and down-to-earth Ottoman imagery.

Thus far, we have considered how foreign trade and
travel contributed to Italy's fine and decorative arts. As
the Mamluk empire declined and the Ottoman empire
rose, Italy's luxury goods equaled or surpassed those
produced in the Islamic world. The final chapter, which
follows, examines the reception of Italy's decorative arts
in the Islamic world, focusing on the Ottoman response
and the community of taste that developed around the
Mediterranean.

Chapter 10

..

FROM BAZAAR
TO PIAZZA AND BACK

MEDITERRANEAN TRADE IN MANUFACTURED LUXURY goods became multidirectional in the fifteenth century and remained so during the sixteenth. Italy's mercantile and shipping network, which both facilitated the diffusion of Italian goods and brought into Italy goods from elsewhere, continued to foster a community of taste around the Mediterranean. Though the balance of East-West trade had shifted in Italy's favor, there was no decisive reversal of direction in either the flow of goods or their artistic influence. As the Mamluk textile, glass, and ceramics industries declined, Italian, Spanish, and Chinese imports increased in the eastern Mediterranean but stimulated no artistic response or revival there. The new Mamluk carpets were popular throughout the Mediterranean and had an impact on the Turkish industry, while export brassware, much of it probably made in Syria, inspired Italian imitations. The rising Ottoman empire offered a lucrative market for Italian goods, but competitive industries soon developed. Italian textiles were a major source of inspiration to the rapidly developing Ottoman industry, reversing the direction of artistic and technological transfer that had occurred two centuries earlier. The Italian industry, however, unlike those of Islamic countries earlier, competed forcefully to maintain its favorable balance of trade. The Ottomans and Italians also engaged in some reciprocal artistic exchange in ceramics. The Italians' successful trade in Renaissance luxury goods with the Islamic world underscores Italy's achievement and the widespread community of taste, and exchanges between Italy and

Ottoman Turkey indicate the full recognition and acceptance of an international luxury trade.

Murano glassware received almost unqualified welcome in the East. As early as the fourteenth century, Venetian galleys had carried painted drinking glasses as far as the Black Sea, and exports to the Islamic eastern Mediterranean soared after the collapse of the Syrian industry and improvements in the Italian one. Archaeological evidence and surviving examples show that Venetian glass competed favorably in the Mamluk empire with Barcelona glass, which had closer links to the Islamic glassmaking tradition. Apparently, both Venice and Barcelona produced mosque lamps for export. A lamp (Fig. 179) that bears the legible, though awkwardly formed, name of Sultan Qaitbay and came from his madrasa in Cairo, built in 1474, has traditionally been attributed to Venice but could have been made in Barcelona.[1] The lily-of-the-valley motif is common on Barcelona as well as Venetian glass, and the style of the lamp's other ornament is not particularly Venetian. Indeed, the composition and filler motifs are uncharacteristically awkward. Two undecorated late-fifteenth- or early-sixteenth-century mosque lamps from Cairo, in the Victoria and Albert Museum, London, are Venetian.[2] Both are clear, brownish colorless glass; one closely copies the angular Syrian mosque lamp shape like that of Figure 179, while the other has a globular body and long neck similar to those of the elaborate Venetian piece in Figure 129. The only notice of Venetian glass destined for a Mamluk patron comes from Santo Brasca of Milan's account of

179

his pilgrimage in 1480. His Venetian ship, captained by a Contarini and bound for the port of Jaffa, carried some "crystalline vases" (or vessels) made in Murano for a Mamluk official in Damascus.[3] It seems likely that such individually ordered pieces were mosque lamps.

Despite the generally conservative taste of the Mamluk elite, late-fifteenth- and early-sixteenth-century Venetian glass excavated in Syria and Egypt, or bearing a patina suggesting an Eastern provenance, shows no additional evidence of an export production accommodating Islamic artistic tradition.[4] Eastern Mediterranean customers admired various standard Venetian types shaped and decorated in the usual predominantly Western styles. They seem to have preferred enameled and gilt colorless glass, the type most closely related to fourteenth-century Syrian glass. Other types perhaps distantly related to earlier Egyptian and Syrian marvered glass were also popular: *latticinio* (clear glass combined with threads of milk glass, forming stripes in various patterns) and combinations of colorless with colored glass or of

colored threads with white.[5] Colored glass vessels are rare. The Western goblet was accepted in various forms, as well as mold-blown vessels. Some elegant *latticinio* vases indicate the existence of a market for distinguished pieces. It has been proposed that a group of mold-blown tumblers with lozenge decoration in relief like that Figure 128 that were excavated in a Jewish cemetery near Damascus served as memorial lights, but there is no evidence that they were ordered rather than adapted for that purpose.[6]

The Ottomans did not develop a glass industry but imported huge quantities of Venetian glassware, whose style elite patrons readily accepted. In 1560, for example, the Venetian ambassador in Istanbul reported that textiles and glasses were the major imports from the Republic, and in 1580 a huge shipment of two thousand glasses en route to Istanbul was lost in a shipwreck off Dalmatia.[7] A dispatch of June 11, 1569, from Ambassador Marcantonio Barbaro to Doge Pietro Loredan contained an order from Grand Vizier Mehmed Solloku Pasha for nine hundred lamps for a mosque under construction, and a larger lamp for his seraglio.[8] Sketches for the lamps indicating their size and shape were enclosed: three hundred each in "the larger shape," the traditional Syrian type (Fig. 180); "the long shape," a Venetian *cesendello* (a hanging lamp, Fig. 181); and the long shape again but fifty percent larger. The sketches bear written instructions that knowledge-able Venetian craftsmen should determine the actual proportions of the lamps, and that some should be plain and others bear *latticinio* decoration. Five types of Vene-tian mosque lamps survive in Istanbul museums.[9] Blue and manganese purple lamps with a Syrian shape in the Islamic Museum relate to one of the undecorated Venetian mosque lamps from Cairo in the Victoria and Albert Museum mentioned above. Three types in the Topkapi Museum have spherical bodies and tall necks in the Venetian style. One of these is made of colorless and green glass with molded spiral ribbing. The rest have spiral *latticinio* decoration, first produced in the 1530s, that corresponds with the grand vizier's commission; on some of them court artists in Istanbul added an Oriental touch: bold cold-painted Ottoman floral motifs (Fig. 182). Also at Topkapi are two *cesendelli* whose unusually large size and *latticinio* decoration, with white stripes alternat-ing with red or blue ones, also correspond with the 1569

commission. Though this Roman shape was known in the eastern Mediterranean in late antiquity, it disappeared there until the Venetian glass versions arrived. Contemporary visual sources show that Venetians and Turks used the *cesendello* in the same way. In Venetian paintings, it hangs in churches; in a 1552 book illustration of Turkish religious customs, it hangs above a figure kneeling in prayer.[10]

Italian ceramics had great influence in Spain after the Christian reconquest was completed in 1492 but only a modest impact in the eastern Mediterranean. By the end of the fifteenth century even the popular Hispano-Moresque lusterware had been modified to compete with Renaissance earthenware. Embossed and molded ornament was introduced, at first to coats of arms to dramatize them, and finally to the entire body of a piece to compete with the shapes of contemporary Italian metalwork and molded glassware.[11] On the whole, the decorative arts of Christian Spain echoed those of Renaissance Italy. It is now believed that gold-tooled leather bookbinding spread from Naples to Spain toward the end of the century rather than vice versa several decades earlier.[12]

179 Mosque lamp bearing the name of Sultan Qaitbay, enameled colorless glass, Barcelona or Venice. Museum of Islamic Art, Cairo (333).

180 Drawing for a mosque lamp, sent to Venice from Istanbul by Ambassador Marcantonio Barbaro, June 11, 1569. Archivio di Stato, Venice (Senato, Dispacci degli Ambasciatori da Costantinopoli, filza 4, fol. 105v).

181 Drawing for a lamp, sent to Venice from Istanbul by Ambassador Marcantonio Barbaro, June 11, 1569. Archivio di Stato, Venice (Senato, Dispacci degli Ambasciatori da Costantinopoli, filza 4, fol. 104r).

180 181

Italian maiolica seems not to have been popular in Egypt and Syria. There is archaeological evidence of thirteenth-century South Italian tin-glazed pottery at crusader-occupied sites in Greece, Syria, and the Holy Land,[13] but little evidence of widespread later Italian imports even after the decline of local industries in the fifteenth century. By that time the Mamluk elite had already acquired a taste for Chinese porcelain, which Egyptian and Syrian potters had begun to imitate. Archaeological evidence from Fustat indicates that the Cairo elite supplemented the limited supply of porcelain with large quantities of Valencia ware that, like earlier Egyptian and Syrian ceramics, used metallic luster. Italian merchant galleys probably supplied much of the Spanish pottery. Sultan Qaitbay's presentation of both Hispano-Moresque and porcelain vessels to Lorenzo de' Medici in 1487 undoubtedly reflects contemporary Mamluk taste. Sherds from Fustat also indicate little importation of Italian maiolica before the Ottoman conquest in 1517, probably because of established—and conservative—local taste.[14]

Italian ceramics had greater success in the Ottoman empire. Excavated fragments increase at Fustat after 1517, and there was also a good market in Istanbul, at least during the early sixteenth century while the new competing industry was developing in Iznik.[15] Relationships between Iznikware and maiolica have not been studied fully, but it seems likely that similarities between early Iznikware, which dates from about the 1470s or 1480s to the 1520s, and contemporary maiolica *alla porcellana* result from common sources rather than direct influence.[16] Both drew inspiration from objects prized throughout the Mediterranean area: Chinese blue-and-white porcelain and—to a lesser degree in maiolica—Islamic metalwork decorated with arabesques. It has been suggested that the naturalistic floral style developed about 1550 in the *nakkashane* (the court design studio primarily responsible for the arts of the book—calligraphy, illuminations, and bindings) and soon adopted by Iznik potters (see Fig. 114) may owe something to Venetian botanical drawings known or presumed to have reached Istanbul.[17] Though the style was stimulated by the import and cultivation of exotic flowers such as the tulip, Islamic artistic tradition furnished no precedent for such naturalistic representation. The few surviving pieces of Iznikware in Western shapes (see Fig. 111) or with European decorative motifs—plates with either coats of arms or a single *tondino* with a bust of a man in Ottoman dress—indicate minimal concessions to the export market and local patrons with Western tastes.[18]

To further their imperial image-building program, Mehmed the Conqueror's successors sporadically invited Italian artists to Istanbul. His son Bayezid II disapproved of representational art, but in 1506 he invited Michelangelo to design and construct a bridge across the Golden Horn from Istanbul to Pera; he also sought Leonardo da Vinci's assistance.[19] Unlike Leonardo, Michelangelo had not yet demonstrated any architectural or engineering expertise. After he became famous as a sculptor, painter, and architect, he was again invited. This time Tommaso di

182 Mosque lamp, colorless and opaque white glass (painted floral motifs added in Istanbul), Venice, late sixteenth century. Topkapi Sarayi Muzesi, Istanbul (34/468).

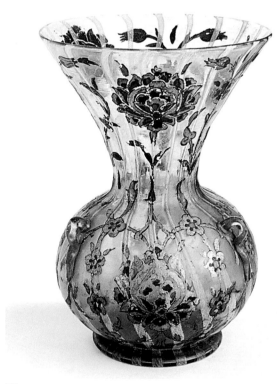

Tolfo, a Florentine painter working in Edirne, asked Michelangelo, in a letter dated April 1, 1519, to come paint for Tommaso's "most illustrious" patron, who had recently developed an interest in figurative art.[20] The network of facilitators in place suggests that the unnamed patron may have been Sultan Selim I (r. 1512–20), who had recently conquered Syria and Egypt and had a palace in Edirne. According to Tommaso, the Grandi bankers in Florence would arrange money for the trip, letters of recommendation to high authorities in Ragusa would be provided, and authorities in Ragusa would secure an escort to Edirne. Several Italian painters of lesser stature worked in Istanbul in the early 1530s; their names are unknown.[21]

The taste of grand viziers and favored courtiers greatly influenced Suleyman I's artistic patronage. In a famous example, a pro-Venetian network produced for the sultan, who had himself received training as a goldsmith in his youth, jewel-encrusted regalia that—more elaborately and specifically than Mehmed II's medals—advertised his image as a magnificent new Alexander and hopeful successor to the Hapsburg emperors and the Christian pope.[22] Grand Vizier Ibrahim Pasha, who was born on Venetian territory and promoted trade with Venice, directed the project. Alvise Gritti, the illegitimate son of a doge and a resident of Istanbul, helped him invent the objects, and other court officials participated in arrangements with consortia of Venetian merchants and craftsmen. One, headed by the goldsmiths Luigi Caorlini and Vincenzo Levrerio, produced the gem-encrusted helmet, allegedly worth 144,400 ducats, represented in a contemporary Venetian engraving (Fig. 175). Another consortium provided a jewel-studded saddle and saddlecloth worth 100,000 ducats; a jeweled scepter and throne worth 40,000 ducats are also recorded. As he progressed to Vienna in 1532, Suleyman displayed these symbols of power in triumphal parades modeled on those celebrating Holy Roman Emperor Charles V's coronation by Pope Clement VII in Bologna in 1529–1530. The helmet, eyewitnesses noted, strikingly resembled the three-tiered papal tiara, and it also incorporated imagery associated with Alexander the Great and Charles V. Like the earlier coronation, Suleyman's pompous display was highly publicized in engravings, which popularized his image as "the Magnificent" in Europe.[23] The deaths of Alvise Gritti

in 1534 and Ibrahim Pasha in 1536, a series of conservative grand viziers, and Suleyman's old-age piety ended these ostentatious Western-style artistic commissions.

Textiles continued to be Italy's principal export. By the mid–fourteenth century, the highest-quality Italian textiles began to have some artistic impact in central Asia, where the textile industry was responsive to the export market, and in other production centers closer to the eastern Mediterranean (see Fig. 29). As the Mamluk economy and industries declined in the late fourteenth and fifteenth centuries, Italian eastbound exports soared. Most were cheap woolens and linens from Lombardy, but the market for fine Venetian and Florentine silks and velvets steadily increased in Damascus, and Egypt undoubtedly traded the high-quality textiles for spices and porcelain.[24] Little is known about how the Mamluk elite regarded and used luxury Italian textiles. Italian-style tailoring must have been fashionable toward 1500, when Sultan Muhammad (r. 1496–98) banned overcoats with narrow sleeves.[25] Italian designs had no impact on local production. Traditional hierarchical protocol for the types and values of garments given as rewards by the sultan guaranteed their exchange value for the many officials who received them and set standards for elite society as a whole, thus probably exerting a conservative influence on the local textile industry.

Italian techniques and designs predominated in Spain. Clothing captured from the last Muslim ruler of Granada in 1492 included a robe tailored in traditional Islamic style from an Italian-style velvet made in Christian Spain.[26] Boosted by the immigration of Genoese craftsmen, the Spanish industry produced high-quality fabrics distinguishable from the Italian models only in details. Indeed, in 1495 King Ferdinand ordered Catalonian merchants to declare whether their textiles were Genoese, Venetian, or local products.[27]

The Ottomans were huge consumers of Italian luxury textiles for at least a century while their new artistic culture was developing. Display of Italian textiles was consistent with the imperial image, advanced by Mehmed II and Suleyman I, of a great new eastern Mediterranean and European power. Manuscript illuminations show that Italian-style textiles were worn at both their courts. Costanzo da Ferrara's miniature of a seated scribe at Mehmed's court suggests that Italian designs were being

183 Attributed to Costanzo da Ferrara, *Seated Scribe*, ca. 1470s. Isabella Stewart Gardner Museum, Boston.

184 Ceremonial kaftan associated with Sultan Suleyman I, voided velvet on cloth of gold, Italy, sixteenth century. Topkapi Sarayi Muzesi, Istanbul (13/840).

185 Double panel of velvet, Turkey, sixteenth century. The Metropolitan Museum of Art, New York, Rogers Fund, 1917 (17.29.10).

locally imitated by the 1470s (Fig. 183): the blossoms and leaves sprouting from the promegranate motifs echo contemporary Ottoman bookbindings, and the layout, with cusped, blossom-filled frames, is consistent with that of later Ottoman textiles. Miniatures from Suleyman's time represent the sultan and his attendants wearing Italian-style textiles both at court and on the European battleground.[28] Despite great progress in the local industry, the court's demand for Italian imports remained strong until Suleyman, in the 1550s, adopted austere dress, after which the Venetian government reported plummeting trade.[29] Later in the century, however, trade resumed: a court register of 1593 lists velvets from Venice, Genoa, and Florence purchased from three shops in Istanbul.[30] Many of the royal kaftans in patterned silk that were preserved over the centuries in the Topkapi Sarayi treasury appear to be made from Italian fabrics or closely imitate them.[31] Also preserved there are uncut bolts of Italian velvet, some with designs that inspired a group of seventeenth-century Ushak carpets.[32] Because known examples of such carpets are still in Turkey, they were probably made for the local market, thus illustrating continuing Turkish esteem for Italian designs.

The organization and production of the Ottoman textile industry intentionally rivaled that of Italy.[33] Bayezid II undoubtedly anticipated that it would serve as an important source of revenue as well as fulfilling the needs of the court's textile protocol and rewards system when in 1483 he presented to the Venetian ambassador three early examples of local velvets.[34] The new industry was headquartered advantageously at Bursa, the principal Anatolian entrepôt for raw silk from the East destined for both the local industry and export to Europe. In 1502 there were at least a thousand looms in Bursa producing a variety of luxury fabrics, evidence of tremendous capital investment. Bursa authorities that year issued an edict prohibiting irregularities in prices and quality. The edict's provisions suggest the intention was more to maintain the exchange value of textiles given as rewards by the sultan than to protect their competitiveness in the international market, the main purpose of much more detailed legislation in Italy.[35] By 1525 silk weaving was also practiced in Istanbul, where palace control gradually increased during the course of the century. The Ottoman industry derived some benefit from the sophisticated production of the *nakkashane*.[36] Weaving technology was so

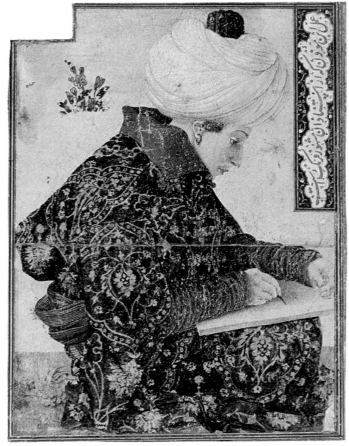

183

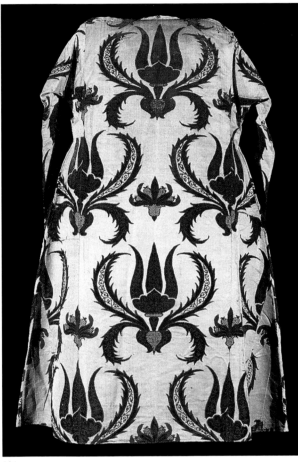

184

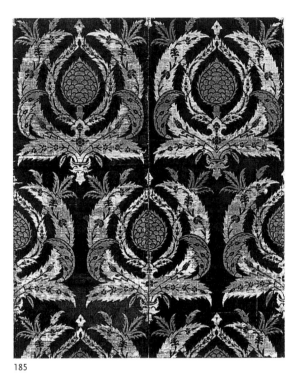

185

complicated and specialized, however, that skilled crafts-
men must have been responsible for adapting to their
textiles designs emanating from the *nakkashane* and popu-
lar at court.

No chronology has been established for the develop-
ment of the various designs in sixteenth-century Turkish
textiles: Italian-inspired pomegranate and ogival designs,
creative reinterpretations of traditional Oriental ogival
and undulating vertical-stem patterns analogous to Re-
naissance designs in boldness and scale, original fabrics—
some in *nakkashane* styles—and numerous ingenious
blends. The variety responded primarily to the range
in local taste, though some types seem to have been
intended chiefly for export.

The only surviving ceremonial kaftan associated with
Sultan Suleyman I (Fig. 184) shows that while the Italian
textile industry still received high-level Ottoman commis-
sions, it was beginning to have to compete with Turkish

products.[37] This sumptuous cloth-of-gold was made to
order in Italy, perhaps as a gift. Its voided velvet design
distantly imitates an Ottoman pattern exemplified on
the double panel of brocaded velvet in Figure 185.[38] The
latter exemplifies the Ottoman talent for blending motifs:
an Italian pinecone and feathery Ottoman *saz* leaves
overlaid with tiny floral sprays are arranged, in Italian
style, like a bouquet in a vase. The imitation's awkward
vine scroll overlay and fork-like tulips indicate that the
craftsman did not have a detailed model. A letter of
September 1554 demonstrates how the contemporary
diplomatic infrastructure facilitated such prestigious long-
distance commissions as the ordering of the kaftan's
fabric.[39] A high Ottoman official in Cairo, having ordered
silks to be woven in Venice from designs sent by way
of the consul in Cairo, Daniele Barbarigo, asked an
acquaintance in Venice, a former consul in Aleppo named
Propicia Mano, to help speed up the delivery.

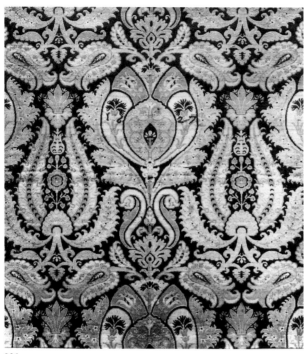

186

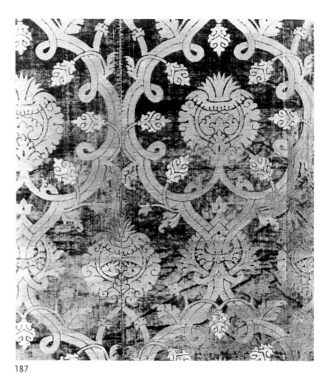

187

Meanwhile, rising European demand for high-quality Ottoman textiles challenged Italy's international predominance. Sixteenth-century Italian paintings provide little evidence about what patterns were popular in Italy, but a textile in Titian's *Entombment* of about 1566, in the Prado, indicates that one of the most distinctively Turkish designs was well known. Perhaps for picturesque effect, Nicodemus wears a robe with the *cintemani* motif: bold clusters of three balls such as those combined with other motifs in Figure 145.[40] Competition between the Italian and Ottoman industries intensified during the second half of the sixteenth century as each copied the other's fabrics to sell at cheaper prices in Europe and the eastern Mediterranean.[41] Italian imitations reached the highest levels of European society.[42]

Fierce competition led to policies and practices foreshadowing those of today's global economy. For example, the Venetian government, caught between the conflicting interests of its industries and commerce, vacillated between protectionism and free trade. In 1490 the Senate revived an earlier prohibition against foreign brocades. In 1514, however, textiles coming overland through Greece and the Balkans were permitted entry provided duties

were paid, and in 1542 textiles coming from Cyprus were exempted from duties. The regulations encouraging trade remained in effect until 1569, when restrictions on Oriental imports protecting industry were reimposed.[43]

There was also reciprocal violation of the intellectual property rights implicit in textile standards and marks of origin. The copying that had long been common at Italian production centers, where regulation and enforcement were purely local, easily became international. The Italian and Ottoman textile industries operated under similar quality controls regarding materials, dyes, thread counts, and loom widths that, far from preventing copying, maintained it at a sophisticated level. Both industries adopted stamped and woven trademarks, but the Turks became as adept as the Italians at copying these. Furthermore, use of the same raw materials facilitated copying and made it harder to detect. Even today, identifying the origin of these textiles is an art and a science, with few firm guidelines.[44] Some designs show signs of borrowing. For example, the silk lampas in Figure 186 is an Italian version of the naturalistic floral style invented in the *nakkashane* about 1550: the main blossoms and leaves have more plasticity and livelier outlines, and the floral

overlay is heavier than in Ottoman textiles.[45] The velvet in Figure 187 has thick, flat double stems forming the ogives and stiff drawing that indicate an Ottoman version of the Italian ogival pomegranate pattern.[46]

Technique can be a more reliable indicator of origin than design. For example, Figure 187 has the heavy backing, with cotton wefts, and coarse silk pile common in Turkish velvets. Usually Italian pile is more compact and refined, the fabric more pliable, in part because of the silk ground wefts used. The stiffness and durability of Turkish velvets made them popular fabrics in home furnishings, as evidenced by numerous large surviving examples such as Figure 187 that are sewn together from more than one loom width. Too few technical distinctions are known, however, and copying was too expert to permit attribution of some surviving fabrics. The piece in Figure 188 exemplifies a group of uniform-pile velvets whose large ogival patterns completely merge Italian and Ottoman design elements, the result of repeated reciprocal copying.[47]

This reciprocal copying occurred quite peacefully because it benefited both parties. Italians and Ottomans recognized the economic importance of trade and industrial development and accepted the commercial and artistic exchange required to become and remain competitive. The political and ideological conflicts of the time are evident in the pictorial arts, though the Mamluk mode in Venetian painting, Mehmed's medals, and Suleyman's regalia show that rivals occasionally adopted each other's imagery to further their own interests. Since the Middle Ages, however, most artistic exchange had occurred in nonfigurative luxury goods, and the community of taste that the luxury trade had fostered in the Mediterranean facilitated continuing exchange. Because of their international contacts and cosmopolitan taste, leading merchants who supplied the elite, such as the networks serving the Ottoman court, and leading merchant citizens, such as the Venetian nobility, also played a role in promoting artistic exchange. In both East and West consumers acquired a range of tastes that craftsmen learned to satisfy. Furthermore, such competition and exchange clearly neither hindered the development of a strong Ottoman artistic culture nor threatened the Italian one. Sixteenth-century East-West trade and artistic exchange softened a clash of civilizations, establishing a historical precedent for cultural coexistence and mutual enrichment.

186 Silk fragment, lampas weave, Italy, beginning of the seventeenth century. Musée de la Mode et du Textile, Paris (29459 [1194]).

187 Detail of joined widths of velvet, Turkey, sixteenth century. Victoria and Albert Museum, London (1357-1857).

188 Detail of a fragment of uniform pile velvet, Italy or Turkey, sixteenth century. Museo Nazionale del Bargello, Florence (Coll. Carrand, no. 2543).

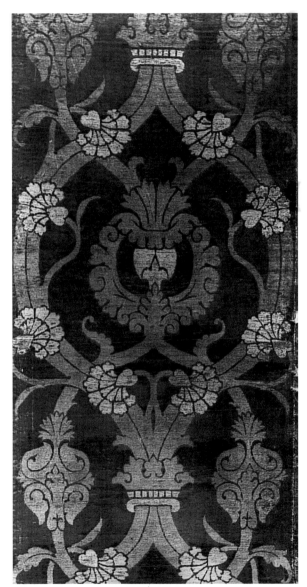

188

Notes

■■■■■■■■■■■■■■■■■■■■■■■■■■■■■■■■■■■

Introduction

1. The sentences quoted appear in separate paragraphs and are transposed in my text: *Visit to the Holy Places of Egypt, Sinai, Palestine, and Syria in 1384 by Frescobaldi, Gucci, and Sigoli,* trans. Theophilius Bellorini and Eugene Hoade (Jerusalem, 1948), pp. 183, 182. The Italian version is: "[V]eramente tutta cristianità per un anno si potrebbe fornire di mercatanzia in Damasco. . . . [S]ono tanti li ricchi e nobili e delicati lavorii d'ogni ragione, che se tu avessi i denari nell'osso della gamba, sanza fallo te la romperesti per comprare di quelle cose . . . " (Cesare Angelini, ed., *Viaggi in Terrasanta* [Florence, 1944], pp. 227–228 and 226). Simone Sigoli, Leonardo Frescobaldi, and Giorgio Gucci, all Florentines, wrote separate accounts of their pilgrimage with a group of thirteen Tuscans. Sigoli's, the first to be published (Simone Sigoli, *Viaggio al monte Sinai,* ed. Luigi Fiacchi and Francesco Poggi [Florence, 1829]), is also the most vivid on the bazaars and crafts of Damascus.

2. Vasari's comments on Islamic inlaid brassware appear in chapter 34 of his introduction on techniques in both the 1550 and 1568 editions: Giorgio Vasari, *Le vite de' più eccellenti pittori scultori e architettori,* ed. Rosanna Bettorini and Paola Barocchi (Florence, 1966), 1, pt. 1: 168–169; see Ronald W. Lightbown, "L'esoticismo," in *Storia dell'arte italiana,* ed. Giulio Einaudi (Turin, 1981), 10: 467–468. Vasari claimed to have seen ancient iron rings inlaid with foliage and half-figures, perhaps inferring their existence from the principal literary source on antique artistic techniques, Pliny's *Natural History.* Pliny, however, does not mention any such inlay on Greek and Roman iron rings (Plinius Secundus, *The Natural History of Pliny,* trans. John Bostock [London, 1857], 6:71–73), or other metal objects. Vasari presented his theory of progress in Italian art in the preface to part 3 of his 1568 edition (ed. Bettorini and Barocchi 1966, 4, pt. 1: 3–13).

3. Graziella Berti and Liana Tongiorgi, *I bacini ceramici del Duomo di S. Miniato (ultimo quarto del XII secolo)* (Genoa, 1981), pp. 14, 16–18. This tin-glazed ware, painted mostly in blue and brown, is the first known to have been imported in huge quantities for everyday use.

4. Eros Biavati, "Bacini di Pisa," *Faenza* 38 (1952): 92; Alan Caiger-Smith, *Tin Glaze Pottery in Europe and the Islamic World: The Tradition of One Thousand Years in Maiolica, Faience, and Delftware* (London, 1973), p. 41; *Eredità dell'Islam: Arte islamica in Italia,* ed. Giovanni Curatola, exh. cat., Palazzo Ducale, Venice (Venice, 1993), pp. 117–118, 140, cat. nos. 47–48.

5. There is no agreement on the origin of the Pisa Griffin except that it probably derives from a bronze-casting tradition shared by Persia and Fatimid Egypt that presumably spread to Spain and perhaps North Africa during the eleventh century. See *Al-Andalus: The Art of Islamic Spain,* ed. Jerrilynn E. Dodds, exh. cat., Metropolitan Museum of Art, New York (New York, 1992), p. 216, cat. no. 15; Rachel Ward, *Islamic Metalwork* (New York, 1993), pp. 64–66; *Eredità dell'Islam,* pp. 127–131, cat. no. 43; *Europa und der Orient, 800–1900,* ed. Gereon Sievernich and Hendrik Budde, exh. cat., Berliner Festspiele (Berlin, 1989), p. 592, cat. no. 1/32. It is closely related to large bronze animals decorating fountains in Spain; Umberto Scerrato, *Metalli islamici* (Milan, 1966), pp. 78–80, 83. Pisan legends provide different accounts of its arrival: as booty from the Balearic Islands in 1114 and as a miraculous discovery made when the cathedral's foundations were laid in 1064. It has also been connected with an inscription on the facade of the cathedral predating 1075 that

mentions a large bronze statue captured in North Africa; Marilyn Jenkins, "New Evidence for the Possible Provenance and Fate of the So-Called Pisa Griffin," *Islamic Archaeological Studies* 1 (1978): 79–85. Oleg Grabar emphasizes both that it had minimal local impact despite its beauty and significance as a work of art and that its meaning has changed over the years according to its function; Grabar, "Trade with the East and the Influence of Islamic Art on the 'Luxury Arts' in the West," in *Il Medio Oriente e l'Occidente nell'arte del XIII secolo,* ed. Hans Belting, Atti del XXIV congresso internazionale di storia dell'arte (Bologna, 1979), 2:28; Oleg Grabar, "Europe and the Orient: An Ideologically Charged Exhibition," *Muqarnas* 7 (1990): 3. For the founding of the cathedral, see Adriano Peroni, ed., *Il Duomo di Pisa* (Modena, 1995), 1:13–14, 29.

6. Bianca Maria Scarfi proposes that the Lion of Venice was acquired from the eastern Mediterranean in the twelfth century. The column supporting it was erected in 1172, and the sculpture was in place by 1293. It has suffered numerous repairs, which make attribution difficult. Scarfi suggests a Hellenistic origin with strong Oriental influence and dates the sculpture ca. late 4th–early 3rd century B.C. *The Lion of Venice: Studies and Research on the Bronze Statue in the Piazzetta,* ed. Bianca Maria Scarfi (Venice, 1990), pp. 9, 33, 57–60, 98–99, 109–111, with illustrations.

7. A winged lion appears as the emblem of Venice on coins and banners during the fourteenth century; Mary Hollingsworth, *Patronage in Renaissance Italy: From 1400 to the Early Sixteenth Century* (London, 1994), p. 112. In the Piazza San Marco, the Lion of Venice is paired with a statue of Saint Theodore, the city's original patron saint, atop a similar column; see Patricia Fortini Brown, *Venice and Antiquity: The Venetian Sense of the Past* (New Haven, Conn., and London, 1996), p. 18. For fifteenth- and sixteenth-century representations of the columnar monuments, see Giovanna Nepi Scirè, "Le Lion de la Piazzetta dans la peinture vénitienne," in *The Lion of Venice,* pp. 132–140, with illustrations. The earliest representation of the two monuments is a French manuscript illumination of about 1400 (*Livres du Graut Caam,* Bodleian Library, Oxford; see Scirè, fig. 4). In a famous painting of the city's emblem in the Doge's Palace, Venice, 1516, Vittore Carpaccio shows a more naturalistic beast straddling land and sea—the *terrafirma* and *mar* of the Venetian empire (Scirè, fig. 5; also see Patricia Fortini Brown, *Venetian Narrative Painting in the Age of Carpaccio* [New Haven, Conn., 1988], p. 9 and pl. 1).

8. Richard Ettinghausen, "The Decorative Arts and Painting: Their Character and Scope," and "The Impact of Muslim Decorative Arts and Painting on the Arts of Europe," in *The Legacy of Islam,* ed. Joseph Schact and Clifford Edmund Bosworth, 2d ed. (Oxford, 1974), pp. 294–295, 313–316; Oleg

Grabar, introduction to *Treasures of Islam* (Geneva and London, 1985), pp. 16–19; O. Grabar 1979, pp. 32–33; O. Grabar 1990, "Europe and the Orient," pp. 5, 7–9.

9. Courtly scenes are conspicuous in the art of the Ayyubid (1169–1260) and early Mamluk periods. Glass and metalwork featuring both courtly scenes and Christian subjects were made in Syria—metalwork also in Egypt—during the thirteenth century, presumably for Muslim and Christian feudal lords, who coexisted in the Latin states of the Syria-Palestine region; for crusaders; and for the Ayyubid court; see O. Grabar 1979, p. 31; and Esin Atil, *Art of the Arab World,* exh. cat., Freer Gallery of Art, Washington (Washington, 1975), pp. 64–65, 68. Examples include a large inlaid brass basin made for Sultan al-Malik al-Salih Najm al-Din Ayyub (r. 1240–49) in the Freer Gallery of Art (inv. no. 55.10; Atil 1975, fig. 27), on which there are scenes from the life of Christ, and Figure 118, an enameled and gilt glass beaker in the Walters Art Gallery, Baltimore, that features a "Christ Entering Jerusalem" (see Chapter 6, note 13).

10. Richard Ettinghausen, "Arabic Epigraphy: Communication or Symbolic Affirmation," in *Near Eastern Numismatics, Iconography, Epigraphy, and History: Studies in Honor of George C. Miles,* ed. Dickran K. Kouymjian (Beirut, 1974), pp. 300, 307; Oleg Grabar, *The Mediation of Ornament* (Princeton, N.J., 1992), pp. 103–118.

11. See Ettinghausen 1974, "Decorative Arts and Painting," p. 289.

12. O. Grabar 1992, pp. 33–41.

13. See the friezes *Angels with Eucharistic Wine and Grapes* in Horst Woldemar Janson, *The Sculpture of Donatello* (Princeton, N.J., 1963), pl. 109. For examples of Islamic vessels used in Christian services during the time of the Crusades, see Avinoam Shalem, *Islam Christianized: Islamic Portable Objects in Medieval Church Treasuries of the Latin West* (Frankfurt am Main, 1996), pp. 129–130.

14. *Circa 1492: Art in the Age of Exploration,* ed. Jay A. Levenson, exh. cat., National Gallery of Art, Washington (New Haven, Conn., and London, 1991), p. 133, cat. no. 17; *Europa und der Orient,* pp. 569–570, cat. no. 4/43.

15. For example, see the curtain in Jacopo Bellini's *Annunciation* in San Alessandro, Brescia, 1444 (fig. 19 in Colin Eisler, *The Genius of Jacopo Bellini* [New York, 1989]), and the bedcover in Fra Filippo Lippi's painting in the Galleria Nazionale del Palazzo Barberini, Rome, ca. 1465 (fig. 91 in Peter Thornton, *The Italian Renaissance Interior, 1400–1600* [New York, 1991]).

16. None of the legends associating surviving textiles with diplomatic gifts from Muslim rulers through the period of the Crusades, however, can be verified; see Shalem 1996, pp. 37–39, 46–49.

17. The "Veil of Saint Anne" in the Church of Saint Anne,

Apt, Vaucluse, is a linen robe that bears the name of the Fatimid caliph al-Mustali, the date 1096/97, and the place of manufacture, Damietta, Egypt. Probably seized in the Holy Land during the First Crusade, it is the most famous surviving example of the *tiraz* garments discussed in Chapter 3; Patricia A. Baker, *Islamic Textiles* (London, 1995), p. 57, illustrates a replica of the now fragmentary original.

18. Two large Sicilian or South Italian silks surviving in the treasury of San Francesco, Assisi, are associated with the funeral cart of Saint Francis, either in 1226, when his body was carried from Porziuncola to the Church of San Giorgio (*Bibliotheca Sanctorum* [Rome, 1964], 5:109), or in 1230, when his remains were transferred to the new Church of San Francesco (Rosalia Bonito Fanelli et al., *Il Tesoro della Basilica di San Francesco ad Assisi* [Assisi, 1980], pp. 14, 78–81, cat. nos. 17–18 and figs. 1–4). See also Chapter 2, note 13. For the widespread ecclesiastical use of Islamic textiles in medieval Europe, see Rafique Ali Jairazbhoy, *Oriental Influences in Western Art* (Bombay, 1965), pp. 31–36.

19. Shalem 1996, pp. 30, 56–66, 76–77, 132–135.

20. Richard A. Goldthwaite, *Wealth and the Demand for Art in Italy, 1300–1600* (Baltimore and London, 1993), pp. 224–237; Lisa Jardine, *Worldly Goods: A New History of the Renaissance* (New York, London, Toronto, Sydney, and Auckland, 1996), pp. 6–19, 66–72. For a representative list of published inventories, see Thornton, pp. 363–365, whose painted illustrations of Renaissance interiors show Oriental objects on display shelves, mantels, and headboards, most prominently in depictions of chambers and studies, the most personal rooms in Italian homes. Decorative objects other than paintings and sculptures are listed in some of the Florentine inventories cited by John Kent Lydecker, "The Domestic Setting of the Arts in Renaissance Florence," Ph.D. diss., Johns Hopkins University, 1987. For the new importance of collecting as a mark of power, and collectors as arbiters of taste, see Eilean Hooper-Greenhill, *Museums and the Shaping of Knowledge* (London and New York, 1992), pp. 53–57.

21. See Thornton, fig. 35.

22. Lightbown 1981, pp. 450, 455, 471; *Eredità dell'Islam*, p. 39.

23. For example, Lightbown 1981, pp. 445–448; O. Grabar 1990, "Europe and the Orient," p. 5.

24. Arthur Lane, *Italian Porcelain, with a Note on Buen Retiro* (London, 1954), p. 2; John Carswell, *Blue and White: Chinese Porcelain and Its Impact on the Western World,* exh. cat., David and Arthur Smart Gallery, University of Chicago (Chicago, 1985), p. 16; Edward A. Maser, "European Imitators and Their Wares," in Carswell 1985, pp. 37–38; Arthur Christopher Moule and Paul Pelliot, eds., *Marco Polo: The Description of the World* (London, 1976), 1:352.

25. For the special problems in East-West architectural relations, see Deborah Howard, *Venice and the East: The Impact of the Islamic World on Venetian Architecture, 1100–1500* (New Haven, Conn., and London, 2000), pp. xiv–xv, 43–62; Oleg Grabar, "Islamic Architecture and the West: Influences and Parallels," in *Islam and the Medieval West,* ed. Stanley Ferber, exh. cat., University Art Gallery, Binghamton, N.Y. (Binghamton, N.Y., 1975), pp. 60–66; Ernst J. Grube, "Elementi islamici nell'architettura veneta del Medioevo," *Bollettino del Centro Internazionale di Architettura Andrea Palladio* 8 (1966): 231–256.

26. Otto Demus, *The Church of San Marco in Venice* (Washington, 1960), pp. 70–73, 89–90, 97; Deborah Howard, *The Architectural History of Venice* (London, 1980), pp. 27–35; André Grabar, "The Byzantine Heritage," chap. 2 in Michelangelo Muraro and André Grabar, *Treasures of Venice* (Geneva, 1963), pp. 26–41.

27. For example, Howard 2000, pp. 101–109, 133–169, 171–180; Deborah Howard, "Venice and Islam in the Middle Ages: Some Observations on the Question of Architectural Influence," *Architectural History* 34 (1991): 59–74; Howard 1980, pp. 38–45, 77–85; Grube 1966, pp. 246–248; Giovanni Lorenzoni, "Sui problematici rapporti tra l'architettura veneziana e quella islamica," in *Venezia e l'Oriente Vicino,* ed. Ernst J. Grube, Atti del primo congresso internazionale sull'arte veneziana e l'arte islamica (Venice, 1989), pp. 101–105.

28. For historical background, see Christine Smith, *The Baptistery of Pisa* (New York and London, 1978), pp. 15–28; Gino Benvenuti, *Storia della Repubblica di Pisa* (Pisa, 1982), pp. 21–50; Janet Ross and Nelly Erichsen, *The Story of Pisa* (1909; reprint, Nedelen-Liechtenstein, 1970), pp. 8–25. For the use of ancient Roman building material, see Peroni, 1:153–164; P. F. Brown 1996, pp. 8–9. For the Islamic aspect of the exterior decoration, see O. Grabar 1975, p. 63; Walter Horn, "Romanesque Churches in Florence: A Study in Their Chronology and Stylistic Development," *Art Bulletin* 25 (1943): 130–131; Enzo Carli, *La Piazza del Duomo di Pisa* (Rome, 1956), pp. xiv–xvi; John Beckwith, "The Influence of Islamic Art on Western Medieval Art," *Apollo* 103 (April 1976): 274–275—all except Grabar with illustrations.

29. See fig. 111 in Derek Hill and Lucien Golvin, *Islamic Architecture in North Africa* (London, 1976).

30. By contrast, it has been argued that some thirteenth-century Pisan geometric marble inlay imitates contemporary Egyptian and Syrian wood carving with such sophistication that an imported model—a portable object such as a door or screen—must have been available; Rachel Meoli Toulmin, "Pisan Geometric Patterns of the Thirteenth Century and the Islamic Sources," *Antichità Viva* 16, no. 1 (1977): 3–12.

31. For the economy and society of Norman Sicily, see Shelomo D. Goitein, "Sicily and Southern Italy in the Cairo

Geniza Documents," *Archivio storico per la Sicilia orientale* 67 (1971): 9–13, 16; the travelogue of lbn Jubair, a Spanish Muslim, in Francesco Gabrieli and Umberto Scerrato, *Gli arabi in Italia: Cultura, contatti e tradizione,* 2d ed. (Milan, 1985), pp. 738–745. For the Palatine Chapel, see Umberto Scerrato, "Arte normanna e archeologia islamica in Sicilia," in *I Normanni: Popolo d'Europa 1030–1200,* ed. Mario D'Ono-frio, exh. cat., Palazzo Venezia, Rome (Venice, 1994), pp. 339–349; Slobodan Ćurčić, "Some Palatine Aspects of the Cappella Palatina in Palermo," *Dumbarton Oaks Papers* 41 (1987): 125–144; Gabrieli and Scerrato, pp. 302–303, 359–396; Giovanna Ventrone Vassallo, "La Sicilia islamica e postislamica dal IV/X al VII/XIII secolo," in *Eredità dell'Islam,* pp. 185–188—all with illustrations.

32. The *muqarnas* vault, usually executed in stucco, originated in central Asia and Persia in the late eleventh or early twelfth century and did not become common in Western Islamic architecture for another hundred years. A wooden *muqarnas* was executed in the Mosque of al-Qarawiyyun in Fez, Morocco, in 1135–1142/43 (Gabrieli and Scerrato, p. 328), and another in the Mouchroutas, a great hall in the imperial palace complex in Constantinople, about the middle of the twelfth century (Ćurčić, pp. 141–142; Scerrato 1994, pp. 346, 348). The Mouchroutas, planned by a Persian artist, had painted and gold-leaf decoration featuring figures dressed in Persian style like those of the Palermo ceiling. It has been argued that the Normans must have recruited carpenters and painters capable of executing the *muqarnas* from nearby Muslim lands where they maintained good relations—the style of the paintings suggests Fatimid Egypt or Syria—and that contemporary architectural fashion in Constantinople may have inspired the Normans to plan such a ceiling, though it is uncertain which *muqarnas* is the earlier.

33. For Venice's early trading privileges in Syria and Egypt and mid-thirteenth-century Venetian commercial activity in Damascus, see Wilhelm von Heyd. *Histoire du commerce du Levant au Moyen Âge* (Leipzig, 1885–1886), 1:374–375, 411–416.

34. The stucco window grills originally above the court-yard entrance to the Great Mosque, photographed by the Bonfils studio before the fire of 1893, look much like those above Porta Sant'Alippio; see Keppel Archibald Cameron Creswell, *Early Muslim Architecture* (Oxford, 1932), 1:111–112, 118–119 and pls. 35b–c; see also Howard 2000, fig. 126.

35. Demus, pp. 104–105; Grube 1966, p. 247; Lorenzoni, p. 89; Howard 2000, pp. 99–109; and Howard 1991, pp. 61–63.

36. In Hill and Golvin, see figs. 8 (Mosque of Ibn Tulun, finished 879), 23 (Al-Azhar Mosque, finished 972), and 48 (Mosque of Sultan Baybars, 1262/63).

37. For consular visits to Cairo, see Heyd, 1:176.

38. See Howard 2000, pp. 88–94 and figs. 94, 100, 111; P. F. Brown 1988, pp. 33–37, 146 and figs. 16, 84.

39. First proposed in Demus 1960, p. 105; also see P. F. Brown 1996, p. 24. Howard (2000, pp. 65–109) examines additional Egyptian settings in twelfth- and thirteenth-century mosaics in Saint Mark's.

40. Carol Herselle Krinsky, "Representations of the Temple of Solomon before 1500," *Journal of the Warburg and Courtauld Institutes* 33 (1970): 6; Howard 2000, pp. 200–204; Howard 1991, p. 67.

41. Howard 2000, pp. 171–180; Howard 1991, pp. 65–71; Howard 1980, pp. 79–85; Edoardo Arslan, *Gothic Architecture in Venice,* trans. Anne Engel (London, 1991), pp. 141–143, 148–149.

42. See Chapter 1. There is some evidence that Venetians hesitated to develop trade with Egypt and Syria in the late 1340s and early 1350s because numerous patricians had invested heavily in Black Sea trade; Eliyahu Ashtor, *Levant Trade in the Later Middle Ages* (Princeton, N.J., 1983), pp. 69–73. A few Venetian merchants were still active in Tabriz and Sultaniyya in the 1360s and 1370s, after the Mongols lost power and the local sultan attempted to encourage Venetian trade; Luciano Petech, "Les marchands italiens dans l'empire mongol," *Journal asiatique* 250 (1962): 569–570.

43. For the Kalyan minaret, built in 1127–1129, Bukhara's most famous surviving monument, see John Lawton, *Samar-kand and Bukhara* (London, 1991), pp. 83–84, 92–93, whose illustrations include similar monuments in the area. For this style of brickwork, see Arthur Upham Pope, *Persian Architecture: The Triumph of Form and Color* (New York, 1965), pp. 139–144, with illustrations.

44. For the tomb of Uljaitu and the development of glazed brick and tile decoration, see Douglas Pickett, *Early Persian Tilework: The Medieval Flowering of "Kashi"* (Madison, N.J., and London, 1997), pp. 21, 31–41, 53, 65–75. For other examples of Persian decoration before the mid–fourteenth century, see Pickett, pls. 55 and 61; Derek Hill and Oleg Grabar, *Islamic Architecture and Its Decoration* (Chicago and London, 1964), figs. 206, 233, 314.

45. See Bernhard Degenhart and Annegrit Schmitt, *Corpus der italienischen Zeichnungen 1300–1400,* pt. 2 vol. 1 (Berlin, 1980), pp. 26, 37; Helmut Boese, *Die lateinischen Handschriften der Sammlung Hamilton zu Berlin* (Wiesbaden, 1966), pp. 184–185; Anna Lomazzi, "Primi Monumenti del Volgare," in *Storia della cultura veneta* (Vicenza, 1976), 1: 609–612; Lorenzo Renzi, "I primi volgarizzamenti: Il 'Cato' e il 'Panfilo' del Codice Saibante-Hamilton," in *Storia della Cultura Veneta* (Vicenza, 1976), 1:629, 631. I discuss Mongol figures and costumes in fourteenth-century Italian painting in Chapter 9. Howard (2000, pp. 53–59, 100, and figs. 48, 229)

proposes that Venetian travelers may have brought back Islamic drawings of such geometric patterns on squared paper similar to later examples.

46. Ashtor 1983, pp. 66–70.

47. See fig. 17 in Howard 1991. Other Venetian examples of Islamic-style crenellations are cited in Howard 2000, pp. 127–128, 164, 178 and figs. 149, 151, 152.

48. Howard 1991, p. 67 and figs. 15, 16; and Howard 2000, pp. 142–146 and figs. 62, 69, which reproduce nineteenth-century drawings of a doorway in Alexandria and an eleventh-century minaret in Aleppo.

49. Howard 2000, pp. 133–169; Howard 1991, pp. 68–69.

Chapter 1. Trade, Travel, and Diplomacy

1. Ragei El Mallakh and Dorothea El Mallakh, "Trade and Commerce," in *The Genius of Arab Civilization, Source of Renaissance,* ed. John Hayes, 3d ed. (New York and London, 1992), pp. 251–254; Frederic C. Lane, *Venice: A Maritime Republic* (Baltimore and London, 1973), pp. 67–79.

2. Heyd, 1:131–138, 152–161, 313–333. For example, Pisa transported crusaders, arms, and pilgrims; sold goods seized at sea; and received land grants on the coast between Latakia and Acre, where warehouses, baths, bakeries, mills, and wells were built. Pisan citizens had privileges and protection in the Holy Land, where they did business with both Christians and Muslims, and Pisan merchants had a station as far away as Babylon; Ross and Erichsen, pp. 17–18.

3. For Venetian privileges in Byzantium, see Roberto S. Lopez, "Il problema della bilancia dei pagamenti nel commercio di Levante," in *Venezia e il Levante fino al secolo XV,* ed. Agostino Pertusi (Florence, 1973), 1, pt. 1: 441.

4. Heyd, 1: 374–375, 411–416.

5. According to a trade manual compiled by Francesco Pegolotti in the early fourteenth century, these were the goods exported from Damascus and Cyprus; Marco Spallanzani, *Ceramiche orientali a Firenze nel Rinascimento* (Florence, 1978), pp. 42–43. See also Ugo Tucci, "Il commercio veneziano e l'oriente al tempo di Marco Polo," in *Marco Polo, Venezia e l'Oriente,* ed. Alvise Zorzi (Milan, 1981), pp. 56, 64–65. For Pegolotti, see note 11 below.

6. Pegolotti listed glazed and painted earthenware, leather, wool, and furs as Tunisian exports; Spallanzani 1978, p. 43. See also Michael A. Cook, "Economic Developments," in *The Legacy of Islam,* ed. Joseph Schact and Clifford Edmund Bosworth, 2d ed. (Oxford, 1974), pp. 232–234; Giorgio Fedalto, "Stranieri a Venezia e Padova," in *Storia della cultura veneta: Dal primo Quattrocento al Concilio di Trenta* (Vicenza, 1980), 3, pt. 1: 525.

7. Esin Atil, *Renaissance of Islam: Art of the Mamluks,* exh. cat., Smithsonian Traveling Exhibition Service, Washington (Washington, 1981), pp. 12–15; Sean Gough, "The Mamluk

Sultanate," *Hali* 43, no. 1 (1981): 33; Giuliano Lucchetta, "L'Oriente Mediterraneo nella cultura di Venezia tra il Quattro e il Cinquecento," in *Storia della cultura veneta: Dal primo Quattrocento al Concilio di trenta* (Vicenza, 1980), 3, pt. 2: 407.

8. Heyd, 2:25–37; F. C. Lane, pp. 82, 130–131; Francesco Gabrieli, "Venezia e i Mamelucchi," in *Venezia e l'Oriente fra tardo Medioevo e Rinascimento,* ed. Agostino Pertusi (Florence, 1966), p. 421.

9. Thomas T. Allsen, *Commodity and Exchange in the Mongol Empire: A Cultural History of Islamic Textiles* (Cambridge, 1997), pp. 11–45.

10. For the Italian silk trade in Persia and central Asia, see Ashtor 1983, pp. 57–63; Petech, pp. 560, 568–570; Anne E. Wardwell, "Flight of the Phoenix: Crosscurrents in Late Thirteenth- to Fourteenth-Century Silk Patterns and Motifs," *Bulletin of the Cleveland Museum of Art* 74 (1987): 2–4; Jacques Anqueteil, *Routes de la soie: Des déserts de l'Asie aux rives du monde occidental, vingi-deux siècles d'histoire* (Paris, 1992), pp. 215–230; Fernand Braudel, *Civilization and Capitalism, Fifteenth–Eighteenth Century,* vol. 3, *The Perspective of the World* (New York, 1984), pp. 118–119. The impressive new capital of Sultaniyya was almost as large as Tabriz, but Sultaniyya's population and importance declined after Uljaitu's death in 1316; Pope, p. 172; Pickett, pp. 65–66.

11. Pegolotti compiled, from earlier reports of numerous overseas agents and his own experience in Cyprus, practical information on the ports of the eastern Mediterranean and Black Sea and on the caravan centers of Asia, listing local duties, taxes, currencies, and weights and measures—presented comparatively, using Genoese standards. See Heyd, 2:221–252; Roberto S. Lopez, "Venezia e le grande linee dell'espansione commerciale nel secolo XIII," in *La civiltà veneziana nel secolo di Marco Polo,* ed. Riccardo Bacchelli (Florence, 1955), p. 55; Petech, pp. 549, 552, 554, 558–559; Anqueteil, pp. 229–230; Henry Yule, trans. and ed., *Cathay and the Way Thither,* vol. 3, *Missionary Friars—Rashiduddin—Pegolotti—Marignolli,* Hakluyt Society Publications, 2d ser. (London, 1914), 37: 138–164.

12. Heyd, 2:44–45, 73–131, 217; Ashtor 1983, pp. 38–44, 54–60. For a concise description of routes to Mongol Asia, see F. C. Lane, pp. 79–85, 129–131.

13. Venetian embassies to Lajazzo are recorded in 1307, 1310, and 1317; Ashtor 1983, pp. 38–44.

14. Petech, pp. 557, 559–569.

15. Petech, pp. 552–558.

16. Horace K. Mann, *The Lives of the Popes in the Middle Ages,* vol. 17 (London, 1931), pp. 38–69; Kenneth M. Setton, *The Papacy and the Levant (1204–1571)* (Philadelphia, 1976), 1:97–98, 106, 115–117, 120, 133, 146–147; Petech, pp. 561–567.

17. Petech, p. 566.

18. Mann, 17:47.

19. Some of these textiles had been made into ecclesiastical vestments (inv. nos. 825, 907, 920, 932, 933, 946, 949, 963, 978, 987, 1000), and fifty were listed as pieces of fabric (inv. nos. 1143–1172): Émile Molinier, *Inventaire du trésor du Saint Siège sous Boniface VIII (1295)* (Paris, 1888).

20. Christopher Dawson, ed., *Missions to Asia: Narratives and Letters of the Franciscan Missionaries in Mongolia and China in the Thirteenth and Fourteenth Centuries* (New York, 1966), pp. xv–xxxiv; Mann, 17:82–105; Igor de Rachewiltz, *Papal Envoys to the Great Khans* (Stanford, Calif., 1971), pp. 84–103, 149–180.

21. Mann, 17:40–42; Setton 1976, 1:115–133.

22. Rachewiltz, pp. 171–174; Mann, 17:90–96; Dawson, pp. xxxi–xxxiii.

23. Rachewiltz, p. 176; Mann, 17:68, Petech, p. 568.

24. Details of the venture emerge from statements by the heirs of Giovanni Loredan, who died en route, and his father-in-law, who provided capital and sued to recover his investment and share of the profits: Lopez 1955, pp. 51–60; Roberto S. Lopez, "I successori di Marco Polo e la febbre della seta," in *Marco Polo, Venezia e l'Oriente,* ed. Alvise Zorzi (Milan, 1981), pp. 289–290; Petech, p. 559. The *colleganza* arrangement between Giovanni and his father-in-law, with different parties contributing capital and labor to the venture, lost favor during the fourteenth century, though changing commercial practices continued to support family enterprises; F. C. Lane, pp. 138–140; Petech, p. 551.

25. These gifts were customarily several times the value of the "gifts" that foreigners brought before the sultan to present to him. The famous Moroccan traveler Ibn Battuta, who stayed in Delhi from 1333 to 1342, vividly described the sultan's largesse and the stream of Eastern merchants who took advantage of it; see Ibn Battuta, *Travels in Asia and Africa, 1325–1354,* trans. and ed. Hamilton Alexander Rosskeen Gibb (New York, 1969), pp. 184–214. Ibn Battuta did not mention any Europeans in Delhi. Their presence was undoubtedly rare, and differences of language and culture probably restricted contacts between Muslims and Christians; Lopez 1955, pp. 58–59.

26. See Donald L. Hill, "Mechanical Technology," in *The Genius of Arab Civilization, Source of Renaissance,* ed. John Hayes, 3d ed. (New York and London, 1992), pp. 233–238.

27. The florin of Florence, introduced in 1252, and the ducat of Venice, introduced in 1284, contained 3.56 grams of pure gold; Herbert E. Ives, "The Venetian Gold Ducat and Its Imitations," ed. Philip Grierson, *Numismatic Notes and Monographs* 128 (1954): 1, 5. The modern U.S. dollar equivalent is based on the value of the gold at $300 per ounce ($300 multiplied by 3.56, divided by 28.35 [the number of grams per ounce], multiplied by the number of ducats). Equivalents based on the commonly used British price index for this period are more than double this amount; see Peter Spufford, *Handbook of Medieval Exchange* (London, 1986), pp. 198–201, 335.

28. For European textiles exported to the Orient, see Heyd, 2:706–710; Braudel 1984, p. 111.

29. Maffeo and Niccolò Polo reportedly exchanged their Venetian glass jewels in China for merchandise worth twice their value in the 1260s, and in 1338 the Venetian Senate permitted a Genoese merchant to buy more than 1,000 ducats' worth to take to China, provided that he sail on Venetian vessels—an offer he declined. Two Venetians, however, were not recompensed for glass jewels presented to the Il-Khanid sultan of Persia in 1286. See Lopez 1955, pp. 50–51; Petech, pp. 555, 561.

30. Pearls were generally duty-free in Mamluk, Armenian, and Mongol territories; see Heyd, 1:378, 412; Lopez 1955, p. 59; Franco Brunello, *Marco Polo e le merci dell'Oriente* (Vicenza, 1986), pp. 103–104. Curiously, documentary sources are silent on trade in ultramarine, the valuable blue pigment derived from lapis lazuli, which Marco Polo purportedly saw mined in northeastern Afghanistan; like gold leaf, it was used in the best European paintings by specific allocation. Ultramarine would have been ideal for transport to Italy on the return journey and could have been one of the costly "spices"—a broad category that included dyestuffs—carried overland to the Mediterranean; see Rutherford J. Gettens and George L. Stout, *Painting Materials: A Short Encyclopaedia* (New York, 1966), pp. 165–167; Brunello, pp. 89–90.

31. Braudel 1984, pp. 116, 118–119; Gabrieli, p. 421; Ashtor 1983, pp. 66–132; Eliyahu Ashtor, "Observations on Venetian Trade in the Levant in the Fourteenth Century," reprint no. 6 in *East-West Trade in the Medieval Mediterranean,* ed. Benjamin Z. Kedar (London, 1986), pp. 533–560.

32. F. C. Lane, pp. 285–286; J. Michael Rogers, "The Gorgeous East: Trade and Tribute in the Islamic Empire," in *Circa 1492: Art in the Age of Exploration,* ed. Jay A. Levenson, exh. cat., National Gallery of Art, Washington (New Haven, Conn., and London, 1991), pp. 70–72.

33. F. C. Lane, pp. 124–134, 337–339, 348–352; Lucchetta 1980, "L'Oriente Mediterraneo," p. 408.

34. Lucchetta 1980, "L'Oriente Mediterraneo," p. 408; Paolo Preto, *Venezia e i turchi* (Florence, 1975), p. 26.

35. Venice defeated the Genoese fleet in the Adriatic in 1380 and acquired Corfu, at the entrance to the Adriatic, in 1386; F. C. Lane, pp. 186–198; Braudel 1984, pp. 118–119. Genoa, after losing to the Ottomans, between 1334 to 1423, most of its possessions on the Black Sea route, concentrated on trade with the Maghreb and the Iberian Peninsula; see Lopez 1973, p. 450.

36. Heyd, 2:430–438; Lucchetta 1980, "L'Oriente Mediterraneo," p. 409; Howard 2000, pp. 36, 120–131. The Venetians had two *funduqs* in Alexandria.

37. Ashtor 1983, p. 407. In 1375 Venice's ambassador to the sultan in Cairo sought to expand residential facilities in Damascus because permission to live outside the commercial quarter had been denied; Ashtor 1983, pp. 122–123.

38. For the institution of the Fondaco de' Turchi, see Ugo Tucci, "Tra Venezia e mondo turco: I mercanti," in *Venezia e i turchi: Scontri e confronti di due civiltà* (Milan, 1985), pp. 51–52. For the earlier state use of the palace, see Fedalto, p. 524; Thomas Okey, *The Old Venetian Palaces and Old Venetian Folk* (London, 1907), pp. 263–264.

39. Heyd, 2:430, 434–438, 456–458; Rachel Ward, "Metallarbeiten der Mamluken-Zeit: Hergestellt für den Export nach Europa," in *Europa und der Orient, 800–1900*, ed. Gereon Sievernich and Hendrik Budde, exh. cat., Berliner Festspiele (Berlin, 1989), pp. 208–209. The reluctance of Muslims to have direct contact with infidels, to learn their languages, or to travel in their lands also restricted cross-cultural contacts; see Bernard Lewis, *The Muslim Discovery of Europe* (New York and London, 1982), pp. 71–80, 89–106, 121–129.

40. Ashtor 1983, pp. 253–254, 397–398.

41. Atil 1981, pp. 16–18; Gough, p. 34.

42. Eliyahu Ashtor, "L'Exportation des textiles occidentaux dans le Proche Orient musulman au bas Moyen Âge, 1370–1517," reprint no. 4 in *East-West Trade in the Medieval Mediterranean*, ed. Benjamin Z. Kedar (London, 1986), pp. 303–308.

43. Baker 1995, p. 78; Eliyahu Ashtor, "L'Apogée du commerce vénitien au Levant: Un nouvel essai d'explication," reprint no. 6 in *Technology, Industry, and Trade: The Levant versus Europe, 1250–1500*, ed. Benjamin Z. Kedar (Hamsphire, U.K., and Brookfield, Vt., 1992), pp. 318–319; Ashtor 1983, pp. 200–206; Gough, p. 34.

44. Ruy Gonzalez de Clavijo, *Embassy to Tamerlane, 1403–1406*, trans. Guy le Strange (London, 1928), pp. 287–288.

45. Atil 1981, p. 53; Ward 1989, pp. 205–206; J. Michael Rogers, "To and Fro: Aspects of Mediterranean Trade and Consumption in the Fifteenth and Sixteenth Centuries," in *Villes au Levant: Hommage à André Raymond*, vols. 55–56 of *Revue du Monde Musulman et de la Méditerranée* (1990–1992): 62–66.

46. Atil 1981, p. 118; Ashtor 1983, pp. 211–212.

47. Ashtor (1992, pp. 320–322, 324–326) proposes that the fall of the Karamis, the merchant families who for centuries had controlled trade from the Gulf and Red Sea to Egypt and Syria, and the counterproductive monopolistic policies of Sultan Barsbay contributed to both Venice's trading hegemony and the Mamluk decline. Cook (pp. 242–243) observes that the influence of Italian merchants on their governments gave them a critical advantage, because merchants in the contemporary Islamic world had no political power.

48. See Atil 1981, pp. 17–18.

49. Lopez 1973, pp. 448–450.

50. Goldthwaite, pp. 13–20, 40–52, 211–214, 225–232; Jardine, pp. 6–19, 33–34, 66–72.

51. In 1421, after Florence purchased the port of Livorno from Genoa, the Signoria appointed six *consoli di mare* to oversee the construction of two merchant galleys and six smaller armed ships to sail to Alexandria, where Venice was making huge profits. The following year the number of consuls was expanded because of their added responsibility for encouraging and developing the arts. Scipione Ammirato, *Istorie fiorentine*, ed. Scipione Ammirato il Giovane (Florence, 1826), 6:420–421, 432–433.

52. Clavijo, pp. 119–120. The local lord was not satisfied until he also received a fine piece of mohair, probably from Anatolia.

53. Heyd, 2:469; Ashtor 1986, "L'Exportation des textiles," p. 369.

54. Rogers 1990–1992, p. 60.

55. Braudel 1984, p. 119. F. C. Lane (pp. 228–229) points out that Mocenigo was arguing specifically against war with Filippo Maria Visconti in Lombardy, though his remarks applied to Venetian foreign policy in general.

56. Gabrieli, pp. 424–427; F. C. Lane, p. 288.

57. Preto, pp. 26–27; Lucchetta 1980, "L'Oriente Mediterraneo," p. 376.

58. The *bailo's* term was reduced from two years to one, and he lost almost all personal tax exemptions; he was subjected to imprisonment or house arrest during hostilities in 1537 and 1570; Bruno Simon, "I rappresentanti diplomatici veneziani a Costantinopoli," in *Venezia e i turchi: Scontri e confronti di due civiltà* (Milan, 1985), pp. 56, 67.

59. Fernand Braudel, *The Mediterranean and the Mediterranean World in the Age of Philip II*, 2d rev. ed., trans. Siàn Reynolds (New York, 1976), 1:388–389; Fulvio Salimbeni, "I turchi in terraferma," in *Venezia e i turchi: Scontri e confronti di due civiltà* (Milan, 1985), p. 232.

60. Ugo Tucci, "Mercanti, viaggiatori, pellegrini nel Quattrocento," in *Storia della cultura veneta, dal primo Quattrocento al Concilio di Trenta* (Vicenza, 1980), 3, pt. 2: 325–326.

61. Franz Babinger, *Mehmed the Conqueror and His Time*, trans. Ralph Manheim, ed. William C. Hickman (Princeton, N.J., 1978), pp. 368–378.

62. Tucci 1985, p. 38.

63. See note 51 above; Ammirato, 6:426–429, 432–434; Silvia Auld, "Kuficising Inscriptions in the Work of Gentile da Fabriano," *Oriental Art*, n.s. 32 (1986): 247, 254.

64. John Wansbrough, "Venice and Florence in the Mam-

luk Commercial Privileges," *Bulletin of the School of Oriental and African Studies* 28 (1965): 483.

65. Cosimo de' Medici was *gonfaloniere* at the time of the council; Ammirato, 6:270–272, 289–290.

66. Julian Raby, "Court and Export: Part 1. Market Demands in Ottoman Carpets, 1450–1550," in *Oriental Carpet and Textile Studies* 2 (1986): 32.

67. Babinger, pp. 381–388, with illustrations; also see Chapter 9.

68. Ashtor 1992, p. 312.

69. In 1479 a Turkish envoy to Lorenzo de' Medici requested engravers, wood carvers, inlayers, and bronze sculptors; supposedly some were sent. Marco Spallanzani, "Fonti archivistiche per lo studio dei rapporti fra Italia e l'Islam: Le arti minori nei secoli XIV–XVI," in *Venezia e l'Oriente Vicino*, ed. Ernst J. Grube, Atti del primo congresso internazionale sull'arte veneziana e l'arte islamica (Venice, 1989), p. 85.

70. The sultan's letter to the doge, carried back by Ambassador Giovanni Emo, lists the gifts; Gabrieli, p. 431.

71. Rogers 1990–1992, p. 62; Lightbown 1981, pp. 451–452 and fig. 309.

72. Mamluk sultans sent Chinese porcelain to Doge Foscari in 1442, to King Charles VII of France in 1447, to Doge Malipiero in 1461, to Catherine Cornaro of Cyprus in 1470, to Doge Barbarigo in 1490, and to the Signoria of Venice in 1498 and 1508; Heyd, 2:697 n. 7. Porcelain is listed in the will of Maria, the Angevin queen of Naples and Sicily, of 1323; the same family perhaps owned the early-fourteenth-century Yuan Gagnières-Fonthill Vase in the National Museum of Ireland, Dublin; Béla Kristinkovics and Maurizio Korach, "Un antico documento sulla porcellana cinese in Europa," *Faenza* 53 (1967): 27, 29–30.

73. Most of the porcelain exported during the late Yuan (1279–1368) and early Ming dynasties went to Persia, transported by Muslim merchants living in China, and both the decorative patterns and shapes of the blue-and-white ware were influenced by Islamic ceramics and metalwork. Exports to Mamluk Egypt and Syria, which presumably increased during the great Chinese trading expeditions to the Indian Ocean and the Red Sea led by Admiral Zheng He between 1405 and 1433, continued on Arab ships after Chinese subjects were forbidden to engage in long-distance maritime trade. Mamluk potters imitated celadon during the fourteenth century and were strongly influenced by blue-and-white ware during the fifteenth. It has been suggested that the Mamluk elite's taste for increasingly available Chinese porcelain contributed to the demise of the enameled-glass industry. See Margaret Medley, "Chinese Ceramics and Islamic Design," in *The Westward Influence of the Chinese Arts from the Fourteenth to the Eighteenth Century*, ed. William

Watson (London, 1972), pp. 3–6; John Ayers, "Early Ming Taste in Porcelain," *Victoria and Albert Museum Bulletin* 2 (1966): 21–25; Atil 1981, 118, 149–151.

74. Christopher Hibbert, *The Rise and Fall of the House of Medici* (London, 1974), p. 172. For the history of exotic animals and zoos, see Jairazbhoy, pp. 44–45. The Spanish embassy, on its way to Tamerlane in Samarkand at the beginning of the fifteenth century, was joined by one from the Mamluk sultan bearing six ostriches and a giraffe; Clavijo, pp. 149, 226. The Ming emperors of China confused the giraffes they received as tribute with the mythical *qilin*, a symbol of good fortune; Louise Levathes, *When China Ruled the Seas: The Treasure Fleet of the Dragon Throne, 1405–1433* (New York and Oxford, 1994), pp. 140–143, 149, 151, 172–173.

75. It is not certain how the Tazza Farnese traveled from Persia, where it was drawn by a Timurid court artist, to Rome. Sultan Uzun Hasan may have presented it to Pope Paul II (1467–71), from whose large collection of antiquities Lorenzo acquired numerous objects. Valued at 10,000 florins, the tazza was Lorenzo's most precious item. Rogers 1991, "The Gorgeous East," p. 73; *Il tesoro di Lorenzo il Magnifico: Le gemme*, ed. Nicole Dacos, Antonio Giuliano, and Ulrico Pannuti, exh. cat., Palazzo Medici-Riccardi, Florence (Florence, 1973), pp. 4, 71, 134 and pl. 1; Julian Raby, "Exotica from Islam," in *The Origins of Museums: The Cabinet of Curiosities in Sixteenth- and Seventeenth-Century Europe*, ed. Oliver Impey and Arthur MacGregor (Oxford, 1985), p. 253 n. 5.

76. Ashtor 1983, pp. 248–249.

77. Ashtor 1986, "L'Exportation des textiles," p. 360.

78. Spallanzani 1989, p. 85, Goldthwaite, p. 20.

79. The anonymous French pilgrim's observations are quoted in Béatrix Ravà, *Venise dans la littérature française depuis les origines jusqu'à la mort de Henri IV* (Paris, 1916), p. 70; see also Fedalto, p. 525. For the mission of the Ottoman ambassador, see Babinger, p. 378. The Venetian government frequently suspended sumptuary laws for its own citizens on feast days and during the visits of dignitaries; P. F. Brown 1988, p. 168. Marin Sanudo, secretary to the Venetian Senate, recorded customary protocol on the occasion of Turkish Ambassador Heinican's visit in June 1525: on the fifth the ambassador first addressed the Senate wearing Turkish dress, and on the eighth the ambassador and his delegation were sent silk and scarlet garments "as usual" (*iusta il consueta*); *I diarii di Marino Sanuto* (Venice, 1879–1903), 39: cols. 23, 39.

80. See Tucci 1985, p. 38; Esin Atil, *The Age of Sultan Süleyman the Magnificent*, exh. cat., National Gallery of Art, Washington (Washington, 1987), pp. 183 and 231 n. 41.

81. For example, a miniature in the *Suleymanname* of Arfi,

transcribed in 1558 (Topkapi Sarayi Muzesi, Istanbul, inv. no. H.1517, fol. 220a), shows Sultan Suleyman the Magnificent and two of his archers wearing Italian textiles as they survey the battle of Mohacs in 1526, won by the Ottomans, who subsequently ruled Hungary; Atil 1987, p. 89 and fig. 41b.

82. The gifts were recorded by the Mamluk writer Ibn Iyas; J. Michael Rogers, "Carpets in the Mediterranean Countries, 1450–1500: Some Historical Observations," in *Oriental Carpet and Textile Studies* 2 (1986): 19–20.

83. Tashin Öz, *Turkish Textiles and Velvets, Fourteenth–Sixteenth Centuries* (Ankara, 1950), p. 26; Louise W. Mackie, "Rugs and Textiles," in *Turkish Art,* ed. Esin Atil (Washington, 1980), p. 360.

84. Gabrieli, p. 427; F. C. Lane, pp. 289–291; Braudel 1976, 1:543–544; Lucchetta 1980, "L'Oriente Mediterraneo," pp. 409–415.

85. Overland imports singled out included gold and silver cloth, woolens, spices, and sugar; Braudel 1976, 1:544.

86. Braudel 1976, 1:545, 562; F. C. Lane, pp. 291–293; Lucchetta 1980, "L'Oriente Mediterraneo," pp. 427, 429, 431–432; Giuliano Lucchetta 1980, "Viaggiatori e racconti di viaggi nel Cinquecento," in *Storia della cultura veneta: Dal primo Quattrocentro al Concilio di Trenta* (Vicenza 1980), 3, pt. 2: 441, 445.

87. Braudel 1976, 1:548, 552, 565–566.

88. Negotiations began in June 1518 but got nowhere until after Wolsey received about sixty "Damascene" carpets, in October 1520. Wolsey's unusually large consideration required the Senate's approval, and its standing gift fund had to be supplemented by merchant contributions and the sale of some ambassadorial gifts. The carpets specified by Wolsey must have been the Mamluk type, first made in Cairo toward the end of the fifteenth century, or the closely related para-Mamluk type, often associated with Damascus; Kurt Erdmann, "Venezia e il tappeto orientale," in *Venezia e l'Oriente fra tardo Medioevo e Rinascimento,* ed. Agostino Pertusi, Corso internazional di alta cultura 5, Venice, 1963 (Florence, 1966), pp. 529–532.

89. Tucci 1985, pp. 40–55.

90. Gülru Necipoğlu, "Süleyman the Magnificent and the Representation of Power in the Context of Ottoman-Hapsburg-Papal Rivalry," *Art Bulletin* 71 (1989): 401–403, 407; see also Chapter 10, note 22.

91. Polyglot Bibles and psalters with texts in Arabic, Aramaic, and Syriac began to be printed in the second decade of the sixteenth century for the use of European scholars and Oriental Christians. About 1535 the Venetian publishers Paganino and Alessandro Paganini prepared an Arabic text of the Quran, probably for export, but abandoned the project. The Tipografia Medicea, founded in Rome in 1584 and transferred to Florence in 1614, published both Christian and Islamic scholarly texts in Arabic primarily for export. Preto, p. 146; Alastair Hamilton, "Eastern Churches and Western Scholarship," in *Rome Reborn: The Vatican Library and Renaissance Culture,* ed. Anthony Grafton, exh. cat., Library of Congress (Washington, 1993), pp. 235–239, 246–249. A copy of the Paganini Quran has recently come to light in the Biblioteca dei Frati Minori di San Michele ad Isola, Venice (Coll. A.V. 22); *Eredità dell'Islam,* pp. 480–481, cat. no. 298, with an illustration.

Chapter 2. Patterned Silks

1. For the role of textiles in the Muslim world, see Lisa Golombek, "The Draped Universe of Islam," in *Content and Context of Visual Arts in the Islamic World,* ed. Priscilla P. Soucek (University Park, Pa., and London, 1988), pp. 26–36; Baker 1995, pp. 15–17, 50–57, 66–68. Allsen (pp. 11–13, 16–26, 46–94) discusses the close relationship between Islamic and Mongol textile culture and substantiates Marco Polo's account of the presentation of honorific garments and the wearing of holiday colors at the court of the great khan in Beijing (Moule and Pelliot, 1:221–222, 225). For textile customs in Europe, see Rebecca Martin, *Textiles in Daily Life in the Middle Ages,* exh. cat., Cleveland Museum of Art (Bloomington, Ind., 1985).

2. There is no proof that the chasuble was made for Thomas à Becket, archbishop of Canterbury, and presented to the Fermo cathedral by Bishop Presbyterio (1184–1204). In 1220 Becket's remains were translated to a shrine, which was destroyed in 1538; by 1450 there was traffic in his relics. Annabelle Simon-Cahn, "The Fermo Chasuble of St. Thomas Becket and Hispano-Moresque Cosmological Silks: Some Speculations on the Adaptive Reuse of Textiles," *Muqarnas* 10 (1993): 1–5.

3. Florence Lewis May, *Silk Textiles of Spain, Eighth to Fifteenth Century* (New York, 1957), pp. 57–59; Simon-Cahn, p. 3.

4. A high official of the Church might even have considered such royal imagery appropriate—King Roger II of Sicily did when he had the *muqarnas* of the Palatine Chapel painted with traditional Islamic princely pleasures framed by arabesques, geometric interlace, and Arabic inscriptions that glorify him and wish him good fortune and long life as the bearer of God's favor on earth. See Gabrieli and Scerrato, p. 360; and Scerrato, pp. 346–347, both with illustrations.

5. James C. Y. Watt and Anne E. Wardwell, *When Silk Was Gold: Central Asian and Chinese Textiles,* exh. cat., Metropolitan Museum of Art, New York, and Cleveland Museum of Art (New York, 1997), pp. 127–138; Anne E. Wardwell, "Important Asian Textiles Recently Acquired by the Cleveland Museum of Art," *Oriental Art* 38, no. 4 (winter 1992–93): 244–247; Anne E. Wardwell, "Two Silk and Gold Tex-

tiles of the Early Mongol Period," *Bulletin of the Cleveland Museum of Art* 79 (1992): 354–373.

6. Otto von Falke, *Decorative Silks,* 3d ed. (New York, 1936), pp. 23–24; Ruth Grönwoldt, *Webereien und Stickereien des Mittelalters,* vol. 7 of *Bildkatalog des Kestner-Museums Hannover, Textilien 1* (Hanover, 1964), pp. 35–38; Adèle Coulin Weibel, *Two Thousand Years of Textiles: The Figured Textiles of Europe and the Near East* (New York, 1972), p. 57; Jennifer Harris, ed., *Textiles: Five Thousand Years: An International History and Illustrated Survey* (New York, 1993), pp. 165–167.

7. The Geniza documents, from a Jewish archive in Cairo, record a brisk export trade in two grades of silk fabric, robes and the material for them, and highly valued turbans; Goitein, pp. 13–14.

8. Rosalia Varoli Piazza, "La produzione di manufatti tessili nel Palazzo Reale di Palermo: 'Tiraz' o 'ergasterion,'" in *I Normanni: Popolo d' Europa, 1030–1200,* ed. Mario D'Onofrio, exh. cat., Palazzo Venezia, Rome (Venice, 1994), pp. 288–290.

9. Rotraud Bauer, "Il Manto di Ruggiero II," in *I Normanni: Popolo d'Europa, 1030–1200,* ed. Mario D'Onofrio, exh. cat., Palazzo Venezia, Rome (Venice, 1994), pp. 279–287; Harris, p. 73; Ettinghausen 1974, "The Impact of Muslim Decorative Arts and Painting," p. 299; *Eredità dell'Islam,* pp. 205–206, cat. no. 95.

10. Thirteeth-century Christian Spanish kings favored silks encrusted with pearls and gems as a symbol of royal authority; May, p. 107.

11. Bauer, pp. 281, 284.

12. The names Marzuq, Ali, and [Mah]mud appear in ink under the embroidered cuff of an alb (a full-length white vestment worn at the celebration of the Eucharist) made for William II in 1181; Bauer, p. 281. Like other imperial vestments made in Palermo during the late twelfth and early thirteenth centuries and subsequently taken to Germany, this alb has embroidered inscriptions in both Arabic and Latin; Irene A. Bierman, "Art and Politics: The Impact of Fatimid Uses of 'Tiraz' Fabrics," Ph.D. diss., University of Chicago, 1980, pp. 129–137. Ibn Jubair, a Spanish pilgrim returning from Mecca in 1184/85, interviewed a young embroiderer named Yahya ibn Fityun about the royal court; Gabrieli and Scerrato, p. 741.

13. Bonito Fanelli 1980, figs. 1–3; see Introduction, note 18. Two of the recorded altar cloths survive; the third is lost. Bonito Fanelli (1980, pp. 14, 80–81) identifies the donor as John of Brienne, a Franciscan tertiary and former king of Jerusalem, whose daughter married King Frederick II of Sicily in 1225, and who commanded papal forces in South Italy from 1228 to 1237. The *Bibliotheca Sanctorum* (Rome,

1964), 5:1079, ascribes the gift to the Byzantine emperor Baldovino II (r. 1229–37).

14. The cope in the Church of Santa Corona, Vicenza, is traditionally believed—without proof—to have been given by King Louis IX of France to Bartolomeo da Breganze, who arrived in Vicenza as bishop in 1260; *Federico e la Sicilia: Dalla terra alla corona,* vol. 2, *Arti figurative e arti suntuarie,* ed. Maria Andoloro, exh. cat., Real Albergo dei Poveri, Palermo (Palermo, 1995), pp. 105–108, cat. no. 16. Pope Boniface VIII donated his Sicilian-made cope to the cathedral of Anagni, his birthplace; *Eredità dell'Islam,* p. 204, cat. no. 94; *Tesori d'arte dei musei diocesani,* ed. Pietro Amato, exh. cat., Castel Sant'Angelo, Vatican City (Turin, 1986), pp. 64–65.

15. Falke, pp. 23–24; Grönwoldt 1964, pp. 35, 37–38; Ruth Grönwoldt, "Imperial Vestments and Church Apparels of the Staufer Era," *Bulletin du Centre International d'Étude des Textiles Anciens* 47–48 (1978): 44; *Europa und der Orient,* p. 562, cat. no. 4/32 (where the shroud fragment in Figure 15 is attributed to Spain or Syria rather than Sicily); *Federico e la Sicilia,* 2:105–108, cat. no. 16.

16. See the sources cited in note 15 above.

17. The fragment in Figure 16 was found in a cemetery in Egypt near Medinat-al-Fayoum. It measures 55 × 34 cm. and is attributed by the museum to Iran, Seljuk period, thirteenth–fourteenth century. Other scholars, however, consider it an Egyptian or Syrian adaptation of a Seljuk pattern; Weibel, p. 98, and Grönwoldt 1978, p. 44.

18. Leonie von Wilckens, *Staatliche Museen zu Berlin, Kunstgewerbemuseum, Kataloge: Mittelalterliche Seidenstoffe* (Berlin, 1992), p. 89, cat. no. 172. The samite in Figure 17 is a particular type of compound weave; see the Glossary.

19. *Europa und der Orient,* pp. 565–566, cat. 4/36. The silk in Figure 18 is attributed to Sicily by Falke, p. 24 and fig. 160.

20. Harris, p. 167; Lisa Monnas, "Developments in Figured Velvet Weaving in Italy during the Fourteenth Century," *Bulletin du Centre International d'Étude des Textiles Anciens* 63–64 (1986): 63. Mass exports of European textiles, especially woolens and linens but also silks, to the Muslim eastern Mediterranean began in the thirteenth century; Ashtor 1986, "Observations on Venetian Trade," pp. 581–586. In 1274 a Lucchese *sendal* (a combination of silk and linen) was purchased for Violante, the consort of Alfonso X of Castile; May, p. 119.

21. Florence Elder de Roover, "Lucchese Silks," *Ciba Review* 80 (June 1950): 2902–2903, 2907–2909.

22. Inv. no. 46.156.30; Weibel, p. 129; Falke, p. 31; Molinier, no. 1129. The inventory of 1295 lists nearly two hundred Lucchese fabrics in a variety of patterns; Molinier, especially nos. 1216–1229. For an example of the Spanish models, see a twelfth-century silk with gold accents in the Kunstgewerbe-

museum, Berlin, inv. no. 84,281; Wilckens 1992, pp. 63–64, cat. no. 108; see also Falke, fig. 153.

23. Molinier, nos. 826, 934, 1439; Ileana Chiappini di Sorio, "La tessitura serica à Venezia: Della origine e di alcune influenze iconografiche," in *Venezia e l'Oriente Vicino,* ed. Ernst J. Grube, Atti del primo congresso internazionale sull'arte veneziana a l'arte islamica (Venice, 1989), pp. 203–206; Doretta Davanzo Poli and Stefania Moronato, *Le stoffe dei veneziani* (Venice, 1994), pp. 13–25.

24. Anne E. Wardwell, "The Stylistic Development of Fourteenth- and Fifteenth-Century Italian Silk Design," *Aachener Kunstblätter* 47 (1976–1977): 177.

25. John White, *Art and Architecture in Italy, 1250–1400,* 2d ed. (London, 1987), pp. 202–207, 344–348. The traditional attribution is exemplified by Sandrina Bandera Bistoletti, *Giotto: Catalogo completo dei dipinti* (Florence, 1989), pp. 20–28; the opposing view is argued in Alastair Smart, *The Assisi Problem and the Art of Giotto* (Oxford, 1971).

26. The painted Islamic-style geometric textiles have been catalogued by Brigitte Klesse, *Seidenstoffe in der Italienischen Malerei des 14. Jahrhunderts* (Bern, 1967), pp. 25, 34–54 and cat. nos. 1–110. Klesse proposes that the early depictions were based on Spanish models and varied over time as painters repeated the patterns and passed them on to their pupils as part of their style. The connection between these painted textiles and Spanish silks was made by Gustave Soulier, *Les influences orientales dans la peinture toscane* (Paris, 1924), pp. 108–109.

27. Klesse, pp. 25, 26, 34, 40, 44 and cat. nos. 16, 17, 31, 33.

28. Falke, pp. 21–22, 39; Weibel, p. 48; May, pp. 75–76, 83–84, 90–97; Baker 1995, p. 62.

29. Mechthild Lemberg, *Abegg-Stiftung Bern in Riggisberg,* vol. 2, *Textilien* (Bern, 1973), pl. 20. For the textiles from the tombs of Don Felipe and his wife, Dona Leonor, see also May, pp. 93–97. Don Felipe may have received the textiles in his and his wife's tombs from the emirs of Granada, whom he served shortly before his death.

30. For example, see the fragment in the Cooper Union Museum, New York, inv. no. 1902.1.978; Weibel, p. 104, cat. no. 85 and fig. 85.

31. For example, see a twelfth-century silk in Saint-Sernin, Toulouse; *Europa und der Orient,* p. 561, cat. no. 4/31. This is one of several textiles Falke (pl. 5) attributed to Sicily that are now considered Spanish.

32. Louise W. Mackie, "Toward an Understanding of Mamluk Silks: National and International Considerations," *Muqarnas* 2 (1984): 136–139.

33. Fourteenth-century Spanish geometric patterns comparable in scale to those of the Assisi paintings have a slightly different interlacery style. For example, see a large banded fabric (108 × 243 cm.) with repeats of about fifteen centimeters in the Hispanic Society of America, New York, inv. no. H909; Linda Wooley, "Spanish Textiles," *Hali* 17, no. 3 (1995): 70, fig. 4.

34. Molinier, nos. 929–931, 939, 960, 1232 (a piece with broad stripes five *braccia* long), 1233. Patterns with pinecones and European armorial motifs are also mentioned.

35. Baker 1995, pp. 52–53; Harris, p. 179.

36. The example in the Cleveland Museum of Art (inv. no. 1990.2) has an imitation Arabic inscription woven in a Chinese technique and rows of felines and eagles in roundels with Chinese-style ornament; Watt and Wardwell, pp. 154–155, cat. no. 43, with illustrations; Wardwell 1992–1993, p. 246, fig. 5; Wardwell 1992, pp. 361–363, fig. 5. The example in the David Collection, Copenhagen (inv. no. 20/1994) also uses a Chinese technique and has a Persian inscription with the name of the Salghur sultan Abu Bakr ibn Saud (r. ca. 1226–60) and a dense pattern consisting of staggered horizontal rows of cross forms with curvilinear outlines made up of Chinese cloud-collars (arched forms with scalloped outside, and cusped inside, edges) and mixed Chinese and Islamic filling ornament; Watt and Wardwell, p. 135 and fig. 63. Both textiles are loom width, and the authors argue that they were made in the eastern Iranian cultural world by weavers familiar with the Chinese tradition as a result of the Mongol practice of transporting captured craftsmen to distant regions of the empire.

37. Bandera Bistoletti, illustrations on pp. 31, 33, 41; Smart 1971, pls. 52, 53, 74.

38. See the bed curtains whose top bands are inscribed in imitation Arabic script in the frescoes of the Upper Church of San Francesco, Assisi. These frescoes, *Isaac Blessing Jacob* and *The Rejection of Esau,* are attributed to the anonymous Isaac Master and usually dated in the early to mid-1290s; for illustrations, see Bandera Bistoletti, pp. 17, 21; Smart 1971, pls. 32a, 33; Klesse, cat. 51b. Similar textiles without inscribed bands often cover the background of late-thirteenth- and early-fourteenth-century Tuscan painted crucifixes; for examples, see Klesse, cat. nos. 14, 79, 93–94.

39. In the Chapel of Saint Gregory in the same church, fragments of late-thirteenth-century frescoes show fictive wall hangings of the same fabric—without the Western-style ornament in the geometric forms; James H. Stubblebine, *Duccio di Buoninsegna and His School* (Princeton, N.J., 1979), 1:24–25; 2: figs. 551–552. Stubblebine argues that either Duccio or the artist who frescoed the walls of the chapel imitated the other, or that both imitated the same fabric—which he proposes was similar to an Italian silk with heraldic birds in the Victoria and Albert Museum, cited in note 42

below. The original location of Duccio's panel was formerly believed to be the Chapel of Saint Gregory; evidence countering this belief is presented in Irene Hueck, "La tavola di Duccio e la Compagnia delle Laudi di Santa Maria Novella," in *La Maestà di Duccio restaurata,* Le Uffizi: Studi e richerche, 6 (Florence, 1990), pp. 33–46. Luciano Bellosi (*Cimabue* [Milan, 1998], pp. 130, 287–288) argues that Duccio painted the chapel's frescoes, not Cimabue, as other scholars have proposed.

40. Klesse, in note 26 above.

41. *Bibliotheca Sanctorum,* 5:1092; Bonito Fanelli 1980, pp. 13–17.

42. For example, a late-thirteenth- or early-fourteenth-century Italian silk in the Victoria and Albert Museum, London (inv. no. 8633-1863; Wardwell 1976–1977, p. 179 and fig. 1; another fragment of the same fabric in the Art Institute of Chicago is cited in Stubblebine, note 39 above), that has traditional addorsed animals and foliate elements in star-shaped strapwork compartments was inspired by contemporary Spanish designs combining geometric interlace with figures, for example, a silk in the Kunstgewerbemuseum, Berlin (inv. no. 62, 99; Wilckens 1992, pp. 74–75, cat. no. 13, with an illustration). The Italian fabric has a slightly larger repeat. An Eastern Islamic rather than Spanish origin has also been proposed for the Berlin silk: Anne E. Wardwell, "'Panni tartarici': Eastern Islamic Silks Woven with Gold and Silver, Thirteenth and Fourteenth Centuries," *Islamic Art* 3 (1988–1989): 112–113, fig. 59, which illustrates another fragment of the same fabric in the Art Institute of Chicago, inv. no. 52.1252.

43. The Cleveland Museum of Art tentatively attributes it to Lucca, first half of the fourteenth century; it measures 86.4 × 29.2 cm. Wardwell 1976–1977, pp. 179–182; Harris, p. 167.

44. See Falke, p. 31 and figs. 231–235; *Europa und der Orient,* p. 567, cat. no. 4/38.

45. Chapter 1, note 19.

46. See the meticulous study based on both Italian and northern European inventories and paintings in Wardwell 1976–1977, pp. 177–221.

47. See notes 1, 5, 36 above. About a thousand households of Herati craftsmen were sent to Besh Baliq in 1222, and in the 1230s about 10–25 percent of them returned; Allsen, pp. 38–41.

48. The fragment in Figure 22 measures 12.1 × 18.2 cm.; Watt and Wardwell, pp. 146–147, cat. no. 37; Pauline Simmons, *Chinese Patterned Silks* (New York, 1958), p. 23. It comes from the cope now in San Domenico, Perugia (Wardwell 1988–1989, fig. 22). Wardwell (1988–1989, pp. 98, 101) assigns the vestments associated with Benedict XI, which include a shoe also in Perugia (her fig. 21) to a later date on

the basis of Italian silks used in them; her fig. 15 and pl.8-B illustrate the tiny pattern silk from Cangrande's tomb, and fig. 3 another example in the Cleveland Museum of Art (inv. no. 85.33). See also Licisco Magagnato, ed., *Le stoffe di Cangrande: Ritrovamenti e ricerche sul '300 veronese* (Florence, 1983), pp. 41–44, 164, and illustrations on pp. 21, 24–25, 43.

49. Wardwell 1988–1989, pp. 97–102. The textiles cited in note 36 above use both Chinese strap gold and Islamic wrapped gold threads for exceptionally rich surface effects.

50. Wardwell 1988–1989, p. 143, nos. 98–100.

51. Klesse, p. 56 and cat. no. 135; Andrew Martindale, *Simone Martini* (Oxford, 1988), pp. 19–21. Simone's interest in costume is discussed in Chapter 9.

52. Inv. no. 18.225; Wardwell 1988–1989, p. 110 and fig. 57; see also p. 139, no. 51, for the inventory description. The cope's fabric is clearly represented in *Saint Louis Received into the Franciscan Order* and *The Funeral of Saint Louis;* Martindale, pls. 16 and 18.

53. Bonito Fanelli 1980, p. 17.

54. Klesse, pp. 55–56 and cat. no. 136; Magagnato, p. 188.

55. Wardwell 1976–1977, p. 186.

56. Wardwell 1976–1977, p. 186; Wardwell 1987, p. 11.

57. It measures 12.1 × 18.2 cm.; Wardwell 1976–1977, p. 183; Simmons, p. 23.

58. It measures 22.9 × 28.6 cm., a Founders Society Purchase by the Detroit Institute of Arts, William H. Murphy Fund. Weibel, p. 133, cat. no. 192.

59. Klesse, cat. nos. 149, 232; Wardwell 1976–1977, pp. 182–183.

60. Antonio Santangelo, *Tessuti d'arte italiani dal XII al XVIII secolo* (Milan, 1959), p. 22.

61. Wardwell 1988–1989, pp. 98, 101; Simmons, p. 23. According to Dr. Manfred Schneider at the Kulturhistorisches Museum der Hansestadt Stralsund, the reverse of the fabric bears a mark of origin in Chinese or Arabic, and the garment, which was stored new, retains a parchment label inscribed in medieval script with the Latin name for Stralsund (Sundis); the exceptional documentary importance of the dalmatic for the production of, and international trade in, central Asian textiles is under study.

62. Klesse (pp. 65, 67, 75–76 and cat. nos. 160, 162) and Magagnato (p. 182) propose that Paolo Veneziano's mantles imitate Mongol textiles, which blend Chinese and Islamic elements, such as those cited in note 36 above and Figure 32. But no examples with inscribed bands and undulating floral patterns are known. Because the imitation inscriptions on the mantles follow an Italian convention, it is far more likely that Paolo was creatively updating the traditional Islamic robes of honor discussed in Chapter 3. He must also have invented the improbable undulating inscribed band in the center of the cloth of honor in the same painting; the angels

hold this textile vertical so that its Chinese ogival pattern is clearly displayed.

63. Wardwell 1987, pp. 7–9, 14–23. For central Asian and Persian examples, also see Wardwell 1988–1989, pp. 98, 106–109; for Italian examples, also see Wardwell 1976–1977, pp. 183–185.

64. Wardwell 1987, p. 14; Wardwell 1988–1989, pp. 112–113. The additional embroidery includes the arms of the Aragon family of Barcelona.

65. Wardwell 1987, pp. 16–17; Wardwell 1988–1989, p. 114. For Italian grape-leaf-and-vine designs, also see Wardwell 1976–1977, p. 182.

66. Wardwell 1987, figs. 28 (Cleveland Museum of Art, inv. no. 71.75; Italian) and 17 (Cleveland Museum of Art, inv. no. 26.509; Islamic); and a different design in figs. 19 (Kunstgewerbemuseum, Berlin, inv. no. 99.32; Italian) and 18 (Cleveland Museum of Art, inv. no. 43.51; Asian).

67. Wilckens 1992, pp. 115–116, cat. no. 236.

68. See Andrea Orcagna, *Christ Giving the Keys of the Church to Saint Peter,* 1354–1357, Strozzi Chapel, Santa Maria Novella, Florence (Klesse, p. 136, fig. 3, and cat. no. 264), and Klesse, figs. 101–102 and pl. 6.

69. For the Mamluk fabric, see Mackie 1984, pp. 133–134; Wardwell 1987, pp. 22–23; Atil 1981, p. 225. For the Master of the Bambino Vispo's *Madonna and Child* in the Martin von Wagner-Museum, Würzburg, see Klesse, pp. 72–73, 308 and fig. 87.

70. Mackie 1984, p. 134.

71. For an Italian imitation of the larger medallion, see a fourteenth-century lampas weave silk in the Kunstgewerbe-museum, Berlin (inv. no. K 6116; Wilckens 1992, p. 114, cat. no. 231).

72. Mackie 1984, pp. 127, 130–131, 136–139.

73. The drapery on the back of the Madonna's throne, which is not clearly described (see Monica Chiellini, *Cimabue* [Florence, 1988], fig. 64), resembles a striped silk, believed to be Mamluk, in a chasuble in the Herzog Anton Ulrich-Museum, Braunschweig (inv. no. MA 25.1836); see Leonie von Wilckens, *Herzog Anton Ulrich-Museum, Braunschweig: Die mittelalterlichen Textilien, Katalog der Sammlung* (Braunschweig, 1994), pp. 17–20, cat. no. 3.

74. For Figure 32, see *Circa 1492,* p. 133, cat. no. 17; *Europa und der Orient,* pp. 569–570, cat. no. 4/43. For other central Asian examples, see Wardwell 1988–1989, pp. 100, 106 and figs. 5, 13, 14, 41, 42.

75. Inv. no. 765-1893; Wardwell 1976–1977, p. 183 and fig. 10.

76. Rosalia Bonito Fanelli and Paolo Peri, *Tessuti italiani del Rinascimento: Collezioni Franchetti Carrand,* exh. cat., Palazzo Pretorio, Prato (Florence, 1981), p. 28, cat. no. 28. This darkened fragment has a rose background: it is illus-

trated in color in Santangelo, pl. 11. A brighter example on a blue background in the Kunstgewerbemuseum, Berlin, was destroyed in World War II: for a color illustration, see Santangelo, pl. 12.

77. Wardwell 1976–1977, p. 183.

78. Donata Devoti, "Stoffe Lucchesi del Trecento," *Critica d'arte,* n.s., 13, no. 81 (September 1966): 29. Devoti compares the inscribed medallion to a damask (fig. 5) that exemplifies the lighter, more delicate version of the Mamluk pattern.

79. It measures 106.7 × 68.6 cm.; Martin, p. 15, cat. no. 2; Wardwell 1976–1977, pp. 198–202.

80. Wardwell 1976–1977, pp. 178, 203–205. Degenhart and Schmitt (pt. 2, 1:136–177, with illustrations; and 6: 427) argue convincingly that the textile designs in Jacopo Bellini's sketchbook in the Louvre (Département des Arts Graphiques, Album, fol. 88v) are leaves taken from a late-fourteenth-century Venetian pattern book to be used as inexpensive drawing surfaces rather than Jacopo's own drawings for his paintings (see Wardwell 1976–1977, p. 214) or the contemporary silk-weaving industry (see Falke, p. 44).

81. Monnas, pp. 63–100 (summarized in Harris, pp. 168–171); de Roover, p. 2924; Davanzo Poli and Moronato, pp. 25–26. For the velvet scabbard cover from Cangrande della Scala's tomb, see also Magagnato, p. 287.

82. Monnas, pp. 65–67: Victoria and Albert inv. no. 884-1899 is a checked velvet (fig. 1), and inv. nos. 882-1899 and 8314-1863 are tartans (figs. 2, 3). For Simone Martini's paintings in the Chapel of Saint Martin at Assisi, see Martindale, pp. 19–21 and fig. 30.

83. Citing the documentation for the type of velvet in Figure 36, Monnas (pp. 70–71) dates it in the late fourteenth century and notes that it exists in two versions, which differ in color and quality (pp. 73–74). Also see Devoti, p. 34; and Weibel, pp. 140–141, cat. no. 221.

84. Wardwell 1988–1989, pp. 112–114.

85. Falke, p. 45; Weibel, pp. 65–66; Harris, pp. 169–170.

86. Chiara Buss et al., *Tessuti serici italiani, 1450–1530,* exh. cat., Castello Sforzesco, Milan (Milan, 1983), pp. 17–22; Davanzo Poli, pp. 31–52.

87. Davanzo Poli, p. 169; Wardwell 1976–1977, pp. 206–208. Also see Klesse, p. 105 and cat. nos. 423, 440.

88. Inv. no. 25929; Devoti, p. 32; also see Klesse, p. 110 and cat. no. 450.

89. Harris, p. 169.

90. See Lotus Stack, *The Pile Thread: Carpets, Velvets, and Variations,* exh. cat., Minneapolis Institute of Arts (Minneapolis, Minn., 1991), pp. 18–19.

91. For other examples of such luxurious red velvets, see a cape in the Art Institute of Chicago, ca. 1500 (inv. no. 51.52, Weibel, p. 142, cat. no. 229), and those illustrated in Buss, pp. 126–128, cat. nos. 31–32.

92. Rosalia Bonito Fanelli, "I 'doni' dall'Oriente e da 'Champagne, Provins et Ultramonti': Commerci, chiesa e moda," in *Drappi, velluti, taffetà et altre cose: Antichi tessuti a Siena e nel suo territorio,* exh. cat., Chiesa di Sant'Agostino, Siena (Siena, 1994), pp. 53–54.

93. It measures 108 × 52.1 cm.; Martin, pp. 45 and 59, cat. no. 31.

94. For example, see Domenico Ghirlandaio, *The Last Supper,* ca. 1480, San Marco, Florence (fig. 77 in Thornton).

95. A luxury-quality example in fine linen embroidered in gold and polychrome silk, probably made in Egypt, survives in the Museo dell'Opera Metropolitana del Duomo, Siena; inv. no. 3989; Bonito Fanelli 1994, pp. 51–52 and 102, cat. no. 2. It arrived as a wrap for relics of Saint John the Baptist's right arm, presented to the bishop of Siena by the despot of Morea, Thomas Paleologus, in 1453.

Chapter 3. Oriental Script in Italian Paintings

1. For a general discussion of legible and illegible inscriptions in Italian painting, see Moshe Barasch, "Some Oriental Pseudo-Inscriptions in Renaissance Art," *Visible Language* 23, nos. 2–3 (spring and summer 1989): 171–187. There has been extensive discussion of pseudo-Arabic inscriptions, but considerable disagreement remains about their legibility and meaning in an Italian context. For recent consideration, with references, see Maria Vittoria Fontana, "L'influsso dell'arte islamica in Italia," in *Eredità dell'Islam: Arte islamica in Italia,* ed. Giovanni Curatola, exh. cat., Palazzo Ducale, Venice (Venice, 1993), pp. 456–459, 466–467; Hidemichi Tanaka, "Oriental Script in the Paintings of Giotto's Period," *Gazette des Beaux-Arts,* 6th ser., 113 (1989): 214–226; Hidemichi Tanaka, "Arabism in Fifteenth-Century Italian Painting," *Art History* (Tohoku University, Japan) 19 (1997): 1–22; Auld 1986, pp. 246–265; O. Grabar 1992, p. 117; Ettinghausen 1974, "The Impact of Muslim Decorative Arts and Painting," pp. 294, 316–320.

2. For types of Arabic script during this period, see David James, *Qurans of the Mamluks* (London, 1988), pp. 16–20; Mohamed Zakariya, "Islamic Calligraphy: A Technical Overview," in *Brocade of the Pen: The Art of Islamic Writing,* ed. Carol Garret Fisher, exh. cat., Kresge Art Museum, Michigan State University (East Lansing, Mich., 1991), 10–13.

3. Oral communication from Mohamed Zakariya. Also see note 37 below.

4. For the vault frescoes, see White, pp. 202, 344; Bandera Bistoletti, p. 24 and the illustration on p. 25.

5. Hidemichi Tanaka, "Giotto and the Influences of the Mongols and Chinese on His Art," *Art History* (Tohoku University, Japan) 6 (1984): 8–10 and figs. 7–8; Tanaka 1989, pp. 221–224 and figs. 5–6.

6. Nicholas Poppe, *The Mongolian Monuments in Hp'ags-pa Script,* 2d ed., trans. and ed. John R. Krueger (Wiesbaden, 1957), pp. 1–7 and pls. 7–9 (illustrations of *pai-zus*); cited in Tanaka 1984, p. 8 and figs. 22–23. See also Morris Rossabi, *Khubilai Khan: His Life and Times* (Berkeley and Los Angeles, 1988), pp. 154–158 and figs. 11 (inscription on the base of a porcelain bowl) and 12 (a *pai-zu*).

7. Moule and Pelliot, 1:79, 90, 92; Marco Polo described gold, gilt silver, and silver tablets of different weights presented according to rank (pp. 203–204).

8. Two of the original letters from khans of Persia to King Philip of France survive in the French national archives, one from Arghun, dated 1289, and the other from Uljaitu, dated 1305; *La terre du Bouddha: Jérusalem, Rome et le Grand Khan,* exh. cat., Musée National des Arts Asiatiques, Guimet (Paris, 1994), pp. 72–73, cat. no. 15, and pp. 76–77, cat. no. 17, with illustrations; see also Mann, 17:50, 65. Both letters are on long narrow cotton scrolls and bear the seals, stamped in red ink in Chinese, by which the great khan granted authority to the khans of Persia. A similar red seal appears on a Persian draft of a letter of 1245 from Great Khan Guyuk to Innocent IV, carried back from Karakorum by Friar John of Plano Carpini, that is preserved in the Vatican archives; Rachewiltz, pp. 102–103, 213.

9. See Rossabi, note 6 above. Marco Polo described in detail the making of paper money, the red authorization seals stamped on it, and its use throughout the Mongol empire; Moule and Pelliot, 1: 238–242. It has been proposed that Italian painters knew 'Pags Pa from these seals on paper money; see Tanaka 1997, p. 3.

10. See Chapter 1, note 22.

11. Ettinghausen 1974, "The Impact of Muslim Decorative Arts and Painting," p. 294; S. D. T. Spittle, "Cufic Lettering in Christian Art," *Archaeological Journal* 111 (1954): 151–152.

12. See Introduction, note 40.

13. Otto Kurz, "The Strange History of an Alhambra Vase," reprint no. 17 in *Selected Studies: The Decorative Arts of Europe and the Islamic East* (London, 1977), 1:205–212. For Alhambra vases, see Summer S. Kenesson, "Nasrid Luster Pottery: The Alhambra Vases," *Muqarnas* 9 (1992): 93–115 (pp. 105–107 for the vase in Stockholm); Alice Wilson Frothingham, *Lustreware of Spain* (New York, 1951), pp. 43–63.

14. Maxime Rodinson, *Europe and the Mystique of Islam,* trans. Roger Veinus (Seattle and London, 1987), pp. 29, 40–41; Hamilton, pp. 235–239. The earliest polyglot Bible (1514–1517) compared texts in Hebrew, Aramaic, Greek, and Latin; the first polyglot Psalter (1516) added Arabic. A late-twelfth- or early-thirteenth-century Arabic-Latin dictionary is known to have passed from the the humanist Niccolò di Niccoli (1364–1437) to the Library of San Marco; Auld 1986, p. 255.

15. Smart 1971, pp. 185–186; Erwin Rosenthal, "The Crib of Greccio and Franciscan Realism," *Art Bulletin* 36 (1954): 58–59.

16. Also see the *Triumph of Saint Thomas Aquinas over Averroes* by Benozzo Gozzoli, ca. 1480, in the Louvre; in it Aquinas displays a book in Latin above three other texts, one in pseudo-Arabic, and Aristotle holds a book in Greek; see *Europa und der Orient,* p. 137, fig. 153.

17. White, p. 340; Bandera Bistoletti, p. 150.

18. According to Monica Blanchard at the Institute of Christian Oriental Research, Catholic University, Washington, even the similar forms have extraneous or missing elements, and other contemporary Eastern scripts can also be ruled out as models.

19. Fontana 1993, pp. 466–467.

20. A detailed account of the Italian depictions and their connection with Islamic *tiraz* textiles appears in Bierman 1980, pp. 169–205.

21. For *tiraz* fabrics and robes of honor, see Bierman 1980, pp. 3–95; Patricia A. Baker, "Islamic Honorific Garments," *Costume* 25 (1991): 25–29; Baker 1995, pp. 53–69; Weibel, p. 45; Atil 1981, pp. 223–225; Atil 1987, p. 29; Oleg Grabar, "Patronage in Islamic Art," in *Islamic Art and Patronage: Treasures from Kuwait,* ed. Esin Atil, exh. cat., Walters Art Gallery, Baltimore (New York, 1990), pp. 31–32.

22. Ettinghausen 1974, "Arabic Epigraphy," pp. 304, 307, 309; O. Grabar 1992, pp. 64–66, 117.

23. O. Grabar 1992, p. 117.

24. The statement appears in the "Life of Pope Eugene IV," in Vespasiano da Bisticci, *Le vite,* ed. Aulo Greco (Florence, 1970), 1:19. Also see Aby Warburg, *Gesammelte Schriften* (Leipzig and Berlin, 1932), 1:389. The impact of these Eastern costumes on fifteenth-century Italian paintings is discussed in Chapter 9.

25. See Chapter 2, note 36.

26. In his reappraisal of the Rucellai Madonna's artistic importance and influence, Hayden B. J. Maginnis (*Painting in the Age of Giotto: A Historical Reevaluation* [University Park, Pa., 1977], p. 71) has drawn attention to the "unrivalled delicacy and specificity" of the ornamental band on the Virgin's mantle.

27. Baker 1995, p. 57, with an illustration of a replica of the now fragmented robe; Bierman 1980, pp. 84–87, with sketches showing how such garments were made from lengths of fabric folded at the shoulders and seamed at the sides for sleeves.

28. Richard Ettinghausen, *Arab Painting* (Lausanne, 1962), pp. 104–105, 114.

29. Illustrated in Bandera Bistoletti, p. 38.

30. See Ettinghausen, as in note 28 above; and Oleg Grabar, "The Illustrated Maqāmat of the Thirteenth Cen-tury: The Bourgeoisie and the Arts," in *The Islamic City,* ed. Albert Habib Hourani and Samuel Miklos Stern (Oxford, 1970), pp. 207–210. Howard (2000, pp. 85, 94) proposes that Islamic illustrated books such as the *Maqamat* were known in Venice in the thirteenth century.

31. This luster-ware bowl dating from the tenth to the twelfth century is now in the Museo Nazionale di San Matteo, Pisa, inv. no. Bacino 72, 130; *Eredità dell'Islam,* p. 140, cat. no. 48.

32. See Chapter 2, note 12.

33. Bierman 1980, pp. 96, 123–138, 200–205. Bierman also acknowledges that, inconsistent with this theory, there is no record of such Arabic inscribed borders on clothing worn at Frederick II's court in Apulia on the Italian mainland (pp. 144, 147), and the Sicilian precedent alone does not explain the widespread representation of similar honorific garments in later Italian painting (pp. 196–197).

34. For Frederick's coronation, see Bauer, p. 286.

35. Grönwoldt 1978, pp. 43–46; Bauer, p. 287. Islamic-style honorific garments with bands of inscriptions like those in the Italian versions seem not to appear in German painting until the fourteenth century, when they also appear in French ivories; Kurt Erdmann, "Arabische Schriftzeichen als Orna-mente in der abendländischen Kunst des Mittelalters," *Abhandlungen der geistes- und sozialwissenschaftlichen Klasse* (Akademie der Wissenschaften und der Literatur, Mainz) 9 (1953): 498–500.

36. For a textile example, see the Mamluk banded silk cited in Chapter 2, note 73.

37. Literature on Gentile's painting often mentions proposed readings of the pseudo-Arabic inscriptions: "La Illahi Illa Allah" ("There is no God but God") on the cloth under the Christ Child, and a Latin signature, FABR. GEN., on the Madonna's halo; for example, see Luigi Grassi, *Tutta la pittura di Gentile da Fabriano* (Milan, 1953), p. 56; Luciano Berti and Antonio Paolucci, *L'età di Masaccio: Il primo Quattrocento a Firenze,* exh. cat., Palazzo Vecchio, Florence (Florence, 1990), p. 138. Auld (1986, p. 256) and Keith Christiansen, *Gentile da Fabriano* (London, 1982), p. 99, doubt this reading of the cloth, and Mohamed Zakariya rejects it (oral communication). The reading of the halo is clearly wrong. For the Latin inscription on the Virgin's mantle, see Auld 1986, p. 264. Earlier Byzantine (early eleventh to mid–twelfth century) and European (eleventh through thirteenth century) pseudo-Kufic (or kufesque) ornament commonly features a mirror-image group of three elements that derives from the word "Allah" in highly decorative *kufic;* Richard Ettinghausen, "Kufesque in Byzantine Greece, the Latin West, and the Muslim World," in *Richard Ettinghausen: Islamic Art and Archaeology, Collected Papers,* ed. Myriam Rosen-Ayalon (Berlin, 1984), pp. 752–769; Erdmann 1953, pp. 470–

498. The elements in Italian pseudo-Arabic, however, are much more random.

38. Auld 1986, pp. 247, 258–259.

39. John Pope-Hennessy, *Fra Angelico,* 2d ed. (Ithaca, N.Y., 1974), pls. 18, 23a.

40. For example, inscriptions in Hebrew, Greek, and Latin mentioned in the Gospel of Saint John (19:20) appear at the top of the cross in the *Deposition,* now in the Museo di San Marco, Florence, that Fra Angelico painted for Palla Strozzi, a promoter of ancient Greek studies, about 1430–1434; see Pope-Hennessy 1974, p. 176 and pl. 98.

41. Donatello's bronze effigy of Baldassare Cossa (the antipope John XXIII), 1425–1427, in the Baptistery, Florence, shows him wearing episcopal gloves with a pseudo-Arabic border. Imitation *tiraz* bands appear on Pope Martin V's sleeves in the monument by Simone Ghini, ca. 1431, in San Giovanni Laterano, Rome, and on the cushion under Bartolommeo Aragazzi's head in the monument by Michelozzo, 1429–1438, in the Duomo, Montepulciano; Ronald W. Lightbown, *Donatello and Michelozzo: An Artistic Partnership and Its Patrons in the Early Renaissance* (London, 1980), 1:45 and 2: pls. 16, 96, 46.

42. The painting, in the Sellar collection, Edinburgh, is attributed to Toscani in Luciano Bellosi, "Il Maestro della Crocefissione Griggs: Giovanni Toscani," *Paragone* 17, no. 193 (March 1966): p. 49 and pl. 1.

43. For the Ottoman practice, see Atil 1981, p. 223. Pisanello drew the Turkish-style hunting gear—a quiver and bow case—that the Byzantine emperor John VII Paleologus brought to Ferrara in 1438; for the drawing, now in the Art Institute of Chicago, see Chapter 9, note 18. In Vincenzo Catena's painting *A Warrior Adoring the Infant Christ and the Virgin,* ca. 1520, National Gallery, London, a Spanish-style metalwork headstall, similar to a late-fifteenth- or early-sixteenth-century example in the British Museum, London (inv. no. MLA 1890, 10-4, 1), appears on the warrior's horse.

44. A similar ceremonial tent, with bands of decorative pseudo-Arabic script, is more fully represented in another version of Mantegna's painting, attributed to his school, in the National Museum, Kraków (*Europa und der Orient,* p. 168, fig. 181).

45. *Story of Lancelot,* 1370, Bibliothèque Nationale de France, Paris (MS. fr. 343, fol. 31v); see Thornton, p. 322, fig. 353.

46. Candace Adelson and Roberta Landini, "The 'Persian' Carpet in Charles Le Brun's 'July' Was a Sixteenth-Century Florentine Table Tapestry," *Bulletin du CIETA* 68 (1990): 57; for the sultan's gifts to Lorenzo, see Chapter 1, note 71.

47. Ettore Camesasca, ed., *All the Paintings of Raphael,* trans. Luigi Grasso (New York, 1963), 2: pl. 34. Castiglione, who completed his book in 1516, considered the fashion for

dressing in the French, Spanish, German, or Turkish manner unpatriotic and "an augury of servitude"; Baldesar Castiglione, *The Book of the Courtier,* trans. Charles S. Singleton (New York, 1959), pp. 120–121.

48. Maginnis, p. 70.

49. Spallanzani (1978, p. 100) proposed that imported metalwork, glass, and ceramics as well as textiles could have inspired the pseudo-Arabic script in Italian paintings; Auld (1986, p. 258), who did not mention Giotto's pseudo-Arabic halos, considered metalwork the second most likely source after textiles for the bold pseudo-Arabic script on Gentile da Fabriano's later halos.

50. The arms on the dish in the Dauphin collection, Geneva, which may be those of the Pallavicini of Venice, were added after the object reached Italy; see James W. Allan, "Metalwork," in *Treasures of Islam* (Geneva and London, 1985), p. 271, cat. no. 280. This dish may be the earliest surviving example of a group of fourteenth-century inlaid brass dishes, all with prominent inscriptions, that are discussed in James W. Allan, *Metalwork of the Islamic World: The Aron Collection* (London, 1986), pp. 42–43, 92.

51. *Visit to the Holy Places,* p. 182; also quoted in Allan 1986, p. 51.

52. For examples, see Richard Offner, *The Fourteenth Century: Bernardo Daddi, His Shop and Following,* vol. 3, pt. 4 of *A Critical and Historical Corpus of Florentine Painting,* ed. Miklós Boskovits (Florence, 1991), pls. 16.1–2, 15.3–4.

53. For the Washington panel, see Christiansen 1982, pp. 21, 92–93 and pl. 18; for the *Coronation of the Virgin,* see Christiansen 1982, pp. 18–19, 95–96 and pl. 20. For the halos in these paintings, see Auld 1986, pp. 246–247, 250, 264.

54. The pseudo-Arabic halos in Gentile's Florentine works and their relation to Italian textiles and Mamluk brassware are discussed in Auld 1986, pp. 246–265, who assumed the halos unprecedented in Florentine painting and also listed Gentile's Latin inscriptions and their sources. For the *Madonna and Child* fresco, 1425, in the cathedral of Orvieto, see Keith Christiansen, "Revisiting the Renaissance: 'Il Gentile Disvelato,'" *Burlington Magazine* 131, no. 1037 (August 1989): 541 and fig. 29. In the *Coronation of the Virgin* in the J. Paul Getty Museum, one of Gentile's first Florentine paintings, the pseudo-Arabic–inscribed halo of the Virgin is juxtaposed with the Latin-inscribed halo of Christ (Christiansen 1982, pl. 20); in the central panel of the Quartaresi altarpiece of 1425, one of his last, the halos are inscribed in Latin, not pseudo-Arabic (Christiansen 1982, pl. 48).

55. For Masaccio's triptych, see Luciano Berti and Rosella Foggi, *Masaccio: Catalogo completo* (Florence, 1989), pp. 26–28, with an illustration. There is no justification for reading the Muslim confession of faith—"There is no God but God and Muhammad is his Prophet"—in some of Masaccio's

"letter" forms and combinations, as proposed in Rudolf Sellheim, "Die Madonna mit der Schahàda," in *Festschrift Werner Caskel zum siebzigsten Geburtstag 5. März 1966 gewidmet von Freunden und Schülern,* ed. Erwin Gräf (Leiden, 1968), pp. 308–310; oral communication from Mohamed Zakariya. Nonetheless, this reading has made its way into the literature: see, for example, Lightbown 1981, p. 452.

56. The Pisa polyptych was commissioned by Giuliano di Ser Colino degli Scarsi, a notary; Masaccio executed it in Pisa between February 19 and December 26, 1426; Berti and Foggi, p. 45. For the Uffizi painting, see Berti and Foggi, p. 32 and the illustrations on pp. 34–35.

57. See the *Madonna and Child with Angels,* formerly in the Heim Gallery, Paris; the *Madonna and Child* in the Heimatmuseum Römstedthaus, Bergen; and the *Madonna and Child* in the Oratorio della Madonna delle Calle, Montemignaio; Bellosi 1966, pp. 49–56 and figs. 16–18.

58. See the *Virgin Mary Annunciate* in the Detroit Institute of Arts (Laurence B. Kanter et al., *Painting and Illumination in Early Renaissance Florence,* exh. cat., Metropolitan Museum of Art, New York [New York, 1994], pp. 347–348, cat. no. 51, with an illustration), and the *Coronation of the Virgin* in the Louvre (Pope-Hennessy 1974, fig. 129; a later date is proposed on pp. 215–216).

59. Auld 1986, pp. 247, 254, 258–259; Sellheim, pp. 311–315. For grain shipments from North Africa in 1420 and 1421, see Ammirato, 6:408–410.

60. The ambassador to Tunis was Bartolomeo Galea, and the ambassadors to Cairo were Felice Brancacci and Carlo Federighi; Auld 1986, p. 247; Sellheim, pp. 311–313. The identification of the Vanni Castellani arms in the San Giovenale altarpiece disproves Sellheim's theory (pp. 313–315) that Brancacci commissioned it for his chapel in the Carmine in anticipation of his mission. Furthermore, Masaccio completed the San Giovenale altarpiece before Brancacci received his diplomatic commission on June 14, 1422, and before Masaccio joined Masolino in painting Brancacci's chapel in the Church of the Carmine, Florence, in 1425 (see Berti and Foggi, p. 82; Christiansen 1982, p. 48). Other Florentines involved in the new galley line to Alexandria are mentioned in Ammirato, 6:420–434. One was Palla Strozzi, who went first to Rome, to inform Pope Martin V about the threat of war, and then to Naples, to seek Alfonso of Aragon's permission to use Neapolitan ships for Florentine cargoes in case of war; Ammirato, 6:440–441.

61. See the discussion of Mantegna's *Virgin and Child with Seraphim and Cherubim* in the Metropolitan Museum, New York, in *Andrea Mantegna,* ed. Jane Martineau, exh. cat., Royal Academy of Arts, London, and Metropolitan Museum of Art, New York (Milan, 1992), p. 139, cat. no. 12.

62. Eisler, figs. 42–43. See also the discussion of Jacopo Bellini's *Madonna and Child,* in the Los Angeles County Museum of Art, in Christiansen 1987, pp. 174–177 and pl. 5.

63. For the *Annunciation* in Brescia, see Eisler, figs. 17–18. For Jacopo's early works and his relationship with Gentile da Fabriano, see Keith Christiansen, "Venetian Painting of the Early Quattrocento," *Apollo* 125 (March 1987): 166–177.

64. Alberta De Nicolò Salmazo, "Padova," in *La pittura veneta: Il Quattrocento,* ed. Mauro Lucco (Milan, 1989), 2:523 and fig. 602.

65. See Ronald W. Lightbown, *Mantegna* (Oxford, 1986), pp. 69, 71; and Lightbown 1981, pp. 452–453.

66. Pseudo-Arabic halos last appear in Mantegna's art in the *Adoration of the Magi,* now in the Uffizi, that was painted for the chapel of the Gonzaga Palace in Mantua about 1460–1464, immediately after the artist entered the service of Marquis Ludovico; Lightbown 1981, p. 453 and fig. 308; and Lightbown 1986, pp. 88–91 and pl. 50. The depictions of Oriental costumes, physiognomies, and animals in this painting are unusually detailed.

67. The pseudo-Arabic elements are noted in Fontana 1993, p. 467.

68. The pseudo-script on the *Stigmatization of Saint Francis* was noted by Tanaka (1989, p. 220); see Bandera Bistoletti, pp. 55–56, with an illustration.

69. As noted by Tanaka (1989, p. 220), pseudo-script runs around the gilt outside edge of the wooden crucifix in the Dominican Church of Santa Maria Novella, Florence, which most scholars date about 1290–1300 and no longer attribute to Giotto; the traditional attribution to Giotto is supported in Bandera Bistoletti, pp. 46–47, with an illustration, and argued against in Smart 1971, pp. 74–81 and pl. 12. Pseudo-script also surrounds the predella panels in the gilt wooden frame of a polyptych in the Capitolo dei Canonici of Saint Peter's, Rome, executed by Giotto's workshop and usually dated about 1330; see Wolfgang Fritz Wolbach, *Catalogo della Pinacoteca Vaticana I: I dipinti dal X secolo fino a Giotto* (Vatican City, 1979), figs. 96–97, 101–102. According to a donation record of 1343, Cardinal Stefaneschi, canon of Saint Peter's, had commissioned Giotto to execute the polyptych and *The Navicella,* a mosaic formerly in the nave of Old Saint Peter's; see Smart 1971, pp. 67–72; and Alastair Smart, *The Dawn of Italian Painting, 1250–1400* (Ithaca, N.Y., 1978), p. 58. Because of their location, these were both important paintings. For a proposed earlier dating of the polyptych, see Chapter 9, note 8.

70. For example, see the *mihrab* (prayer niche) of al-Afdal in the Mosque of Ibn Tulun, Cairo, 1094; Hill and Golvin, fig. 17.

71. See note 37 above; and Linda Safran, *San Pietro at Otranto: Byzantine Art in South Italy* (Rome, 1992), pp. 123–124, fig. 70 and pl. 13 (a band of pseudo-Kufic on the arch

over the apse—a common location—in San Pietro, Otranto), and fig. 122 (a Byzantine miniature with a pseudo-Kufic frame in the National Library, Athens [cod. 152, fol. 10r], datable about 1300). Erdmann's important study (1953, pp. 496–498) cites only six thirteenth-century examples of pseudo-Kufic ornament in northern Italy: a painted band under a lunette in the Castle of Angera, Lombardy (fig. 496); three miniatures (the frame around a *Maestà* in a missal, Biblioteca Civica, Mantua [D.III.15], fig. 116); the frame around a *Crucifixion* in the Pontifical of Bishop Friedrich von Wangen of Trent (cathedral sacristy, Trent. [fol. 61], fig. 117); decorations of the bed in the *Death of the Virgin* in the Book of Epistles of Giovanni Gaibana, Padua, 1259 (cathedral treasury, Padua [fol. 64v], fig. 118); the outer borders on stained-glass windows in the Upper Church of San Francesco, Assisi, attributed to a German craftsman (figs. 119a–c); the frame around the painted panel of an altar from the Cloister of Santa Petronilla agli Umiliati, Pinacoteca, Siena (fig. 120).

72. Fontana (1993, p. 456) has suggested that Giotto's frames on the vault of the Arena Chapel could have been inspired by the stained-glass windows in Assisi mentioned in note 71 above. The blend of pseudo-Kufic and floral elements in the windows, however, bears no resemblance to Giotto's vault frames, and these windows alone could hardly have inspired all the pseudo-Arabic framing ornament in early-fourteenth-century painting. For illustrations of the windows, see Giuseppe Marchini, *Le vitrate dell'Umbria* (Rome, 1973), pls. 9, 13–14, 18–19. The updating of an absorbed tradition proposed here has a parallel in two Venetian miniatures from the *Mariegola of the Scuola of San Giovanni Evangelista:* bands of contemporary-style cursive pseudo-Arabic frame the Greco-Byzantine–style representations long common in such Venetian confraternity statute books. Dates in the first third of the fourteenth century and about 1345–1349 have been proposed for the miniatures, which are now in the Cleveland Museum of Art (59.128) and the Georges Wildenstein Collection, Paris; see William Wixom, "A Venetian Mariegola Miniature," *Bulletin of the Cleveland Museum of Art* 48 (1961): 206–209, figs. 1 (Cleveland) and 4 (Paris).

73. Inv. no. A.1-1976. John Pope-Hennessy, "The Madonna Reliefs by Donatello," *Apollo* 103 (March 1976): 178–179 and fig. 21; figs. 18–19 show surviving bronze and plaster casts that lack the rim. The style, date, and meaning of the roundel are further examined in Anthony Radcliffe and Charles Avery, "The 'Chellini Madonna' by Donatello," *Burlington Magazine* 118, no. 879 (June 1976): 377–387. Donatello's roundel is currently exhibited with a colored-glass cast in the tradition of Venetian molded-glass plaques.

74. Camesasca, 1: pl. 5.

75. For the attribution, see Federico Zeri, *Italian Paintings in the Walters Gallery of Art* (Baltimore, 1976), 2:400, cat. no. 273.

Chapter 4. Carpets

1. Spallanzani 1989, p. 89. The estate inventory of Lorenzo de' Medici of 1492 provides relative valuations for an exceptional variety of imported and domestic objects. Thirteen Oriental carpets kept in a chest in the antechambers to Lorenzo's ground floor bedroom ranged from 10 to 70 florins in value; Marco Spallanzani and Giovanna Gaeta Bertelà, *Libro d'inventario dei beni di Lorenzo il Magnifico* (Florence, 1992), pp. 8–9. The average value of Damascene metalwork in Lorenzo's chambers was under 10 florins, though more costly pieces were listed in his study and his son Giuliano's chambers; Spallanzani and Gaeta Bertelà, pp. 13, 46–47, 78–79. See also Chapter 8. The most valuable items in Lorenzo's inventory are the classical and early Islamic antiquities, such as cameos and vessels made of onyx and rock crystal, that he kept in his study; Spallanzani and Gaeta Bertelà, pp. 34–35; Goldthwaite, p. 248; and Carl Johan Lamm, *Mittelalterliche Gläser und Steinschnittarbeiten aus dem Nahen Osten,* ed. Friedrich Sarre, vol. 5 of *Forschungen zur islamischen Kunst* (Berlin, 1930), 1:189, 192, 225–226, 234, 521.

2. These were the carpets requested by Cardinal Wolsey; see Chapter 1, note 88.

3. As indicated in note 1 above, the carpets were kept in a chest outside Lorenzo's ground floor bedchamber. The *spalliera* paintings by Uccello and Pesellino were in that bedchamber, and the paintings by Pollaiuolo, in the main reception room (*sala grande*); Spallanzani and Gaeta Bertelà, pp. 11, 26. For Uccello's paintings, see John Pope-Hennessy, *Paolo Uccello,* 2d ed. (London and New York, 1969), pp. 152–153, pls. 51, 61, 71; see also the discussion of the dates of the panels and alterations made when they were moved to the new Medici palace, in Pietro Roccasecca, *Paolo Uccello: Le battaglie* (Milan, 1997), pp. 9–10, 24–27. For the lost paintings by Pollaiuolo, see Leopold D. Ettlinger, *Antonio and Piero Pollaiuolo* (Oxford, 1978), pp. 164–165, cat. no. 44.

4. For the valuation of Martelli's sculptures, see Lydecker, pp. 132–133.

5. The agent's letter of 1473 indicates that he was able to send saluki dogs, which Lorenzo also wanted; Spallanzani 1989, pp. 84, 88. The inventory of 1492 lists three carpets with Medici arms: two seem to have been a pair, and the third featured the Medici and Orsini arms; Spallanzani and Gaeta Bertelà, p. 8. Like the Spanish-style vase in Figure 97 (see Chapter 5, note 38), the last was probably ordered for Lorenzo's marriage to Clarice Orsini in 1469. Direct trade between Florence and Istanbul during the 1460s and 1470s, which Sultan Mehmet II encouraged while he was at war

with Venice, facilitated Lorenzo's carpet purchases; see Raby 1986, "Court and Export, Part 1," p. 32.

6. Reported in a letter of May 4, 1501, from a Florentine agent in Istanbul to Giovanni Becchi in Florence; Raby 1986, "Court and Export, Part 1," p. 33.

7. Genoa also traded actively in this part of Anatolia. Italian paintings, however, illustrate nothing like the thirteenth-century carpets with geometric designs found in the Mosque of Alaeddin, Konya, and another mosque nearby. See Erdmann 1966, pp. 534–535; John Mills, *Carpets in Pictures,* Themes and Painters in the National Gallery, 2d ser., no. 1 (London 1975), pp. 6–7, 9; Kurt Erdmann, *The History of the Early Turkish Carpet,* trans. Robert Pinner (London, 1977), pp. 7–14; Mackie 1980, pp. 303–306; Donald King and David Sylvester, *The Eastern Carpet in the Western World,* exh. cat., Hayward Gallery, London (Rugby, 1983), p. 12; Raby 1986, "Court and Export, Part 1," p. 30; Michael Franses, "The 'Historical' Carpets from Anatolia," in *Orient Stars: A Carpet Collection,* exh. cat., Deichtorhallen, Hamburg, and Linden-Museum, Stuttgart (London, 1993), pp. 264–265.

8. Most of the floor coverings are "carpite," which probably had no pile; inventory number 1464 reads "Item, unam parvam antiquam pilosam et fractam," and number 1466 groups together 109 assorted "tappetia, computatis magnis et parvis," which may have had pile; Molinier, pp. 125–126. See also John Mills, "Early Animal Carpets in Western Paintings—a Review," *Hali* 1, no. 3 (1978): 235.

9. King and Sylvester, p. 12.

10. Mills 1975, pp. 7–9; Mills 1978, "Early Animal Carpets," pp. 234–243, which includes a list of animal carpet images specifying which ones show knots. Depictions with lines between rows indicate a very coarse pile of three to four rows per inch, and some of the large carpets appear to be made from several strips sewn together—a technical feature of several carpets mentioned in later Venetian inventories.

11. Thornton, p. 65.

12. Erdmann 1966, p. 535; Mills 1978, "Early Animal Carpets," pp. 236–237; King and Sylvester, pp. 26, 49; Franses 1993, "The 'Historical' Carpets from Anatolia," p. 270.

13. Michael Franses and John Eskenazi, *Turkish Rugs and Old Master Paintings,* exh. cat., Colnaghi, London and New York (London, 1996), pp. 4–5, with illustrations.

14. Erdmann 1996, p. 536; Kurt Erdmann, *Seven Hundred Years of Oriental Carpets,* ed. Hanna Erdmann, trans. Mary H. Beattie and Hildegard Herzog (Berkeley and Los Angeles, 1970), p. 18; King and Sylvester, p. 49.

15. First, a Spanish armorial carpet of the type ordered by Pope John XXII (1316–34) appears in a fresco executed by the Sienese painter Matteo di Giovanetti in 1344–1346; King and Sylvester, pp. 11, 50 and fig. 2. For a surviving fifteenth-century example, see *Circa 1492,* pp. 169–170, cat. no. 52.

Some of these carpets probably reached Italy. An early-fifteenth-century Sienese *Marriage of the Virgin,* in the National Gallery, London, shows a carpet with a field that is not visible but could feature heraldic devices surrounded by a characteristically Spanish border; Mills 1975, pp. 9–10 and pl. 2. A carpet with birds that look like parrots in *The Visit of Saint Catherine of Siena to Pope Gregory XI in Avignon,* by Giovanni di Paolo, ca. 1440, in the Thyssen-Bornemisza Collection, Lugano, probably refers to the carpet with parrots and "swans" that chroniclers mention as constantly before the throne of Pope Benedict XII (1334–42) in Avignon. According to the chroniclers, Pope Benedict XII was fond of carpets and insisted that his favorite, with parrots and white swans, should always be placed before his throne. The visit of Saint Catherine of Siena to Avignon occurred in 1376. Giovanni di Paolo must have heard about the carpet and showed one like it before the throne of Pope Gregory XI to authenticate the setting of his painting; Erdmann 1970, pp. 19–20 and fig. 7. For Giovanni di Paolo's painting, also see Mills 1978, "Early Animal Carpets," p. 241.

16. See *Hali* 9, no. 3 (1988): 5.

17. John Mills, "Small Pattern Holbein Carpets in Western Paintings," *Hali* 1, no. 4 (1978): 327, fig. 1. It has been proposed that a similar carpet, now in fragments, is the earliest surviving example of the Small Pattern Holbein type; Friedrich Spuhler, "Carpets and Textiles," in *Islamic Art in the Keir Collection,* ed. Basil William Robinson (London and Boston, 1988), pp. 55–57, pl. 19 (Keir Collection, inv. no. T2).

18. Goldthwaite, pp. 225–236, 243, 248–249.

19. Girolamo del Santo's *Miracle of the Tumbler,* ca. 1510, in the Scuola del Santo, Padua, provides a clearer view than Figure 78 of a contemporary elite dinner setting. A group sits under a loggia around a table covered with a large carpet in a Small Pattern Holbein design; a glass tumbler that has fallen, unbroken, onto the pavement below indicates that the group is dining (Thornton, p. 314, fig. 346).

20. There was also a carpet of modest value stored in Lorenzo's bedstead; Spallanzani and Gaeta Bertelà, pp. 8–9, 34, 82, 93.

21. Adelson and Landini, p. 57.

22. Inv. no. 1951.2.8.34; see Thornton, pp. 65 and 297, fig. 318.

23. Among the carpets described as "new" are a pair 7 *braccia* long for the floor, "with circles" (*da compasso*), that may have been Small Pattern Holbeins; one "with five wheels" and one "with three wheels" (*cum rote*) that were probably Large Pattern Holbeins; and six "with the mosque" that must have been prayer rugs. As in most Renaissance inventories, many descriptions are imprecise, and it is not certain that all fifty-two *tapeti* listed had pile; some may have been made at the Gonzaga court in Mantua, and one is said

to be "from Ravenna." See David Sanderson Chambers, *A Renaissance Cardinal and His Worldly Goods: The Will and Inventory of Francesco Gonzaga (1444–1483)* (London, 1992), pp. 82, 106, and 153–154, inv. nos. 297, 309, 310, 318, 330, 335, 337, 338, 342. For Italian descriptive terminology, see Raby 1986, "Court and Export, Part 1," pp. 33–34.

24. For example, the inventory of 1584 of the Correr of Venice lists table carpets from Cairo, Turkey, Persia, and Circassia or the Caucasus, and more Circassian or Caucasian carpets for benches or chests; Thornton, pp. 64–65. Marin Sanudo noted that twelve Persian carpets displayed on the house of Marco da Molin in the Procuratie Vecchie for the procession of July 8, 1525, were "unique in Italy, finely worked" ("12 tapedi azamini, che in Italia non li e simili, sotilmente lavorati"); Sanudo, 42: col. 63. Also see Erdmann 1966, pp. 530, 538–539; Raby 1986, "Court and Export, Part 1," p. 29; Rogers 1986, pp. 13–15, 18. The painting *Madonna and Child with Angels,* 1432–1436, by the Sienese artist Sassetta in the Museo Diocesano, Cortona, depicts a type of straw matting imported from North Africa for use in summer; see Thornton, p. 63, fig. 70.

25. Rogers 1991, "The Gorgeous East," p. 73.

26. See Bernard Berenson, *Italian Pictures of the Renaissance: Florentine School* (London, 1963), 1: fig. 33. The textile's border is illegible; the geometric pattern of its field is consistent with the popular Spanish-style textiles discussed in Chapter 2.

27. It cannot be determined from the paintings if these objects had pile. King and Sylvester (pp. 13, fig. 6, and 14) distinguish these textiles from the imported animal carpets. Mills (1978, "Early Animal Carpets," pp. 237–238, 243) lists the *cassone* depictions and emphasizes the European character of the designs.

28. Raby 1986, "Court and Export, Part 1," p. 35.

29. For the volume of the carpet trade in Italy, see Raby 1986, "Court and Export, Part 1," pp. 31–35.

30. See the editorial and document published in *Hali* 3, no. 3 (1981): 175, 181.

31. Sanudo, 21: col. 46; Rogers 1986, p. 18.

32. Sanudo (13: col. 131) describes the donor as "mastro Stephano strazaruol," and it is not clear from the text whether he supplied just the tapestries (or hangings) or the carpets as well; Rogers 1986, pp. 17–18.

33. Sanudo, 42: cols. 62–63; Rogers 1986, pp. 17–18. The carpets in two of the rows on the Doge's Palace were sets, one probably with similar designs of the Mamluk type ("a la damaschina, overo cairin"), and the other with similar shapes ("tapedi grandi di tavola").

34. Lucchetta 1980, "L'Oriente Mediterraneo," p. 399. Tapestries (or hangings), but not specifically carpets, decorated the state Arsenal and shops in the Rialto for visits of

Turkish ambassadors in 1514 (Sanudo, 17: col. 543) and 1525 (Sanudo, 39: col. 42) respectively; Paolo Preto, p. 124 n. 18.

35. The *Departure of the Prince from Britain, His Arrival in Brittany, and Departure of the Betrothed Couple for Rome,* in the Accademia, Venice, shows carpets decorating the processional route (see King and Sylvester, front endpaper), and *Saint Ursula Taking Leave of Her Father* in the National Gallery, London, shows them hanging from windows and draped over a gondola (see Mills 1975, pl. 9).

36. The Mamluk carpet in the Scuola di San Rocco measures 3.75 by 9.70 m.; Giovanni Curatola, "Four Carpets in Venice," in *Oriental Carpet and Textile Studies* 2 (1986): 123–127 and fig. 1.

37. Carpets bearing Holbein's name have been separated into two groups. Both appear in paintings that the artist executed in London during the early sixteenth century: the Small Pattern Holbein in the *Portrait of Georg Gisze,* in the Gemäldegalerie, Berlin, and the Large Pattern Holbein in the *Portrait of Two Ambassadors,* in the National Gallery, London; Erdmann 1966, p. 536. For discussion of the Small Pattern Holbein carpets, with lists and illustrations of paintings depicting them and surviving originals, see Erdmann 1970, pp. 5–56; Mills 1978, "Small Pattern Holbein Carpets," pp. 326–334; Charles Grant Ellis, "'Small Pattern Holbein' Carpets in Paintings: A Continuation," *Hali* 3, no. 3 (1981): 216–217; John Mills, "Three Further Examples," *Hali* 3, no. 3 (1981): 217; King and Sylvester, pp. 14, 26–27, 52–56.

38. Friedrich Spuhler, *Die Orientteppiche im Museum für Islamische Kunst Berlin,* Veröffentlichen des Museums für Islamische Kunst, 1 (Berlin, 1987), p. 30, cat. no. 1.

39. For the Keir Collection carpet, see King and Sylvester, pp. 52–53, cat. no. 6, with an illustration. The variants of this border are discussed in Robert Pinner and Jackie Stanger. "'Kufic' Borders on 'Small Pattern Holbein' Carpets," *Hali* 1, no. 4 (1978): 335–336; under their classification, the borders on the Keir Collection carpet and in Mantegna's painting are type A, and that in Previtali's painting is type B, which is unknown on surviving examples of Small Pattern Holbeins. These border patterns may descend from the decorative treatment of the letters in the Arabic word for God in *kufic* script; see Irene A. Bierman, "The Significance of Arabic Script on Carpets," *Hali* 5, no. 1 (1982): 20–21.

40. Gigetta Dalli Regoli, "La Madonna di Piazza: 'Ce n'é d'assai più belle, nessuna più perfetta,'" in *Scritti di storia dell'arte in onore di Federico Zeri* (Milan, 1984), 1: 213, 223–224 and figs. 230–231; Mills 1978, "Small Pattern Holbein Carpets," p. 328, figs. 6, 8–9.

41. Mills 1978, "Small Pattern Holbein Carpets," pl. 1; Pinner and Stanger, p. 336: type D.

42. Erdmann 1970, p. 22; Mills 1975, pp. 17–23; Mills 1978, "Small Pattern Holbein Carpets," p. 334; King and Sylvester,

pp. 27, 56–57; Charles Grant Ellis, "On 'Holbein' and 'Lotto' Rugs," in *Oriental Carpet and Textile Studies* 2 (1986): 163–170. Also see note 37 above.

43. Spuhler 1987, p. 32, cat. no. 6. For examples of Large Pattern Holbeins with one and two centered compartments and the staggered composition, see "Anatolian Civilizations 11: Some Carpets from the Thirteenth to Sixteenth Centuries," *Hali* 6, no. 2 (1984): pp. 157–159, figs. 5–10.

44. King and Sylvester, pp. 56–58; and Michael Franses, "The 'Crivelli' Star," in *Orient Stars: A Carpet Collection,* exh. cat., Deichtorhallen, Hamburg, and Linden-Museum, Stuttgart (London, 1993), pp. 273–274. A similar carpet appears in the background, together with a Large Pattern Holbein in the foreground, of Crivelli's *Annunciation* in the National Gallery, London; see Pietro Zampetti, *Carlo Crivelli* (Florence, 1986), pl. 74.

45. Michael Franses, "The 'Bellini' Keyhole," in *Orient Stars: A Carpet Collection,* exh. cat., Deichtorhallen, Hamburg, and Linden-Museum, Stuttgart (London, 1993), pp. 277–283 and 375–376 n. 392; John Mills, "Carpets in Paintings: The 'Bellini,' 'Keyhole,' or 'Re-entrant' Rugs," *Hali* 13, no. 4 (1991): 86–103; King and Sylvester, pp. 14–16, 58; Johanna Zick, "Eine Gruppe von Gebetsteppichen und ihre Datierung," *Berliner Museum: Berichte aus den ehemalig Preussischen Kunstsammlungen* 11 (September 1961): 6–14. Franses provides the most complete list of Italian paintings representing these carpets, and Mills the most illustrations. In the text, the paragraphs on prayer rugs that follow are adapted from my essay "Lotto: A Carpet Connoisseur," in *Lorenzo Lotto: Rediscovered Master of the Renaissance,* exh. cat., National Gallery of Art, Washington; Accademia Carrara di Belle Arti, Bergamo; and Galeries Nationales du Grand Palais, Paris (Washington, New Haven, Conn., and London, 1997), pp. 59–67.

46. Mills 1991, p. 90; Michael Franses and Ian Bennett, "The Topkapi Prayer Rugs," *Hali* 10, no. 3 (1988): 27.

47. Giovanni Bellini's *Doge Loredan and Four Advisors,* 1507, Bode Museum, Berlin, is illustrated in Mills 1991, fig. 30.

48. Richard Ettinghausen, "The Early History, Use, and Iconography of the Prayer Rug," in *Prayer Rugs,* exh. cat., Textile Museum, Washington, and Montclair Art Museum, Montclair, N.J. (Washington, 1974), pp. 11–15.

49. Walter B. Denny, "Saff and Sejjadeh: Origins and Meaning of the Prayer Rug," in *Oriental Carpet and Textile Studies* 3, no. 2 (1990): 95–97; Ettinghausen 1974, "Early History," pp. 18–23; Mills 1991, pp. 90–91; Zick, p. 7; Volkmar Enderlein, "Zwei ägyptische Gebetsteppiche im Islamischen Museum," *Forschungen und Berichte, Staatliche Museen zu Berlin* 13 (1971): 9; Charles Grant Ellis, *Oriental Carpets in the Philadelphia Museum of Art* (Philadelphia, 1988), pp. 78–79. The triangular forms with hooked extensions above the

keyhole in Figure 77 were long associated with the *minbar,* the pulpit in a mosque; recently, these forms have been reinterpreted as variants of a motif appearing in several carpet patterns that represents a squinch of a dome (Alberto Levi, "Architectural Motifs in Early Turkish Rugs," in *Oriental Carpet and Textile Studies* 5, no. 1 [1999]: 41–46).

50. For the manuscript illuminations, see Denny, p. 95 and fig. 5; O. Grabar 1970, p. 212 and fig. 3; these representations also show a *minbar,* mentioned in note 49 above. For the Persian tiles, see Arthur Lane, *Victoria and Albert Museum, Department of Ceramics: A Guide to the Collection of Tiles* (London, 1939), p. 4 and pl. 1A.

51. Franses 1993, "The 'Bellini' Keyhole," pp. 282–283.

52. Denny, pp. 100–103; Franses 1993, "The 'Bellini' Keyhole," p. 282. See the fifteenth-century Anatolian *saf* in the Türk ve Islam Eserleri Museum, Istanbul (inv. no. 720; see Denny, fig. 22) and the late-fifteenth- or early-sixteenth-century symmetrical re-entrant carpet in the Musée Cantonal de Valère, Sion, Switzerland (see Mills 1991, fig. 31).

53. Suraiya Faroqhi, *Towns and Townsmen of Ottoman Anatolia: Trade, Crafts, and Food Production in an Urban Setting, 1520–1650* (Cambridge, 1984), p. 138; and Raby 1986, "Court and Export, Part 1," p. 35.

54. The Mamluk prayer rug is in the Museum für Islamische Kunst, Berlin (inv. no. 88,30); *Prayer Rugs,* exh. cat., Textile Museum, Washington, and Montclair Art Museum, Montclair, N.J. (Washington, 1984), p. 46 and fig. 19; Mills 1991, p. 89 and fig. 3. For the para-Mamluk re-entrant carpets, made near Damascus or in Anatolia, in two *Madonna and Child Enthroned with Saints* altarpieces by Lorenzo Lotto, one from 1505 in Santa Cristina al Tiverone, Treviso, and the other from 1521 in Santo Spirito, Bergamo, see Mills 1991, pp. 89–90, cover of *Hali* 13, no. 4, and fig. 4. The register of the Ottoman court treasury in Istanbul of 1485 lists four prayer rugs from Damascus, probably of the para-Mamluk type; Raby 1986, "Court and Export, Part 1," pp. 35–36.

55. Chambers, pp. 153–154, inv. nos. 318 (the *saf*), 330, 335 ("in the Moorish style with a mosque"), 337, 338, 342 ("black").

56. Pompeo Gherardo Molmenti, *La storia di Venezia nella vita privata dalle origini alla caduta della repubblica,* 7th ed. (Bergamo, 1928), 2:477, 486; and Raby 1986, "Court and Export, Part 1," p. 34. The Badoer inventory lists a total of seventeen carpets, and the Correr inventory, a total of thirty-one in Venice and six more from Padua. Probably through the Venetian merchants who sold carpets to King Henry VIII, the term spread to England, where it was misinterpreted as "muskets carpets" (the Italian words for "mosque," "fly," and "musket" are very similar); King and Sylvester, p. 30.

57. See Mills 1991, p. 92; the Stockholm painting is illus-

trated in Rodolfo Pallucchini, *Bassano* (Bologna, 1982), pl. 18. Jacopo Bassano, in about the 1540s, represented a Small Pattern Holbein carpet in the *Madonna and Child Enthroned with Saints,* Alte Pinakothek, Munich; see Mills 1978, "Small Pattern Holbein Carpets," fig. 33.

58. Mack, pp. 59, 62, 65–66; Robert Pittenger, "A Miscellany in Oils," *Hali* 10, no. 2 (1988): 18–19; Zick, p. 14; Mills 1991, p. 92; Franses 1993, "The 'Bellini' Keyhole," p. 376 n. 392.

59. Spuhler 1987, p. 37; Zick, pp. 7–9; King and Sylvester, p. 58; Mills 1991, pp. 93–94; Franses 1993, "The 'Bellini' Keyhole," p. 278.

60. Inward-opening borders are very rare; for an example, see an early-sixteenth-century carpet fragment in the Keir Collection (inv. no. T6), Spuhler 1988, pp. 58–59, with an illustration.

61. For example, a fresco, ca. 1505–1508, attributed to Garofalo in the palace of Ludovico il Moro (Palazzo Costibili), Ferrara, shows four different re-entrant carpets; see Mills 1991, figs. 18a–d.

62. According to Lotto's account book, on January 1, 1548, he pawned a large Turkish table carpet with thick pile ("un tapedo turchescho da mastabe alto di pelo et forma largo") in the ghetto of Venice to make modest cash loans to two friends from the Marches; Pietro Zampetti, ed., *Il "Libro di spese diverse" con aggiunta di lettere e altri documenti* (Venice and Rome, 1969), pp. xxix, 37, 38, 74, 75, 410.

63. Depictions and examples of Lotto carpets are discussed in Erdmann 1970, pp. 57–60; Charles Grant Ellis, "The 'Lotto' Pattern as a Fashion in Carpets," in *Festschrift für Peter Wilhelm Meister zum 65. Geburtstag am 16. mai 1974,* ed. Annaliese Ohm and Horst Reber (Hamburg, 1975), pp. 19–31; John Mills, "Lotto Carpets in Western Paintings," *Hali* 3, no. 4 (1981): 278–289; King and Sylvester, pp. 67–69; Ellis 1988, pp. 22–28.

64. King and Sylvester, p. 68. Lotto carpets three elements wide normally have the quatrefoils in the center, as in a sixteenth-century carpet in the Philadelphia Museum of Art (inv. no. 55-65-9); Ellis 1988, pp. 22–23, cat. no. 6.

65. For para-Mamluk carpets, see Mills 1981, "Eastern Mediterranean Carpets in Western Paintings," *Hali* 4, no. 1 (1981): 54–55; Robert Pinner and Michael Franses, "The East Mediterranean Carpet Collection in the Victoria and Albert Museum," *Hali* 4, no. 1 (1981): 40–41; King and Sylvester, pp. 16, 27; Ellis 1988, pp. 4–7 (who argues that all examples are Anatolian). Prayer rugs from Damascus are listed in an inventory of the Ottoman court treasury in Istanbul in 1485; see note 54 above. Mention in Italian fifteenth- and sixteenth-century inventories of Damascene carpets is unreliable because these inventories apply the term "Damascene" broadly to Islamic-style ceramics and metalwork, some of

which was neither made in nor imported from Damascus; see Spallanzani 1978, pp. 105–106, and Spallanzani 1989, pp. 83, 86. Moreover, the carpets "from Damascus" could also be Mamluk or Turkish carpets marketed there; see Erdmann 1966, pp. 538–539.

66. See the para-Mamluk carpet fragment in the Textile Museum, Washington (inv. no. AR34.32.1; Ernst Kühnel and Louisa Bellinger, *The Textile Museum Catalogue Raisonné: Cairene Rugs and Others Technically Related, Fifteenth–Seventeenth Century* [Washington, 1957], pp. 77–78 and pls. 45, 46; King and Sylvester, p. 66), and a rug formerly in the Campana Collection, Milan (illustrated in Volkmar Gantzhorn, *The Christian Oriental Carpet* [Cologne, 1991], p. 212, no. 325).

67. For Mamluk carpets, see Erdmann 1966, pp. 539–540; Erdmann 1970, pp. 21–23; Atil 1981, pp. 226–227; Mills 1981, "Eastern Mediterranean Carpets," pp. 53–54; Pinner and Franses, pp. 37–38; King and Sylvester, pp. 17, 27, 59–63.

68. Spuhler 1987, p. 58, cat. no. 63.

69. Inv. no. 5279; King and Sylvester, pp. 24, 61–62, with illustrations.

70. Pier Virgilio Begni Redona, *Alessandro Bonvicino II Moretto da Brescia* (Brescia, 1988), pp. 450–456; plates on pp. 452–453 show the three walls with carpets and p. 454, the women on the fourth wall without carpets.

71. Maurice S. Dimand and Jean Mailey, *Oriental Rugs in the Metropolitan Museum of Art* (New York, 1973), p. 221, cat. no. 72. Ushak (or Uşak) carpets are discussed by King and Sylvester, pp. 16–17, 70–72; Atil 1987, pp. 181–182; Julian Raby, "Court and Export, Part 2: The Uşak Carpets," in *Oriental Carpet and Textile Studies* 2 (1986): 177–187, where it is proposed that they were originally elite court objects.

72. Inv. no. 88,112; Spuhler 1987, pp. 42–43, cat. no. 27, with an illustration on p. 170.

73. A carpet that may be Persian appears on a balcony in the background of Paolo Veronese's *Marriage at Cana,* 1562–1563, in the Louvre; the work was one of the artist's "Suppers" that were criticized in 1573 by the Inquisition Tribunal, which challenged Veronese's picturesque figures and their undecorous actions but did not mention his settings; see Robert Klein and Henri Zerner, *Italian Art, 1500–1600: Sources and Documents* (Englewood Cliffs, N.J., 1966), pp. 129–132. The critic Bellori did not list the Oriental carpets on the tables among the inappropriate details in Caravaggio's *Supper at Emmaus* in either of its two versions; John Varriano, "Caravaggio and the Decorative Arts in the Two *Suppers at Emmaus,*" *Art Bulletin* 68 (1986): 219 n. 14.

74. Thornton, p. 65; Rogers 1991, "The Gorgeous East," p. 73; Chambers, p. 82.

75. Adelson and Landini, pp. 53–54 and 57–62 and fig. 2.

76. Donald King, "The Inventories of the Carpets of King Henry VIII," *Hali* 5, no. 3 (1982): 300.

Chapter 5. Ceramics

1. The principal sources of Oriental inspiration in Italian medieval and Renaissance ceramics have long been recognized; see Bernard Rackham, *Guide to Italian Maiolica* (London, 1933); Arthur Lane, *Later Islamic Pottery: Persia, Syria, Egypt, Turkey* (London, 1957); Giuseppe Liverani, *Five Centuries of Italian Majolica* (New York, 1960); Caiger-Smith, especially p. 41. Only recently, however, has the persistence of these contacts been recognized; for example, see Ernst J. Grube, "Apporti orientali nella decorazione della graffita veneta," in *Atti del convegno "La ceramica graffita medievale e rinascimentale nel Veneto," Bollettino del Museo Civico di Padova* (Padua, 1987), pp. 145–146; Fontana 1993, pp. 461–463, 468.

2. Cipriano Piccolpasso, *I tre libri dell'arte del vasaio,* trans. and ed. Ronald Lightbown and Alan Caiger-Smith (London, 1980), 1: fol. 46v. For the changing meanings of the term "maiolica," see Wendy M. Watson, *Italian Renaissance Maiolica from the William A. Clark Collection,* exh. cat., Corcoran Gallery of Art, Washington, and Mount Holyoke College Art Museum, South Hadley, Mass. (London, 1986), p. 14.

3. Piccolpasso, 1: fols. 65v, 66r, 69v, 70r; Caiger-Smith, pp. 101–102; Pierre-Alain Mariaux, *La majolique: La faïence italienne et son décor dans les collections suisses XVème–XVIIème siècles,* exh. cat., Musée Historique de Lausanne (Geneva, 1995), pp. 79–83, with illustrations.

4. *Bacini* with painted animal and geometric decorations in brown and green on the Church of San Lanfranco in Pavia, datable to about 1150, are cited as the earliest Italian maiolica prototypes: David Whitehouse, "La Liguria e la ceramica medievale nel Mediterraneo," in *Atti, IV convegno internazionale della ceramica* (Albisola, 1971), pp. 276–279; Caiger-Smith, p. 83. For the regional character and different traditions of early Italian tin-glazed pottery, also see Liverani, pp. 15–18; David Whitehouse, "The Origins of Italian Maiolica," *Archaeology* 31 (March 1978): 42–49; Fontana 1993, pp. 461–463.

5. For *bacini* in the Pisa area, see Graziella Berti, *Pisa, Museo Nazionale di San Matteo: Ceramiche medievale e postmedievale* (Florence, 1997), pp. 10–11, 25–26, 29; Graziella Berti, "Keramische 'Bacini' mittelalterliche Kirchen Pisas aus islamischer und örtlicher Produktion," in *Europa und der Orient, 800–1900,* ed. Gereon Sievernich and Hendrik Budde, exh. cat., Berliner Festspiele (Berlin, 1989), p. 607. Persian-style pottery is extremely rare but also widely dispersed among the *bacini;* Whitehouse 1971, pp. 281–282; Graziella Berti and Liana Tongiorgi, "Bacini ceramici su alcune chiese della campagna lucchese," *Faenza* 59 (1973): 12–13. A useful summary of the various origins of Islamic *bacini* appears in Gabrieli and Scerrato, pp. 400–440. Italian pottery among twelfth-century and later Pisa *bacini* includes pieces from Sicily, proto-maiolica from South Italy, and Ligurian incised

ware as well as Pisan archaic maiolica; see Whitehouse 1971, pp. 276–278.

6. Graziella Berti and Catia Renzi-Rizzo, *Pisa: Le "maioliche arcaiche," secoli XIII–XV (Museo Nazionale di San Matteo),* appendice "Nomina vasorum" (Florence, 1997), pp. 48, 137–141, fig. 61, and pp. 276–284, where a close connection between Pisan archaic maiolica and Spanish ceramics is proposed. See also Liana Tongiorgi and Graziella Berti, "Bacini della Chiesa di San Martino a Pisa databili al secolo XIV," in *Atti, IV convegno internazionale della ceramica* (Albisola, 1971), pp. 309–311; because the locally made *bacini* on San Martino were carefully arranged by pattern, these authors suggest that they were ordered by the architect.

7. Bernard Rackham, *Victoria and Albert Museum: Catalogue of Italian Maiolica,* 2d ed. (London, 1977), 1:4, cat. no. 14. For the style of Orvieto green-and-brown ware, also see Liverani, pp. 16–18; Whitehouse 1978, pp. 43–48; Gabrieli and Scerrato, p. 441; Caiger-Smith, p. 83.

8. For a Syrian example, see a late-twelfth- or early-thirteenth-century bowl in the Freer Gallery of Art, Washington (inv. no. 42.13); Esin Atil, *Ceramics from the World of Islam,* exh. cat., Freer Gallery of Art, Washington (Washington, 1973), pp. 74–75, cat. no. 29. It is believed that such Syrian incised and glaze-painted ceramics inspired similar *sgraffito* wares produced in northern Italy from the middle of the thirteenth into the sixteenth century, though the technique was also common in Persia, the Caucasus, and Byzantium; see Grube 1987, pp. 146–157; *The Meeting of Two Worlds: The Crusades and the Mediterranean Context,* exh. cat., University of Michigan Museum of Art (Ann Arbor, Mich., 1981), pp. 49–50; Whitehouse 1971, pp. 271–275; Spallanzani 1978, pp. 81–82. For an Egyptian example from the second half of the eleventh century, see a *bacino* from San Sisto now in the Museo Nazionale di San Matteo, Pisa; Gabrieli and Scerrato, fig. 533. A *bacino* from Sant'Andrea, Pisa, in the same museum is a rare Spanish early-twelfth-century example of this design; *Eredità dell'Islam,* pp. 117–118, cat. no. 35.

9. For two exceptional examples, see Whitehouse 1978, pp. 44, 48.

10. Alessandro Alinari and Fausto Berti, "Zaffera fiorentina per lo speziale e la mensa," in Giovanni Conti et al., *Zaffera et simili nella maiolica italiana* (Viterbo, 1991), pp. 27–28; Galeazzo Cora, *Storia della maiolica di Firenze e del contado, secoli XIV e XV* (Florence, 1973), 1:45–47.

11. Spallanzani 1978, p. 43; Spallanzani 1989, p. 84.

12. A. Lane 1957, p, 17; Spallanzani 1978, pp. 45–48, 50, 54. In addition, the inheritance of Matteo di Francesco Vivoresi of 1389 included an "Alexandrian bowl," which Spallanzani (1978, pp. 45–46) equated with earlier Fatimid lusterware appearing among the Pisa *bacini*. This type was

rare after about 1200 (Caiger-Smith, p. 40), however, and it is
unlikely that whoever prepared the inventory knew enough
about Islamic ceramics to identify it. Probably Vivoresi's
bowl had been exported from Alexandria, where the Datini
firm, for example, traded in ceramics. Though Damascus
was the principal pottery center in the Mamluk empire,
there were kilns in Cairo, and objects circulated freely within
the empire.

13. Atil 1981, pp. 148, 150–151; Cristina Tonghini, "Il
periodo Burji (784/1328–923/1517)," in *Eredità dell'Islam:
Arte islamica in Italia,* ed. Giovanni Curatola, exh. cat.,
Palazzo Ducale, Venice (Venice, 1993), p. 284. Damascus
potters by 1430 were producing for a local mosque blue-and-
white tiles strongly influenced by contemporary Chinese
porcelain. A vivid account of Tamerlane's occupation of
Damascus, based on eyewitness reports, appears in the *Vita
Tamerlani,* written in 1416 by Bertrando de Mignanelli, a
Sienese merchant residing in Damascus who fled the inva-
sion but returned in the fall of 1402. Tamerlane took "the
official teachers of the arts, in large numbers" out of the
city before reducing it "to a mountain of ashes"; Walter J.
Fischel, "A New Latin Source on Tamerlane's Conquest of
Damascus, 1400/1401: B. de Mignanelli's 'Vita Tamerlani,'
1416," *Oriens* 9, no. 2 (1956): 225.

14. A. Lane (1957, p. 30) and Spallanzani (1978, p. 70) have
connected this jar with the three Damascene *albarelli* listed in
Piero de' Medici's inventory of 1465 because the Medici coat
of arms includes a lily. The family's use of the lily, however,
postdates 1465, when it was granted them by Louis XI of
France; see the sources cited in note 36 below. A date after
1465 seems late for this object.

15. For examples, see A. Lane 1957, pp. 16–17 and pls.
8–14; Atil 1981, pp. 147–148 and 173–174, cat. nos. 82–83.

16. Inv. nos. 1601-1888, and 363-1889; for the latter, see A.
Lane 1957, pl. 8; and Spallanzani 1978, p. 72 and fig. 8.

17. See A. Lane 1957, pp. 29–35 and pls. 13a, 14; Atil 1981,
pp. 149–151; Spallanzani 1978, figs. 3–5.

18. *Eredità dell'Islam,* p. 119, cat. no. 36.

19. For fifteenth-century Valencian imitation of earlier
Syrian types, see Frothingham 1951, pp. 169–173. For the
development of Málaga and Hispano-Moresque ceramics
and their close relationship, see Caiger-Smith, pp. 54–79;
and Frothingham 1951, pp. 15–163.

20. The Italian is: "uno albarello lungho di Domascho
o di Maiolica"; Spallanzani 1978, p. 72.

21. The jars were to be "à la domasquina" and "daurates";
A. Lane 1957, p. 17.

22. Liverani, p. 29; Spallanzani 1978, pp. 2, 50, 74, who
cites a purchase order in 1476 from Filippo Strozzi to his
agent in Venice for four bowls and a pitcher of "Damascus
porcelain" ("porcellane domaschine").

23. For documents relating to this Florentine ware, which
is usually dated in the second quarter of the fifteenth cen-
tury, see Cora, 1:54–59, who proposes (p. 54) that four blue
jugs the Hospital of Santa Maria Nuova acquired from Barto-
lommeo di Matteo in 1406 may have been early examples of
this style and (p. 59) cites the 1426/27 order for 588 "dama-
schine" vessels as proof of the style's Syrian origin.

24. For the style and technique of *zaffera,* see Alinari and
Berti, pp. 30–56, with numerous illustrations; Caiger-Smith,
p. 85. For the related Syrian ceramics, see A. Lane 1957, p. 18
and fig. 11.

25. Anna Moore Valeri, "Florentine 'Zaffera a rilievo'
Maiolica: A New Look at the 'Oriental Influence,'" *Archeolo-
gia medievale* 9 (1984): 478–479, 490–492; Anna Moore Valeri,
"La foglia di quercia: Le sue origini ed il suo sviluppo,"
Faenza 79 (1993): 128–134. For other examples of the oak
leaf on archaic maiolica, see Whitehouse 1978, p. 48; and
Rackham 1977, 2: pl. 1.

26. Moore Valeri (1984, 478–497) argues that *zaffera*
developed from archaic maiolica beginning in the late
fourteenth century, used the same Oriental motifs as other
fourteenth- and fifteenth-century Florentine decorative arts,
and was strongly influenced by Islamic ceramics only after
about 1435, when Hispano-Moresque elements appear. The
connection between *zaffera* and other Italian decorative arts
is also emphasized in Mariaux, pp. 67, 73. Alinari and Berti
(pp. 47–52), however, point out that the makers of *zaffera*
adopted several Islamic compositional conventions, such as
contour panels around the animals, and that workshops
most sensitive to Islamic schemes probably used imported
models.

27. Moore Valeri 1984, pp. 495–496.

28. An inventory of the Monticoli family of Udine of
1413 lists twelve small flat dishes and twelve bowls, and an
inventory of the De Feci family of Siena of 1450 lists twenty-
seven pieces, all kept in chests; Thornton, p. 106.

29. *The Story of Nastagio degli Onesti: The Nuptial Feast,*
in a private collection, belongs to a series executed in 1482–
1483 that was commissioned by the groom's father, Antonio
Pucci, probably for the chambers of the newlyweds. The
Pucci-Bini arms appear on the loggia, where the idealized
nuptials take place. Anne B. Barriault, *"Spalliera" Paintings
of Renaissance Tuscany: Fables of Poets for Patrician Homes*
(University Park, Pa., 1994), pp. 143–144 and pl. 5.

30. Thornton, p. 106.

31. Rackham 1933, p. 16; Liverani, p. 21; Caiger-Smith,
p. 76; Cora, 1: 129.

32. For example, see a Valencian luster-painted *albarello* of
the first half of the fifteenth century in the Hispanic Society
of America, New York (inv. no. E 624), that has a *hojaflor*
scroll in the same position; see Alice Wilson Frothingham,

Catalogue of Hispano-Moresque Pottery in the Collection of the Hispanic Society of America (New York, 1936), pl. 17.

33. See Rackham 1933, p. 29; Rackham 1977, 1: 13–14, cat. no. 50; Cora, 1:459, no. 130a.

34. See *Europa und der Orient,* pp. 611–612, cat. no. 4/118; Caiger-Smith, pp. 60–61, 76.

35. See Rackham 1933, p. 16; Cora, 1:464, no. 178a. Various Florentine *albarello* shapes are illustrated in Cora, 2: pl. 146.

36. See Frothingham 1951, pp. 127–128, 182; *Circa 1492,* p. 171, cat. no. 53.

37. The Medici documents are cited in Cora, 1:134.

38. The vase is 39.4 cm. high, a gift of the Women's Committee to the Detroit Institute of Arts with additional funds from Robert H. Tannahill. The dependence of the Detroit vase on Valencian models led Cora (1: 134) to assign it to the Medici-Orsini marriage of 1469 rather than that of Lorenzo's son Piero to Alfonsina Orsini in 1487.

39. Frothingham 1951, pp. 121–131; Caiger-Smith, p. 75.

40. See Liverani, p. 21.

41. See Rackham 1977, 1:32, cat. no. 115.

42. Rackham 1933, p. 16; Caiger-Smith, p. 22. For Florentine *zaffera* with contour panels, see a jug with confronted rampant lions in the Victoria and Albert Museum, London (inv. no. 2562-1856), in Rackham 1933, pl. 9, and the *albarelli* with animals and Hispano-Moresque floral motifs in Cora, 2: pl. 137.

43. See Timothy Wilson, "Renaissance Ceramics," in Rudolf Distelburger et al., *Western Decorative Arts, Part I: Medieval, Renaissance, and Historicizing Styles, Including Metalwork, Enamels, and Ceramics,* Collections of the National Gallery of Art: Systematic Catalogue (Milan, 1993), pp. 120–121; Liverani, p. 23; Cora, 1:143; Caiger-Smith, pp. 87, 93; Mariaux, p. 73. It has often been suggested that the "peacock feather" (or "peacock-feather eye") motif on the bottom of Figure 99 has an Oriental origin, but sources and means of transmission have never been identified. Faenza potters soon developed the motif into an allover pattern with chromatic shadings and contrasts similar to those of the Persian palmette; see Liverani, p. 23 and pl. 10; Rackham 1933, p. 17; Caiger-Smith, pp. 87, 93; Cora, 1: 141.

44. For example, see a Florentine plate with bold strapwork surrounding the arms of the Altoviti family in Cora, 2: pl. 250, and a plate of about 1520 with a broad band of knots framing a female bust (Victoria and Albert Museum, London, inv. no. 2453-1856) in Rackham 1977, 2: pl. 37, cat. no. 231.

45. The humanist scribe Felice Feliciano, who promoted the new Islamic bookbinding style discussed in Chapter 7, used strapwork and knots for borders and initials in his manuscripts; these elements also appear in manuscripts made for the Gonzaga of Mantua; *The Painted Page: Italian Renaissance Book Illumination, 1450–1550,* ed. Jonathan J. G. Alexander, exh. cat., Royal Academy of Arts, London, and Pierpont Morgan Library, New York (Munich and New York, 1994), pp. 15–16, 77–79, cat. nos. 21–22, with illustrations. Strapwork fills most of the frames for illustrations in an incomplete edition of Petrarch's *Libro degli Homini Famosi* printed in Poiano, near Verona, in 1476 by Feliciano and Innocente Zileto; Lilian Armstrong, "Marco Zoppo e il libro dei disegni del British Museum: Riflessioni sulle teste 'all' antica,'" in *Marco Zoppo e il suo tempo,* ed. Berenice Giovanucci Vigi (Bologna, 1993), pp. 84, 87, with an illustration.

46. For Figure 101, see *Europa und der Orient,* pp. 612–613, cat. no. 4/121. For its design, see Arthur Mayger Hind, "Two Unpublished Plates of the Series of Six 'Knots' Engraved after Designs by Leonardo da Vinci," *Burlington Magazine* 12, no. 55 (October 1907): 41–43. For the use of prints in Italian maiolica, see Caiger-Smith, p. 94; and Watson, pp. 20–21.

47. See Atil 1975, p. 148, cat. no. 80; and Chapter 8.

48. The sixteenth-century pattern books do not attempt to identify specific arabesque ornaments or their origins; Alexandrine N. St. Clair, *The Image of the Turk in Europe,* exh. cat., Metropolitan Museum of Art, New York (New York, 1973), pp. 12–13, figs. 18–20, 22–23; Peter Ward-Jackson, "Some Main Streams and Tributaries in European Ornament, 1500–1750, II," *Victoria and Albert Museum Bulletin* 3 (1967): 91–98; Hans Huth, *Lacquer of the West: The History of a Craft and an Industry, 1550–1950* (Chicago and London, 1971), p. 4. A pair of *albarelli* in the Corcoran Gallery of Art, Washington, probably made in Siena about 1510–1515, which are decorated with bands of knots framing a panel of grotesques, are early ceramic examples of combined Islamic and antique-inspired ornament; Watson, pp. 72–73, 180, cat. nos. 25 and 91.

49. Piccolpasso, 1: fol. 70v, as translated in 2:120.

50. The arrival date of the luster-painting technique in Gubbio is based on unpublished documents. In Deruta it is projected backward from evidence of an already developed production in the 1498 notice and examples of about 1500. See the summary and references in Wilson 1993, p. 138.

51. Liverani, pp. 34–35; Caiger-Smith, p. 98.

52. On some of these showpiece dishes (*piatti di pompa*), the suspension holes are curiously misaligned with the design. Wilson 1993, pp. 138–139, 146.

53. See Chapter 1, notes 70–72.

54. Spallanzani 1978, pp. 55–56; Spallanzani and Gaeta Bertelà, pp. 14–15.

55. In 1475 Filippo Strozzi of Florence ordered his agent in Venice to buy a large quantity of glass, which was certainly locally made, and ten small "porcelain" bowls, two white and two with blue leaves, which may have been the Chinese lotus seedpod type; Spallanzani 1978, p. 50.

56. In 1476 Filippo Strozzi ordered his agent in Venice to buy four bowls and a pitcher of "Damascene porcelain"; Spallanzani 1978, p. 52 and fig. 4. For examples of fifteenth-century Syrian blue-and-white with Chinese inspired decoration, see Carswell 1985, pp. 125–128, cat. nos. 66–70. An unverified document of 1470 mentions porcelain made by an alchemist in Venice that could be opaque white glass, though the date would be early; see Spallanzani 1978, p. 50 n. 61; and A. Lane 1954, p. 2. In 1504 Duke Ercole I d'Este bought seven bowls of "counterfeit porcelain" in Venice, and in 1514 his successor, Alfonso I, tried unsuccessfully to hire a Venetian who had sent him a small bowl and plate of fake porcelain. Arthur Lane (1954, p. 2) suggests the imitator might have been Leonardo Peringer, a mirror maker, who informed the Senate in 1518 that he could make porcelain "like that called Levantine"; also see Lightbown 1981, pp. 459–460; and Chapter 6.

57. The first documented Chinese blue-and-white import to survive is a bowl in the Musei Civici d'Arte Antica, Bologna, that was presented in 1554 by King João III of Portugal to the papal legate Pompeo Zambeccari of Bologna, bishop of Sulmona from 1547 to 1571; Ronald W. Lightbown, "Oriental Art and the Orient in Late Renaissance and Baroque Italy," *Journal of the Warburg and Courtauld Institutes* 32 (1969): 231. A late-fourteenth- or early-fifteenth-century Chinese celadon bowl in the Museo degli Argenti, Palazzo Pitti, Florence, bears an inscription identifying it as a gift from Sultan Qaitbay to Lorenzo de' Medici in 1487, and the inventory of Lorenzo's possessions of 1492 lists celadon; Lightbown 1969, p. 229 and pl. 25a; and Spallanzani 1978, p. 85.

58. See note 55 above.

59. For the Chinese models, see A. I. Spriggs, "Oriental Porcelain in Western Paintings, 1450–1700," *Transactions of the Oriental Ceramic Society* 36 (1964–1966): 73 and pl. 57; Spallanzani 1978, p. 95 and fig. 14. For the Washington painting, see Fern Rusk Shapley, *Catalogue of the Italian Paintings* (Washington, 1979), 1:62–63, and 2: pl. 36.

60. Spriggs, p. 74 and pl. 58; Spallanzani 1978, p. 95; Lightbown 1986, p. 446, cat. no. 43, and pl. 16.

61. Carswell (1985, pp. 88–90, cat. nos. 32–33) identified the porcelain in Bellini's painting, citing examples in a private collection in London that illustrate both shapes and a similar spacing of the decorative motifs. Because few examples of this type survive in Chinese collections, whereas large numbers exist in the oldest Islamic collections—at Topkapi Sarayi Muzesi, Istanbul, and the Archaeological Museum, Tehran (from a shrine in Ardebil)—it is believed that it was exportware popular in Persia, Syria, and Egypt, the source of most Italian imports. Topkapi Palace inventories indicate that little Chinese porcelain reached Istanbul before the conquest and pillage of Damascus, Cairo, and

Tabriz during the second decade of the sixteenth century, which supplied the Ottoman court with the earlier Yuan and Ming dynasty examples that greatly influenced Iznikware from the 1520s onward. See Carswell 1985, pp. 30–31; and Raby, in Nurhan Atasoy and Julian Raby, *Iznik: The Pottery of Ottoman Turkey,* ed. Yanni Petsopoulos (London, 1989), pp. 96, 121.

62. Recent cleaning and technical analysis show that the bowls were part of Bellini's painting and were untouched during later alterations of the background by Titian and perhaps Dosso Dossi; *Titian: Prince of Painters,* exh. cat., Palazzo Ducale, Venice, and National Gallery of Art, Washington (Venice, 1990), pp. 198–200. For Alfonso's attempt to engage an imitator of porcelain, see note 56 above.

63. For Bellini's likely models, see Spriggs, p. 74; and Chapter 1, note 72.

64. Rackham 1933, pp. 11–12; Liverani, pp. 30, 33; Caiger-Smith, pp. 87–88, 93; Cora 1: 145.

65. For example, see the rim of a late-fifteenth-century plate in the Museo Internazionale della Ceramica, Faenza, in Liverani, fig. 11.

66. See Liverani, pp. 30 and 33 and fig. 15, which illustrates Master Benedetto's signature on the bottom of the plate; Rackham 1977, 1: 127, cat. no. 373.

67. Liverani, p. 30; Cora, 1: 108–109; Watson, pp. 64–65; Galeazzo Cora and Angiolo Fanfani, *La maiolica di Cafaggiolo* (Florence, 1982), p. 9. A Cafaggiolo plate formerly in the Gherardesca Collection, Bologna (Cora and Fanfani 1982, cat. no. 32), datable about 1525, imitates the Chinese pattern illustrated in Figure 105. A group of plates signed "J.o Chafaggiolo" show Ottoman-influenced floral arabesque ornament similar to that on the Venetian plate illustrated in Figure 110 (Cora and Fanfani 1982, p. 170 and cat. nos. 43, 44, 48, 50, 51, 53, 58, and 60); these plates have been attributed to Jacopo di Stefano di Filippo, son of one of the founding potters from Montelupo, who is mentioned in documents from 1531 to 1576.

68. For Venetian *berettino* ware, see Rackham 1933, p. 70; and Angelica Alverà Bortolotto, *Storia della ceramica a Venezia dagli albori alla fine della Repubblica* (Florence, 1981), p. 63. Many plates of the type shown in Figure 109 that are datable between 1515 and 1530 bear German arms, owing to their promotion by Andrea Imhof of Nuremberg, who lived in Venice from 1504 to 1509. A plate in the Kunstgewerbemuseum, Berlin (inv. no. 234; Alverà Bortolotto, p. 64 and pl. 47a), which he commissioned for his marriage in 1520, is decorated in the style of contemporary Chinese porcelain (see Figure 107). Similar plates were produced for Venetian families: Timothy Wilson, "Maiolica in Renaisssance Venice," *Apollo* 125 (1987): 185–186. For the *berettino* ware of Faenza, which was developed at the end of the fifteenth

century and reached its peak about the time the style was adopted in Venice, see Liverani, p. 40 and pl. 51.

69. See Rackham 1977, 1: cat. no. 967. For Venetian pottery with Ottoman-style ornament, also see Giambattista Siverio, "Maiolica veneziana del '500," in *Italian Renaissance Pottery,* ed. Timothy Wilson (Over Wallop, Hampshire, 1991), pp. 136–137 and figs. 3, 7, 8; Maria Vittoria Fontana, "Rapporti artistici fra ceramica islamica e ceramica veneta fra il Quattrocento e il Seicento," in *Venezia e l'Oriente Vicino,* ed. Ernst J. Grube, Atti del primo congresso internazionale sull'arte veneziana e l'arte islamica (Venice, 1989), p. 127 and figs. 6, 11, 12.

70. Thornton, p. 110.

71. A Venetian *alla porcellana* plate of about 1540 in the John Philip Kassebaum Collection is decorated with floral scrolls rendered with wiry lines and hooked leaf ends that were probably inspired by *tugra* spiral–style Iznikware; Carswell 1985, p. 151, cat. no. 91.

72. The similar plate is in the Keir Collection (Atasoy and Raby, fig. 328). Iznikware tondinos survive with other styles of decoration: a unique example of about 1534–1540 featuring a bust of a man in Ottoman dress is in the Victoria and Albert Museum (inv. no. 57-1859; Atasoy and Raby, fig. 179); a set with a European coat of arms is listed in note 76 below. For this and other Italian shapes in early Iznikware, see Raby, in Atasoy and Raby, pp. 77, 98, 104, 108, 110, 119, 226; J. Michael Rogers, "'Terra di Salonich, simile a la porcellana': Some Problems in the Identification and Attribution of Earlier Sixteenth Century Iznik Blue and White," in *Italian Renaissance Pottery,* ed. Timothy Wilson (Over Wallop, Hampshire, 1991), pp. 253–254; Atil 1987, pp. 235, 239; A. Lane 1957, p. 51.

73. Raby, in Atasoy and Raby, pp. 108, 113, 264, 268, with an illustration of Sultan Suleyman's *tugra* in fig. 131; *Eredità dell'Islam,* pp. 383, 481–483. For a different view on the origins of the spiral style, see Rogers 1991, "Terra di Salonich," pp. 254–256.

74. See the auction catalogue *Islamic Works of Art,* Sotheby's, London, April 25, 1990, lot 431, pp. 174–175.

75. For the *"tugra* spiral"–style *albarello* made at Cafaggiolo, see Cora and Fanfani 1982, cat. no. 131.

76. The surviving nine dishes, all about the same size, and three larger serving pieces are in different locations: British Museum (inv. nos. 78.12-30.489–491); Calouste Gulbenkian Foundation Museum, Lisbon (inv. nos. 814 and 2250); Musée National de Céramique, Sèvres (inv. nos. MNC 52741 and 52742); Arkeoloji Muzesi, Iznik (inv. no. 4225); Ashmolean Museum, Oxford (inv. nos. C.324 and X.3268); and two private collections; Raby, in Atasoy and Raby, pp. 264–265 and figs. 575–586, 734–737. The shield on these plates was long identified as the arms of the Mocenigo family of Venice, and

similar shields appearing without colors on Mamluk metalwork have also been identified as those of the Benzoni of Venice or the Buonaccorsi of Florence; see Allan 1986, p. 59, fig. 50/5; Atil 1987, p. 241. Raby argues that the shield is more likely Italo-Dalmatian, perhaps of the Spingarolli de Dessa of Dalmatia, and proposes that the only other arms appearing on Iznikware, on a *tondino* in the Museum für Islamische Kunst, Berlin (inv. no. 18,27), are Prussian or Polish, perhaps those of Andrzej Taronowsky of Belina, who participated in diplomatic missions to Istanbul in the 1560s, 1572, and 1575. For a set of at least four flower vases in a unique shape from the same period, with a mark on the base that resembles a European pharmacy mark, see Fontana 1989, p. 126 and fig. 3; Raby, in Atasoy and Raby, p. 268.

77. The interest of David Ungnad, ambassador to the Sublime Porte from 1573 to 1578, in "Nicene tiles . . . called Majolik" with floral decoration is recorded in an entry of September 1577 in the diary of his chaplain, Stefan Gerlach; Raby, in Atasoy and Raby, p. 264. Wolf Dietrich von Raitenau later ordered Ottoman-style trappings from Venice for his mounted bodyguard; see Ernst J. Grube, "Le lacche veneziane e i loro modelli islamici," in *Venezia e l'Oriente Vicino,* ed. Ernst J. Grube, Atti del primo congresso internazionale sull'arte veneziana e l'arte islamica (Venice, 1989), p. 217; see also Chapter 7.

78. Thornton, p. 110.

79. *Europa und der Orient,* pp. 616–617, cat. no. 4/131. The inscription probably refers to the village of Chandiana, outside Padua, or is a dedication to "Suor Chandiana" (Sister Chandiana), its form on other examples; see *Eredità dell'Islam,* pp. 483–484, cat. no. 301. The Ottoman inspiration of this Paduan ware is undisputed: see Rackham 1933, p. 74; A. Lane 1957, p. 57; Caiger-Smith, pp. 88, 93; Giovanni Curatola, "Tessuti e artigianato turco nel mercato veneziana," in *Venezia e i turchi: Scontri e confronti di due civiltà* (Milan, 1985), pp. 190, 193; Atil 1987, p. 242; Fontana 1989, p. 128; Raby, in Atasoy and Raby, p. 268; Siverio, p. 138.

80. *Europa und der Orient,* p. 616, cat. no. 4/130.

81. Lightbown 1969, pp. 229 n. 5 and 232; Spallanzani 1978, pp. 60–62, 94, 97; Marco Spallanzani, "Ceramiche nelle raccolte medicee da Cosimo I a Ferdinando I," in Candace Adelson et al., *Le arti del principato mediceo* (Florence, 1980), pp. 73–89.

82. A. Lane 1954, p. 2; Lightbown 1981, pp. 458–461; Wilson 1993, p. 234.

83. A. Lane 1954, pp. 3–7; Lightbown 1981, pp. 462–465; Maser, pp. 38–40; Galeazzo Cora and Angiolo Fanfani, *La porcellana dei Medici* (Milan, 1986), pp. 15–19; Wilson 1993, pp. 234–236.

84. Raby, in Atasoy and Raby, p. 268; W. David Kingery and Pamela B. Vandiver, "Medici Porcelain," *Faenza* 70

(1984): 450–451. Technical inspiration from Iznikware through an Oriental craftsman was previously proposed by A. Lane 1954, p. 3.

85. Maser, p. 39.

86. The notice of 1781 by Riguccio Galluzi is quoted in Gaetano Guasti, *Di Cafaggiolo e d'altre fabbriche di ceramiche in Toscana* (Florence, 1902), pp. 390–391; Raby, in Atasoy and Raby, p. 377 n. 25.

87. Raby, in Atasoy and Raby, p. 68; his fig. 449 illustrates the other jar in the Victoria and Albert Museum (inv. no. 626-1902).

88. This vessel corresponds closely to two porcelain "oil flasks" described in a Medici inventory of 1732; Wilson 1993, pp. 236–240.

89. The connection between the Ottoman wheat-sheaf style and Medici porcelain is proposed by Raby, in Atasoy and Raby, pp. 239, 268 and figs. 447–452, 587–588. Other examples of Medici porcelain inspired by the wheat-sheaf style cited by Raby are illustrated in Cora and Fanfani 1986, pp. 69, 107, 115, 118, 119, 149.

90. A. Lane 1954, p. 4. In addition to the pieces sent to Duke Alfonso II d'Este in 1575, seventeen were sent to his uncle Don Alfonso in 1583; pieces were sent to King Philip of Spain in 1577, 1581, and 1582.

91. Different versions of the mark are illustrated in Cora and Fanfani 1986.

Chapter 6. Glass

1. For the removal of master craftsmen from Damascus, see Chapter 5, note 13. Atil (1981, p. 118) points out that the Timurid destruction of 1400–1401 was probably not the sole cause of the Mamluk glass industry's demise; she suggests that contributing factors were severe economic depression and inflation, which reduced demand, and the preference for Chinese porcelain, which was beginning to arrive in quantity. Ashtor (1983, pp. 211–212) argues that the primary factors were technological stagnation and inferior raw materials.

2. Glassmakers had established a guild in Barcelona by 1455, and by the end of the century their products were available in Oriental entrepôts such as Beirut; Hugh Tait, ed., *Glass: Five Thousand Years* (New York, 1991), p. 160, with illustrations; also see Chapter 10.

3. Emigration of glassmakers, prohibited by law since the final decades of the thirteenth century, was a serious problem by 1547, when Venetian ambassadors received instructions to watch for violators and to force them to return, under threat of death if necessary. During the second half of the sixteenth century, Venetian glassmakers are recorded in France, Spain, Majorca, Antwerp, and London. Paul N. Perrot, *Three Centuries of Venetian Glass,* exh. cat.,

Corning Museum of Glass, Corning, N.Y. (New York, 1958), p. 21; Tait 1991, p. 163.

4. For the origins of Venetian glass, see Astone Gasparetto, "Matrici e aspetti della vetraria veneziana e veneta medievale," *Journal of Glass Studies* 21 (1979): 77–85; Hugh Tait, *The Golden Age of Venetian Glass* (London, 1979), pp. 9–11.

5. The earliest written record of the craft in Venice appears in an act of December 20, 982, recording Doge Triburio Menio's donation of land on the island of San Giorgio to the Benedictine order. Among the citizens witnessing the act was a *fiolario* (glassblower) named Domenico. Two other glassblowers witnessed Benedictine donations in 1087 and 1090. The importation of alum from Alexandria in 1072 indicates that glass was being produced in Venice. Craftsmen skilled in Byzantine techniques, such as the Greek master mosaicist documented in 1153, were employed at Saint Mark's. See Astone Gasparetto, *Il vetro di Murano dalle origini ad oggi* (Venice, 1958), pp. 36–48; Perrot, pp. 10–11.

6. Perrot, p. 13; Tait 1991, p. 149; Stefano Carboni, "Gregorio's Tale; or, Of Enamelled Glass Production in Venice," in *Gilded and Enamelled Glass from the Middle East,* ed. Rachel Ward (London, 1998), pp. 101–102. Gasparetto (1958, p. 50) also cites broken glass being carried as ballast from Syria to Venice in 1255.

7. Perrot, pp. 10–11; see also Chapter 1, note 29.

8. In 1271 the guild of glassblowers, in existence by 1224, when twenty-nine members were fined for contravening its statutes, was reorganized so that only Venetian citizens could own furnaces, although foreigners could be workers or apprentices; the guild also regulated the size and operating periods of furnaces, and the size, weight, and price of wine and oil bottles. Beginning in 1286 owners of furnaces could apply for exemption from the summer shutdown, and beginning in 1303 there were restrictions on foreigners entering the guild. Decrees of 1275, 1285, and 1295 prohibited the emigration of craftsmen and the export of raw materials used in glassmaking. Decrees of 1275 and 1282 regulated German merchants' purchases of Venetian glass. See Gasparetto 1958, pp. 49–53; Perrot, p. 11; Tait 1979, pp. 9–10; Tait 1991, p. 149; Pieter C. Ritsema van Eck and Henrica M. Zijlstra-Zweens, *Glass in the Rijksmuseum* (Zwolle, 1993), 1:13.

9. Gasparetto 1958, pp. 59–60; Perrot, pp. 11–13; Tait 1991, p. 150. The *cristalleri* had their own guild from 1284 onward.

10. See Tait 1979, pp. 11–12, 16–17; Tait 1991, pp. 151–152; Carboni 1998, pp. 101–103; Stefano Carboni, "Oggetti decorati a smalto di influsso islamico nella vetraria muranse:

Technica e forma," in *Venezia e l'Oriente Vicino,* ed. Ernst J. Grube (Venice, 1989), pp. 153, 155; Marco Verità, "Analyses of Early Enamelled Venetian Glass: Comparison with Islamic Glass," in *Gilded and Enamelled Glass from the Middle East,* ed. Rachel Ward (London, 1998), pp. 129–133; Franz Adrian Dreier, *Venezianische Gläser und 'Façon de Venise,'* vol. 12 of *Katalog des Kunstgewerbemuseums Berlin* (Berlin, 1989), p. 32.

11. Ralph Pinder-Wilson, "Islamic Glass Twelfth–Fifteenth Centuries," in *Glass: Five Thousand Years,* ed. Hugh Tait (New York, 1991), pp. 131–132; Gasparetto 1958, pp. 30–32; Tait 1979, p. 11. The first datable piece of Islamic enameled glass is a bottle in the Museum of Islamic Art, Cairo, bearing the name of an Ayyubid sultan, probably Salah al-Din Yusef, sultan of Aleppo (r. 1237–60) and of Damascus (r. 1250–60). Recently, it has been argued that the bottle represents an early stage in the development of the technique, and that some other pieces usually considered contemporary should be dated in the fourteenth century; Rachel Ward, "Glass and Brass: Parallels and Puzzles," in *Gilded and Enamelled Glass from the Middle East,* ed. Ward (London, 1998), pp. 30–31.

12. Lamm, 1:278–279; Gasparetto 1958, p. 33; Atil 1981, pp. 118, 126–127. Ward (1998, p. 33) has proposed that many of the figured glass vessels were made for export to Europe, but there is little evidence of a commercial market for enameled Syrian glass before the 1340s, when the papal embargo on trade with Egypt and Syria was lifted and such objects began to be mentioned in princely inventories; see J. Michael Rogers, "European Inventories as a Source for the Distribution of Mamluk Enamelled Glass," in *Gilded and Enamelled Glass from the Middle East,* ed. Rachel Ward (London, 1998), pp. 69–72.

13. See John Carswell, "The Baltimore Beakers," in *Gilded and Enamelled Glass from the Middle East,* ed. Rachel Ward (London, 1998), pp. 61–63, with illustrations; Atil 1981, pp. 126–127, cat. no. 45.

14. Pinder-Wilson, p. 135; Avinoam Shalem, "Some Speculations on the Original Cases Made to Contain Enamelled Glass Beakers for Export," in *Gilded and Enamelled Glass from the Middle East,* ed. Rachel Ward (London, 1998), pp. 64–65. The beaker from the ruins of the Church of Santa Margherita, Orvieto, is now in the Louvre (A.O. 6131); see Shalem 1998, p. 64.

15. Inv. no. HST-17 / NM 71 (VII) 1:93; Ingeborg Krueger, "An Enamelled Beaker from Stralsund: A Spectacular New Find," in *Gilded and Enamelled Glass from the Middle East,* ed. Rachel Ward (London, 1998), pp. 107–108, with illustrations. The motif consists of two kneeling figures holding a large vase supporting symmetrical vine scrolls.

16. See *The Treasury of San Marco, Venice,* exh. cat., Metro-politan Museum of Art, New York (Milan, 1984), pp. 180–183, cat. no. 21; Tait 1991, pp. 145–147.

17. Carboni 1998, pp. 101–104.

18. Fragments excavated in central Europe and the Baltic region presumably arrived overland, brought by German merchants, but fragments found in Ireland, Sweden, and the Caucasus as well as in London, Palermo, and Fustat must have been carried by Venetian galleys; see Carboni 1998, pp. 102–103; Tait 1991, p. 152; Dreier, pp. 31–32.

19. Pegolotti's references are cited in Spallanzani 1989, pp. 83, 87. European inventories are discussed in Rogers 1998, pp. 69–72.

20. Spallanzani 1989, p. 84.

21. Spallanzani 1989, pp. 84, 89.

22. Tait 1991, p. 149.

23. Spallanzani 1989, p. 83.

24. The inventory of Piero de' Medici from 1456 is cited in Lamm, 1:495; that of Charles V in Perrot, p. 14; and Rogers 1991, "The Gorgeous East," p. 71.

25. Rogers 1998, p. 71.

26. The passage from Fabri's Latin account of his pilgrimage in 1483–1484 (*Evagatorium in Terrae Sanctae, Arabiae et Aegypti peregrinationem*) is translated in Édouard Garnier, *Histoire de la verrerie et de l'émaillerie* (Tours, 1886), pp. 80–81; also mentioned in Gasparetto 1958, pp. 84–85; Perrot, p. 19; Tait 1991, p. 152.

27. Garnier, p. 81; Mary Margaret Newett, *Canon Pietro Casola's Pilgrimage to Jerusalem* (Manchester, 1907), p. 103.

28. It is $7^1/_2$ in. (19 cm.) high and $5^7/_8$ in. (14.9 cm.) wide; purchased by the Toledo Museum of Art with funds from the Libbey Endowment, Gift of Edward Drummond Libbey. Gasparetto 1958, pp. 78–79; Perrot, p. 15; Tait 1991, p. 157.

29. Tait 1991, pp. 147–148, 161.

30. For the imitation of sapphire blue, emerald green, ruby red, and amethyst violet, see Gasparetto 1958, pp. 66–67. Examples of fourteenth-century Venetian glass medallions and plaques are illustrated in Tait 1991, p. 150, fig. 190.

31. *Eredità dell'Islam,* pp. 323–324, cat. no. 189. For other examples of Syrian colored glass with enameled and gilt decoration, see Martine S. Newby, "The Cavour Vase and Gilt and Enamelled Mamluk Colored Glass," in *Gilded and Enamelled Glass from the Middle East,* ed. Rachel Ward (London, 1998), pp. 35–39, with a list and illustrations; Gasparetto 1958, pp. 30–31 and fig. 14; Gaston Wiet, *Catalogue général du Musée Arabe du Caire: Lampes et bouteilles en verre émaillé* (Cairo, 1929), pp. 8–9, cat. no. 268 and pl. 91.

32. Gasparetto 1958, pp. 31, 76; Carboni 1989, p. 147.

33. Gasparetto 1958, p. 31 and figs. 21, 24, 25.

34. For the scale-and-dot pattern's relation to Islamic glass, see, for example, Eck and Zijlstra-Zweens, 1:18; Perrot, p. 54, cat. no. 36.

35. The imitative qualities of late-fifteenth-century Venetian glass are discussed by Gasparetto 1958, pp. 66–68.

36. For Figure 122 and the style of its decoration, see Gasparetto 1958, pp. 68, 83–84; Perrot, p. 19; Carboni 1989, p. 150. For *tazze* in blue glass with similar enameled and gold-leaf decoration, see Perrot, pp. 55–57, cat. nos. 40–41.

37. The Islamic derivation of the *guastada* is universally recognzied; see the sources cited in note 45 below and in *Islam and the Medieval West,* ed. Stanley Ferber, exh. cat., University Art Gallery, Binghamton, N.Y. (Binghamton, N.Y., 1975), cat. no. G23.

38. Leonardo Frescobaldi recounted that some in his party of thirteen Tuscan pilgrims bought these phials, which could have been of the locally made glass that he praised; his companion Giorgio Gucci also described their sale; *Visit to the Holy Places,* pp. 68, 123; Shalem 1996, p. 20. Fourteenth-century papal inventories list numerous such small phials containing balsam that were also probably souvenirs of pilgrimage; Rogers 1998, pp 69–70.

39. Jean Sauvaget, *Poteries syro-mésopotamiennes du XIVème siècle,* Documents d'Études Orientales de L'Institut Français de Damas, 1 (Paris, 1932), pp. 1–5, with illustrations.

40. Shalem 1996, pp. 24, 238–239; other Islamic glass in medieval European church treasuries is listed on pp. 239–245.

41. A spectacular inlaid brass canteen in the Freer Gallery of Art, Washington (inv. no. 41.10), probably made in Syria in the mid–thirteenth century, is decorated with the same hybrid iconography as the so-called Syro-Frankish glasses; its patron, honored in the Arabic inscription as a border soldier, could have been a crusader or a Muslim; Esin Atil, William Thomas Chase, and Paul Jett, *Islamic Metalwork in the Freer Gallery of Art* (Washington, 1985), pp. 19, 124–136, cat. no. 17, with illustrations. Also in the Freer Gallery (inv. no. 58.2) is the equally exceptional blue-and-white porcelain version of such a piece, with floral decoration in an early-fifteenth-century style; Atil, Chase, and Jett, p. 133, fig. 50. Close to the Venetian glass version of the pilgrim flask in shape and scale is a unique inlaid brass flask in the British Museum, London (inv. no. OA 1833.10-19.7), which may have been made in Khurasan or Punjab about 1200. It has two flattened sides, a long neck, goat-shaped handles, and a squared foot; Ward 1993, pp. 72–74 and fig. 53.

42. This luxurious flask has long been dated in the mid– to late thirteenth century (for example, see Tait 1979, pp. 19–21; and Pinder-Wilson, p. 132), but Ward (1998, pp. 30–31) has presented strong stylistic arguments for a later dating.

43. Atil 1975, p. 138, cat. no. 74. For the shapes of Syrian bottles, also see Atil 1981, p. 119.

44. Eck and Zijlstra-Zweens, 1:19, cat. no. 3.

45. Gasparetto 1958, p. 83 and fig. 21; Carboni 1989, p. 154 and fig. 16 (the pair); Dreer, p. 49; Eck and Zijlstra-Zweens, 1:19. As on another pilgrim flask in the F. Biemann collection, Zurich, the Bentivoglio arms appear without the *palle* (balls), which the House of Aragon conceded to the family in 1489; Rosa Barovier Mentasti et al., *Mille anni di arte del vetro a Venezia,* exh. cat., Palazzo Correr, Venice (Venice, 1982), p. 87, cat. no. 81. The absence of the *palle* raises the possibility that all three flasks predate 1489, but scholars agree that the style and level of accomplishment of the Bologna pair argue against a date as early as the first Bentivoglio-Sforza marriage in 1464.

46. For examples in colored glass, see Barovier Mentasti, p. 87, cat. no. 78; and for those in milk glass, note 50 below. For maiolica examples, see Watson, pp. 158–159, 184. A brass pilgrim's flask incised with Europeanized arabesques, in the Victoria and Albert Museum, London (inv. no. 2086-1855), appears to be a sixteenth-century Venetian work. For the Medici porcelain example, see Cora and Fanfani 1986, pp. 122–123.

47. Perrot (p. 15) cites a recipe for "lattimo bianco" in a fourteenth-century document dealing with mosaic making preserved in Florentine archives. For Chinese porcelain presented to doges by Mamluk sultans, see Chapter 1, note 72.

48. Tait 1991, p. 159.

49. See Chapter 5, notes 55–56.

50. For example, a milk-glass pilgrim flask in the Museo Vetrario, Murano, is decorated with dots and tiny floral motifs in blue *alla porcellana* around two polychrome scenes, "Venus and Mars" and "Cupid Fishing on a Bridge"; Gasparetto 1958, p. 93 and fig. 52, who proposes (pp. 92–93) that Venetian glassmakers deliberately differentiated their milk glass from porcelain.

51. The passage is quoted in Perrot, p. 17.

52. See Chapter 5, note 56. An early mention, in an Italian letter of 1470 published in the nineteenth century, of an alchemist making porcelain in Venice is no longer considered reliable; see A. Lane, 1954, p. 2; Lightbown 1981, pp. 458–459. Lightbown (1981, pp. 459–460) proposes that Peringer was seeking exclusive rights to produce heat-resistant vessels that differed from ordinary milk glass.

53. It is 10.2 cm. high; Perrot, p. 35, cat. no. 11; Tait 1991, p. 159; Barovier Mentasti, p. 96, cat. no. 98.

54. See Flavia Polignano, "Maliarde e cortigiane: Titoli per una *damnatio:* Le dame di Vittore Carpaccio," *Venezia Cinquecento* 2, no. 3 (1992): 5–17 and fig. 2.

55. Tait 1991, p. 163; Perrot, pp. 18–19; Gasparetto 1958, p. 67.

56. Lamm, 1:189, 234–235, 521; 2: pl. 85, nos. 1–2, and pl.

81, no. 8. For the complete list of these items in Lorenzo de' Medici's treasury, see Spallanzani and Gaeta Bertelà, pp. 34–36.

57. Clifford M. Brown, "'Lo insaciabile desiderio nostro de cose antique': New Documents on Isabella d'Este's Collection of Antiquities," in *Cultural Aspects of the Italian Renaissance: Essays in Honor of Paul Oskar Kristeller,* ed. Cecil H. Clough (Manchester, 1976), pp. 324, 325–326.

58. Perrot, pp. 18–19.

59. See Chapter 1, note 75.

60. For the survival of ancient glassmaking techniques in fifth- and sixth-century Sasanian glass and later Islamic glass, see Christoph Clairmont, "Some Islamic Glass in the Metropolitan Museum," in *Islamic Art in the Metropolitan Museum,* ed. Richard Ettinghausen (New York, 1972), pp. 141–145. For twelfth- and thirteenth-century Islamic bichrome trailed (or marvered) glass, some fragments of which have been excavated in Cyprus and England, see James W. Allan, "Investigations into Marvered Glass: 1," in *Islamic Art in the Ashmolean Museum,* Oxford Studies in Islamic Art, 10 (Oxford, 1995), 1:5–7, 16–17, 21–24. To my knowledge, however, no link between these objects and late-fifteenth-century Venetian glass has been established.

61. See Perrot, pp. 15–17 and cat. nos. 3 (see Fig. 128) and 4 (a similar tumbler); Robert Jesse Charleston, "The Import of Venetian Glass into the Near-East, Fifteenth–Sixteenth Century," in *Annales du 3ème congrès des journées internationales du verre* (Liège, 1964), p. 161; Robert Jesse Charleston, "Types of Glass Imported into the Near East, and Some Fresh Examples: Fifteenth–Sixteenth Century," in *Festschrift für Peter Wilhelm Meister zum 65. Geburtstag am 16. mai 1974,* ed. Annaliese Ohm and Horst Reber (Hamburg, 1975), pp. 245–246; Brigitte Klesse and Hans Mayr, *European Glass from 1500–1800: The Ernesto Wolff Collection* (Vienna, 1987), pp. 13–14 and cat. no. 1; Carboni 1989, p. 154; Dreier, pp. 33–34, cat. no. 3. There is no proof of Gasparetto's proposal (1979, pp. 90–91) that lozenge ornament was revived in glassware made for export to the eastern Mediterranean.

62. Helmut Ricke, "Neue Räume—neue Gläser: Die Sammlung des Kunstmuseums Düsseldorf nach der Wiedereröffnung," *Kunst und Antiquitäten* 3 (1985): 59–60.

63. Atil 1981, pp. 120–121: Pinder-Wilson, pp. 132–135, with illustrations.

Chapter 7. Bookbinding and Lacquer

1. Anthony Hobson, *Humanists and Bookbinders: The Origins and Diffusion of the Humanistic Bookbinding, 1459–1559, with a Census of Historiated Plaquette and Medallion Bindings of the Renaissance* (Cambridge, 1989). A summary appears in Anthony Hobson, "Islamic Influence on Venetian Renaissance Bookbinding," in *Venezia e l'Oriente Vicino,* ed.

Ernst J. Grube, Atti del primo congresso internazionale sull'arte veneziana e l'arte islamica (Venice, 1989), pp. 111–123.

2. This practice is documented in the inventory of Piero de' Medici's library of 1464; Tammaro De Marinis, *La legatura artistica in Italia nei secoli XV e XVI* (Florence, 1960), 1:89.

3. Hobson 1989, *Humanists and Bookbinders,* p. 1.

4. Hobson 1989, *Humanists and Bookbinders,* pp. 27–28.

5. *Legature papali da Eugenio IV a Paolo VI,* exh. cat., Biblioteca Apostolica Vaticana, Vatican City (Rome, 1977), pp. 3–15, cat. nos 1–19, 21.

6. Hobson 1989, *Humanists and Bookbinders,* pp. 19–21. For bindings in this style, see also *The History of Bookbinding, 525–1950 A.D.,* exh. cat., Baltimore Museum of Art (Baltimore, 1957), p. 87, cat. no. 195.

7. Duncan Haldane, *Islamic Bookbindings in the Victoria and Albert Museum* (London, 1983), p. 31. cat. no. 7; see also cat. nos. 6, 8–10.

8. For example, see a fourteenth- or fifteenth-century Mamluk binding in the Chester Beatty Library, Dublin (Moritz Collection 12); Gulnar Bosch, John Carswell, and Guy Petherbridge, *Islamic Bookbindings and Bookmaking,* exh. cat., Oriental Institute, University of Chicago (Chicago, 1981), pp. 135–136, cat. no. 37.

9. De Marinis, 1:29; Hobson 1989, *Humanists and Bookbinders,* p. 19.

10. Hobson 1989, *Humanists and Bookbinders,* pp. 21–32. For the Mamluk models, see also Richard Ettinghausen, "Near Eastern Book Covers and Their Influence on European Bindings: A Report on the Exhibition 'History of Bookbinding' at the Baltimore Museum of Art," *Ars Orientalis,* n.s., 3 (1959): 121–122; Bosch, Carswell, and Petherbridge, pp. 68–69.

11. Lat. VI, 270; Hobson 1989, *Humanists and Bookbinders,* pp. 22–23.

12. Cod. Holm, A 223; Hobson 1989, *Humanists and Bookbinders,* pp. 25–26, fig. 18.

13. Hobson 1989, *Humanists and Bookbinders,* pp. 27–28, figs. 21 (Biblioteca Malatestiniana, S. XII. 2 [Zazzeri, 348]) and 22 (Biblioteca Vaticana, Vat. lat. 3005). The *Politica* manuscript is signed by the scribe Ormannus de Erfordia and dated May 10, 1454. In a letter of October 18, 1454, to Vespasiano da Bisticci, Perotti mentioned that he had just finished the Polybius.

14. Hobson 1989, *Humanists and Bookbinders,* pp. 1–12, 33–50.

15. Lightbown 1986, pp. 64–65, 71.

16. Ms. 77; Hobson 1989, *Humanists and Bookbinders,* pp. 33–36, figs. 26 (the illumination of Jacopo Antonio Marcello presenting Guarino's translation of Strabo's *Geography* to

René of Anjou) and 27 (photograph of the original binding). The relationship between Marcello and René of Anjou is described in Millard Meiss, *Andrea Mantegna as Illuminator: An Episode in Renaissance Art, Humanism, and Diplomacy* (New York, 1957), pp. 1–34. The manuscript illuminations are attributed to the circle of Andrea Mantegna by Meiss (pp. 35–75), and to the circle of Jacopo Bellini by Giordana Maria Canova in *The Painted Page,* pp. 24, 87–90, cat. no. 29, with illustrations.

17. Barb. lat. 98; Hobson 1989, *Humanists and Bookbinders,* p. 38.

18. See Julian Raby and Zeren Tanindi, *Turkish Bookbinding in the Fifteenth Century: The Foundation of the Ottoman Court Style,* ed. Tim Stanley (London, 1993), pp. 9–11. See also an Egyptian or Syrian cover of 1469/70 in the Chester Beatty Library, Dublin (MS 3571); Bosch, Carswell, and Petherbridge, pp. 184–185, cat. no. 67.

19. Hobson 1989, *Humanists and Bookbinders,* pp. 38–41, 73–86, and figs. 32–34, 66–72.

20. Hobson 1989, *Humanists and Bookbinders,* pp. 41–50, 255.

21. Hobson 1989, *Humanists and Bookbinders,* pp. 43–44.

22. For Mamluk filigree bindings, see *The History of Bookbinding,* p. 31, cat. no. 38; Bosch, Carswell, and Petherbridge, pp. 69–70; Raby and Tanindi, pp. 10–11.

23. French private collection; Hobson 1989, *Humanists and Bookbinders,* pp. 45–48, fig. 41, and frontispiece.

24. For example, De Marinis, 2:54 and 80–81, nos. 1648, 1656, 1657.

25. For Feliciano's manuscript illuminations and printed book illustrations, see Chapter 5, note 45. At an early date, his bindings and illustrations probably inspired the unique framing ornament on a tabernacle by Domenico di Paris, about 1465–1470, in a private collection in Florence. Made of painted and gilt wood and stucco, it has a high-relief Madonna and Child Enthroned in the center. In composition, its Italianized arabesques and strapwork resemble book-bindings, and the ornament includes medallions and pendants with gilt arabesques on a blue background similar to filigree. Di Paris, trained in Padua, was active in Ferrara from the 1450s (notices to 1492); his tabernacle has a Ferrarese provenance (conversation with Mina Gregori).

26. For the rare European filigree bindings made outside Padua and Venice, see Hobson 1989, *Humanists and Bookbinders,* pp. 48–50, 54.

27. Hobson 1989, *Humanists and Bookbinders,* pp. 51–54; De Marinis, 2:53–54, nos. 1634–1639 on p. 78, and pls. 289–297.

28. His one manuscript on parchment and two Jenson publications on parchment bound in Padua between 1470 and 1478 do not have filigree; Hobson 1989, *Humanists and Bookbinders,* p. 38, figs. 33–34 and pl. 1.

29. For example, see Ernst Philip Goldschmidt, *Gothic and Renaissance Bookbindings* (London, 1928), 1:292–293; *The History of Bookbinding,* pp. 93–94, cat. no. 209; De Marinis, as in note 27 above. For the refutation of this theory, see Chapter 8, note 15.

30. Hobson (1989, *Humanists and Bookbinders,* pp. 52–54) emphasizes the Paduan and Ottoman models.

31. During the reign of Sultan Mehmed II Ottoman bindings and manuscript illuminations were strongly influenced by Timurid and Turkoman Iranian art; see Raby and Tanindi, pp. 34–76. For an example of Ottoman pressure-molded borders and the distinctive lotus palmette motif on the Gratian cover, see the cover on a manuscript finished for Sultan Mehmed II in 1474, now in the Topkapi Palace Library (MS A. 1032); Raby and Tanindi, pp. 158–159, cat. no. 20. For a similar arrangement of cutouts on a round centerpiece, see the filigree doublures on an atlas for Sultan Mehmed II, 1450s, in the Topkapi Palace Library (MS A. 2830); Raby and Tanindi, pp. 132–133, cat. no. 8.

32. See Raby and Tanindi, pp. 44–45.

33. MS Canon. Ital. 78; Hobson 1989, *Humanists and Bookbinders,* pp. 23–24, figs. 15–16. Hobson suggests that the owner was a Florentine who took advantage of increased diplomatic and commercial activity between Florence and Istanbul during the Venetian-Turkish war of 1463–1469. For two examples of printed books bound in Istanbul, see Hobson 1989, *Humanists and Bookbinders,* p. 148, figs. 117–118.

34. Hobson (1989, *Humanists and Bookbinders,* pp. 34–36 and figs. 27–28) has shown that early Paduan gold-tooled bindings drew some inspiration from Mamluk brassware.

35. Hobson 1989, *Humanists and Bookbinders,* pp. 54–57, 148–154; De Marinis, 2:57–61, 77–83; Paul Needham, *Twelve Centuries of Bookbinding, 400–1600* (New York and London, 1960), pp. 122–124, cat. no. 35.

36. Hobson 1989, *Humanists and Bookbinders,* p. 150; *The History of Bookbinding,* pp. 93–94, cat. no. 209; Ettinghausen 1959, p. 128.

37. For the style of bindings during the reign of Bayezid II, see Raby and Tanindi, pp. 92–94, 101–104.

38. For this and related Venetian filigree bindings, see Hobson 1989, *Humanists and Bookbinders,* pp. 150–153; De Marinis, 2:58, 82–83, nos. 1660 bis, 1663, 1670, 1670 bis, 1670 ter; fig. C 31; and pls. 305, 307–309. *The History of Bookbinding,* p. 94, cat. no. 210; Ettinghausen 1959, p. 129; Goldschmidt, 1:291–293, cat. no. 217. De Marinis and Goldschmidt attribute this group to Oriental craftsmen working in Venice.

39. This rare doublure is on a manuscript copy of a comedy recited in Bologna before Pope Clement VII at Charles V's coronation in 1530, A. Ricchi's *I tre tiranni,* in the Biblioteca Governativa, Lucca (Cod. 1375); De Marinis,

2:81–82, no. 1663; and Hobson 1989, *Humanists and Book-binders,* p. 150. For comparable Ottoman compositions, see Atil 1987, pl. 15; and Hobson 1989, *Humanists and Book-binders,* fig. 118.

40. See St. Clair, figs. 18, 22, 26, for examples from early pattern books published in Venice and Paris in 1530; see also Chapter 5, note 48.

41. Atil 1987, pp. 76–77.

42. Cod. arab. LXVIII (= 65); cited by Hobson 1989, *Humanists and Bookbinders,* p. 153.

43. For this and similar Venetian lacquered bindings, see Hobson 1989, *Humanists and Bookbinders,* pp. 153–154; De Marinis, 2:58–60, 83, 100, nos. 1671–1672, 1917e–g, pls. 210, 214 bis–quat.; Ettinghausen 1959, p. 129.

44. Compare, for example, pages in an album illuminated about 1560 in the Universite Kutuphanese, Istanbul (F. 1426, fols. 22b, 27a), reproduced in Atil 1987, pls. 49c–d. For the *saz* or *"saz* leaf and rosette" style, see Atil 1987, p. 26; Yanni Petsopoulos, ed., *Tulips, Arabesques, and Turbans: Decorative Arts from the Ottoman Empire* (New York, 1982), p. 8.

45. The combination of lacquer and filigree is rare in Venetian bindings. Filigree continues to appear in sunken compartments of late-sixteenth-century appointment document covers that are not lacquered. For example, Giovanni Francesco Condolmer's *commissione* as *podestà* of Oderzo in 1577, in the Walters Art Museum, Baltimore (MS W. 492), has Ottoman-style gilt filigree over satin in the sunken center and cornerpieces of its tooled and gilt leather binding. For lacquered bindings with mother-of-pearl accents, see De Marinis, 2:61.

46. For example, the binding of Giovanni Francesco Condolmer's *commissione,* mentioned in note 45 above, juxtaposes two imported styles: a tooled and gilt French fanfare design fills the area between the sunken filigree center and cornerpieces.

47. Anna Contadini, "'Cuoridoro': Tecnica e decorazione di cuoi dorati veneziani e italiani con influssi islamici," in *Venezia e l' Oriente Vicino,* ed. Ernst J. Grube, Atti del primo congresso internazionale sull'arte veneziana e l'arte islamica (Venice, 1989), pp. 231–235, figs. 1–2. The protectionist legislation included customary restrictions on foreign workers and merchandise. In 1569 Doge Pietro Loredan was notified that gilt leather, probably wall coverings, ordered by Ibrahim Bey so pleased him that he was ordering another shipment.

48. Giuseppe Fiocco, "A Small Portable Panel by Titian for Philip II," *Burlington Magazine* 98, no. 643 (October 1956): 343–344.

49. Contadini, pp. 236–238, figs. 3–10 (shields); Huth 1971, p. 4, pl. 6 (quiver).

50. Atil 1987, pp. 148, 160–166 and pls. 99–102 (wicker shields), 104–106 (appliquéd leather objects).

51. For Figure 145, see J. Michael Rogers, *The Topkapi Saray Museum: Costumes, Embroideries, and Other Textiles* (London, 1986), p. 164.

52. Huth 1971, p. 4; Grube 1989, p. 217.

53. In color, texture, and motifs, the floral and cloud-collar (arched motif with scalloped outside and cusped inside edge) arabesques on these shields are closely related to the embroidery on a ceremonial kaftan from the second quarter of the sixteenth century in the Topkapi Sarayi Museum (inv. no. 13/739); see Atil 1987, pp. 166–169 and pl. 120.

54. Huth 1971, pp. 1–11; Grube 1989, pp. 218–219, both with illustrations. The inventory of Giovanni de' Medici of 1417 lists a large Damascene table ("una tafferia grande di Damasco, di legno"), a rare and early documented example of imported Islamic inlaid furniture; Spallanzani 1989, pp. 84, 87.

55. See Atil 1987, pp. 166–169.

Chapter 8. Inlaid Brass

1. See the Introduction, note 2.

2. Spallanzani 1989, p. 83.

3. A basin in the Louvre (inv. no. MAO 101) bears inscriptions honoring Hugh IV of Lusignan in both French and bold *thuluth* Arabic, shields with the arms of Jerusalem and a Maltese cross, and customary early-fourteenth-century Mamluk decoration; the French inscription and the insignia filling the outlined shields were probably added by another craftsman. A bowl sold in London (Christie's 1966, lot 134) that is decorated with bands of Arabic poetry and birds also bears the arms of Hugh IV. D. Storm Rice, "Arabic Inscriptions on a Brass Basin Made for Hugh IV of Lusignan," in *Studi orientalistici in onore di Giorgio Levi Della Vida* (Rome, 1956), 2:390–402; Ward 1989, p. 207, figs. 234–235, and pp. 594–595, cat. no. 4/85; Ward 1993, p. 116. A basin in the Rijksmuseum, Amsterdam (inv. no. NM 7474), bears a Latin inscription and the arms of Elisabeth of Hapsburg-Corinthia; Ward 1989, p. 205, fig. 230, and p. 597, cat. no. 4/90; Ward 1993, p. 116.

4. Allan 1985, p. 271, cat. no. 280, where the dish is attributed to Syria and dated ca. 1250; Allan 1986, p. 43, cat. no. 12, where it is dated in the early fourteenth century. For the changing and overlapping styles of the period, see Atil 1981, pp. 50–51.

5. The Treviso bucket's inscriptions also name the artist, "Master Muhammad," a rare occurrence at this time, and "al-Hajj Muhammad" (Muhammad who has made the pilgrimage to Mecca); see *Eredità dell'Islam,* pp. 313–315, cat. no. 180.

6. Inv. no. 1881.8-2.22; Ward 1989, p. 204 and cat. no. 4/94, p. 599; Ward 1993, p. 116, where the inscription is translated into English. This coat of arms has been associated with the

Benzoni of Venice or the Buonaccorsi of Florence; Allan 1986, p. 59. Similar arms that appear in color on a set of late-sixteenth-century Iznikware dishes were long identified as those of the Mocenigo of Venice, but have recently been described as Italo-Dalmatian, perhaps of the Spingarolli de Dessa of Dalmatia; see Chapter 5, note 76.

7. Marco Spallanzani, "Metalli islamici nelle collezioni medicee dei secoli XV–XVI," in Candace Adelson et al., *Le arti del principato mediceo* (Florence, 1980), pp. 97–98, 111; Spallanzani 1989, pp. 83, 85, 88.

8. Ward 1989, pp. 204–205, and pp. 597–598, cat. no. 4/91; Ward 1993, pp. 28, 116; Allan 1986, pp. 58–59.

9. The height of the candlestick in Figure 149, 12.5 cm., is typical of later export candlesticks with European arms. For other examples, presumably made in Damascus for export to Europe, see *Eredità dell'Islam,* pp. 488–489, cat. no. 306 (Museo Civico Correr, Venice, inv. nos. cl.XII, 22–25, which are 12, 12.5, and 13 cm. high; two of the four bear the arms of the Contarini of Venice); Allan 1986, pp. 53–54 (Victoria and Albert Museum, inv. no. 2095A-55, which is 14.8 cm. high and bears the arms of the Badoer of Venice, and inv. no. 2438-56, which bears two unidentified Italian coats of arms). The most popular sizes for Mamluk patrons seem to have been about 37 to 43 cm. and 20 to 23 cm. high; see Atil 1981, pp. 52, 64–67; Allan 1986, pp. 50–51; Ward 1993, pp. 26, 109. Large candlesticks were also exported: one in the Museum für Islamische Kunst, Berlin (inv. no. 1.3594), that is 31 cm. high bears the arms of the Surian family of Venice; see Allan 1986, p. 52; Ward 1989, p. 208, fig. 237, and p. 598, cat. no. 4/92.

10. A good example of export brassware with perfunctory inscriptions is a late-fourteenth- or early-fifteenth-century inlaid bowl in the Keir Collection that has an inscribed band, interrupted by three European coats of arms, repeating incomplete words that can be read as "the Just Possessor"; see Géza Fehérvári, "Metalwork," in *Islamic Art in the Keir Collection,* ed. Basil William Robinson (London and Boston, 1988), pp. 125–126 and illustration on p. 123.

11. See Atil, Chase, and Jett, pp. 26, 28; Allan 1986, p. 57; Ward 1989, p. 209; Rogers 1990–1992, pp. 62–67; Ward 1993, pp. 22–25, 108, 113, 115.

12. Venice shipped large amounts of copper to Egypt and Syria beginning in the 1350s; Ashtor 1983, pp. 156–159. According the pilgrim Leonardo Frescobaldi, the cargo of the Venetian ship on which he traveled to Alexandria in 1384 consisted principally of "Lombard cloth, silver bullion, copper, oil, and saffron"; *Visit to the Holy Places,* p. 35. Copper wire was shipped in 1434; Allan 1986, p. 58. A treaty of 1507 between Venice and Egypt specifically mentions *li rami* among outbound merchandise, a plural that suggests these were formed vessels rather than raw copper (or brass);

Assadulla Souren Melikian-Chirvani, "Venise, entre l'orient et l'occident," *Bulletin d'études orientales* (Institut Français de Damas) 27 (1974): 125. Both Venetian and Egyptian sources of the period probably use words for copper to refer to luxury metalwork that was (inlaid) brass, composed of copper with zinc or tin; for Egyptian sources, see Allan 1986, pp. 50, 57.

13. Atil 1981, pp. 53, 100–103, 108–109; Tonghini 1993, pp. 283–284; Ward 1993, pp. 116–119. Allan (1986, p. 59) emphasizes that Mamluk patronage of inlaid brassware did not entirely disappear during the second quarter of the fifteenth century, between the decline described by al-Maqrizi and the reign of Sultan Qaitbay.

14. Atil, Chase, and Jett, p. 178.

15. The theory is summarized and refuted in Hans Huth, "'Sarazenen' in Venedig?" in *Festscrift für Heinz Ladendorf,* ed. Peter Block and Gisela Zick (Cologne, 1970), pp. 58–61. Huth's argument has been widely supported; see Allan 1989, pp. 167–168. For examples of previous scholarship articulating the theory, see Scerrato 1966, pp. 147–151; Hans-Ulrich Haedeke, *Metalwork,* trans. Vivienne Menkes (London, 1970), p. 58; Basil William Robinson, "Oriental Metalwork in the Gambier-Parry Collection," *Burlington Magazine* 109, no. 768 (March 1967): 170–173.

16. The inlaid coffer appeared on the Venetian market in the early nineteenth century and is known from an engraving (Huth 1970, pl. 26, fig. 1). For the term *azzimina* in the inventory of 1589 of the Tribuna of the Uffizi Palace in Florence, see note 31 below. Spallanzani (1980, "Metalli islamici," p. 106) observes that in the Medici inventories the terms *domaschino* and *alla domaschina* prevail in the fifteenth and first half of the sixteenth centuries, the term *all'azzimina* replaces them in the late sixteenth into the seventeenth, and thereafter the term *turchesco* is preferred.

17. The box is now in the Courtauld Institute, London; see Robinson, pp. 170–173, fig. 91. Mahmud al-Kurdi's name appears on the rim of the bowl. His Arabic signature is in an unusual form: "'amal i mu'allim Mahmud" (work of the master Mahmud). The Roman version transliterates the Arabic into Roman script without punctuation or division between words: AMELIMALENMAMUD.

18. Huth 1970, pp. 58–61.

19. Ward 1989, pp. 208–209; Ward 1993, p. 115; Allan 1986, pp. 55–58; James W. Allan, "Venetian-Saracenic Metalwork: The Problems of Provenance," in *Venezia e l'Oriente Vicino,* ed. Ernst J. Grube, Atti del primo congresso internazionale sull'arte veneziana e l'arte islamica (Venice, 1989), pp. 167–183.

20. Spallanzani 1980, "Metalli islamici," pp. 102–103, 105–106, who accepts the theory that this type of brassware was made in Italy by Muslim immigrants.

21. Allan 1986, pp. 55–56; Allan 1989, pp. 168–170.

22. Most scholars who argue for an eastern Mediterranean origin do not name a production center; for example, see Atil, Chase, and Jett, pp. 178–179; and Melikian-Chirvani, pp. 111, 124. Some argue for a western Persian origin: for example, see Ward 1993, pp. 102–103; and Huth 1970, pp. 66–67. Sylvia Auld ("Master Mahmud: Objects Fit for Prince," in *Venezia e l'Oriente Vicino,* ed. Ernst J. Grube, Atti del primo congresso internazionale sull'arte veneziana e l'arte islamica [Venice, 1989], pp. 186–187) speculates that the prominent signatures on pieces in the new style, which are inconsistent with Islamic tradition, could mean that these craftsmen were not working in a Muslim environment.

23. Allan 1986, pp. 58, 100; Ward in note 19 above. One such ewer is in the Victoria and Albert Museum, London (inv. no M.31-1946; *Europa und der Orient,* p. 606, cat. no. 4/105, where it is attributed to Venice, ca. 1560); another is in the Museo Nazionale di Capodimonte, Naples. The Victoria and Albert Museum has several ewers in the same shape with engraved Renaissance-style ornament that was certainly executed in Italy (inv. nos. 8429-1863, 8430-1863, 573-1899, M44-1946). Allan (p. 58) also cites two buckets with European-style canted bottoms and rims—one with Western-shaped handles signed by Muhammad Badr in the Museo Poldi-Pezzoli, Milan (inv. no. 1659), and the other, unsigned, with an Islamic handle in the Courtauld Institute, London—and several turned candlesticks in the Victoria and Albert Museum, London (inv. nos. M.69-1934 and 307-1897). The Victoria and Albert Museum has a canted bucket with Renaissance decoration and an Islamic-style handle (inv. no. 3650-1856). Allan (p. 100) proposes that perhaps the flat-lidded boxes also were made in Venice for decoration in the eastern Mediterranean.

24. For example, both Melikian-Chirvani (pp. 109–124) and Allan (1986, pp. 57–58) date both groups in the late fifteenth and early sixteenth centuries, while Ward (1989, pp. 208–209; 1993, p. 115) dates the Damascus group from the first half of the fifteenth century.

25. Melikian-Chirvani, pp. 111–114; *Europa und der Orient,* pp. 602–603, cat. 4/99, where it is attributed to Venice, end of the fifteenth century. The shield of the Priuli family on the inside bottom of the bowl appears in a roundel in the center of a floral arabesque that misunderstands Islamic forms; see Melikian-Chirvani, fig. 3.

26. Inv. no. cl.XII,8; *Eredità dell'Islam,* p. 486, cat. no. 303. It is signed "Decorated by the humble servant of God" and "Zayn al-Din 'Umar." For examples of boxes decorated in the Syrian style with European arms, see the bowl with the arms of the Dolfin family of Venice in the Aron Collection (Allan 1986, pp. 98–99, cat. no. 15) and a box in the British Museum (inv. no. 1878.12-30.698; Ward 1993, fig. 92).

27. Ludovico de Varthema, *The Travels of Ludovico di Varthema in Egypt, Syria, Arabia Deserta, and Arabia Felix, in Persia, India, and Ethiopia,* trans. John Winter Jones and ed. George Percy Badger, Hakluyt Society Publications, 1st ser. (London, 1863), 32:15. Varthema commented that these merchants were ill-treated by Mamluk officials.

28. Atil, Chase, and Jett, pp. 171–173, with an illustration of the Chinese prototype in fig. 61; Allan 1986, p. 102; *Europa und der Orient,* p. 605, cat. no. 4/103, which refers to a description by the Sicilian Arab poet Ibn Hamdis (1056–1133); Ward 1993, p. 115; *Eredità dell'Islam,* p. 229, cat. no. 170, and p. 488, cat. no. 305. It has been hypothesized that in the Islamic world these objects held scented candles and were rolled, not swung; see Rachel Ward, "Incense and Incense Burners in Mamluk Egypt and Syria," in *Transactions of the Oriental Ceramic Society, 1990–1991* (London, 1992), pp. 72–80.

29. See the sources cited in note 28 above, especially Ward 1992, pp. 78–79.

30. The inventory of Piero de' Medici of 1463 lists one *palla da profummi, domaschina;* Lorenzo's inventory of 1492 lists three *palle dommaschine straforate da profumare;* Spallanzani 1980, "Metalli islamici," pp. 111–112. For the two in the grand-ducal collection, see note 31 below. The inventory of the Pico family of Modena of 1474 lists a similar Italian object: "a ball of silver gilt in the Venetian manner with musk paste inside"; Thornton, p. 251.

31. Inv. nos. 292, 299; Spallanzani 1980, "Metalli islamici," pp. 102–103, 114–115 and figs. 27–28 (photographed open to show the gimbals). The two *profumieri di metallo* listed in Cosimo I's inventory of 1553 are probably the ones in the Bargello that are described in the inventory of Francesco I's Tribuna of 1589: "una palla d'acciaio lavorata all'azzimina, straforata, entrovi un vasetto sur bilico, serve per profumiera, catena d'argento," and another, similar, with a brass chain.

32. On the basis of the marginally lower average value of the pieces *alla domaschina,* 8.4 florins compared with 10.3 florins for the *domaschini,* Spallanzani (1980, "Metalli islamici," pp. 96–97, 107) proposes that the former were Florentine imitations, of which no examples survive.

33. Spallanzani 1980, "Metalli islamici," pp. 100–101, 107–108; he proposes that valuations in Lorenzo's estate inventory may have been inflated for reasons of status and prestige, and the lower average cost of metalwork in the sale of 1495–1496 was closer to market prices.

34. For the relationship and increasing differences between medieval princely treasuries and the fifteenth-century Medici collections, see Hooper-Greenhill, pp. 47–54.

35. A late-fifteenth-century Persian vase from the Tribuna also survives in the Museo Nazionale del Bargello (inv. no. 289; Spallanzani 1980, "Metalli islamici," pp. 103–104); it is

decorated in a style closely related to that of Figure 151. For the lost fifth object, a standing incense burner, and changes in the supply and demand for Islamic metalwork in Italy, see Spallanzani 1980, "Metalli islamici," pp. 103, 108–110.

36. Auld 1989, pp. 188–189. See also a box with pseudo-Arabic on the lid in the Metropolitan Museum, New York (inv. no. 66.197.2); St. Clair, p. 13 and cat. no. 29, with an illustration.

37. Allan 1986, p. 106, cat. no. 20; he notes a late-fifteenth-century Syrian candlestick with a baluster stem (Museo Civico Medievale, Bologna; see Scerrato 1966, p. 143, fig. 62, left) that was probably made for export. The Aron Collection candlesticks are 25.3 cm. high.

38. *Europa und der Orient,* p. 603, cat. no. 4/100. The back of the plate is engraved with a German coat of arms.

39. For European printed sources of arabesque ornament, used increasingly during the second quarter of the sixteenth century, see Chapter 5, note 48, and Chapter 7, note 40.

40. Robinson, p. 170.

41. For examples, see Haedeke, figs. 69, 75, 76.

42. Allan 1986, p. 60; Haedeke, p. 83; Atil, Chase, and Jett, p. 178, fig. 63 (a tray in the Österreichisches Museum für Angewandte Kunst, Vienna [inv. no. GO.81], signed and dated by Nicolo Rugina in 1550).

Chapter 9. The Pictorial Arts

1. Leonardo Olschki, "Asiatic Exoticism in Italian Art of the Early Renaissance," *Art Bulletin* 26 (1944): 99, 104–106.

2. Charles Verlinden, *L'esclavage dans l'Europe médiévale* (Ghent, 1977), 2:360–366, 395–401, 427–428, 449–456, 459–460, 474–475, 489.

3. See Rona Goffen, *Spirituality and Conflict: Saint Francis and Giotto's Bardi Chapel* (University Park, Pa., and London, 1988), pp. 39–40, 51–76; White, pp. 334–335; Bandera Bistoletti, pp. 139–140.

4. For example, see paintings in the Upper Church of San Francesco, Assisi, illustrated in Bandera Bistoletti, pp. 17, 21 (frescoes by the Isaac Master), and 38 (*Saint Francis Proposing the Trial by Fire to the Sultan*). For an earlier example of this subject, see Goffen, fig. 31. Other Byzantine-style representations of Arab or Muslim types are discussed in Soulier, pp. 161–162.

5. Missions to China are symbolically commemorated in Andrea da Firenze's representation of the universal Church in the *Apotheosis of Saint Thomas Aquinas,* 1366–1368, in the chapter house attached to the Dominican church of Santa Maria Novella, Florence. The three Polos, who were instrumental in opening relations between the great khan and the Holy See, appear in Chinese guise, emphasizing the role played by merchants, perhaps including the patron Buonamico di Lupo Guidalotti. See the discussions of the

painting, all with illustrations, in Maria Grazia Chiappori, "Riflessi figurativi dei contatti Oriente-Occidente e dell'opera poliana nell'arte medievale italiana," in *Marco Polo, Venezia e l'Oriente,* ed. Alvise Zorzi (Milan, 1981), pp. 285–288; Olschki, p. 100; White, pp. 563–566. For cooperation between Italian merchants and missionaries in China, see Petech, pp. 553–558.

6. Olschki, pp. 99–100; 104–106; Chiara Frugoni, *Pietro and Ambrogio Lorenzetti,* trans. Lisa Pelletti (Florence, 1988), pp. 59–61; White, p. 379; Tanaka 1984, pp. 9–10. For the fragment showing a violent rainstorm in Bombay, also see Maginnis, pp. 144–145. A complete representation of Pope Boniface VIII, a Franciscan, receiving Saint Louis, king of France, also survives from the series (see Frugoni, fig. 72).

7. Verlinden, 2:360, 456–461, 566–571; Iris Origo, "The Domestic Enemy: The Eastern Slaves in Tuscany in the Fourteenth and Fifteenth Centuries," *Speculum* 30, no. 3 (July 1955): 326–328.

8. See Chapter 1, notes 16–17. Possibly the earliest surviving representation of a Mongol figure in Italian painting, one that has not been noted in literature on the subject, is the mounted warrior in the left background of the *Crucifixion of Saint Peter,* a panel of a polyptych in the Capitolo dei Canonici of Saint Peter's, Rome, executed by Giotto's workshop. The profile head with narrow mustache, short pointed beard, pigtail, and broad face with an upturned nose is convincing; the warrior wears a tall rounded hat with an upturned brim. The altarpiece is usually dated about 1330, but a date about the time of the Jubilee of 1300 has also been proposed; Julian Gardner, "The Stephaneschi Altarpiece: A Reconsideration," *Journal of the Warburg and Courtauld Institutes* 37 (1974): 57–67, 94–98, and pl. 19c.

9. Chiappori, pp. 283–285.

10. For examples in Lorenzetti's art, see Frugoni, figs. 73, 85, 89. For Simone Martini's attention to foreign fashions, see Stella Mary Newton, "Tomaso da Modena, Simone Martini, Hungarians, and St. Martin," *Journal of the Warburg and Courtauld Institutes* 48 (1980): 237–238.

11. Moule and Pelliot, 1:171.

12. Chiappori, pp. 281–282; Julian Raby, *Venice, Dürer, and the Oriental Mode,* Hans Huth Memorial Studies, no. 1 (London, 1982), pp. 17–18; Julian Raby, "Picturing the Levant," in *Circa 1492: Art in the Age of Exploration,* ed. Jay A. Levenson, exh. cat., National Gallery of Art, Washington (New Haven, Conn., and London, 1991), p. 78.

13. Département des Arts Graphiques, Musée du Louvre, Paris, inv. no. 2325; *Pisanello: Le peintre aux sept vertus,* exh. cat., Musée du Louvre, Paris (Paris, 1996), pp. 332–333, cat. no. 219; Maria Fossi Todorow, *I disegni del Pisanello e della sua cerchia* (Florence, 1966), pp. 21–24, 64–65, cat. no. 15;

Chiappori, p. 288 and fig. 293 (the painted version of the figure).

14. Michael Vickers, "Some Preparatory Drawings for Pisanello's Medallion of John VIII Paleologus," *Art Bulletin* 60 (1978): 417–424; Roberto Weiss, *Pisanello's Medallion of the Emperor John VIII Paleologus* (Oxford, 1966), pp. 14–20; Raby 1982, p. 18; Raby 1991, pp. 78–79; Chiappori, p. 288; James A. Fasanelli, "Some Notes on Pisanello and the Council of Florence," *Master Drawings* 3, no. 1 (1965): 36–47; Soulier, p. 127; Olschki, p. 102.

15. In addition to the sources cited in note 14 above, see *Pisanello: Le peintre aux sept vertus,* pp. 195–206, cat. no. 112; Fossi Todorow, pp. 80–81, cat. no. 57r.

16. *Pisanello: Le peintre aux sept vertus,* pp. 195–196; Vickers, pp. 419–420. Though the name in the inscription presumably refers to one of Barsbay's predecessors, the term "Abu Nasr" (father of Nasr) was also sometimes used for Barsbay. A letter from Sultan Barsbay to the emperor, addressing him as "a friend of the pope" and mentioning a gift, suggests this textile was sent shortly before the conference.

17. Vickers, p. 419; *Pisanello: Le peintre aux sept vertus,* pp. 196–197, where it is suggested that Pisanello executed a painted portrait that served as a model for a later manuscript illumination.

18. Inv. no. 1961.331; Vickers, p. 421, figs. 7–8; Fossi Todorow, p. 81, cat. no. 58r, tav. 69, 71; *Pisanello: Le peintre aux sept vertus,* p. 206, cat. no. 113.

19. *Pisanello: Le peintre aux sept vertus,* p. 197.

20. For Pisanello's heads with forked beards and long curly hair on Louvre ms. MI. fol. 1062v, see Vickers, p. 423 and fig. 6. Vickers argues that these heads are studies, not of the patriarch Joseph II, as Fasanelli (p. 30) and others propose, but of the emperor wearing a different hat. The patriarch fell gravely ill in Ferrara, died in Florence, and was buried in Santa Maria Novella before the end of the council. A painted tomb effigy that shows him completely bald (Lightbown 1981, fig. 305) supports Vickers and disproves another proposal that Benozzo Gozzoli portrayed him among the Magi in the *Procession of the Magi* in the chapel of the Medici-Riccardi Palace, Florence, 1459; see Cristina Acidini Luchinat, ed., *The Chapel of the Magi: Benozzo Gozzoli's Frescoes in the Palazzo Medici-Riccardi, Florence,* trans. Eleanor Daunt (London and New York, 1994), p. 43, with an illustration.

21. Bisticci, 1:19; Weiss 1966, *Pisanello's Medallion,* p. 15.

22. Weiss 1966, *Pisanello's Medallion,* p. 21, pl. 11; Vickers, p. 424, fig. 12.

23. See Jardine, pp. 57–63; Kenneth M. Setton, *Europe and the Levant in the Middle Ages and the Renaissance* (London, 1974), pp. 69–71.

24. Weiss 1966, *Pisanello's Medallion,* p. 24, pl. 15.

25. See Chapter 3, note 24.

26. For the *Battle of the Milvian Bridge,* see Weiss 1966, *Pisanello's Medallion,* pp. 22–23, 32 and pl. 12; Vickers, p. 423, fig. 13.

27. For the visage and costume of the foreground figure in Piero's *Flagellation,* see *Pisanello: Le peintre aux sept vertus,* p. 197. The uncertain dating of Piero's paintings with costumes from the council—the *Baptism of Christ,* ca. 1452–1453, National Gallery, London; *Flagellation of Christ* (Fig. 163); and *Dream of Constantine, Battle of Maxentius, Discovery and Trial of the Cross, Battle of Chosroes,* and *Exaltation of the Cross* in Arezzo—complicates the identification of their visual sources and their interpretation. There is no agreement about the role the contemporary Ottoman threat and fall of Constantinople in 1453 play in Piero's iconography, especially in the *Flagellation.* See Ronald W. Lightbown, *Piero della Francesca* (New York, London, and Paris, 1992), pp. 17, 46–59, 116–117, 151–154, 162–164, 170–173, with illustrations; Marilyn Aronberg Lavin, *Piero della Francesca: The Flagellation* (New York, 1972), pp. 59–62; Marilyn Aronberg Lavin, *Piero della Francesca: San Francesco, Arezzo* (New York, 1994), pp. 7–8, 14–29, 77.

28. Ernst Hans Gombrich, "Apollonio di Giovanni: A Florentine *Cassone* Workshop Seen through the Eyes of a Humanist Poet," *Journal of the Warburg and Courtauld Institutes* 18 (1955): 16–29, pls. 7a–b; Ellen Callmann, *Apollonio di Giovanni* (Oxford, 1974), pp. 20, 48–51, 56–57, 63–64 and cat. nos. 8 (*Xerxes' Invasion of Greece,* fig. 52), 9 (its lost companion panel, *The Triumph of the Greeks over the Persians,* fig. 53), and 23 (*The Conquest of Trebizond,* fig. 125).

29. *Europa und der Orient,* pp. 641–642, cat. no. 5/16; Weiss 1966, *Pisanello's Medallion,* pp. 24, 27 and fig. 2 (an anonymous woodcut of Mehmed the Conqueror); Raby 1991, p. 79; Raby 1982, p. 18.

30. Raby 1982, pp. 20–22. For an early example of the *taj,* see Andrea Mantegna's *Adoration of the Magi* of the mid-1460s, now in the Uffizi, Florence, which is filled with exotic Oriental details; Lightbown 1986, pp. 86–91, pl. 50.

31. Julian Raby, "Pride and Prejudice: Mehmed the Conqueror and the Italian Portrait Medal," in *Studies in the History of Art: Italian Medals* (Washington, 1987), 21:172–185; Raby 1991, p. 79; Jaynie Anderson, "Collezioni e collezionisti della pittura veneta del Quattrocento: Storia, sfortuna e fortuna," in *La pittura nel Veneto: Il Quattrocento,* ed. Mauro Lucco (Milan, 1989), 1:273; Babinger, pp. 201, 377–388, 494, 504–506.

32. George Francis Hill, *A Corpus of Italian Medals of the Renaissance before Cellini* (Oxford, 1930), 1:37; Raby 1987, pp. 175–176; Maria Andoloro, "Costanzo da Ferrara: Gli anni a Costantinopoli alla corte di Maometto II," in *Studi in onore di Cesare Brandi,* nos. 38–40 of *Storia dell'arte* (1980): 190.

33. Andoloro, pp. 187–202; Raby 1987, pp. 176–178; Julian Raby, "Costanzo da Ferrara," in *The Currency of Fame: Portrait Medals of the Renaissance,* ed. Stephen K. Scher, exh. cat., Frick Collection, New York, and National Gallery of Art, Washington (New York, 1994), pp. 87–89.

34. P. F. Brown 1988, pp. 52–55; Babinger, pp. 368–378; Massimo Villa, "Gentile e la politica del 'sembiante' a Stambul," in *Venezia e i turchi: Scontri e confronti di due civiltà* (Milan, 1985), pp. 160–161.

35. For illustrations, see Andoloro, figs. 1–4. Most scholars consider the undated piece the original, and the version of 1481 a reissue occasioned by the sultan's death; for example, Raby 1987, p. 176; Andoloro, pp. 186–187; G. F. Hill, 1:80, nos. 321–322.

36. Andoloro, pp. 196–198; *Circa 1492,* p. 212, cat. no. 108 (by Raby); Raby 1994, p. 88. The miniature remained in Istanbul until the nineteenth century. A close copy showing *A Seated Painter* is in the Freer Gallery of Art, Washington (inv. no. 32.38); see Jürg Meyer zur Cappellen, *Gentile Bellini* (Stuttgart, 1985), pp. 125–126, cat. nos. A4 (the Gardner Museum miniature, attributed to Gentile), A4a–b (copies) and figs. 8–9.

37. Andoloro, pp. 202–203 and figs. 14–20; *Circa 1492,* p. 212, cat. no. 108 (by Raby); Meyer zur Cappellen, pp. 98–102 and figs. 5–8, 12–14. Two sheets in the British Museum (inv. no. 1950, 1:5, 6, nos. 7–8) are considered originals; they show seated figures of a janissary guard and a woman holding a mirror. The copies in the Département des Arts Graphiques, Musée du Louvre (inv. nos. 4653–4655) and Städelsches Kunstinstitut, Frankfurt am Main (inv. nos. 3956–3957) show four men and one woman, all standing.

38. The other work, in a fresco series representing the life of Enea Silvio de Piccolomini (Pope Pius II [1458–64], also a distinguished poet known in literary circles as Aeneus Sylvius), in the Piccolomini Library, Siena, begun with the help of Pintoricchio's shop in 1504, is *The Arrival of Aeneus Sylvius Piccolomini in Ancona;* see Enzo Carli, *Il Pintoricchio* (Milan, 1960), pp. 69–78. In scenes of Piccolomini's distinguished diplomatic missions for the Church, Pintoricchio's many stereotypical Oriental figures convey the international atmosphere and significance of the events. The *Arrival* portrays Piccolomini as pope, with his allies and supporters of the Crusade that he organized and intended to lead from Ancona against the Ottomans in 1464. To represent one of these supporters, perhaps Calapino Bajazet, a fugitive pretender to the Ottoman throne then residing at the Vatican (Carli, p. 78), Pintoricchio used one of Costanzo's authentic Turkish figures (Louvre inv. no. 4655; see Andoloro, p. 202 and fig. 16; *Circa 1492,* p. 212, cat. no. 108 [by Raby]; Meyer zur Cappellen, fig. 125). More imposing and elegant in costume and pose than the man in Figure 166, therefore

suitable as a model for an Ottoman dignitary, this figure was also Pintoricchio's source for the Turk to the right of Saint Catherine in Figure 167.

39. Raby 1991, pp. 77–78; Andoloro, p. 202; Carli, pp. 43–45; Soulier, pp. 170–171.

40. For the other figure copied from Costanzo, see note 38 above.

41. Raby 1991, p. 78.

42. British Museum, inv. no. 1:5, 6, no. 7; see Andoloro, p. 202, fig. 14; Meyer zur Cappellen, fig. 118; Carli, p. 45.

43. P. F. Brown 1988, p. 55 and p. 278, cat. no. 13-10. The signature on his *Departure of Venetian Ambassadors to the Court of the Emperor* reads as follows: "Gentile Bellini has given this monument to his country, having been called to the Ottoman and made a knight as a reward" (Gentilis patriae dedit havc monumenta belinus, othomano accitus, munere factus eques). The paintings in the Great Council Hall were destroyed by fire in 1577.

44. Raby 1982, pp. 20–22; Raby 1991, pp. 79–80.

45. Villa, figs. 125–126; *Europa und der Orient,* p. 630, cat. no. 5/4 and fig. 725; G. F. Hill, 1:113–114, no. 432; Meyer zur Cappellen, p. 130, cat. no. A1oc and fig. 21. The three crowns on the reverse refer to Constantinople, Iconium, and Trebizond. Gentile's signature refers to the title *Eques Auratus,* conferred by Sultan Mehmed, and *Comes Palatinus,* conferred by Emperor Frederick III in 1469; see Babinger, pp. 370, 379–381; P. F. Brown 1988, pp. 51–52. Mehmed II also supposedly honored Ambassador Dario and Costanzo da Ferrara.

46. A flattering Renaissance-style allegory on the reverse refers to another anticipated conquest by the sultan, which has been variously interpreted. G. F. Hill, 1:237–238, cat. no. 911; James David Draper, "Bertoldo di Giovanni," in *The Currency of Fame: Portrait Medals of the Renaissance,* ed. Stephen K. Scher, exh. cat., Frick Collection, New York, and National Galley of Art, Washington (New York, 1994), pp. 127–128, cat. no. 39; *Europa und der Orient,* pp. 630–631, cat. no. 5/6 and fig. 727; Babinger, pp. 381–388.

47. Meyer zur Cappellen, pp. 68, 128–129, cat. no. A1o; Babinger, pp. 376–377, 379.

48. Angiolello was captured on a voyage that began in 1468, lived at the sultan's court from 1474 to 1481, and returned to Vicenza between 1483 and 1490; his *Historia turchesca* was published posthumously in 1559. See Lucchetta 1980, "L'Oriente Mediterraneo," pp. 382–383; P. F. Brown 1988, p. 55; Villa, pp. 160–162, 167; Babinger, pp. 378–379.

49. The seventeenth-century Venetian art historian Carlo Ridolfi (*Le maraviglie dell'arte: Ovvero le vite degli illustri pittori veneti e dello stato, descritto da Carlo Ridolfi,* ed. Detlev Freiherrn von Hadeln [Berlin, 1914; reprint Rome, 1965],

1:57–58) listed a portrait of Mehmed's wife and an image of a beheaded John the Baptist that inspired the sultan to order a slave decapitated to prove an anatomical error in Gentile's painting, an incident that allegedly prompted the artist to return to Venice; see Villa, pp. 167–168.

50. Raby 1991, p. 79 and p. 213, cat. no. 110; Raby 1982, pp. 21–25. Raby suggested that Dürer might have seen drawings by Gentile in addition to the painting, which was in progress during his visit and does not include details that appear in Dürer's watercolor rendition of these three figures in the British Museum, London.

51. From the Bible and travelers' accounts, Ambrogio Lorenzetti and other fourteenth-century painters imaginatively constructed some plausible topography and settings of the Holy Land; Maginnis, pp. 113–114, 138. Interest in more precise visual information on the geography and monuments of the Greek and Byzantine worlds increased during the fifteenth century; P. F. Brown 1996, pp. 76–92. Representations of Constantinople in the *cassone* panels of Apollonio di Giovanni's workshop of the 1460s draw upon visual information both predating and postdating the Ottoman conquest; Callmann, pp. 48–51, 56–57 and figs. 52, 53, 125; Gombrich, p. 29 n. 2 and pls. 7a–b. Andrea Mantegna seems to have consulted Josephus's *Jewish War* for the layout of Jerusalem, and perhaps a view of the city for the distant approximation of the Dome of the Rock, which Europeans confused with Solomon's temple, in the background of his *Agony in the Garden* in the Musée des Beaux-Arts, Tours, a predella panel from the San Zeno Altarpiece, 1456–1459; Lightbown 1986, pp. 73–74 and pl. 38.

52. The term "Mamluk mode" was coined by Julian Raby; Raby 1982, pp. 35–83; Julian Raby, "The European Vision of the Muslim Orient in the Sixteenth Century," in *Venezia e l'Oriente Vicino,* ed. Ernst J. Grube, Atti del primo congresso internazionale sull'arte veneziana e l'arte islamica (Venice, 1989), pp. 41–42; Raby 1991, p. 80.

53. The Venetian "eyewitness style," which includes the group of paintings using Mamluk iconography, was defined by Patricia Fortini Brown; P. F. Brown 1988, pp. 2–30, 57–97, 189–217.

54. Raby 1991, pp. 80–81 and pp. 210–211, cat. no. 106; Raby 1982, pp. 55–63; P. F. Brown 1988, pp. 197–199; Paolo Cuneo, "Sulla raffigurazione della città di Damasco in una tela di scuola belliniana conservata al Louvre," in *Venezia e l'Oriente Vicino,* ed. Calogero Muscarà, Simposio internazionale sull'arte veneziana e l'arte islamica (Venice, 1991), pp. 44–46.

55. The embassy of Domenico Trevisan to Sultan Qansuh al-Ghuri in Cairo in 1512 is described by the ambassador's secretary, Zaccaria Pagani of Belluno; Lucchetta 1980, "L'Oriente Mediterraneo," pp. 418–419.

56. This emir lived in central Damascus; Cuneo, p. 45. Another emir, the *naib* of the city, lived and gave audiences at the Dar al-sa'ada south of the city; *The Encyclopaedia of Islam,* new ed., s.v. "Damascus," 2:285. The painting shows the senior Mamluk official with the elaborate horned *al-na'ura* (waterwheel) turban, worn by the sultan in Cairo and a few emirs, and attended by scribes and sitting on a stool, like the sultan at the reception in Cairo in 1512. But this Damascus emir, unlike the sultan, shares the stool with his scribes.

57. Two paintings and a tapestry are known; Meyer zur Capellen, p. 144, cat. nos. B8a–c, figs. 87–89.

58. P. F. Brown 1988, pp. 68–69, 199–203. The date of Cima da Conegliano's *Saint Mark Healing Ananias* for the same series in Santa Maria dei Crocifieri, now in the Gemäldegalerie, Berlin (P. F. Brown 1988, pl. 118), is uncertain; it also borrows costumes from the Louvre painting.

59. For Mansueti's *Saint Mark Healing Ananias* and *Episodes from the Life of Saint Mark,* both now in the Ospedale Civile, Venice, and *Saint Mark Baptizing Ananias,* Pinacoteca di Brera, Milan, see P. F. Brown 1988, pp. 76, 199–203 and pls. 76, 77, 122, 123; Raby 1982, pp. 35, 40, 43 and figs. 20–22. For the *Adoration of the Magi,* see *Europa und der Orient,* pp. 631–633, cat. no. 5/7, fig. 275.

60. In addition to its repetition in all the paintings mentioned, this robe and stole occur in Mansueti's drawing *Three Mamluk Dignitaries* in the Royal Library, Windsor (inv. no. 062); *Europa und der Orient,* pp. 631–633, cat. no. 5/8, fig. 729; Raby 1982, p. 40, fig. 43.

61. Raby 1991, p. 80; P. F. Brown 1988, pp. 69–72, 209–216; Raby 1982, pp. 66–76; Pietro Zampetti, "L'oriente del Carpaccio," in *Venezia e l'Oriente fra Tardo Medioevo e Rinascimento,* ed. Agostino Pertusi, Corso internazionale di alta cultura 5, Venice, 1963 (Florence, 1966), pp. 514–526; Krinsky, p. 17.

62. The Florentines Frescobaldi, Gucci, and Sigoli, on their pilgrimage in 1384, visited the Church of Saint George outside Beirut, where the saint allegedly slew the dragon; *Visit to the Holy Places,* pp. 89, 147. In 1483–1484 the Swiss Dominican Felix Fabri visited the supposed site of the saint's martyrdom in Lydda, on the Palestinian coast; Hilda Frances Margaret Prescott, *Friar Felix at Large: A Fifteenth-Century Pilgrimage to the Holy Land* (New Haven, Conn., 1950), p. 193.

63. See P. F. Brown 1988, color pls. 36–37.

64. See P. F. Brown 1988, pl. 131. Carpaccio used costumes from both sources, as well as the Dome of the Rock and the Holy Sepulchre, to establish a Jerusalem locale for *The Disputation of Saint Stephen,* executed in 1506–1511 for the Scuola di San Stefano and now in the Pinacoteca di Brera, Milan (see P. F. Brown 1988, color pls. 15, 41).

65. Phyllis Williams Lehman, *Cyriacus of Ancona's Egyp-*

tian Visit and Its Reflections in Gentile Bellini and Hieronymous Bosch (New York, 1978), pp. 3–11, 14–15; Raby 1982, pp. 35, 41–43, 52, 60; P. F. Brown 1988, pp. 74–75, 203–209; Raby 1991, pp. 77–80. Gentile accepted the Scuola di San Marco's important commission for a new series of paintings in 1492 but did not begin until 1504 and left the *Saint Mark Preaching* unfinished when he died in 1506. Though his brother Giovanni made some improvements when he completed the painting, the imagery is Gentile's.

66. For example, the four dignitaries at the extreme right derive from the *Reception,* the two men in striped robes in the center derive from Reeuwich, the repetitious long white shawls echo Mansueti, and some of the veiled women come from a drawing by Carpaccio, now in the Princeton University Art Museum, Princeton, N.J. (see Lehman, fig. 12), that is based on Reeuwich.

67. For illustrations of Saint Mark's, the Scuola di San Marco, and Hagia Sophia, see Lehman, figs. 18, 19, 23. The fenestrated tympana of Hagia Sophia are so transformed—or vaguely remembered—that they would not mislead Venetians familiar with that monument.

68. See the Introduction, note 39.

69. Lehman, pp. 8–11, 14–15; Roberto Weiss, "Ciriaco d'Ancona in Oriente," in *Venezia e l'Oriente fra tardo Medioevo e Rinascimento,* ed. Agostino Pertusi, Corso internazionale di alta cultura 5, Venice, 1963 (Florence, 1966), pp. 329–332. The antique monuments are also described in Zaccaria Pagani's account of his diplomatic visit in 1512, and the hieroglyphs on Gentile's obelisk have been interpreted with the help of the *Hypnerotomachia Poliphili,* published in 1499; P. F. Brown 1988, pp. 206, 209. For earlier, different Venetian images of the Pharos and Pillar of Pompey designating an Alexandrian setting, see Howard 2000, pp. 71–76, 90–94 and figs. 67, 70, 72, 97, 100.

70. Biblioteca Medicea-Laurenziana, Florence: Laurentianus Ashburnensis 1174, fol. 143v; Lehman, pp. 10–11 and fig. 33. The illumination shows the giraffe in the same position, but tethered to a short, spindly palm tree. As the *Reception of the Ambassadors* (Fig. 169) illustrates, exotic animals were common in Mamluk cities. The three Florentine pilgrims who visited Cairo in 1384 described the sultan's giraffes and elephants—in greater detail than the people of Cairo; *Visit to the Holy Places,* pp. 48–49, 103–104, 169–170.

71. Raby 1982, p. 78.

72. Raby 1982, p. 83; Villa, pp. 177–179; P. F. Brown 1988, pp. 235–241. The demise of the Mamluk mode is visible in paintings executed for the Scuola di San Marco. Objectively rendered Mamluk figures, who populate the three scenes painted by Mansueti between 1505 and 1526, fade into clichés and stereotypes—of Turks as well as Egyptians—in the *Martyrdom of Saint Mark,* which Gentile and Giovanni

Bellini had begun and Vittore Belliniano completed in 1526 (see P. F. Brown 1988, pl. 39). The two scenes that Paris Bordone painted in 1534–1535 are set in Venice and are in the new style of Titian (see P. F. Brown 1988, pls. 142–143).

73. Cecil Gould, "The Oriental Element in Titian," in *Tiziano e Venezia,* Convegno internazionale di studi, Venice, 1976 (Verona, 1980), 1:233–235.

74. See *Titian, Prince of Painters,* pp. 194–197, cat. no. 18.

75. See P. F. Brown 1988, pl. 144.

76. Raby 1989, pp. 42–43; Linda Klinger and Julian Raby, "Barbarossa and Sinan: Portrait of Two Ottoman Corsairs from the Collection of Paolo Giovio," in *Venezia e l'Oriente Vicino,* ed. Ernst J. Grube, Atti del primo congresso internazionale sull'arte veneziana e l'arte islamica (Venice, 1989), pp. 47–50.

77. The paintings are mentioned by Vasari (6, pt. 1: 162 [*Portrait of Suleyman,* in the duke of Urbino's gallery of famous men] and 168 [portraits of Suleyman's wife at sixteen years of age and of her daughter Cameria]) and Ridolfi (1:192, 194, where the third is called a lady-in-waiting).

78. Harold E. Wethey, *The Paintings of Titian,* vol. 2, *The Portraits* (London, 1971), pp. 190–191 and fig. 269 (*Cameria as Saint Catherine,* ca. 1552, collection of Count Antoine Seilern, London), p. 205 and fig. 270 (*Sultana,* ca. 1552, John and Mable Ringling Museum of Art, Sarasota, Fla.).

79. Wethey, 2:204; Wilhelm Suida, "New Light on Titian's Portraits—II," *Burlington Magazine* 68, no. 399 (June 1936): 281–282, pls. I,F (medal with a profile bust of Sultan Suleyman, Kunsthistorisches Museum, Vienna) and I,H (painting after Titian, formerly E. Marinucci collection, Rome); Stefania Mason Rinaldi, "Le virtù della Repubblica e le gesta dei capitani: Dipinti votivi, ritratti, Pietà," in *Venezia e la difesa del levante: Da Lepanto a Candia, 1570–1670,* exh. cat., Arsenale, Venice (Venice, 1986), p. 20, cat. no. 3 (painting after Titian featuring an enormous turban, Kunsthistorisches Museum, Vienna).

80. For this image and other prints derived from it (illustrated in Necipoğlu, figs. 1–4), see Chapter 10, note 22.

81. See Necipoğlu, p. 416, fig. 24; Jardine, pp. 388–389.

82. Raby 1989, p. 43; *Europa und der Orient,* p. 240, fig. 285. Necipoğlu (p. 419) proposes that the tapestry project failed because of conservative opposition to Ibrahim Pasha's costly patronage of Western-style objects.

83. Raby 1989, pp. 43–44; *Europa und der Orient,* p. 242, figs. 292–295. Lorck also drew a cityscape of Istanbul over eleven meters long that had little impact.

84. Raby 1989, p. 44; *Europa und der Orient,* p. 307, figs. 372–373.

85. In the L. A. Mayer Memorial, Jerusalem, there is a manuscript on Turkish paper with watercolor illustrations,

probably by a European artist, that a Frenchman acquired in Istanbul on June 25, 1587; Otto Kurz, "The Turkish Dresses in the Costume Book of Rubens," reprint no. 15 in *Selected Studies: The Decorative Arts of Europe and the Islamic East* (London, 1977), 1:275–287. Most of the figures in this manuscript derive from Nicolay, and many are similar to illustrations in a book by Vecellio published in Venice in 1590.

86. For fifteenth- and sixteenth-century Italian writing on the Islamic world, see Lucchetta 1980, "Viaggiatori e racconti," pp. 433–489; Lucchetta 1980, "L'Oriente Mediterraneo," pp. 378–383, 385–386, 419–426; Tucci 1980, pp. 317–353; Preto, pp. 286–292; Varthema, pp. iv–xxi.

87. Rinaldi, pp. 13–31.

88. For the costume books of Vico, Franco, and Rota, see Anna Omodeo, *Mostra di stampe popolari venete del '500,* exh. cat., Gabinetto di Disegni e Stampe degli Uffizi, Florence, no. 20 (Florence, 1965), pp. 6–9, 37–48, 55, 57.

89. Raby 1982, pp. 40–41 and figs. 24–27; Villa, p. 179 and figs. 39–42, 58, 87–88, 114–121.

90. Gabinetto di Disegni, Gallerie Nazionali degli Uffizi, Florence, inv. nos. 2947F–2954F, 2956F–2967F; another in the series was lost during World War II. Anna Forlani, "Jacopo Ligozzi nel gran serraglio," *FMR* 1 (March 1982): 72–103, with color illustrations; Omodeo, pp. 48–51; *Europa und der Orient,* pp. 632–637, cat. nos. 5/9–5/11.

91. Illustrated in Forlani, p. 85; and in Omodeo, fig. 50.

92. According to the Venetian *bailo,* in Istanbul from 1604 to 1607 the mufti (highest religious authority), kadiasker (Chief Justice of Anatolia), mullahs (doctors of Islamic law), and kadis (judges or magistrates) wore turbans that were larger than normal as marks of their revered status; Ottaviano Bon, *The Sultan's Seraglio: An Intimate Portrait of Life at the Ottoman Court,* trans. and ed. John Withers, annotated by Godfrey Goodwin (London, 1996), p. 132.

Chapter 10. From Bazaar to Piazza and Back

1. The Venetian attribution appears in Wiet, pp. 100–101, cat. no. 333; Gasparetto 1958, fig. 42; Perrot, p. 17; Robert Jesse Charleston, "The Import of Western Glass into Turkey: Sixteenth–Eighteenth Centuries," *Connoisseur* 162, no. 651 (May 1966): 18; Charleston 1964, pp. 158–160; Dreier, p. 34; Pinder-Wilson, p. 135. Carboni (1989, pp. 150–151; 1998, pp. 104 and 106 n. 47) has proposed the plausible reattribution to Barcelona for technical reasons and because of details in the decoration.

2. Charleston 1966, p. 19 and figs. 3 and 4.

3. Lamm, 1:494. For the pilgrimage of Santo Brasca, who later became chancellor to Ludovico Sforza, duke of Milan (r. 1481–99), see also Ravà, p. 68.

4. Charleston 1975, pp. 245–272; Charleston 1964, pp. 161–163; Dreier, pp. 36–37, cat. nos. 5–7.

5. For Islamic marvered glass, most of which seems to be from the thirteenth and fourteenth centuries, see Chapter 6, note 60.

6. See Chapter 6, note 61. The suggested use of these tumblers as memorial lights in a cemetery is discussed in Dreier, pp. 33–34, cat. no. 3.

7. Charleston 1966, p. 18; Eck and Zijlstra-Zweens, 1:13.

8. Charleston 1964, pp. 164–165; Charleston 1966, p. 18; Carboni 1989, p. 151.

9. Charleston 1964, pp. 166–167; Charleston 1966, p. 19 and figs. 2 and 9; Carboni 1989, pp. 151–152 and figs. 8–9.

10. See Charleston 1966, figs. 6 (Marco Basiati's *Agony in the Garden,* signed and dated 1510, in the Gallerie dell'Accademia, Venice) and 8 (a woodcut in B. Georgievitz, *Libellus . . . de diversas res Turcharum . . .* [Rome, 1552]).

11. For example, see a plate with gadroons and the embossed arms of Pope Leo X, datable about 1516–1521, in the Musei Civici d'Arte Antica, Bologna, inv. no. 2798; *Eredità dell'Islam,* pp. 342–343, cat. no. 202. Caiger-Smith (pp. 77–79, 103–104) notes the general reversal in the direction of ceramic trade between Spain and Italy toward the end of the fifteenth century.

12. Hobson 1989, *Humanists and Bookbinders,* pp. 57–58; Needham, pp. 101–105, cat. no. 28.

13. Whitehouse 1978, pp. 43–44, 46; Caiger-Smith, p. 84.

14. Rogers 1990–1992, pp. 60, 68 n. 17; Charleston 1964, pp. 160–161; Tait 1991, p. 159.

15. Raby, in Atasoy and Raby, p. 104.

16. Raby, in Atasoy and Raby, pp. 77–79, 90–94 and figs. 55–58, 273–279.

17. Raby, in Atasoy and Raby, pp. 222–223.

18. Raby, in Atasoy and Raby, pp. 77, 98, 104, 108, 119, 226; Rogers 1991, "Terra di Salonich," pp. 253–254; Atil 1987, pp. 235, 239; A. Lane 1957, p. 51. In addition to the *tondini* mentioned in Chapter 5, the examples usually cited are an early squat ewer bearing the name Ibrahim of Kütahya in Armenian (British Museum, London, inv. no. OA G 1983.1; see Atasoy and Raby, fig. 96) and the *tondino* with the male bust of about 1534–1540 (Victoria and Albert Museum, London, inv. no. 57-1859; see Atasoy and Raby, fig. 179).

19. Friedrich Sarre, "Michelangelo und der türkische Hof," *Repertorium für Kunstwissenschaft* 32 (1909): 62–63; Jardine, pp. 242–243.

20. Sarre, pp. 61–62, 64–66.

21. See Chapter 9, note 76.

22. Necipoğlu, pp. 401–423, with illustrations of some of the engravings that inspired the regalia and others that publicized it; Otto Kurz, "A Gold Helmet Made in Venice for Sultan Sulayman the Magnificent," reprint no. 13 in *Selected Studies: The Decorative Arts of Europe and the Islamic East* (London, 1977), 1:249–258; Jardine, pp. 379–383. Ironically,

an unpaid balance of 100,000 ducats bankrupted the Caorlini consortium in 1536.

23. See Necipoğlu, figs. 2–4, 7–8.

24. Ashtor 1986, "L'Exportation des textiles," 306–307, 369–370; Rogers 1990–1992, p. 61.

25. Mackie 1984, p. 140.

26. Museo del Ejercito, Madrid, inv. no. 24.702; review of the exhibition *Arte y Cultura en Torno a 1492,* Seville, in *Hali* 14, no. 6 (1992): 115.

27. Buss, p. 18. For example, see a late-fifteenth-century silk lampas with an ogival pomegranate design in the Victoria and Albert Museum, London, inv. no. 1228-1877; Albert Frank Kendrick, "Textiles," in *Spanish Art,* ed. Robert Rattray Tatlock (London, 1927), pp. 65–67, pl. 9A; Falke, p. 39.

28. See Chapter 1, note 81.

29. See Chapter 1, notes 89–90. In the 1550s the Hapsburg ambassador, Ogier Ghiselin de Busbecq, observed that Suleyman wore only watered green mohair in public, following the example of the Prophet Muhammad, who habitually wore green in his old age; Rogers 1986, p. 40.

30. Öz, p. 73.

31. Mackie 1980, p. 361. For example, the brocaded crimson velvet of a ceremonial kaftan associated with Sultan Ahmed I (r. 1603–07) in the Topkapi Sarayi Museum, inv. no. 13/837, virtually copies the ogive and pomegranate design of Figure 40; see Rogers 1986, p. 153, cat. no. 31; Patricia A. Baker, Hülya Tezcan, and Jennifer Wearden, *Silks for the Sultans: Ottoman Imperial Garments from Topkapi Palace* (Ertug and Kocabiyik, 1996), pp. 196–198. For other examples, see Baker, Tezcan, and Wearden, pp. 178–195.

32. See, for example, Topkapi inv. no. 13/1008; Christine Klose, "Textiles as Models for Turkish Carpets of the Sixteenth and Seventeenth Centuries," *Oriental Carpet and Textile Studies* 5, no. 1 (1999): 48–51 and fig. 7, with illustrations of other Italian models and the carpets they inspired.

33. Mackie 1980, pp. 343–361; Atil 1987, pp. 177–181, 183–212; Rogers 1986, pp. 15–40; Harris, pp. 86–87.

34. See Chapter 1, note 83.

35. Rogers 1986, pp. 20–21. For Venetian quality controls, see Davanzo Poli, pp. 31–36.

36. Atil 1987, pp. 29–34; Rogers 1986, p. 23.

37. Rogers 1986, p. 48, cat. no. 14; Atil 1987, p. 183.

38. Weibel, p. 124, cat. no. 152.

39. Rogers 1986, p. 29.

40. For the painting in Madrid, see *Titian, Prince of Painters,* pp. 354–355, cat. no. 70. For an Ottoman example, see a kaftan associated with Sultan Selim I in the Topkapi Sarayi Museum (inv. no. 13/41); illustrated in Rogers 1986, p. 48, cat. no. 14.

41. Curatola 1985, pp. 188–189; Giovanni Curatola, "Quali rapporti fra tessuti veneziani e tessuti ottomani?" in *Venezia e l'Oriente Vicino,* ed. Ernst J. Grube, Atti del primo congresso internazionale sull'arte veneziana e l'arte islamica (Venice, 1989), pp. 212–213.

42. For example, an Aragonese inventory lists "a blue Turkish-style fabric from Florence"; Buss, p. 17.

43. Curatola 1985, p. 186.

44. Nancy Andrews Reath, "Velvets of the Renaissance, from Europe and Asia Minor," *Burlington Magazine* 50, no. 291 (June 1927): 298–304; J. Heinrich Schmidt, "Turkish Brocades and Italian Imitations," *Art Bulletin* 15 (1933): 374–383; Curatola 1985, pp. 188–189; Mackie 1980, pp. 356, 361; Atil 1987, p. 208.

45. For Ottoman examples, see Atil 1987, figs. 118, 142, 143, 145, 146.

46. See Reath, p. 303.

47. Reath, p. 303.

Glossary

■ ■

For further information on textile terms, see Dorothy K. Burnham, *Warp and Weft: A Textile Terminology* (Toronto, 1980), and Rebecca Martin, *Textiles in Daily Life in the Middle Ages* (Bloomington, Ind., 1985).

albarello A tall cylindrical ceramic drug jar, made with slightly concave sides in the Islamic world, and with concave or straight sides in Italy.

bacini Ceramic bowls set decoratively into the fabric of Italian church facades and towers from the late eleventh to the fifteenth century.

berettino A ceramic glaze, developed in Faenza in the early sixteenth century, in which a little cobalt blue added to the thick white enamel produces a gray to lavender-blue background for the painted decoration.

blazon A badge common in the Mamluk empire, consisting of a medallion or roundel containing one or more devices indicating personal prestige and political standing.

blind tooling Ornament incised or stamped into leather using metal tools or dies bearing carved designs; different tools are used to construct the composition.

bouclé An uncut weft loop of a fabric, usually of metal thread.

calcedonio A type of marbled Venetian glass, inspired by ancient Roman glass, that simulates semiprecious stones such as agate, chalcedony, onyx, malachite, lapus lazuli, and jasper.

cassone Italian word for a storage chest, often decorated with paintings.

cesendello A Venetian hanging glass lamp with a long cylindrical body.

chasuble The outer garment worn by a priest celebrating the Eucharist.

cintemani An Ottoman motif composed of clusters of three balls enclosing crescents, symbolizing imperial power.

compound weave A weave in which the warp or the weft is divided into two or more series, one of which appears on the face and the other(s) on the reverse as needed for the pattern, resulting in a uniform texture.

cope A semicircular cape worn as a processional garment in liturgical services.

dalmatic A shin-length tunic with open sides and rectangular sleeves worn during liturgical services, either as the principal garment or under a chasuble.

damask A usually reversible fabric in which different binding systems used in the pattern and background, usually of the same color, reflect light differently.

diasper A historic term usually used for lampas (q.v.).

doublure An ornamental inside lining of a book cover.

filigree In bookbinding, ornamental openwork cut from leather and laid over a contrasting background, a technique of Persian origin.

gilt tooling Ornament of gold leaf pressed into leather with heated metal tools or dies bearing carved designs; different tools are used to construct the composition.

223

Kaaba The holy Muslim shrine at Mecca, focus of prayer and goal of pilgrimage.

kaftan Ankle-length, long-sleeved outer garment.

kufic A stately style of Arabic script that emphasizes straight uprights and angular strokes fixed on a horizontal base. It appeared in early Qurans and architectural decoration, later assuming more decorative or severely abstract forms.

lampas A weave in which the background and the pattern are formed by different sets of warps and wefts; the wefts of the pattern float on the surface as needed, resulting in contrasts in texture and sheen between the raised pattern and smoother background.

latticinio Venetian glass in which clear glass is imbedded with threads of opaque white milk glass forming stripes in various patterns.

lattimo Venetian opaque white milk glass.

luster A ceramic technique in which a metallic film is painted onto an already fired glaze, then gently refired, creating shifting iridescent reflections. First developed in Mesopotamia, the technique spread across the Islamic world, reaching Spain in the fourteenth century, and was practiced in Italy from about 1490 to 1560.

madrasa A college for teaching Muslim theology, law, and tradition.

maiolica An Italian term originally used for the popular fourteenth- and fifteenth-century Spanish lusterware shipped to Italy via the island of Majorca, later applied to Italian lusterware and tin-glazed earthenware in general.

marvering Technique of decorating glass by pressing colored trails into the molten vessel. Originating in antiquity, it was practiced in Egypt and Syria during the Middle Ages.

mihrab The niche in a mosque orienting prayer toward Mecca.

millefiori A type of Venetian glass, inspired by ancient Roman glass, in which slices from different-colored rods are fused together in blossom-like patterns and embedded in blown glass.

minbar The pulpit-like structure in a mosque from which the Friday sermon is preached.

miter Liturgical headdress of a bishop.

nipt diamond waes On glass vessels, a long-used English term for the raised diamond pattern formed by pinching together vertically applied threads of glass while they are still warm; the same pattern is also made in molded glass.

orphrey An ornamental border or band on an ecclesiastical vestment, usually embroidered.

nakkashane The Ottoman court design studio, primarily responsible for the arts of the book.

naskh Term currently used for fine cursive Arabic script, derived from ordinary handwriting, in literary texts and small Qurans.

pai-zu A type of passport, made as a gold or silver plate or tablet, identifying official envoys and mandating their safe passage and supply within the Mongol empire.

'Pags Pa A script commissioned by Kublai Khan in 1260 for the spoken Mongol language, intended for use on official documents. Currently it is also called "square" or "quadratic" script because of the outlines of its letters.

pile-on-pile velvet A velvet in which the same type of pile is woven in two or more heights, creating a pattern.

saf A large rug with a pattern featuring a row or rows of niches. Such rugs were made for mosques and the use of the Muslim community during prayer.

saz An Ottoman motif, a long feathery leaf, and the style of ornament in which it is used with other floral motifs; it is named after a bamboo reed pen.

samite A fabric woven in weft-faced compound twill.

satin A weave in which the weft threads disappear beneath the finer and more numerous warp threads—or vice versa—resulting in a very smooth, glossy surface.

selvedges The longitudinal edge of a textile closed by weft loops, often in a different color or weave from the rest of the fabric.

sgraffito A mid-thirteenth- to sixteenth-century Italian ceramic technique in which the design is incised on the wet clay vessel, then painted with colored glazes that run during firing; probably derived from Syrian, or perhaps Byzantine examples.

spalliera Italian word for paintings custom made for installation on walls and furniture.

tabby The simplest weave, also called plain weave, in which the warps and wefts are interwoven on the principle of under one and over one.

taj Ottoman turban, introduced by Sultan Mehmed II, consisting of a small white turban wound around a red cap with vertical ribbing.

tazza Italian word for a shallow footed bowl or goblet.

thuluth (or thulth) A bold cursive Arabic script used throughout the Islamic world in the late Middle Ages; it was the predominant type on Islamic luxury goods imported by Italians between 1300 and 1600.

tin-glazing Ceramic technique in which a clay vessel is covered with a white glaze containing tin oxide, which renders the glaze opaque and provides an optimal base for painted decoration.

tiraz A band of standardized Arabic inscriptions marking royal Islamic honorific garments and other textiles, and the royal weaving establishments in which they were made; derives from the Persian word for embroidery.

tondino An Italian ceramic or metal plate with a distinctive broad flat rim.

twill A weave in which the regular displacement of weft threads passing over one or more and under two or more warp threads creates diagonal ribs.

tugra A calligraphic emblem, developed into a distinctive art form and used as the imperial monogram by the Ottoman sultans.

Uighur A cursive Turkic script commonly used in the Mongol empire.

velvet A pile weave in which an extra warp is raised above the foundation over metal rods in loops that may be cut to form tufts or left as loops.

voided velvet A velvet in which areas of ground weave are left free of pile by weaving the extra pile warp into the ground rather than raising it over rods.

warp The longitudinal threads of a textile, arranged on the loom before weaving.

weft The transverse threads of a textile, interwoven with the warp.

zaffera Italian word for Asian cobalt blue pigment; by extension, a descriptive term for fifteenth-century Florentine ceramics using an impure version of it that rises in slight relief during firing (also called relief-blue).

zawiya A Muslim religious institution, usually for study and meditation.

Bibliography

Acidini Lucinat, Cristina, ed. *The Chapel of the Magi: Benozzo Gozzoli's Frescoes in the Palazzo Medici-Riccardi, Florence.* Translated by Eleanor Daunt. London and New York, 1994.

Adelson, Candace, and Roberta Landini. "The 'Persian' Carpet in Charles le Brun's 'July' Was a Sixteenth-Century Florentine Table Tapestry." *Bulletin du Centre International d'Étude des Textiles Anciens* 68 (1990): 53–68.

Al-Andalus: The Art of Islamic Spain. Edited by Jerrilynn D. Dodds. Exh. cat. Metropolitan Museum of Art, New York. New York, 1992.

Alinari, Alessandro, and Fausto Berti. "Zaffera fiorentina per lo speziale e la mensa." In Giovanni Conti et al., *Zaffera et simili nella maiolica italiana,* 25–94. Viterbo, 1991.

Allan, James W. "Metalwork." In *Treasures of Islam,* 248–293. Geneva and London, 1985.

———. *Metalwork of the Islamic World: The Aron Collection.* London, 1986.

———. "Venetian-Saracenic Metalwork: The Problems of Provenance." In *Venezia e l'Oriente Vicino,* edited by Ernst J. Grube, 167–183. Atti del primo congresso internazionale sull'arte veneziana e l'arte islamica. Venice, 1989.

———. "Investigations into Marvered Glass: I." In *Islamic Art in the Ashmolean Museum,* Oxford Studies in Islamic Art, 10, 1:1–30. Oxford, 1995.

Allsen, Thomas T. *Commodity and Exchange in the Mongol Empire: A Cultural History of Islamic Textiles.* Cambridge, 1997.

Alverà Bortolotto, Angelica. *Storia della ceramica a Venezia dagli albori alla fine della Repubblica.* Florence, 1981.

Ammirato, Scipione. *Istorie fiorentine.* Edited by Scipione Ammirato il Giovane. 11 vols. Florence, 1824–1827.

"Anatolian Civilizations II: Some Carpets from the Thirteenth to Sixteenth Centuries." *Hali* 6, no. 2 (1984): 155–163.

Anderson, Jaynie. "Collezioni e collezionisti della pittura veneta del Quattrocento: Storia, sfortuna e fortuna." In *La pittura nel Veneto: Il Quattrocento,* edited by Mauro Lucco, 1:271–294. Milan, 1989.

Andoloro, Maria. "Costanzo da Ferrara: Gli anni a Costantinopoli alla corte di Maometto II." In *Studi in onore di Cesare Brandi,* nos. 38–40 of *Storia dell'arte* (1980): 185–212.

Andrea Mantegna. Edited by Jane Martineau. Exh. cat., Royal Academy of Arts, London, and Metropolitan Museum of Art, New York. Milan, 1992.

Angelini, Cesare, ed. *Viaggi in Terrasanta.* Florence, 1944.

Anquetil, Jacques. *Routes de la soie: Des déserts de l'Asie aux rives du monde occidental, vingt-deux siècles d'histoire.* Paris, 1992.

Armstrong, Lilian. "Marco Zoppo e il libro dei disegni del British Museum: Riflessioni sulle teste 'all'antica.'" In *Marco Zoppo e il suo tempo,* edited by Berenice Giovannucci Vigi, 79–95. Bologna, 1993.

Arslan, Edoardo. *Gothic Architecture in Venice.* Translated by Anne Engel. London, 1991.

Ashtor, Eliyahu. *Levant Trade in the Later Middle Ages.* Princeton, N.J., 1983.

———. "L'Exportation des textiles occidentaux dans le Proche Orient musulman au bas Moyen Âge, 1370–1517." Reprint no. 4 in *East-West Trade in the Medieval Mediterranean,* edited by Benjamin Z. Kedar, 303–377. London, 1986.

————. "Observations on Venetian Trade in the Levant in the Fourteenth Century." Reprint no. 6 in *East-West Trade in the Medieval Mediterranean,* edited by Benjamin Z. Kedar, 533–586. London, 1986.

————. "L'Apogée du commerce vénitien au Levant: Un nouvel essai d'explication." Reprint no. 6 in *Technology, Industry, and Trade: The Levant versus Europe, 1250–1500,* edited by Benjamin Z. Kedar, 307–326. Hampshire, U.K., and Brookfield, Vt., 1992.

Atasoy, Nurhan, and Julian Raby. *Iznik: The Pottery of Ottoman Turkey.* Edited by Yanni Petsopoulos. London, 1989.

Atil, Esin. *Ceramics from the World of Islam.* Exh. cat., Freer Gallery of Art, Washington. Washington, 1973.

————. *Art of the Arab World.* Exh. cat., Freer Gallery of Art, Washington. Washington, 1975.

————. *Renaissance of Islam: Art of the Mamluks.* Exh. cat., Smithsonian Institution Traveling Exhibition Service, Washington. Washington, 1981.

————. *The Age of Sultan Süleyman the Magnificient.* Exh. cat., National Gallery of Art, Washington. Washington, 1987.

Atil, Esin, William Thomas Chase, and Paul Jett. *Islamic Metalwork in the Freer Gallery of Art.* Washington, 1985.

Auld, Silvia. "Kuficising Inscriptions in the Work of Gentile da Fabriano." *Oriental Art,* n.s., 32 (1986): 246–265.

————. "Master Mahmud: Objects Fit for a Prince." In *Venezia e l'Oriente Vicino,* edited by Ernst J. Grube, 185–201. Atti del primo congresso internazionale sull'arte veneziana e l'arte islamica. Venice, 1989.

Ayers, John. "Early Ming Taste in Porcelain." *Victoria and Albert Museum Bulletin* 2 (1966): 21–36.

Babinger, Franz. *Mehmed the Conqueror and His Time.* Translated by Ralph Manheim, edited by William C. Hickman. Princeton, N.J., 1978.

Baker, Patricia A. "Islamic Honorific Garments." *Costume* 25 (1991): 25–35.

————. *Islamic Textiles.* London, 1995.

Baker, Patricia A., Hülya Tezcan, and Jennifer Wearden. *Silks for the Sultans: Ottoman Imperial Garments from Topkapi Palace.* Ertug and Kocabiyik, 1996.

Bandera Bistoletti, Sandrina. *Giotto: Catalogo completo dei dipinti.* Florence, 1989.

Barasch, Moshe. "Some Oriental Pseudo-Inscriptions in Renaissance Art." *Visible Language* 23, nos. 2–3 (spring and summer 1989): 171–187.

Barovier Mentasti, Rosa, Attilia Dorigato, Astone Gasparetto, and Tullio Gasparetto. *Mille anni di arte del vetro a Venezia.* Exh. cat., Palazzo Ducale and Palazzo Correr, Venice. Venice, 1982.

Barriault, Anne B. *"Spalliera" Paintings of Renaissance Tuscany: Fables of Poets for Patrician Homes.* University Park, Pa., 1994.

Bauer, Rotraud. "Il Manto di Ruggiero II." In *I Normanni: Popolo d'Europa, 1030–1200,* edited by Mario D'Onofrio, 278–287. Exh. cat., Palazzo Venezia, Rome. Venice, 1994.

Beckwith, John. "The Influence of Islamic Art on Western Medieval Art." *Apollo* 103 (April 1976): 270–281.

Begni Redona, Pier Virgilio. *Alessandro Bonvicino II Moretto da Brescia.* Brescia, 1988.

Bellosi, Luciano. "Il Maestro della Crocefissione Griggs: Giovanni Toscani." *Paragone* 17, no. 193 (March 1966): 44–58.

————. *Cimabue.* Milan, 1998.

Benvenuti, Gino. *Storia della Repubblica di Pisa.* Pisa, 1982.

Berenson, Bernard. *Italian Pictures of the Renaissance: Florentine School.* 2 vols. London, 1963.

Berti, Graziella. "Keramische 'Bacini' mittelalterliche Kirchen Pisas aus islamischer und örtlicher Produktion." In *Europa und der Orient, 800–1900,* edited by Gereon Sievernich and Hendrik Budde, 607–608. Exh. cat., Berliner Festspiele. Berlin, 1989.

————. *Pisa, Museo Nazionale di San Matteo: Ceramiche medievale e post-medievale.* Florence, 1997.

Berti, Graziella, and Catia Renzi-Rizzo. *Pisa: Le "maioliche arcaiche," secoli XIII–XV (Museo Nazionale di San Matteo), appendice, "Nomina vasorum."* Florence, 1997.

Berti, Graziella, and Liana Tongiorgi. "Bacini ceramici su alcune chiese della campagna lucchese." *Faenza* 59 (1973): 4–13.

————. *I bacini ceramici del Duomo di S. Miniato (ultimo quarto del XII secolo).* Genoa, 1981.

Berti, Luciano, and Rossella Foggi. *Masaccio: Catalogo completo.* Florence, 1989.

Berti, Luciano, and Antonio Paolucci. *L'età di Masaccio: Il primo Quattrocento a Firenze.* Exh. cat., Palazzo Vecchio, Florence. Florence, 1990.

Biavati, Eros. "Bacini di Pisa." *Faenza* 38 (1952): 92–94.

Bibliotheca Sanctorum. 13 vols. Rome, 1961–1969.

Bierman, Irene A. "The Significance of Arabic Script on Carpets." *Hali* 5, no. 1 (1982): 18–22.

————. "Art and Politics: The Impact of Fatimid Uses of 'Tiraz' Fabrics." Ph.D. diss., University of Chicago, 1980.

Bisticci, Vespasiano da. *Le vite.* Edited by Aulo Greco. 2 vols. Florence, 1970.

Boese, Helmut. *Die lateinischen Handschriften der Sammlung Hamilton zu Berlin.* Wiesbaden, 1966.

Bon, Ottaviano. *The Sultan's Seraglio: An Intimate Portrait of Life at the Ottoman Court.* Translated and edited by John Withers, annotated by Godfrey Goodwin. London, 1996.

Bonito Fanelli, Rosalia. "I 'doni' dall'Oriente e da 'Champagne, Provins et Ultramonti': Commerci, chiesa e moda." In *Drappi, velluti, taffettà et altre cose: Antichi tessuti a Siena e*

nel suo territorio, edited by Marco Ciatti, 50–59. Exh. cat., Chiesa di Sant'Agostino, Siena. Siena, 1994.

Bonito Fanelli, Rosalia, Ulrich Alexander Middeldorf, and Maria Grazia Ciardi Duprè Dal Poggetto. *Il Tesoro della Basilica di San Francesco ad Assisi.* Assisi, 1980.

Bonito Fanelli, Rosalia, and Paolo Peri. *Tessuti italiani del Rinascimento: Collezioni Franchetti Carrand.* Exh. cat., Palazzo Pretorio, Prato. Florence, 1981.

Bosch, Gulnar, John Carswell, and Guy Petherbridge. *Islamic Bookbindings and Bookmaking.* Exh. cat., Oriental Institute, University of Chicago. Chicago, 1981.

Braudel, Fernand. *The Mediterranean and the Mediterranean World in the Age of Philip II.* 2d rev. ed. Translated by Siàn Reynolds. 2 vols. New York, 1976.

———. *Civilization and Capitalism, Fifteenth–Eighteenth Century.* Vol. 3, *The Perspective of the World.* Translated by Siàn Reynolds. New York, 1984.

Brown, Clifford M. "'Lo insaciabile desiderio nostro de cose antique': New Documents on Isabella d'Este's Collection of Antiquities." In *Cultural Aspects of the Italian Renaissance: Essays in Honor of Paul Oskar Kristeller,* edited by Cecil H. Clough, 324–353. Manchester, 1976.

Brown, Patricia Fortini. *Venetian Narrative Painting in the Age of Carpaccio.* New Haven, Conn., 1988.

———. *Venice and Antiquity: The Venetian Sense of the Past.* New Haven, Conn., and London, 1996.

Brunello, Franco. *Marco Polo e le merci dell'Oriente.* Vicenza, 1986.

Buss, Chiara, Marina Molinelli, and Graziella Berti. *Tessuti serici italiani, 1450–1530.* Exh. cat., Castello Sforzesco, Milan. Milan, 1983.

Caiger-Smith, Alan. *Tin Glaze Pottery in Europe and the Islamic World: The Tradition of One Thousand Years in Maiolica, Faience, and Delftware.* London, 1973.

Callmann, Ellen. *Apollonio di Giovanni.* Oxford, 1974.

Camesasca, Ettore, ed. *All the Paintings of Raphael.* Translated by Luigi Grasso. 2 vols. New York, 1963.

Carboni, Stefano. "Oggetti decorati a smalto di influsso islamico nella vetraria muranese: Technica e forma." In *Venezia e l'Oriente Vicino,* edited by Ernst J. Grube, 147–156. Atti del primo congresso internazionale sull'arte veneziana e l'arte islamica. Venice, 1989.

———. "Gregorio's Tale; or, Of Enamelled Glass Production in Venice." In *Gilded and Enamelled Glass from the Middle East,* edited by Rachel Ward, 101–106. Papers given at a conference at the British Museum, London, April 1995. London, 1998.

Carli, Enzo. *La Piazza del Duomo di Pisa.* Rome, 1956.

———. *Il Pintoricchio.* Milan, 1960.

Carswell, John. *Blue and White: Chinese Porcelain and Its Impact on the Western World.* With contributions by Edward A. Maser and Jean McClare Mudge. Exh. cat., David and Arthur Smart Gallery, University of Chicago. Chicago, 1985.

———. "The Baltimore Beakers." In *Gilded and Enamelled Glass from the Middle East,* edited by Rachel Ward, 61–63. Papers given at a conference at the British Museum, London, April 1995. London, 1998.

Castiglione, Baldesar. *The Book of the Courtier.* Translated by Charles S. Singleton. New York, 1959.

Chambers, David Sanderson. *A Renaissance Cardinal and His Worldly Goods: The Will and Inventory of Francesco Gonzaga (1444–1483).* London, 1992.

Charleston, Robert Jesse. "The Import of Venetian Glass into the Near-East, Fifteenth–Sixteenth Century." *Annales du 3ème congrès des journées internationales du verre,* 158–168. Liège, 1964.

———. "The Import of Western Glass into Turkey: Sixteenth–Eighteenth Centuries." *Connoisseur* 162, no. 651 (May 1966): 18–26.

———. "Types of Glass Imported into the Near East, and Some Fresh Examples: Fifteenth–Sixteenth Century." In *Festschrift für Peter Wilhelm Meister zum 65. Geburtstag am 16. mai 1974,* edited by Annaliese Ohm and Horst Reber, 245–272. Hamburg, 1975.

Chiappini di Sorio, Ileana. "La tessitura serica a Venezia: Della origine e di alcune influenze iconografiche." In *Venezia e l'Oriente Vicino,* edited by Ernst J. Grube, 203–209. Atti del primo congresso internazionale sull'arte veneziana e l'arte islamica. Venice, 1989.

Chiappori, Maria Grazia. "Riflessi figurativi dei contatti Oriente-Occidente e dell'opera poliana nell'arte medievale italiana." In *Marco Polo, Venezia e l'Oriente,* edited by Alvise Zorzi, 281–288. Milan, 1981.

Chiellini, Monica. *Cimabue.* Florence, 1988.

Christiansen, Keith. *Gentile da Fabriano.* London, 1982.

———. "Venetian Painting of the Early Quattrocento." *Apollo* 125 (March 1987): 166–177.

———. "Revising the Renaissance: 'Il Gentile Disvelato.'" *Burlington Magazine* 131, no. 1037 (August 1989): 539–541.

Circa 1492: Art in the Age of Exploration. Edited by Jay A. Levenson. Exh. cat., National Gallery of Art, Washington. New Haven, Conn., and London, 1991.

Clairmont, Christoph. "Some Islamic Glass in the Metropolitan Museum." In *Islamic Art in the Metropolitan Museum,* edited by Richard Ettinghausen, 141–152. New York, 1972.

Clavijo, Ruy Gonzalez de. *Embassy to Tamerlane, 1403–1406.* Translated by Guy le Strange. London, 1928.

Contadini, Anna. "'Cuoridoro': Tecnica e decorazione di

cuoi dorati veneziani e italiani con influssi islamici." In *Venezia e l'Oriente Vicino,* edited by Ernst J. Grube, 231–251. Atti del primo congresso internazionale sull'arte veneziana e l'arte islamica. Venice, 1989.

Cook, Michael A. "Economic Developments." In *The Legacy of Islam,* edited by Joseph Schact and Clifford Edmund Bosworth, 210–243. 2d ed. Oxford, 1974.

Cora, Galeazzo. *Storia della maiolica di Firenze e del contado, secoli XIV e XV.* 2 vols. Florence, 1973.

Cora, Galeazzo, and Angiolo Fanfani. *La maiolica di Cafaggiolo.* Florence, 1982.

———. *La porcellana dei Medici.* Milan, 1986.

Creswell, Keppel Archibald Cameron. *Early Muslim Architecture.* Vol. 1. Oxford, 1932.

Cuneo, Paolo. "Sulla raffigurazione della città di Damasco in una tela di scuola belliniana conservata al Louvre." In *Venezia e l'Oriente Vicino,* edited by Calogero Muscarà, 43–52. Simposio internazionale sull'arte veneziana e l'arte islamica. Venice, 1991.

Curatola, Giovanni. "Tessuti e artigianato turco nel mercato veneziano." In *Venezia e i turchi: Scontri e confronti di due civiltà,* 186–195. Milan, 1985.

———. "Four Carpets in Venice." *Oriental Carpet and Textile Studies* 2 (1986): 123–130.

———. "Quali rapporti fra tessuti veneziani e tessuti ottomani?" In *Venezia e l'Oriente Vicino,* edited by Ernst J. Grube, 211–216. Atti del primo congresso internazionale sull'arte veneziana e l'arte islamica. Venice, 1989.

Ćurčić, Slobodan. "Some Palatine Aspects of the Cappella Palatina in Palermo." *Dumbarton Oaks Papers* 41 (1987): 125–144.

Dalli Regoli, Gigetta. "La Madonna di Piazza. 'Ce n'é d'assai più belle, nessuna più perfetta.'" In *Scritti di storia dell'arte in onore di Federico Zeri,* 1:213–232. Milan, 1984.

Davanzo Poli, Doretta, and Stefania Moronato. *Le stoffe dei veneziani.* Venice, 1994.

Dawson, Christopher, ed. *Missions to Asia: Narratives and Letters of the Franciscan Missionaries in Mongolia and China in the Thirteenth and Fourteenth Centuries.* New York, 1966.

Degenhart, Bernhard, and Annegrit Schmitt. *Corpus der italienischen Zeichnungen 1300–1400.* Pt. 2, 8 vols. Berlin, 1980–1990.

De Marinis, Tammaro. *La legatura artistica in Italia nei secoli XV e XVI.* 3 vols. Florence, 1960.

Demus, Otto. *The Church of San Marco in Venice.* Washington, 1960.

De Nicolò Salmazo, Alberta. "Padova." In *La pittura veneta: Il Quattrocento,* edited by Mauro Lucco, 2: 481–540. Milan, 1989.

Denny, Walter B. "Saff and Sajjadeh: Origins and Meaning of the Prayer Rug." *Oriental Carpet and Textile Studies* 3, no. 2 (1990): 93–104.

de Roover, Florence Elder. "Lucchese Silks." *Ciba Review* 80 (June 1950): 2902–2930.

Devoti, Donata. "Stoffe Lucchese del Trecento." *Critica d'arte,* n.s., 13, no. 81 (September 1966): 26–38.

Dimand, Maurice S., and Jean Mailey. *Oriental Rugs in the Metropolitan Museum of Art.* New York, 1973.

Draper, James David. "Bertoldo di Giovanni." In *The Currency of Fame: Portrait Medals of the Renaissance,* edited by Stephen K. Scher, 126–132. Exh. cat., Frick Collection, New York, and National Gallery of Art, Washington. New York, 1994.

Dreier, Franz Adrian. *Venezianische Gläser und "Façon de Venise."* Vol. 12 of *Katalog des Kunstgewerbemuseums Berlin.* Berlin, 1989.

Eck, Pieter C. Ritsema van, and Henrica M. Zijlstra-Zweens. *Glass in the Rijksmuseum.* Vol. 1. Zwolle, 1993.

Eisler, Colin. *The Genius of Jacopo Bellini.* New York, 1989.

Ellis, Charles Grant. "The 'Lotto' Pattern as a Fashion in Carpets." In *Festschrift für Peter Wilhelm Meister zum 65. Geburtstag am 16. mai 1974,* edited by Annaliese Ohm and Horst Reber, 19–31. Hamburg, 1975.

———. "'Small Pattern Holbein' Carpets in Paintings: A Continuation." *Hali* 3, no. 3 (1981): 216–217.

———. "On 'Holbein' and 'Lotto' Rugs." *Oriental Carpet and Textile Studies* 2 (1986): 163–176.

———. *Oriental Carpets in the Philadelphia Museum of Art.* Philadelphia, 1988.

El Mallakh, Ragei, and Dorothea El Mallakh. "Trade and Commerce." In *The Genius of Arab Civilization, Source of Renaissance,* edited by John R. Hayes, 251–263. 3d ed. New York and London, 1992.

Enderlein, Volkmar. "Zwei ägyptische Gebetsteppiche im Islamischen Museum." *Forschungen und Berichte, Staatliche Museen zu Berlin* 13 (1971): 7–15.

Erdmann, Kurt. "Arabische Schriftzeichen als Ornamente in der abendländischen Kunst des Mittelalters." *Abhandlungen der geistes- und sozialwissenschaftlichen Klasse* (Akademie der Wissenschaften und der Literatur, Mainz) 9 (1953): 467–513.

———. "Venezia e il tappeto orientale." In *Venezia e l'Oriente fra tardo Medioevo e Rinascimento,* edited by Agostino Pertusi, 529–545. Corso internazionale di alta cultura 5, Venice, 1963. Florence, 1966.

———. *Seven Hundred Years of Oriental Carpets.* Edited by Hanna Erdmann, translated by Mary H. Beattie and Hildegard Herzog. Berkeley and Los Angeles, 1970.

———. *The History of the Early Turkish Carpet.* Translated by Robert Pinner. London, 1977.

Eredità dell'Islam: Arte islamica in Italia, edited by Giovanni Curatola. Exh. cat., Palazzo Ducale, Venice. Venice, 1993.

Ettinghausen, Richard. "Near Eastern Book Covers and Their Influence on European Bindings: A Report on the Exhibition 'History of Bookbinding' at the Baltimore Museum of Art." *Ars Orientalis,* n.s., 3 (1959): 113–132.

———. *Arab Painting.* Lausanne, 1962.

———. "Arabic Epigraphy: Communication or Symbolic Affirmation." In *Near Eastern Numismatics, Iconography, Epigraphy, and History: Studies in Honor of George C. Miles,* edited by Dickran K. Kouymijian, 297–334. Beirut, 1974.

———. "The Decorative Arts and Painting: Their Character and Scope." In *The Legacy of Islam,* edited by Joseph Schact and Clifford Edmund Bosworth, 274–291. 2d ed. Oxford, 1974.

———. "The Early History, Use, and Iconography of the Prayer Rug." In *Prayer Rugs.* Exh. cat., Textile Museum, Washington, and Montclair Art Museum, Montclair, N.J., 10–25. Washington, 1974.

———. "The Impact of Muslim Decorative Arts and Painting on the Arts of Europe." In *The Legacy of Islam,* edited by Joseph Schact and Clifford Edmund Bosworth, 292–320. 2d ed. Oxford, 1974.

———. "Kufesque in Byzantine Greece, the Latin West, and the Muslim World." In *Richard Ettinghausen: Islamic Art and Archaeology, Collected Papers,* edited by Myriam Rosen-Ayalon, 752–771. Berlin, 1984.

Ettlinger, Leopold D. *Antonio and Piero Pollaiuolo.* Oxford, 1978.

Europa und der Orient, 800–1900. Edited by Gereon Sievernich and Hendrik Budde. Exh. cat. Berliner Festspiele. Berlin, 1989.

Falke, Otto von. *Decorative Silks.* 3d ed. New York, 1936.

Faroqhi, Suraiya. *Towns and Townsmen of Ottoman Anatolia: Trade, Crafts, and Food Production in an Urban Setting, 1520–1650.* Cambridge, 1984.

Fasanelli, James A. "Some Notes on Pisanello and the Council of Florence." *Master Drawings* 3, no. 1 (1965): 36–47.

Fedalto, Giorgio. "Stranieri a Venezia e a Padova." In *Storia della cultura veneta: Dal primo Quattrocenio al Concilio di Trenta.* Vol. 3, pt. 1, 499–535. Vicenza, 1980.

Federico e la Sicilia: Della terra alla corona. Vol. 2, *Arti figurative e arti suntuarie,* edited by Maria Andoloro. Exh. cat., Real Albergo dei Poveri, Palermo. Palermo, 1995.

Fehérvári, Géza. "Metalwork." In *Islamic Art in the Keir Collection,* edited by Basil William Robinson, 107–136. London and Boston, 1988.

Fiocco, Giuseppe. "A Small Portable Panel by Titian for Philip II." *Burlington Magazine* 98, no. 643 (October 1956): 343–344.

Fischel, Walter J. "A New Latin Source on Tamerlane's Conquest of Damascus, 1400/1401: B. de Mignanelli's 'Vita Tamerlani,' 1416." *Oriens* 9, no. 2 (1956): 201–232.

Fontana, Maria Vittoria. "Rapporti artistici fra ceramica islamica e ceramica veneta fra il Quattrocento e il Seicento." In *Venezia e l'Oriente Vicino,* edited by Ernst J. Grube, 125–146. Atti del primo congresso internazionale sull'arte veneziana e l'arte islamica. Venice, 1989.

———. "L'influsso dell'arte islamica in Italia." In *Eredità dell'Islam: Arte islamica in Italia,* edited by Giovanni Curatola, 455–476. Exh. cat., Palazzo Ducale, Venice. Venice, 1993.

Forlani, Anna. "Jacopo Ligozzi nel gran serraglio." *FMR* 1 (March 1982): 72–103.

Fossi Todorow, Maria. *I Disegni del Pisanello e della sua cerchia.* Florence, 1966.

Franses, Michael. "The 'Bellini' Keyhole." In *Orient Stars: A Carpet Collection.* Exh. cat., Deichtorhallen, Hamburg, and Linden-Museum, Stuttgart, 277–283 and 375–378 nn. London, 1993.

———. "The 'Crivelli' Star." In *Orient Stars: A Carpet Collection.* Exh. cat., Deichtorhallen, Hamburg, and Linden-Museum, Stuttgart, 273–276. London, 1993.

———. "The 'Historical' Carpets from Anatolia." In *Orient Stars: A Carpet Collection.* Exh. cat., Deichtorhallen, Hamburg, and Linden-Museum, Stuttgart, 262–272. London, 1993.

Franses, Michael, and Ian Bennett. "The Topkapi Prayer Rugs." *Hali* 10, no. 3 (1988): 20–27.

Franses, Michael, and John Eskenazi. *Turkish Rugs and Old Master Paintings.* Exh. cat., Colnaghi, London and New York. London, 1996.

Frothingham, Alice Wilson. *Catalogue of Hispano-Moresque Pottery in the Collection of the Hispanic Society of America.* New York, 1936.

———. *Lustreware of Spain.* New York, 1951.

Fugoni, Chiara. *Pietro and Ambrogio Lorenzetti.* Translated by Lisa Pelletti. Florence, 1988.

Gabrieli, Francesco. "Venezia e i Mamelucchi." In *Venezia e l'Oriente fra tardo Medioevo e Rinascimento,* edited by Agostino Pertusi, 417–432. Corso internazionale di alta cultura 5, Venice, 1963. Florence, 1966.

Gabrieli, Francesco, and Umberto Scerrato. *Gli arabi in Italia: Cultura, contatti e tradizione.* 2d ed. Milan, 1985.

Gantzhorn, Volkmar. *The Christian Oriental Carpet.* Cologne, 1991.

Gardner, Julian. "The Stephaneschi Altarpiece: A Reconsideration." *Journal of the Warburg and Courtauld Institutes* 37 (1974): 57–103.

Garnier, Édouard. *Histoire de la verrerie et de l'émaillerie.* Tours, 1886.

Gasparetto, Astone. *Il vetro di Murano dalle origini ad oggi.* Venice, 1958.

———. "Matrici e aspetti della vetraria veneziana e veneta medievale." *Journal of Glass Studies* 21 (1979): 76–97.

Gettens, Rutherford J., and George L. Stout. *Painting Materials: A Short Encyclopaedia.* New York, 1966.

Goffen, Rona. *Spirituality and Conflict: Saint Francis and Giotto's Bardi Chapel.* University Park, Pa., and London, 1988.

Goitein, Shelomo D. "Sicily and Southern Italy in the Cairo Geniza Documents." *Archivio storico per la Sicilia orientale* 67 (1971): 9–33.

Goldschmidt, Ernst Philip. *Gothic and Renaissance Bookbindings.* 2 vols. London, 1928.

Goldthwaite, Richard A. *Wealth and the Demand for Art in Italy, 1300–1600.* Baltimore and London, 1993.

Golombek, Lisa. "The Draped Universe of Islam." In *Content and Context of Visual Arts in the Islamic World,* edited by Priscilla P. Soucek, 26–37. Papers presented at a colloquium in memory of Richard Ettinghausen, Institute of Fine Arts, New York University, 1980. University Park, Pa., and London, 1988.

Gombrich, Ernst Hans. "Apollonio di Giovanni: A Florentine *Cassone* Workshop Seen through the Eyes of a Humanist Poet." *Journal of the Warburg and Courtauld Institutes* 18 (1955): 16–34.

Gough, Sean. "The Mamluk Sultanate." *Hali* 4, no. 1 (1981): 33–34.

Gould, Cecil. "The Oriental Element in Titian." In *Tiziano e Venezia.* Convegno internazionale di studi, Venice, 1976, 1:233–235. Verona, 1980.

Grabar, André. "The Byzantine Heritage." Chap. 2 in Michelangelo Muraro and André Grabar, *Treasures of Venice,* 25–76. Geneva, 1963.

Grabar, Oleg. "The Illustrated Maqāmāt of the Thirteenth Century: The Bourgeoisie and the Arts." In *The Islamic City,* edited by Albert Habib Hourani and Samuel Miklos Stern, 207–222. A colloquium published under the auspices of the Near Eastern History Group, Oxford, and the Near East Center, University of Pennsylvania. Oxford, 1970.

———. "Islamic Architecture and the West: Influences and Parallels." In *Islam and the Medieval West,* edited by Stanley Ferber, 60–66. Exh. cat., University Art Gallery, Binghamton, N.Y. Binghamton, N.Y., 1975.

———. "Trade with the East and the Influence of Islamic Art on the 'Luxury Arts' in the West." In *Il Medio Oriente e l'Occidente nell'arte del XIII secolo,* edited by Hans Belting.

Atti del XXIV congresso internazionale di storia dell'arte, 2:27–34. Bologna, 1979.

———. Introduction to *Treasures of Islam,* 14–19. Geneva and London, 1985.

———. "Europe and the Orient: An Ideologically Charged Exhibition." *Muqarnas* 7 (1990): 1–11.

———. "Patronage in Islamic Art." In *Islamic Art and Patronage: Treasures from Kuwait,* edited by Esin Atil, 27–39. Exh. cat., Walters Art Gallery, Baltimore. New York, 1990.

———. *The Mediation of Ornament.* Princeton, N.J., 1992.

Grassi, Luigi. *Tutta la pittura di Gentile da Fabriano.* Milan, 1953.

Grönwoldt, Ruth. *Webereien und Stickereien des Mittelalters.* Vol. 7 of *Bildkatalog des Kestner-Museums Hannover, Textilien 1.* Hanover, 1964.

———. "Imperial Vestments and Church Apparels of the Staufer Era." *Bulletin du Centre International d'Étude des Textiles Anciens* 47–48 (1978): 43–50.

Grube, Ernst J. "Elementi islamici nell'archittetura veneta del Medioevo." *Bolletino del Centro Internazionale di Architettura Andrea Palladio* 8 (1966): 231–256.

———. "Apporti orientali nella decorazione della graffita veneta." In *Atti del convegno "La ceramica graffita medievale e rinascimentale nel Veneto." Bollettino del Museo Civico di Padova,* 145–157. Padua, 1987.

———. "Le lacche veneziane e i loro modelli islamici." In *Venezia e l'Oriente Vicino,* edited by Ernst J. Grube, 217–229. Atti del primo congresso internazionale sull'arte veneziana e l'arte islamica. Venice, 1989.

Guasti, Gaetano. *Di Cafaggiolo e d'altre fabbriche di ceramiche in Toscana.* Florence, 1902.

Haedeke, Hans-Ulrich. *Metalwork.* Translated by Vivienne Menkes. London, 1970.

Haldane, Duncan. *Islamic Bookbindings in the Victoria and Albert Museum.* London, 1983.

Hamilton, Alastair. "Eastern Churches and Western Scholarship." In *Rome Reborn: The Vatican Library and Renaissance Culture,* edited by Anthony Grafton, 225–249. Exh. cat., Library of Congress, Washington. Washington, 1993.

Harris, Jennifer, ed. *Textiles: Five Thousand Years: An International History and Illustrated Survey.* New York, 1993.

Heyd, Wilhelm von. *Histoire du commerce du Levant au Moyen Âge.* 2 vols. Leipzig, 1885–1886.

Hibbert, Christopher. *The Rise and Fall of the House of Medici.* London, 1974.

Hill, Derek, and Lucien Golvin. *Islamic Architecture in North Africa.* London, 1976.

Hill, Derek, and Oleg Grabar. *Islamic Architecture and Its Decoration.* Chicago and London, 1964.

Hill, Donald L. "Mechanical Technology." In *The Genius of Arab Civilization, Source of Renaissance,* edited by John R. Hayes, 233–238. 3d ed. New York and London, 1992.

Hill, George Francis. *A Corpus of Italian Medals of the Renaissance before Cellini.* 2 vols. Oxford, 1930.

Hind, Arthur Mayger. "Two Unpublished Plates of the Series of Six 'Knots' Engraved after Designs by Leonardo da Vinci." *Burlington Magazine* 12, no. 55 (October 1907): 41–43.

The History of Bookbinding, 525–1950 A.D. Exh. cat., Baltimore Museum of Art, Baltimore, 1957.

Hobson, Anthony. *Humanists and Bookbinders: The Origins and Diffusion of the Humanistic Bookbinding 1459–1559, with a Census of Historiated Plaquette and Medallion Bindings of the Renaissance.* Cambridge, 1989.

———. "Islamic Influence on Venetian Renaissance Bookbinding." In *Venezia e l'Oriente Vicino,* edited by Ernst J. Grube, 111–123. Atti del primo congresso internazionale sull'arte veneziana e l'arte islamica. Venice, 1989.

Hollingsworth, Mary. *Patronage in Renaissance Italy: From 1400 to the Early Sixteenth Century.* London, 1994.

Hooper-Greenhill, Eilean. *Museums and the Shaping of Knowledge.* London and New York, 1992.

Horn, Walter. "Romanesque Churches in Florence: A Study in Their Chronology and Stylistic Development." *Art Bulletin* 25 (1943): 111–131.

Howard, Deborah. *The Architectural History of Venice.* London, 1980.

———. "Venice and Islam in the Middle Ages: Some Observations on the Question of Architectural Influence." *Architectural History* 34 (1991): 59–74.

———. *Venice and the East: The Impact of the Islamic World on Venetian Architecture, 1100–1500.* New Haven, Conn., and London, 2000.

Hueck, Irene. "La tavola di Duccio e la Compagnia delle Laudi di Santa Maria Novella." In *La Maestà di Duccio restaurata.* Le Uffizi: Studi e richerche, 6, 33–46. Florence, 1990.

Huth, Hans. "'Sarazenen' in Venedig?" In *Festschrift für Heinz Ladendorf,* edited by Peter Block and Gisela Zick, 58–68. Cologne, 1970.

———. *Lacquer of the West: The History of a Craft and an Industry, 1550–1950.* Chicago and London, 1971.

Ibn Battuta. *Travels in Asia and Africa, 1325–1354.* Translated and edited by Hamilton Alexander Rosskeen Gibb. New York, 1969.

Islam and the Medieval West. Edited by Stanley Ferber. Exh. cat., University Art Gallery, Binghamton, N.Y. Binghamton, N.Y., 1975.

Ives, Herbert E. "The Venetian Gold Ducat and Its Imitations." Edited and annotated by Philip Grierson. *Numismatic Notes and Monographs* 128 (1954): 1–37.

Jairazbhoy, Rafique Ali. *Oriental Influences in Western Art.* Bombay, 1965.

James, David. *Qurans of the Mamluks.* London, 1988.

Janson, Horst Woldemar. *The Sculpture of Donatello.* Princeton, N.J., 1963.

Jardine, Lisa. *Worldly Goods: A New History of the Renaissance.* New York, London, Toronto, Sydney, and Auckland, 1996.

Jenkins, Marilyn. "New Evidence for the Possible Provenance and Fate of the So-Called Pisa Griffin." *Islamic Archaeological Studies* 1 (1978): 79–85.

Kanter, Laurence B., Barbara Drake Boehm, Carl Brandon Strehlke, Gaudenz Freuler, Christa C. Mayer Thurson, and Pia Palladino. *Painting and Illumination in Early Renaissance Florence.* Exh. cat., Metropolitan Museum of Art, New York. New York, 1994.

Kendrick, Albert Frank. "Textiles." In *Spanish Art,* edited by Robert Rattray Tatlock, 59–70. London, 1927.

Kenesson, Summer S. "Nasrid Luster Pottery: The Alhambra Vases." *Muqarnas* 9 (1992): 93–115.

King, Donald. "The Inventories of the Carpets of King Henry VIII." *Hali* 5, no. 3 (1982): 293–302.

King, Donald, and David Sylvester. *The Eastern Carpet in the Western World.* Exh. cat., Hayward Gallery, London. Rugby, 1983.

Kingery, W. David, and Pamela B. Vandiver. "Medici Porcelain." *Faenza* 70 (1984): 441–453.

Klein, Robert, and Henri Zerner. *Italian Art, 1500–1600: Sources and Documents.* Englewood Cliffs, N.J., 1966.

Klesse, Brigitte. *Seidenstoffe in der italienischen Malerei des 14. Jahrhunderts.* Bern, 1967.

Klesse, Brigitte, and Hans Mayr. *European Glass from 1500–1800: The Ernesto Wolff Collection.* Vienna, 1987.

Klinger, Linda, and Julian Raby. "Barbarossa and Sinan: A Portrait of Two Ottoman Corsairs from the Collection of Paolo Giovio." In *Venezia e l'Oriente Vicino,* edited by Ernst J. Grube, 47–59. Atti del primo congresso internazionale sull'arte veneziana e l'arte islamica. Venice, 1989.

Klose, Christine. "Textiles as Models for Turkish Carpets of the Sixteenth and Seventeenth Centuries." *Oriental Carpet and Textile Studies* 5, no. 1 (1999): 47–52.

Krinsky, Carol Herselle. "Representations of the Temple of Jerusalem before 1500." *Journal of the Warburg and Courtauld Institutes* 33 (1970): 1–19.

Krisztinkovics, Béla, and Maurizio Korach. "Un antico documento sulla porcellana cinese in Europa." *Faenza* 53 (1967): 27–30.

Krueger, Ingeborg. "An Enamelled Beaker from Stralsund: A

Spectacular New Find." In *Gilded and Enamelled Glass from the Middle East*, edited by Rachel Ward, 107–109. Papers given at a conference at the British Museum, London, April 1995. London, 1998.

Kühnel, Ernst, and Louisa Bellinger. *The Textile Museum Catalogue Raisonné: Cairene Rugs and Others Technically Related, Fifteenth–Seventeenth Century*. Washington, 1957.

Kurz, Otto. "A Gold Helmet Made in Venice for Sultan Sulayman the Magnificent." Reprint no. 13 in *Selected Studies: The Decorative Arts of Europe and the Islamic East*, 1:249–258. London, 1977.

———. "The Strange History of an Alhambra Vase." Reprint no. 17 in *Selected Studies: The Decorative Arts of Europe and the Islamic East*, 1:205–212. London, 1977.

———. "The Turkish Dresses in the Costume Book of Rubens." Reprint no. 15 in *Selected Studies: The Decorative Arts of Europe and the Islamic East*, 1:275–290. London, 1977.

Lamm, Carl Johan. *Mittelalterliche Gläser und Steinschnittarbeiten aus dem Nahen Osten*. Vol. 5 of *Forschungen zur islamischen Kunst*, edited by Friedrich Sarre. 2 vols. Berlin, 1930.

Lane, Arthur. *Victoria and Albert Museum, Department of Ceramics: A Guide to the Collection of Tiles*. London, 1939.

———. *Italian Porcelain, with a Note on Buen Retiro*. London, 1954.

———. *Later Islamic Pottery: Persia, Syria, Egypt, Turkey*. London, 1957.

Lane, Frederic C. *Venice: A Maritime Republic*. Baltimore and London, 1973.

Lavin, Marilyn Aronberg. *Piero della Francesca: The Flagellation*. New York, 1972.

———. *Piero della Francesca: San Francesco, Arezzo*. New York, 1994.

Lawton, John. *Samarkand and Bukhara*. London, 1991.

Legature papali da Eugenio IV a Paolo VI. Exh cat., Biblioteca Apostolica Vaticana, Vatican City. Rome, 1977.

Lehman, Phyllis Williams. *Cyriacus of Ancona's Egyptian Visit and Its Reflections in Gentile Bellini and Hieronymus Bosch*. New York, 1978.

Lemberg, Mechthild. *Abegg-Stiftung Bern in Riggisberg*. Vol. 2, *Textilien*. Bern, 1973.

Levathes, Louise. *When China Ruled the Seas: The Treasure Fleet of the Dragon Throne, 1405–1433*. New York and Oxford, 1994.

Levi, Alberto. "Architectural Motifs in Early Turkish Rugs." *Oriental Carpet and Textile Studies* 5, no. 1 (1999): 41–46.

Lewis, Bernard. *The Muslim Discovery of Europe*. New York and London, 1982.

Lightbown, Ronald W. "Oriental Art and the Orient in Late Renaissance and Baroque Italy." *Journal of the Warburg and Courtauld Institutes* 32 (1969): 228–279.

———. *Donatello and Michelozzo: An Artistic Partnership and Its Patrons in the Early Renaissance*. 2 vols. London, 1980.

———. "L'esoticismo." In *Storia dell'arte italiana*, edited by Giulio Einaudi, 10:445–487. Turin, 1981.

———. *Mantegna*. Oxford, 1986.

———. *Piero della Francesca*. New York, London, and Paris, 1992.

The Lion of Venice: Studies and Research on the Bronze Statue in the Piazzetta. Edited by Bianca Maria Scarfi. Venice, 1990.

Liverani, Giuseppe. *Five Centuries of Italian Majolica*. New York, 1960.

Lomazzi, Anna. "Primi Monumenti del Volgare." In *Storia della cultura veneta*. 1:602–629. Vicenza, 1976.

Lopez, Roberto S. "Venezia e le grande linee dell'espansione commerciale nel secolo XIII." In *La civiltà veneziano nel secolo di Marco Polo*, edited by Riccardo Bacchelli, 39–82. Florence, 1955.

———. "Il problema della bilancia dei pagamenti nel commercio di Levante." In *Venezia e il Levante fino al secolo XV*, edited by Agostino Pertusi. Atti del I convegno internazionale di storia della civiltà veneziana, Venice, 1968. Vol. 1, pt. 1: 431–452. Florence, 1973.

———. "I successori di Marco Polo e la febbre della seta." In *Marco Polo, Venezia e l'Oriente*, edited by Alvise Zorzi, 289–290. Milan, 1981.

Lorenzoni, Giovanni. "Sui problematici rapporti tra l'archittetura veneziana e quella islamica." In *Venezia e l'Oriente Vicino*, edited by Ernst J. Grube, 101–110. Atti del primo congresso internazionale sull'arte veneziana e l'arte islamica. Venice, 1989.

Lucchetta, Giuliano. "L'Oriente Mediterraneo nella cultura di Venezia tra il Quattro e il Cinquecento." In *Storia della cultura veneta: Dal primo Quattrocento al Concilio di Trenta*. Vol. 3, pt. 2: 375–432. Vicenza, 1980.

———. "Viaggiatori e racconti di viaggi nel Cinquecento." In *Storia della cultura veneta: Dal primo Quattrocento al Concilio di Trenta*. Vol. 3, pt. 2: 433–489. Vicenza, 1980.

Lydecker, John Kent. "The Domestic Setting of the Arts in Renaissance Florence." Ph.D. diss., Johns Hopkins University, 1987.

Mack, Rosamond E. "Lotto: A Carpet Connoisseur." In *Lorenzo Lotto: Rediscovered Master of the Renaissance*. Exh. cat., National Gallery of Art, Washington; Accademia Carrara di Belle Arti, Bergamo; and Galeries Nationales du Grand Palais, Paris, 59–67. Washington, New Haven, Conn., and London, 1997.

Mackie, Louise W. "Rugs and Textiles." In *Turkish Art,* edited by Esin Atil, 299–373. Washington, 1980.

———. "Toward an Understanding of Mamluk Silks: National and International Considerations." *Muqarnas* 2 (1984): 127–146.

Magagnato, Licisco, ed. *Le stoffe di Cangrande: Ritrovamenti e ricerche sul '300 veronese.* Florence, 1983.

Maginnis, Hayden B. J. *Painting in the Age of Giotto: A Historical Reevaluation.* University Park, Pa., 1977.

Mann, Horace K. *The Lives of the Popes in the Middle Ages.* 18 vols. London, 1902–1932.

Marchini, Giuseppe. *Le vitrate dell'Umbria.* Rome, 1973.

Mariaux, Pierre-Alain. *La Majolique: La faïence italienne et son décor dans les collections suisses XVème–XVIIème siècles.* Exh. cat., Musée Historique de Lausanne. Geneva, 1995.

Martin, Rebecca. *Textiles in Daily Life in the Middle Ages.* Exh. cat., Cleveland Museum of Art. Bloomington, Ind., 1985.

Martindale, Andrew. *Simone Martini.* Oxford, 1988.

Maser, Edward A. "European Imitators and Their Wares." In John Carswell, *Blue and White: Chinese Porcelain and Its Impact on the Western World,* 37–42. Exh. cat., David and Arthur Smart Gallery, University of Chicago. Chicago, 1985.

Mason Rinaldi, Stefania. "Le virtù della Repubblica e le gesta dei capitani: Dipinti votivi, ritratti, Pietà." In *Venezia e la difesa del Levante: Da Lepanto a Candia, 1570–1670.* Exh. cat., Arsenale, Venice. Venice, 1986.

May, Florence Lewis. *Silk Textiles of Spain, Eighth to Fifteenth Century.* New York, 1957.

Medley, Margaret. "Chinese Ceramics and Islamic Design." In *The Westward Influence of the Chinese Arts from the Fourteenth to the Eighteenth Century,* edited by William Watson, 1–10. Colloquies on Art and Archaeology in Asia, no. 3, University of London. London, 1972.

The Meeting of Two Worlds: The Crusades and the Mediterranean Context. Exh. cat., University of Michigan Museum of Art. Ann Arbor, 1981.

Meiss, Millard. *Andrea Mantegna as Illuminator: An Episode in Renaissance Art, Humanism, and Diplomacy.* New York, 1957.

Melikian-Chirvani, Assadulla Souren. "Venise, entre l'orient et l'occident." *Bulletin d'études orientales* (Institut Français de Damas) 27 (1974): 109–126.

Meyer zur Capellen, Jürg. *Gentile Bellini.* Stuttgart, 1985.

Mills, John. *Carpets in Pictures.* Themes and Painters in the National Gallery, 2d ser., no. 1. London, 1975.

———. "Early Animal Carpets in Western Paintings—a Review." *Hali* 1, no. 3 (1978): 234–243.

———. "Small Pattern Holbein Carpets in Western Paintings." *Hali* 1, no. 4 (1978): 326–334.

———. "Eastern Mediterranean Carpets in Western Paintings." *Hali* 4, no. 1 (1981): 53–55.

———. "Three Further Examples." *Hali* 3, no. 3 (1981): 217.

———. "Lotto Carpets in Western Paintings." *Hali* 3, no. 4 (1981): 278–289.

———. "Carpets in Paintings: The 'Bellini,' 'Keyhole,' or 'Re-entrant' Rugs." *Hali* 13, no. 4 (1991): 86–103.

Molinier, Émile. *Inventaire du trésor du Saint Siège sous Boniface VIII (1295).* Paris, 1888.

Molmenti, Pompeo Gherardo. *La storia di Venezia nella vita privata dalle origini alla caduta della repubblica.* 7th ed. 3 vols. Bergamo, 1928.

Monnas, Lisa. "Developments in Figured Velvet Weaving in Italy during the Fourteenth Century." *Bulletin du Centre International d'Étude des Textiles Anciens* 63–64 (1986): 63–100.

Moore Valeri, Anna. "Florentine 'Zaffera a rilievo' Maiolica: A New Look at the 'Oriental Influence.'" *Archeologia medievale* 9 (1984): 477–500.

———. "La foglia di quercia: Le sue origini ed il suo sviluppo." *Faenza* 79 (1993): 128–134.

Moule, Arthur Christopher, and Paul Pelliot, eds. *Marco Polo: The Description of the World.* 2 vols. London, 1976.

Necipoğlu, Gülru. "Süleyman the Magnificent and the Representation of Power in the Context of Ottoman-Hapsburg-Papal Rivalry." *Art Bulletin* 71 (1989): 401–427.

Needham, Paul. *Twelve Centuries of Bookbinding, 400–1600.* New York and London, 1960.

Newby, Martine S. "The Cavour Vase and Gilt and Enamelled Mamluk Colored Glass." In *Gilded and Enamelled Glass from the Middle East,* edited by Rachel Ward, 35–39. Papers given at a conference at the British Museum, London, April 1995. London, 1998.

Newett, Mary Margaret. *Canon Pietro Casola's Pilgrimage to Jerusalem.* Manchester, 1907.

Newton, Stella Mary. "Tomaso da Modena, Simone Martini, Hungarians, and St. Martin." *Journal of the Warburg and Courtauld Institutes* 48 (1980): 234–238.

Offner, Richard. *The Fourteenth Century: Bernardo Daddi, His Shop and Following.* Vol. 3, pt. 4 of *A Critical and Historical Corpus of Florentine Painting,* edited by Miklós Boskovits. Florence, 1991.

Okey, Thomas. *The Old Venetian Palaces and Old Venetian Folk.* London, 1907.

Olschki, Leonardo. "Asiatic Exoticism in Italian Art of the Early Renaissance." *Art Bulletin* 26 (1944): 95–106.

Omodeo, Anna. *Mostra di stampe popolari venete del '500.* Exh.

cat., Gabinetto di Disegni e Stampe degli Uffizi, Florence, no. 20. Florence, 1965.

Origo, Iris. "The Domestic Enemy: The Eastern Slaves in Tuscany in the Fourteenth and Fifteenth Centuries." *Speculum* 30, no. 3 (July 1955): 321–366.

Öz, Tashin. *Turkish Textiles and Velvets, Fourteenth–Sixteenth Centuries.* Ankara, 1950.

The Painted Page: Italian Renaissance Book Illumination, 1450–1550. Edited by Jonathan J. G. Alexander. Exh. cat., Royal Academy of Arts, London, and Pierpont Morgan Library, New York. Munich and New York, 1994.

Pallucchini, Rodolfo. *Bassano.* Bologna, 1982.

Peroni, Adriano, ed. *Il Duomo di Pisa.* 3 vols. Modena, 1995.

Perrot, Paul N. *Three Great Centuries of Venetian Glass.* Exh. cat., Corning Museum of Glass, Corning, N.Y. New York, 1958.

Petech, Luciano. "Les marchands italiens dans l'empire mongol." *Journal asiatique* 250 (1962): 549–574.

Petsopoulos, Yanni, ed. *Tulips, Arabesques, and Turbans: Decorative Arts from the Ottoman Empire.* New York, 1982.

Piccolpasso, Cipriano. *I tre libri dell'arte del vasaio.* Translated and edited by Ronald Lightbown and Alan Caiger-Smith. 2 vols. London, 1980.

Pinder-Wilson, Ralph. "Islamic Glass Twelfth–Fifteenth Centuries." In *Glass: Five Thousand Years,* edited by Hugh Tait, 126–136. New York, 1991.

Pinner, Robert, and Michael Franses. "The East Mediterranean Carpet Collection in the Victoria and Albert Museum." *Hali* 4, no 1 (1981): 37–52.

Pinner, Robert, and Jackie Stanger. "'Kufic' Borders on 'Small Pattern Holbein' Carpets." *Hali* 1, no. 4 (1978): 335–338.

Pisanello: Le peintre aux sept vertus. Exh. cat., Musée du Louvre, Paris. Paris, 1996.

Pittenger, Robert. "A Miscellany in Oils." *Hali* 10, no. 2 (1988): 16–19.

Plinius Secundus. *The Natural History of Pliny.* Translated and annotated by John Bostock. Vol. 6. London, 1857.

Polignano, Flavia. "Maliarde e cortigiane: Titoli per una *damnatio:* Le dame di Vittore Carpaccio." *Venezia Cinquecento* 2, no. 3 (1992): 5–23.

Pope, Arthur Upham. *Persian Architecture: The Triumph of Form and Color.* New York, 1965.

Pope-Hennessy, John. *Paolo Uccello.* 2d ed. London and New York, 1969.

———. *Fra Angelico.* 2d ed. Ithaca, N.Y., 1974.

———. "The Madonna Reliefs by Donatello." *Apollo* 103 (March 1976): 172–191.

Poppe, Nicholas. *The Mongolian Monuments in Hp'ags-pa Script.* 2d ed. Translated and edited by John R. Krueger. Wiesbaden, 1957.

Prayer Rugs. Exh. cat., Textile Museum, Washington, and Montclair Art Museum, Montclair, N.J. Washington, 1984.

Prescott, Hilda Frances Margaret. *Friar Felix at Large: A Fifteenth-Century Pilgrimage to the Holy Land.* New Haven, Conn., 1950.

Preto, Paolo. *Venezia e turchi.* Florence, 1975.

Raby, Julian. *Venice, Dürer, and the Oriental Mode.* Hans Huth Memorial Studies, no 1. London, 1982.

———. "Exotica from Islam." In *The Origins of Museums: The Cabinet of Curiosities in Sixteenth- and Seventeenth-Century Europe,* edited by Oliver Impey and Arthur MacGregor, 251–258. Oxford, 1985.

———. "Court and Export, Part 1: Market Demands in Ottoman Carpets, 1450–1550," and "Court and Export, Part 2: The Uşak Carpets." *Oriental Carpet and Textile Studies* 2 (1986): 29–38, 177–187.

———. "Pride and Prejudice: Mehmed the Conqueror and the Italian Portrait Medal." In *Studies in the History of Art: Italian Medals,* 21:172–185. Washington, 1987.

———. "The European Vision of the Muslim Orient in the Sixteenth Century." In *Venezia e l'Oriente Vicino,* edited by Ernst J. Grube, 41–46. Atti del primo congresso internazionale sull'arte veneziana e l'arte islamica. Venice, 1989.

———. "Picturing the Levant." In *Circa 1492: Art in the Age of Exploration,* edited by Jay A. Levenson, 77–81. Exh. cat., National Gallery of Art, Washington. New Haven, Conn., and London, 1991.

———. "Costanzo da Ferrara." In *The Currency of Fame: Portrait Medals of the Renaissance,* edited by Stephen K. Sher, 87–89. Exh. cat., Frick Collection, New York, and National Gallery of Art, Washington. New York, 1994.

Raby, Julian, and Zeren Tanindi. *Turkish Bookbinding in the Fifteenth Century: The Foundation of the Ottoman Court Style.* Edited by Tim Stanley. London, 1993.

Rachewiltz, Igor de. *Papal Envoys to the Great Khan.* Stanford, Calif., 1971.

Rackham, Bernard. *Guide to Italian Maiolica.* London, 1933.

———. *Victoria and Albert Museum: Catalogue of Italian Maiolica.* 2d ed. 2 vols. London, 1977.

Radcliffe, Anthony, and Charles Avery. "The 'Chellini Madonna' by Donatello." *Burlington Magazine* 118, no. 879 (June 1976): 377–387.

Ravà, Béatrix. *Venise dans la littérature française depuis les origines jusqu'à la mort de Henri IV.* Paris, 1916.

Reath, Nancy Andrews. "Velvets of the Renaissance, from Europe and Asia Minor." *Burlington Magazine* 50, no. 291 (June 1927): 298–304.

Renzi, Lorenzo. "I primi volgarizzamenti: Il 'Cato' e il 'Panfilo' del Codice Saibante-Hamilton." In *Storia della cultura veneta,* 1:629–631. Vicenza, 1976.

Rice, D. Storm. "Arabic Inscriptions on a Brass Basin Made for Hugh IV of Lusignan." In *Studi orientalistici in onore di Giorgio Levi Della Vida,* 2:390–402. Rome, 1956.

Ricke, Helmut. "Neue Räume—neue Gläser: Die Sammlung des Kunstmuseums Düsseldorf nach der Wiedereröffnung." *Kunst und Antiquitäten* 3 (1985): 44–63.

Ridolfi, Carlo. *Le maraviglie dell'arte: Ovvero le vite degli illustri pittori veneti e dello stato, descritto da Carlo Ridolfi.* Edited by Detlev Freiherrn von Hadeln. 2 vols. Berlin, 1914. Reprint, Rome, 1965.

Robinson, Basil William. "Oriental Metalwork in the Gambier-Parry Collection." *Burlington Magazine* 109, no. 768 (March 1967): 169–173.

Roccasecca, Pietro. *Paolo Uccello: Le battaglie.* Milan, 1997.

Rodinson, Maxime. *Europe and the Mystique of Islam.* Translated by Roger Veinus. Seattle and London, 1987.

Rogers, J. Michael. "Carpets in the Mediterranean Countries, 1450–1550: Some Historical Observations." *Oriental Carpet and Textile Studies* 2 (1986): 13–28.

———. *The Topkapi Saray Museum: Costumes, Embroideries, and Other Textiles.* London, 1986.

———. "To and Fro: Aspects of Mediterranean Trade and Consumption in the Fifteenth and Sixteenth Centuries." In *Villes au Levant: Hommage à André Raymond.* Vols. 55–56 of *Revue du monde musulman et de la Méditerranée* (1990–1992): 57–74.

———. "The Gorgeous East: Trade and Tribute in the Islamic Empire." In *Circa 1492: Art in the Age of Exploration,* edited by Jay A. Levenson, 69–74. Exh. cat., National Gallery of Art, Washington. New Haven, Conn., and London, 1991.

———. "'Terra di Salonich, simile a la porcellana': Some Problems in the Identification and Attribution of Earlier Sixteenth Centruy Iznik Blue and White." In *Italian Renaissance Pottery,* edited by Timothy Wilson, 235–260. Papers written in association with a colloquium at the British Museum, London. Over Wallop, Hampshire, 1991.

———. "European Inventories as a Source for the Distribution of Mamluk Enamelled Glass." In *Gilded and Enamelled Glass from the Middle East,* edited by Rachel Ward, 69–73. Papers given at a conference at the British Museum, London, April 1995. London, 1998.

Rosenthal, Erwin. "The Crib of Greccio and Franciscan Realism." *Art Bulletin* 36 (1954): 57–60.

Ross, Janet, and Nelly Erichsen. *The Story of Pisa.* 1909. Reprint, Nedelen-Liechtenstein, 1970.

Rossabi, Morris. *Khubilai Khan: His Life and Times.* Berkeley and Los Angeles, 1988.

Safran, Linda. *San Pietro at Otranto: Byzantine Art in South Italy.* Rome, 1992.

Salimbeni, Fulvio. "I turchi in terrafirma." In *Venezia e i turchi: Scontri e confronti di due civiltà,* 232–243. Milan, 1985.

Santangelo, Antonio. *Tessuti d'arte italiani dal XII al XVIII secolo.* Milan, 1959.

Sanudo, Marin. *I diarii di Marino Sanuto.* 58 vols. Venice, 1879–1903.

Sarre, Friedrich. "Michelangelo und der türkische Hof." *Repertorium für Kunstwissenschaft* 32 (1909): 61–66.

Sauvaget, Jean. *Poteries Syro-Mésopotamiennes du XIVème siècle.* Documents d'études orientales de L'Institut Français de Damas, 1. Paris, 1932.

Scerrato, Umberto. *Metalli islamici.* Milan, 1966.

———. "Arte normanna e archaeologia islamica in Sicilia." In *I Normanni: Popolo d'Europa, 1030–1200,* edited by Mario D'Onofrio, 339–349. Exh. cat., Palazzo Venezia, Rome. Venice, 1994.

Schmidt, J. Heinrich. "Turkish Brocades and Italian Imitations." *Art Bulletin* 15 (1933): 374–383.

Scirè, Giovanna Nepi. "Le Lion de la Piazzetta dans la peinture vénitienne." In *The Lion of Venice: Studies and Research on the Bronze Statue in the Piazzetta,* edited by Bianca Maria Scarfi, 125–127. Venice, 1990.

Sellheim, Rudolf. "Die Madonna mit der Schahàda." In *Festschrift Werner Caskel zum siebzigsten Geburtstag 5. März 1966 gewidmet von Freunden und Schülern,* edited by Erwin Gräf, 308–315. Leiden, 1968.

Setton, Kenneth M. *Europe and the Levant in the Middle Ages and the Renaissance.* London, 1974.

———. *The Papacy and the Levant (1204–1571).* 4 vols. Philadelphia, 1976–1984.

Shalem, Avinoam. *Islam Christianized: Islamic Portable Objects in the Medieval Church Treasuries of the Latin West.* Vol. 7 of *Ars Faciendi.* Frankfurt am Main, 1996.

———. "Some Speculations on the Original Cases Made to Contain Enamelled Glass Beakers for Export." In *Gilded and Enamelled Glass from the Middle East,* edited by Rachel Ward, 64–67. Papers given at a conference at the British Museum, London, April 1995. London, 1998.

Shapley, Fern Rusk. *Catalogue of the Italian Paintings.* 2 vols. Washington, 1979.

Simmons, Pauline. *Chinese Patterned Silks.* New York, 1958.

Simon, Bruno. "I rappresentanti diplomatici veneziani a Costantinopoli." In *Venezia e i turchi: Scontri e confronti di due civiltà,* 56–69. Milan, 1985.

Simon-Cahn, Annabelle. "The Fermo Chasuble of St. Thomas Becket and Hispano-Mauresque Cosmological Silks: Some Speculations on the Adaptive Reuse of Textiles." *Muqarnas* 10 (1993): 1–5.

Siverio, Giambattista. "Maiolica veneziana del '500." In *Italian Renaissance Pottery,* edited by Timothy Wilson,

136–140. Papers written in association with a colloquium at the British Museum, London. Over Wallop, Hampshire, 1991.

Smart, Alastair. *The Assisi Problem and the Art of Giotto.* Oxford, 1971.

———. *The Dawn of Italian Painting, 1250–1400.* Ithaca, N.Y., 1978.

Smith, Christine. *The Baptistery of Pisa.* New York and London, 1978.

Soulier, Gustave. *Les influences orientales dans la peinture toscane.* Paris, 1924.

Spallanzani, Marco. *Ceramiche orientali a Firenze nel Rinascimento.* Florence, 1978.

———. "Ceramiche nelle raccolte medicee da Cosimo I a Ferdinando I." In Candace Adelson et al., *Le arti del principato mediceo,* 73–94. Florence, 1980.

———. "Metalli islamici nelle collezioni medicee dei secoli XV–XVI." In Candace Adelson et al., *Le arti del principato mediceo,* 95–115. Florence, 1980.

———. "Fonti archivistiche per lo studio dei rapporti fra Italia e l'Islam: Le arti minori nei secoli XIV–XVI." In *Venezia e l'Oriente Vicino,* edited by Ernst J. Grube, 83–100. Atti del primo congresso internazionale sull'arte veneziana e l'arte islamica. Venice, 1989.

Spallanzani, Marco, and Giovanna Gaeta Bertelà. *Libro d'inventario dei beni di Lorenzo il Magnifico.* Florence, 1992.

Spittle, S. D. T. "Cufic Lettering in Christian Art." *Archaeological Journal* 111 (1954): 138–152.

Spriggs, A. I. "Oriental Porcelain in Western Paintings, 1450–1700." *Transactions of the Oriental Ceramic Society* 36 (1964–1966): 73–87.

Spufford, Peter. *Handbook of Medieval Exchange.* London, 1986.

Spuhler, Friedrich. *Die Orientteppiche im Museum für Islamische Kunst Berlin.* Veröffentlichen des Museums für Islamische Kunst, 1. Berlin, 1987.

———. "Carpets and Textiles." In *Islamic Art in the Keir Collection,* edited by Basil William Robinson, 49–106. London and Boston, 1988.

Stack, Lotus. *The Pile Thread: Carpets, Velvets, and Variations.* Exh. cat., Minneapolis Institute of Arts. Minneapolis, Minn., 1991.

St. Clair, Alexandrine N. *The Image of the Turk in Europe.* Exh. cat., Metropolitan Museum of Art, New York. New York, 1973.

Stubblebine, James H. *Duccio di Buoninsegna and His School.* 2 vols. Princeton, N.J., 1979.

Suida, Wilhelm. "New Light on Titian's Portraits—II." *Burlington Magazine* 68, no. 399 (June 1936): 281–283.

Tait, Hugh. *The Golden Age of Venetian Glass.* London, 1979.

———. ed. *Glass: Five Thousand Years.* New York, 1991.

Tanaka, Hidemichi. "Giotto and the Influences of the Mongols and the Chinese on His Art." *Art History* (Tohoku University, Japan) 6 (1984): 1–15.

———. "Oriental Script in the Paintings of Giotto's Period." *Gazette des Beaux-Arts,* 6th ser., 113 (1989): 214–226.

———. "Arabism in Fifteenth-Century Italian Painting." *Art History* (Tohoku University, Japan) 19 (1997): 1–22.

La terre du Bouddha: Jérusalem, Rome et le Grand Khan. Exh. cat., Musée National des Arts Asiatiques, Guimet. Paris, 1994.

Tesori d'arte dei musei diocesani. Edited by Pietro Amato. Exh. cat., Castel Sant'Angelo, Vatican City. Turin, 1986.

Il Tesoro di Lorenzo il Magnifico, Le Gemme. Vol. 1. Edited by Nicole Decos, Antonio Giuliano, and Ulrico Pannuti. Exh. cat., Palazzo Medici-Riccardi, Florence. Florence, 1973.

Thornton, Peter. *The Italian Renaissance Interior, 1400–1600.* New York, 1991.

Titian: Prince of Painters. Exh. cat., Palazzo Ducale, Venice, and National Gallery of Art, Washington. Venice, 1990.

Tonghini, Cristina. "Il periodo Burji (784/1328–923/1517)." In *Eredità dell'Islam: Arte islamica in Italia,* edited by Giovanni Curatola, 283–285. Exh. cat., Palazzo Ducale, Venice. Venice, 1993.

Tongiorgi, Liana, and Graziella Berti. "Bacini della Chiesa di San Martino a Pisa databili al secolo XIV." In *Atti, IV convegno internazionale della ceramica,* 307–316. Albisola, 1971.

Toulmin, Rachel Meoli. "Pisan Geometric Patterns of the Thirteenth Century and the Islamic Sources." *Antichità Viva* 16, no. 1 (1977): 3–12.

The Treasury of San Marco, Venice. Exh. cat., Metropolitan Museum of Art, New York. Milan, 1984.

Tucci, Ugo. "Mercanti, viaggiatori, pellegrini nel Quattrocento." In *Storia della cultura veneta: Dal primo Quattrocento al Concilio di Trenta.* Vol. 3, pt. 2: 317–353. Vicenza, 1980.

———. "Il commercio veneziano e l'oriente al tempo di Marco Polo." In *Marco Polo, Venezia e l'Oriente,* edited by Alvise Zorzi, 41–68. Milan, 1981.

———. "Tra Venezia e mondo turco: I mercanti." In *Venezia e i turchi: Scontri e confronti di due civiltà,* 38–55. Milan, 1985.

Varoli Piazza, Rosalia. "La produzione di manufatti tessili nel Palazzo Reale di Palermo: 'Tiraz' o 'ergasterion.'" In *I Normanni: Popolo d'Europa, 1030–1200,* edited by Mario D'Onofrio, 288–290. Exh. cat., Palazzo Venezia, Rome. Venice, 1994.

Varriano, John. "Caravaggio and the Decorative Arts in the Two *Suppers at Emmaus.*" *Art Bulletin* 58 (1986): 218–224.

Varthema, Ludovico de. *The Travels of Ludovico di Varthema in Egypt, Syria, Arabia Deserta, and Arabia Felix, in Persia, India, and Ethiopia,* A.D. *1503 to 1508.* Translated by John

Winter Jones and edited by George Percy Badger. Hakluyt Society Publications, 1st ser., vol. 32. London, 1863.

Vasari, Giorgio. *Le vite de' più eccellenti pittori scultori e architettori.* Edited by Rosanna Bettorini and Paola Barocchi. 6 vols. Florence, 1966.

Venezia e l'Oriente Vicino. Edited by Ernst J. Grube. Atti del primo congresso internazionale sull'arte veneziana e l'arte islamica. Venice, 1989.

Ventrone Vasallo, Giovanna. "La Sicilia islamica e postislamica dal IV/X al VII/XIII secolo." In *Eredità dell'Islam: Arte islamica in Italia,* edited by Giovanni Curatola, 183–193. Exh. cat., Palazzo Ducale, Venice. Venice, 1993.

Verità, Marco. "Analyses of Early Enamelled Venetian Glass: Comparison with Islamic Glass." In *Gilded and Enamelled Glass from the Middle East,* edited by Rachel Ward, 129–134. Papers given at a conference at the British Museum, London, April 1995. London, 1998.

Verlinden, Charles. *L'esclavage dans l'Europe médiévale.* 2 vols. Ghent, 1977.

Vickers, Michael. "Some Preparatory Drawings for Pisanello's Medallion of John VIII Paleologus." *Art Bulletin* 60 (1978): 417–424.

Villa, Massimo. "Gentile e la politica del 'sembiante' a Stambul." In *Venezia e i turchi: Scontri e confronti di due civiltà,* 160–185. Milan, 1985.

Visit to the Holy Places of Egypt, Sinai, Palestine, and Syria in 1384 by Frescobaldi, Gucci, and Sigoli. Translated by Theophilius Bellorini and Eugene Hoade, preface and notes by Bellarimo Bagatti. Publications of the Studium Biblicum Franciscanum, no. 6. Jerusalem, 1948.

Wansbrough, John. "Venice and Florence in the Mamluk Commercial Privileges." *Bulletin of the School of Oriental and African Studies* 28 (1965): 483–452.

Warburg, Aby. *Gesammelte Schriften.* 2 vols. Leipzig and Berlin, 1932.

Ward, Rachel. "Metallarbeiten der Mamluken-Zeit: Hergestellt für den Export nach Europa." In *Europa und der Orient, 800–1900,* edited by Gereon Sievernich and Hendrik Budde, 202–209. Exh. cat., Berliner Festspiele. Berlin, 1989.

———. "Incense and Incense Burners in Mamluk Egypt and Syria." In *Transactions of the Oriental Ceramic Society, 1990–1991,* 67–82. London, 1992.

———. *Islamic Metalwork.* New York, 1993.

———. "Glass and Brass: Parallels and Puzzles." In *Gilded and Enamelled Glass from the Middle East,* edited by Rachel Ward, 30–34. Papers given at a conference at the British Museum, London, April 1995. London, 1998.

Ward-Jackson, Peter. "Some Main Streams and Tributaries in European Ornament, 1500–1750, II." *Victoria and Albert Museum Bulletin* 3 (1967): 90–104.

Wardwell, Anne E. "The Stylistic Development of Fourteenth- and Fifteenth-Century Italian Silk Design." *Aachener Kunstblätter* 47 (1976–1977): 177–226.

———. "Flight of the Phoenix: Crosscurrents in Late Thirteenth- to Fourteenth-Century Silk Patterns and Motifs." *Bulletin of the Cleveland Museum of Art* 74 (1987): 2–35.

———. "*Panni tartarici:* Eastern Islamic Silks Woven with Gold and Silver, Thirteenth and Fourteenth Centuries." *Islamic Art* 3 (1988–1989): 95–174.

———. "Two Silk and Gold Textiles of the Early Mongol Period." *Bulletin of the Cleveland Museum of Art* 79 (1992): 354–378.

———. "Important Asian Textiles Recently Acquired by the Cleveland Museum of Art." *Oriental Art* 38, no. 4 (winter 1992–1993): 244–251.

Watson, Wendy M. *Italian Renaissance Maiolica from the William A. Clark Collection.* Exh. cat., Corcoran Gallery of Art, Washington, and Mount Holyoke College Art Museum, South Hadley, Mass. London, 1986.

Watt, James C. Y., and Anne Wardwell. *When Silk Was Gold: Central Asian and Chinese Textiles.* Exh. cat., Metropolitan Museum of Art, New York, and Cleveland Museum of Art, Cleveland. New York, 1997.

Weibel, Adèle Coulin. *Two Thousand Years of Textiles: The Figured Textiles of Europe and the Near East.* New York, 1972.

Weiss, Roberto. "Ciriaco d'Ancona in Oriente." In *Venezia e l'Oriente fra tardo Medioevo e Rinascimento,* edited by Agostino Pertusi, 323–337. Corso internazionale di alta cultura 5, Venice, 1963. Florence, 1966.

———. *Pisanello's Medallion of the Emperor John VIII Paleologus.* Oxford, 1966.

Wethey, Harold E. *The Paintings of Titian.* Vol. 2, *The Portraits.* London, 1971.

White, John. *Art and Architecture in Italy, 1250–1400.* 2d ed. London, 1987.

Whitehouse, David. "La Liguria e la ceramica medievale nel Mediterraneo." In *Atti, IV convegno internazionale della ceramica,* 263–294. Albisola, 1971.

———. "The Origins of Italian Maiolica." *Archaeology* 31 (March 1978): 42–49.

Wiet, Gaston. *Catalogue général du Musée Arabe du Caire: Lampes et bouteilles en verre émaillé.* Cairo, 1929.

Wilckens, Leonie von. *Staatliche Museen zu Berlin, Kunstgewerbemuseum, Kataloge: Mittelalterliche Seidenstoffe.* Berlin, 1992.

———. *Herzog Anton Ulrich-Museum, Braunschweig: Die mittelalterlichen Textilien, Katalog der Sammlung.* Braunschweig, 1994.

Wilson, Timothy. "Maiolica in Renaissance Venice." *Apollo* 125 (1987): 184–189.

———. "Renaissance Ceramics." In Rudolf Distelburger et al., *Western Decorative Arts, Part I: Medieval, Renaissance, and Historicizing Styles, Including Metalwork, Enamels, and Ceramics.* Collections of the National Gallery of Art: Systematic Catalogue, 119–241. Milan, 1993.

Wixom, William. "A Venetian Mariegola Miniature." *Bulletin of the Cleveland Museum of Art* 48 (1961): 206–211.

Wolbach, Wolfgang Fritz. *Catalogo della Pinacoteca Vaticana I: dipinti dal X secolo fino a Giotto.* Vatican City, 1979.

Wooley, Linda. "Spanish Textiles." *Hali* 17, no. 3 (1995): 66–75.

Yule, Henry, trans. and ed. *Cathay and the Way Thither.* Vol. 3, *Missionary Friars—Rashiduddin—Pegolotti—Marignolli.* Hakluyt Society Publications, 2d ser., vol. 37. London, 1914.

Zakariya, Mohamed. "Islamic Calligraphy: A Technical Overview." In *Brocade of the Pen: The Art of Islamic Writing,* edited by Carol Garret Fisher, 1–18. Exh. cat., Kresge Art Museum, Michigan State University, East Lansing. East Lansing, Mich., 1991.

Zampetti, Pietro. "L'oriente del Carpaccio." In *Venezia e l'Oriente fra tardo Medioevo e Rinascimento,* edited by Agostino Pertusi, 511–526. Corso internazionale di alta cultura 5, Venice, 1963. Florence, 1966.

———. *Carlo Crivelli.* Florence, 1986.

———. ed. *Il "Libro di spese diverse" con aggiunta di lettere e altri documenti.* Venice and Rome, 1969.

Zeri, Federico. *Italian Paintings in the Walters Gallery of Art.* 2 vols. Baltimore, 1976.

Zick, Johanna. "Eine Gruppe von Gebetsteppichen und ihre Datierung." *Berliner Museum: Berichte aus den ehemalig Preussischen Kunstsammlungen* 11 (September 1961): 6–14.

Photographic Credits

■■■

Numbers at the end of each entry refer to figures.

Index

....................................

Page numbers in italics refer to illustrations.

Designer Nola Burger
Compositor Integrated Composition Systems, Inc.
Text 10/13.25 Dante
Display Scala Sans
Map Bill Nelson
Printer and Binder Tien Wah